PALGRAVE STUDIES IN THEATRE AND PERFORMANCE HISTORY is a series devoted to the best of theatre/performance scholarship currently available, accessible, and free of jargon. It strives to include a wide range of topics, from the more traditional to those performance forms that in recent years have helped broaden the understanding of what theatre as a category might include (from variety forms as diverse as the circus and burlesque to street buskers, stage magic, and musical theatre, among many others). Although historical, critical, or analytical studies are of special interest, more theoretical projects, if not the dominant thrust of a study, but utilized as important underpinning or as a historiographical or analytical method of exploration, are also of interest. Textual studies of drama or other types of less traditional performance texts are also germane to the series if placed in their cultural, historical, social, or political and economic context. There is no geographical focus for this series and works of excellence of a diverse and international nature, including comparative studies, are sought.

The editor of the series is Don B. Wilmeth (Emeritus, Brown University), PhD, University of Illinois, who brings to the series over a dozen years as editor of a book series on American theatre and drama, in addition to his own extensive experience as an editor of books and journals. He is the author of several award-winning books and has received numerous career achievement awards, including one for sustained excellence in editing from the Association for Theatre in Higher Education.

Also in the Series

Undressed for Success by Brenda Foley
Theatre, Performance, and the Historical Avant-garde by Günter Berghaus
Theatre, Politics, and Markets in Fin-de-Siècle Paris by Sally Charnow
Ghosts of Theatre and Cinema in the Brain by Mark Pizzato
Moscow Theatres for Young People: A Cultural History of Ideological Coercion and Artistic Innovation, 1917–2000 by Manon van de Water
Absence and Memory in Colonial American Theatre by Odai Johnson
Vaudeville Wars: How the Keith-Albee and Orpheum Circuits Controlled the Big-Time and Its Performers by Arthur Frank Wertheim
Performance and Femininity in Eighteenth-Century German Women's Writing by Wendy Arons
Operatic China: Staging Chinese Identity across the Pacific by Daphne P. Lei
Transatlantic Stage Stars in Vaudeville and Variety: Celebrity Turns by Leigh Woods
Interrogating America through Theatre and Performance edited by William W. Demastes and Iris Smith Fischer
Plays in American Periodicals, 1890–1918 by Susan Harris Smith
Representation and Identity from Versailles to the Present: The Performing Subject by Alan Sikes
Directors and the New Musical Drama: British and American Musical Theatre in the 1980s and 90s by Miranda Lundskaer-Nielsen
Beyond the Golden Door: Jewish-American Drama and Jewish-American Experience by Julius Novick
American Puppet Modernism: Essays on the Material World in Performance by John Bell

On the Uses of the Fantastic in Modern Theatre: Cocteau, Oedipus, and the Monster
by Irene Eynat-Confino
Staging Stigma: A Critical Examination of the American Freak Show by Michael M.
Chemers, foreword by Jim Ferris
Performing Magic on the Western Stage: From the Eighteenth-Century to the Present
edited by Francesca Coppa, Larry Hass, and James Peck, foreword by Eugene Burger
Memory in Play: From Aeschylus to Sam Shepard by Attilio Favorini
Danjūrō's Girls: Women on the Kabuki Stage by Loren Edelson
Mendel's Theatre: Heredity, Eugenics, and Early Twentieth-Century American Drama
by Tamsen Wolff
Theatre and Religion on Krishna's Stage: Performing in Vrindavan by David V. Mason
Rogue Performances: Staging the Underclasses in Early American Theatre Culture
by Peter P. Reed
*Broadway and Corporate Capitalism: The Rise of the Professional-Managerial Class,
1900–1920* by Michael Schwartz
Lady Macbeth in America: From the Stage to the White House by Gay Smith
Performing Bodies in Pain: Medieval and Post-Modern Martyrs, Mystics, and Artists
by Marla Carlson
*Early-Twentieth-Century Frontier Dramas on Broadway: Situating the Western
Experience in Performing Arts* by Richard Wattenberg
Staging the People: Community and Identity in the Federal Theatre Project
by Elizabeth A. Osborne
Russian Culture and Theatrical Performance in America, 1891–1933
by Valleri J. Hohman
Baggy Pants Comedy: Burlesque and the Oral Tradition by Andrew Davis
Transposing Broadway: Jews, Assimilation, and the American Musical
by Stuart J. Hecht
*The Drama of Marriage: Gay Playwrights/Straight Unions from Oscar Wilde to the
Present* by John M. Clum
*Mei Lanfang and the Twentieth-Century International Stage: Chinese Theatre Placed
and Displaced* by Min Tian
Hijikata Tatsumi and Butoh: Dancing in a Pool of Gray Grits by Bruce Baird
Staging Holocaust Resistance by Gene A. Plunka
Acts of Manhood: The Performance of Masculinity on the American Stage, 1828–1865
by Karl M. Kippola
Loss and Cultural Remains in Performance: The Ghosts of the Franklin Expedition
by Heather Davis-Fisch
Uncle Tom's Cabin on the American Stage and Screen by John W. Frick
Theatre, Youth, and Culture: A Critical and Historical Exploration
by Manon van de Water
Stage Designers in Early Twentieth-Century America: Artists, Activists, Cultural Critics
by Christin Essin
Audrey Wood and the Playwrights by Milly S. Barranger
Performing Hybridity in Colonial-Modern China by Siyuan Liu
A Sustainable Theatre: Jasper Deeter at Hedgerow by Barry B. Witham

The Group Theatre: Passion, Politics, and Performance in the Depression Era
 by Helen Chinoy and edited by Don B. Wilmeth and Milly S. Barranger
*Cultivating National Identity through Performance: American Pleasure Gardens and
 Entertainment* by Naomi J. Stubbs
Entertaining Children: The Participation of Youth in the Entertainment Industry
 edited by Gillian Arrighi and Victor Emeljanow
America's First Regional Theatre: The Cleveland Play House and Its Search for a Home
 by Jeffrey Ullom

America's First Regional Theatre

The Cleveland Play House and Its Search for a Home

Jeffrey Ullom

AMERICA'S FIRST REGIONAL THEATRE
Copyright © Jeffrey Ullom, 2014.

Softcover reprint of the hardcover 1st edition 2014 978-1-137-39434-7

All rights reserved.

First published in 2014 by
PALGRAVE MACMILLAN®
in the United States—a division of St. Martin's Press LLC,
175 Fifth Avenue, New York, NY 10010.

Where this book is distributed in the UK, Europe and the rest of the world, this is by Palgrave Macmillan, a division of Macmillan Publishers Limited, registered in England, company number 785998, of Houndmills, Basingstoke, Hampshire RG21 6XS.

Palgrave Macmillan is the global academic imprint of the above companies and has companies and representatives throughout the world.

Palgrave® and Macmillan® are registered trademarks in the United States, the United Kingdom, Europe and other countries.

ISBN 978-1-349-48388-4 ISBN 978-1-137-39435-4 (eBook)
DOI 10.1057/9781137394354

Library of Congress Cataloging-in-Publication Data

Ullom, Jeffrey, 1971–
　America's first regional theatre : the Cleveland Play House and its search for a home / by Jeffrey Ullom.
　　p. cm.—(Palgrave studies in theatre and performance history)
　　Includes index.

　　1. Cleveland Play House (Organization : Cleveland, Ohio)—History.
　I. Title.

PN2277.C572C547 2014
792.09771'32—dc23 2013045631

A catalogue record of the book is available from the British Library.

Design by Newgen Knowledge Works (P) Ltd., Chennai, India.

First edition: May 2014
10 9 8 7 6 5 4 3 2 1

The book is dedicated to Noel and Vaughn

Contents

List of Illustrations	xi
Preface	xiii
Acknowledgments	xv
Introduction	1
1. Building the House	9
2. Averting Disaster and Ignoring Cleveland	29
3. Learning Curve	55
4. "Catch These Vandals!"	75
5. Catering to Cleveland	95
6. Escaping No-Man's-Land	121
7. The "Endangered Theatre"	143
8. A Place to Call Home	175
Conclusion: The New "No-Man's-Land"	195
Notes	203
Bibliography	241
Index	265

Illustrations ~~

1.1	Raymond O'Neil, the first director of the Play House	17
2.1	*The Garden of Semiramis* at the Cedar Avenue Theatre, the earliest-known (and unfortunately blurry) production photo in the archives	36
2.2	O'Neil's brief resignation letter addressed to individual members of the Play House	52
3.1	Rehearsal in the Cedar Avenue Theatre. Sitting in the audience (left to right) are K. Elmo Lowe and Frederic McConnell	59
3.2	Auditorium seating for *After Quiet Pleasures* in the experimental Brooks Theatre	68
4.1	Cleveland's safety director Eliot Ness examines the hole in the roof caused by the firebomb	78
4.2	Members of Local 27 picket outside the Play House	81
5.1	Airman Donald Rauch in a photo sent to the Play House	96
5.2	Production photo of *Heavy Barbara* starring Voskovec and Werich in their clown attire	100
5.3	A sketch of the proposed 77th Street Theatre audience and stage	112
7.1	The Cleveland Play House complex under construction. The original Brooks and Drury Theatres are to the left of the rotunda	154
8.1	Interior of the new Allen Theatre at Playhouse Square	188

Preface

This entire project began with two denials, both within months of each other. The first occurred when I asked Cleveland Play House managing director Kevin Moore, if the theatre had conducted a survey of its current subscribers to gauge their support for the downtown relocation. "No," Moore stated. "It didn't matter, because if we stayed where we were, we'd be dead anyway."[1] The second denial occurred months later in the Cleveland Play House archives, situated in a back room of the massive theatre complex. Working tirelessly to arrange the materials into some semblance of order was archivist Kyra Price who worked part time for the theatre following her job at the Cleveland Museum of Art. Walking into the cinder block–walled room with high ceilings, one immediately saw the metal shelving holding rows and rows of cardboard boxes. Only some were clearly marked, as was the box "Famous Letters" containing correspondence from Tennessee Williams, George Bernard Shaw, Jacques Copeau, and a host of other legendary figures from the world of professional theatre. I stared in amazement at the sheer volume of information contained in this one room, detailing the 90-plus-year history of this legendary institution. At this point in time, I knew that I wanted to write about the Cleveland Play House, but I did not have any form of argument, and the disorganization of the archives made it seem like an impossible task. So, I resolved to start at the beginning, researching the earliest performances of the theatre that took place inside a house. I asked if could see a picture of the first performance space within the Ammon House, but Price denied my request because the archives did not contain a photo of the house or any record of the first performances.

This was a theatre without a defined past or a guaranteed future.

My determination to discover photographic evidence of the famed Ammon House led to numerous online searches and photograph collections in the Cleveland Public Library. Fire insurance maps from 1915 revealed that the Ammon House sat on a piece of land facing Euclid Avenue with two smaller buildings behind it. An old drawing labeled "Residence of Col. J. H. Ammon" taken from *Atlas of Cuyahoga County, Ohio* (1874), 41 years

before the establishment of the theatre, depicted three similar buildings.[2] However, this 1874 drawing featured a two-story dwelling, yet the earliest performances at the Ammon House occurred on the third floor. This discrepancy was confirmed when the compilation of fire insurance maps revealed a small, handwritten "3," signifying that whatever building stood at the corner of 86th St. and Euclid Avenue clearly had three floors. Another search of the Cleveland Public Library and the Cleveland Memory Project (through Cleveland State University) produced a hand-colored drawing titled "Residence of J. H. Ammon, Cleveland, OH," which was published six years after the first rendering.[3] In this picture, however, a larger, taller house was depicted, and the layout of the ground floor (the placement of the doors and the porch) matched with the one detailed on the 1915 fire insurance maps. Finally, I had the found the home of the Cleveland Play House.

The piecing together of five insurance maps and antiquated drawings in order to create a complete map of the 8600 block of Euclid Avenue serves as an appropriate metaphor for the process of researching this book. The collection of documents and photographs contained in the archives can be confusing, and I have tried to document as accurately as possible the contents of the archives and reference them appropriately given the continual processing of the collection. In piecing together a history of the theatre, an issue of taxonomy arose as titles frequently changed during the theatre's long existence. There are numerous examples: the governing body shifts between "Board of Trustees" and "Board of Directors"; the leader of the board is listed as either the "President" or the "Chairman"; and the first "Director" of the theatre later is referred to as the "Executive Director" and "Artistic Director" in various documents. I have chosen to keep the titles as they appear in the original documents. Concerning the theatre, the institution was named the "Play House" until 1993, and any mentioning of the "Cleveland Play House" before this event refers to the entire history of the organization (usually for comparison purposes).

Now, a final note concerning the use of archival material in this work. The Cleveland Play House Archives located in Kelvin Smith Library contains documents up to 2006. Documents taken from this collection are cited as "CPH Archives." Documents created in 2006 till the present are still held in the administrative offices of the Cleveland Play House, located in the Middough Building adjacent to Playhouse Square. Documents taken from this location will be called "Cleveland Play House Administrative Office Files ("CPHAOF"). At some point in the future, documents held at the Middough building will be transferred to the Kelvin Smith Library to join the larger collection.

Acknowledgments

This book has been made possible thanks to the contributions of many colleagues and friends who have offered constant encouragement throughout the years. I am indebted to those not only listed below, but also many unnamed students and families who offered a kind word or unconditional support during any moments of toil.

This book would not have been possible without research assistance from both the Cleveland Play House and the Kelvin Smith Library at Case Western Reserve University. In particular, I am indebted to Cleveland Play House managing director Kevin Moore for his generosity and unwavering support for this project, and my appreciation and thanks extend to others affiliated with the theatre, including Michael Bloom, Mark Alan Gordon, Laura Kepley, Dean Gladden, and the many staff and board members who were willing to be interviewed. From the Special Collections Research Center of the Kelvin Smith Library, thanks to Jill Tatem and Eleanor Blackman who accommodated every last-second request and helped me navigate the massive archives. In addition, I am grateful for university librarian Arnold Hirshon's continual support for this project.

I have been extraordinarily fortunate to benefit from generous and accommodating colleagues throughout the years, beginning at Vanderbilt University with Terryl Hallquist, Jon Hallquist, and Edward H. Friedman. My most heartfelt thanks goes to my friends and colleagues in the Department of Theater at Case Western Reserve University, including Catherine Albers, Jerrold Scott, and my chair, Ron Wilson. Furthermore, I am grateful for the sage advice offered by William Siebenschuh as well as John Orlock, John Grabowski, and John Vacha. Also, I have enjoyed overwhelming support from the dean Cyrus Taylor, and all who work in the office of the dean. Thanks to generous grants from the W. P. Jones Presidential Faculty Development Fund and the Glennan Fellows program, portions of research for this project were completed with the assistance of two students, Elizabeth Huddleston and Kelly McCready. In particular,

I am especially grateful to McCready for her exceptional work in editing early drafts of the manuscript and providing valuable criticism.

The enthusiasm for the project demonstrated by Don B. Wilmeth has allowed the book to be completed, and I thank him as well as Robyn Curtis, Erica Buchman, and all others at Palgrave Macmillan for making this book a reality.

As for my friends and family, I owe them an enormous debt of gratitude for their patience, affection, and support throughout this endeavor. My most heartfelt thanks to my beloved wife, Megan, my amazing parents, Bob and Peggy Ullom, to Melanie Alban who sacrificed many hours in support of this project, my inspiration Noel and Vaughn Ullom, James Ullom, Fabio Serafini, Jerry Portele, and Chad Eric Bergman.

Introduction

On May 3, 2012, the lobby lights flashed momentarily, alerting the audience to the imminent performance and prompting a rush toward the entrance of the Allen Theatre. Patrons proceeded up a slight incline and around a wall, finally able to view the entire auditorium and behold the splendor of the new theatre. Framed by a wooden proscenium arch, the large stage floor was populated with chairs and music stands, ready for the musicians to begin warming up for the performance. Any set decoration behind the orchestra was minimal at best, revealing the depth and height of the stage space. Looking around the auditorium, one could see metallic acoustic panels punctured by tiny holes so that the decorative paneling and artwork along the wall could be seen through the obstruction. Patrons took their seats in the intimate, 512-seat theatre as the lights dimmed and a brief curtain speech was given. Following a brief round of applause, the house darkened further, and a blue wash of lights colored the back wall of the theatre. The conductor ascended his platform, nodded to the audience, turned to face his orchestra, and raised his baton to initiate the performance. This was the new Cleveland Play House.

Tom Stoppard and composer André Previn's *Every Good Boy Deserves Favor* is unanimously heralded as one of the most brilliant, complex, and well-respected works of the last century. However, *Every Good Boy Deserves Favor* remains an anomaly in contemporary theatre in that it is rarely produced yet is considered one of the great theatrical works of the twentieth century. The Cleveland Play House's collaboration with the Cleveland Orchestra for the inaugural New Ground Theatre Festival was the first major professional production of this piece in northeast Ohio since the Cleveland Orchestra's limited presentation at Blossom Music Center in the 1980s.

This type of collaboration would have been unthinkable the previous year. The season before the Cleveland Play House had abandoned its massive complex at 8500 Euclid Avenue to move 71 blocks west to the Allen Theatre in downtown's Playhouse Square. The previous season, the

theatre offered a lineup of seven major productions—two adaptations of films (*The 39 Steps* and a one-man interpretation of *It's a Wonderful Life*) and three novels (*The Kite Runner*, *The Trip to Bountiful*, and *My Name is Asher Lev*). Of the two remaining productions, only Karen Zacarias's *Legacy of Light* served as an original work for the theatre; the seventh show, *Backward in High Heels*, depicted Ginger Roger's experiences in cinema yet relied on musical performances derived from her movies to entertain audiences.[1] In total, of the seven shows for the 2010–11 season, six productions were adaptations of another form, leading critics to wonder if the selections were a commentary on the status of American playwriting. In fact, the struggling finances of the institution once again dictated the populist play choices.

By May 2012, the Cleveland Play House was concluding its first season in its new home with an exciting and provocative production of *Every Good Boy Deserves Favor*, a fitting finish to a season that featured compelling and edgier plays, including Sarah Ruhl's *In the Next Room (or The Vibrator Play)*, John Logan's *Red*, and August Wilson's *Radio Golf*, not to mention a world premiere comedy by Ken Ludwig. Perhaps most astonishing was the play selected to open the new theatre, Bertolt Brecht's *Galileo*.[2] In a press release announcing the new season, Artistic Director Michael Bloom explained his reasoning: "'A new age is dawning and it's great to be alive' is a line from *Galileo*, the play kicking off our 2011–12 Season. It is a fitting sentiment for the rebirth of the Cleveland Play House."[3]

The selection of *Every Good Boy Deserves Favor* also served as an appropriate choice to conclude the Cleveland Play House's first season in its new theatre. A search for identity, if not clarity, informs the play in production. Exemplified by the contrast between the previous two years, the famed Cleveland theatre once again searched for its own identity, trying to define its role artistically and its relationship with the community. Such a drastic shift in programming was emblematic of the sweeping changes experienced by the Cleveland Play House, from near bankruptcy (again) to a new beginning that would be the envy of almost any artistic director in the country. When the Cleveland Play House moved downtown, it provided a fitting conclusion to the consistent theme presented throughout this work: the theatre in search of a home. An analysis of the artistic, administrative, and economic decisions throughout the theatre's history sheds light on the various risks taken by the theatre's leaders, who were all forced to take bold action out of necessity and shared a belief in the mission of the theatre. Whereas the theatre's prior attempts to achieve national acclaim (and its resulting troubles) may have hindered its connection with the community,

the move downtown brought the story of the Cleveland Play House full circle as, once again, the theatre's actions mirrored those of the city.

Obviously, the transition from one location to another is a complex story. When the Cleveland Play House decided to move from its original facility to an arts complex in downtown Cleveland, it did not have adequate space to preserve its massive archives. The entire content of the archives relocated to the Kelvin Smith Library on the Case Western Reserve University campus in December 2011. The collection contains over 1,300 boxes of programs, press clippings, photographs, letters, and numerous documents that not only detail the legacy of the legendary institution, but also the history of Cleveland and the development of culture in northeast Ohio over the past century. In these documents, one can not only discover which productions starred which actors and how much each production cost, but also learn about individuals off the stage and how the various artistic directors developed personal relationships with leaders of Cleveland industry and local politicians. It is fascinating to read correspondence from citizens expressing gratitude or concerns about specific productions, from young theatre artists submitting applications to the theatre's training program, or from theatre professionals around the globe supporting or criticizing the various decisions of the theatre's administration.

In total, it becomes evident that the history of the Cleveland Play House is far more complex than what is provided in the two published histories of the theatre, both written by individuals affiliated with the institution. Never before has an objective study of the history of the theatre been undertaken, and never before have the archives of the Cleveland Play House been available for public use. Utilizing the plethora of board meeting minutes, letters, financial records, newspaper clippings, and a host of other documents, a new history of the legendary theatre can be written that details how the theatre both echoed the development and endured the struggles of the city of Cleveland. The archives are key to providing insight not only to the history of the institution, but also to place it in the context of events occurring in its community. Just as the preferences and dictates of the city are reflected in the play selections (good or bad) and in audience attendance, the theatre mirrors the growth and/or decline of Cleveland through its administrative decisions, its physical presence, and its economic and philanthropic endeavors. Furthermore, due to the longevity of the theatre and the extent of the archives, the history of the Cleveland Play House also emulates trends in American theatre over the past century.

The Cleveland Play House has been a part of the city's cultural landscape for so long that most people have forgotten (or simply never knew) how the

theatre was founded or how it may have adapted to economic demands and popular tastes over the past century. In researching the archives, it is clear that as the city changed, the theatre changed too. Because of its longevity, taxonomy quickly became problematic when searching for the perfect descriptor of the institution. Currently, the Cleveland Play House describes itself as "America's first professional regional theatre."[4] The term "regional" is appropriate in a geographical sense, but the usage of "regional theatre" derives from the movement of the 1950s and 1960s when many respected theatre companies were founded in cities across the nation. The theatre has also referred to itself as a "resident theatre," but its actors did not join Equity until the 1950s, and such a term would be inappropriate today given that the "company" (or what was left of it) was unceremoniously disbanded in the 1980s. A slew of labels have been assigned to the theatre—art, Little, community, elitist, professional, and Progressive among others—and, at one point in time, all of these descriptions were accurate. The changing nature of the theatre reflected the changing nature of the city, and, by placing the history of the Cleveland Play House within the context of its community, a more complete and complex history of the theatre can be told.

The fact that two earlier books detailed productions (up to 1985) allowed this work to focus on the decisions of the theatre's leadership. Being alleviated of the burden of supplying a traditional history charting presentations and social events, this work can focus upon pivotal moments in the theatre's history and analyze how these events and decisions reflected concerns of the city as well. In an effort to uncover both the theatre's past and its future, *America's First Regional Theatre* follows a chronological approach yet does not offer a year-by-year accounting of the institution. The book begins with a first-ever exploration of the founding of the theatre, questioning not only how the theatre was organized, but also how the city-at-large viewed the new organization, both as an artistic endeavor and as a representation of society. In books and the theatre's oft-promoted history, a list of individuals who founded the theatre is frequently cited, but an explanation of who these people were, how they came together, how they may have been perceived by others in the community has never been provided. Because the Cleveland Play House was founded so long ago, it has been assumed by so many that the creation of the theatre was simple and well-supported, but new research suggests otherwise.

Once the theatre had been founded, it faced unforeseen troubles; how the theatre survived provides the focus of the second chapter. This section of the book unearths how the theatre struggled to define its own artistic

mission and find its place within the community. Financial difficulties and lackluster leadership resulted in the theatre enduring a heated battle among its members, further hampering the growth of the institution. The resolution brought about one of the most pivotal moments in the institution's history, and the ramifications of the event are explored in the third chapter. With new leadership and the theatre on firm financial footing, the expansion of the Cleveland Play House—both in size and in community outreach—provided a stark contrast to the first six years of the institution. As the theatre grew, questions arose as to the theatre's role in the community and how it compared to the nationally recognized Cleveland Museum of Art and the Cleveland Orchestra.

The first three chapters describe the earliest history of the theatre, a modest 14-year range from 1915 to 1929. The next three chapters, however, cover nearly six decades as the institution consistently struggled to validate its artistic mission in conjunction with the growing populist tastes of its patrons. In these three chapters, how the actions of the theatre mirrored those of the city become clear when examined in the context of three important developments: the rise of unions, the outbreak of World War II, and the racial tension that resulted in the Hough Riots. Together, these 60 years find the theatre enjoying financial success (mostly) yet coming to terms with its civic obligation and other external forces that greatly impacted both the perception of the theatre and its daily operations. For example, the firebombing of the Cleveland Play House serves as a springboard to examine not only how the rise of unions resulted in violence at the theatre, but also how the debate over organized labor led to violence and death throughout northeast Ohio. Furthermore, new research from the Cleveland Play House archives points to a motive for the firebombing, one never addressed by the local papers or by the leadership of the theatre.

The seventh chapter marks a shift in the book as the history of the Cleveland Play House is compared to the developments in the regional theatre movement. Since the 1950s, the Cleveland theatre increasingly turned its gaze toward the national landscape of professional theatre, wondering how to remain relevant and achieve great acclaim. With the passing of the decades, the theatre was being left behind as the Cleveland Play House found itself burdened by several questionable decisions made by its board of trustees and artistic directors. In a desperate move to receive national recognition, the board pursued two courses of action: the building of a massive theatre complex and the hiring of a nationally recognized artistic director. Unfortunately, both proved disastrous, and utilizing documents

from the archives as well as new interviews with former employees, a complete picture of this turbulent and controversial era of the Cleveland Play House can finally be told. Furthermore, when placed in the context of developments in regional theatre, the struggles of the Cleveland Play House appear even more dire than previously known.

The final chapter turns the story to full circle, examining the Cleveland Play House's much-celebrated move downtown into the Playhouse Square arts complex. The new construction, new financial realities, new outreach endeavors, and new energy all parallel similar developments in Cleveland's urban core. Just as the city is experiencing a youthful rejuvenation, so too is the theatre. In this final chapter, the theatre is seen to be enjoying a period of resolution—a time when many of the struggles and internal debates that the theatre faced throughout its existence have been addressed and concluded. A new hire marks a turning point for the theatre and prompts a discussion of the recent path taken by the theatre and the road that lies ahead for both the Cleveland Play House and the city itself.

In all of these chapters, several themes reappear, establishing a paradox of a theatre that celebrates its longevity yet fails to learn from its past mistakes in order to survive. Nevertheless, the theatre pressed on, signifying its constant battle to attain recognition and/or validation. Furthermore, the determination to expand the theatre inevitably led to fears of ruin, yet those in charge ignored many warning signs. By far, the most recognizable theme evident in the theatre's history is its search for a home. Throughout its long existence, the Cleveland Play House repeatedly strove to solidify its place in American theatre, to find its role within the community, to define (or redefine) its artistic purpose, and to locate to a new building.

To suggest that the theatre was continuously searching is not meant to imply that the theatre was lacking something significant. If anything, the notion of a theatre constantly evolving and searching for its future is a remarkable achievement, and the criteria for the "search" depended upon who was leading the theatre. Just as the city attempted to rebound from disastrous economic failures and violent racial tensions, so did the Cleveland Play House. The symbiotic relationship between the theatre and the city is unlike any other regional theatre in the country. The community feels such a strong sense of ownership for the theatre, mainly because the Cleveland Play House has been not only a mainstay in the city for nearly a century, but also a source of pride. For most of its existence, the theatre was simply known as the Play House, but the addition of "Cleveland" to its name was not only appropriate, but also told of the unique relationship

that exists between the theatre and its community. The theatre and the city both have labored, made mistakes, and survived to tell the tale. Until now, the tale of the Cleveland Play House was told from a limited perspective, but thanks to the release of the institutional archives and new research, a contextual history reveals a theatre and its continual search to define itself and to find where it belongs.

1. Building the House ∽

The seminal work on the history of regional theatre remains by default Joseph Wesley Zeigler's *Regional Theater*, despite the fact that it was published in 1973 and obviously fails to chart the many developments that have occurred since that time.[1] Zeigler's book is an interesting collection of research into the origins of many well-known regional theatres peppered with personal anecdotes and opinions on the various productions that he and others witnessed at these institutions. While often an insightful and amusing read, the book remains incomplete not only because of its limited information concerning contemporary developments, but also because it favors a few theatres while disregarding others that played an equally important role in the development of American theatre. In terms of charting the foundations of many of these institutions, Zeigler sufficiently details the development of the more well-known theatres by recounting the principal artists and the challenges that they faced, namely locating spaces, finding financial backers, attracting audiences, and the transition from amateur to professional status. Predictably, Zeigler recognized several of the nation's most famous theatres—the Alley Theatre in Houston, the Arena Stage in Washington, and the Mark Taper Forum in Los Angeles, all received a detailed description of their foundations while an entire chapter was dedicated to the renowned Guthrie Theater.

It is surprising, then, that the founding of the longest-running professional theatre in America is largely ignored in this book, summarized by Zeigler in one dismissive phrase: it was "begun by 'serious amateurs' and still going strong to this day."[2] Insightful research into the origins of Cleveland Play House has been neglected by every publication referring to the institution's beginnings, including Joseph Wesley Zeigler's *Regional Theatre* and Cleveland's own legendary newspaper, the *Plain Dealer*. When referring to the creation of the theatre (often in articles marking an anniversary), the *Plain Dealer* simply repeats a standard narrative first described in a book written by a participant in the Cleveland Play House's earliest endeavors. Julia McCune Flory, wife of the organization's influential

leader and author of one of the earliest histories of the Cleveland Play House, recalled the events leading to the founding of the Cleveland Play House, unknowingly providing a brief history that would remain unexamined for decades:

> In the early fall of 1915, Charles and Minerva Brooks invited eight friends to meet in their drawing room at 1598 East 115th Street to discuss the forming of an Art Theatre. Those present at this first meeting were Charles and Minerva Brooks, Raymond O'Neil, Ernest and Katharine Angell, Henry Hohnhorst and his wife Anna, George Clisbee, Grace Treat, and Marthena Barrie.[3]

While Flory's account is certainly sufficient in listing the key participants, it remains an overly simplistic narrative. Scholars who research the founding of arts institutions know that such effortless descriptions gloss over the various struggles and challenges that every organization faces in order to define its own aesthetics and form a cohesive and an effective group.

The context that Flory fails to record in her brief assessment prohibits a complete understanding of the individuals involved with this landmark artistic endeavor. Even though the Cleveland Play House and the local press repeated this list of names again and again in their publications, never has a full examination been performed to identify these individuals and their connection to each other. The absence of a complete analysis infers that the foundation of the Cleveland Play House was easy, welcome, and visionary, yet nothing could be further from the truth. Questions abound: What are the events and/or circumstances that brought this specific group of people together at this specific time? How were these people associated with the various arts groups that existed in the 1910s and the larger Cleveland society? Following this initial meeting, questions concerning the theatre's artistic goals and its place in the community lead to a reexamination of its location and the decision to move to Euclid Avenue where it remained for 84 years.

While the official history of the Cleveland Play House correctly states that the location of the theatre resulted from a generous donation from the Francis E. Drury family, an examination of the biographies of the early participants recasts the Euclid Avenue location as a metaphor for the group's perceived place in Cleveland society (both by themselves and by others). To understand the oddity of the Euclid Avenue location, it is first important to look at the thriving theatre scene in downtown Cleveland in the early years of the twentieth century, and contrast this growth with the declining surroundings of the Cleveland Play House's first home on Euclid

Avenue. Once the dissimilarity between the two theatre environments is established, an exploration of the participants involved with the founding of the theatre leads to a better understanding of the context for the origins of the Cleveland Play House, its desired audience, and how the theatre distinguished itself through its initial offerings compared to those of other local theatrical and arts organizations.

THE BUSINESS OF THEATRE

The past, present, and future of the Play House is encompassed in two locations: downtown Cleveland with its collection of large performance houses and the mile-and-a-half stretch of roads that connect the urban center with the eastern suburbs. At the turn-of-the-century, downtown Cleveland not only served as the symbol of growth and prosperity for northeast Ohio with its grand public square and tall office buildings, but the Forest City established its reputation also as a leading theatre center outside of New York City. Many national tours including *Uncle Tom's Cabin* began in Cleveland, and producers and performers alike found willing and growing audiences receptive to the populist fare streaming from the East Coast. In fact, because of the growing number of immigrants looking for work in Cleveland throughout the first decades of the twentieth century, Cleveland experienced extraordinary population growth, increasing by nearly 50 percent over a ten-year period, from 381,768 in 1900 to 560,663 in 1910.[4] Captains of industry seized upon this influx by expanding their factories to accommodate the larger work force, leading to the quick construction of small homes for minority and immigrant families just outside of the city limits. Not surprisingly, downtown theatre producers took advantage of this population growth by enticing immigrants to their performance halls with spectacle-based entertainment, where an inability to understand English was not a barrier for enjoying visual splendors on stage.

While these lower-class workers found theatrical offerings geared toward their demographic, the business and civic leaders of Cleveland prospered as well, leading to an increased support for the arts and other cultural endeavors. In hopes of attracting wealthier patrons, larger audiences, and the latest shows from New York, Cleveland producers built the newest and largest theatre in a thriving downtown. These houses and other smaller theatres offered varieties of entertainment, from legitimate drama featuring Charlotte Cushman as Lady Macbeth at the Cleveland theatre or P. T. Barnum's temperance drama *The Drunkard* at the Athenaeum

to work of highly questionable quality offered at rundown theatres and saloons that often inspired the city council to pass ordinances to prohibit their vulgar offerings for the lower classes.[5]

The battle for prestige ended in 1875 with the construction of the Euclid Avenue Opera House, built by "Uncle" John A. Ellsler. Considered to be "the finest theater in the city" by the *New York Times*, the lavish Euclid Avenue Opera House offered over 1,600 velvet seats for its patrons, making it not only one of the most technologically advanced theatres west of New York City, but also one of the most luxurious.[6] Unfortunately for Ellsler, his determination to maintain a resident company of actors at the opera house quickly forced him into debt. Furthermore, his own productions were overshadowed by the growing number of combination companies that rented his theatre or performed in competing houses. Only three years after opening the doors of the Euclid Avenue Opera House and providing the city with one of its greatest cultural landmarks, the banks foreclosed on Ellsler and auctioned his prized theatre at a sheriff's sale.[7] What makes this moment significant in the history of Cleveland theatre is not the fact that the city's premier performance house was put on the auction block, but, instead, the surprising fact that the new owner was a renowned figure in social and political circles whose selective theatrical predilections directly influenced the creation of the Play House.

How famed politician Marcus A. Hanna found his way into show business is a curious tale. A businessman affiliated with the growing iron and coal industries in Cleveland, Hanna seemed an unlikely candidate to become a theatre owner, but, as legend has it, he bought the Euclid Avenue Opera House on a whim. Historian John Vacha recounted the events:

> Hanna was walking with some friends from his office in the Warehouse District to lunch at the Union Club—or on his way back, according to a variant account. Noticing an unusual commotion in the vicinity of Sheriff Street, they went to investigate and found the opera house on the block. The bidding was already up to $40,000. On an impulse, Hanna raised it a few hundred dollars. Down banged the hammer, and Mark Hanna was suddenly in show business.[8]

Rumors later spread that Hanna, in fact, had designs on the opera house all along and that it was he who foreclosed on Ellsler, making the theatre available for purchase. Nevertheless, Hanna became a leading figure in the arts community, utilizing his new theatre as a status symbol.

Ironically, Hanna did not care much for art; he simply enjoyed meeting famous actors and inviting them to his palatial home for dinners, allowing

him to maintain a high profile in social circles. His obsession with fame and maintaining popular attention served him well in his political pursuits, serving as campaign manager for William McKinley's successful presidential bid in 1896 and resulting in his own election to the US Senate in March 1897. While Hanna lived many of his later years outside of Cleveland (he died in 1904), his association with high-end popular theatre made a lasting impression, partly because he frequently trusted the management of his assets (including that of the Euclid Avenue Opera House) to his sons.[9] The Hanna name became a fixture in the downtown theatre scene—one that was associated with a strong preference for popular entertainments. Hanna's Euclid Avenue Opera House continued to feature touring shows throughout the first decades of the twentieth century, hosting numerous visiting stars including Henry Irving, Ethel Barrymore, Ellen Terry, James O'Neill, and countless other actors. These famous performers attracted thousands of Cleveland's elite to the theatre to view the crowd-pleasing melodramas and romantic spectacles that were all the rage in New York.[10] Hanna himself embodied the type of work most often seen at the Euclid Avenue Opera House—his conservative viewpoint combined with his proclivity toward popular stars and frivolous entertainment meant that there was little room for the works of Ibsen, Chekhov, Strindberg, and Shaw and even less interest in the production theories currently being explored and practiced in European free theatres. The downtown theatres were business endeavors; if serious theatre artists with a penchant for experimentation wanted to find a home for modern plays, then a new theatre in a new location would be needed.

A HOME ON EUCLID AVENUE

The Play House proved an appropriate name for the new experimental theatre as their decision to create the institution occurred in one private house and they mounted their first productions in another. While the former took place in the Brooks' home on East 115th Street in an affluent suburb now known as University Circle, the latter occurred on Euclid Avenue, one of the most famous residential streets in the world. The quick demise of the celebrated boulevard in the 1910s stood in direct contrast to the rise of the Play House that occurred in the following decade, but, in its founding, the Play House belonged on Euclid Avenue. To validate this assessment, it is necessary first to understand the history of Euclid Avenue followed by an investigation into the strange collection of "businessmen and Bohemians" who united to support the new theatre.

To drive down Euclid Avenue today gives little indication that this street, currently dominated by bus traffic and lined with dilapidated and abandoned buildings, was once home to northeast Ohio's titans of industry, including John D. Rockefeller, Samuel Mather, and Jeptha Wade.[11] Initially called Buffalo Road (until 1825) because it served as the main route to upstate New York, Euclid Avenue eventually became known as the "Millionaire's Row" both in Cleveland and around the country. At the turn of the century, Euclid Avenue deservedly received comparisons to the Champs Elysées, Berlin's Unter der Linden, and other grand boulevards of Europe when Cleveland's elite "commissioned the finest architects of the period to design elegant mansions that would reflect and enhance their own economic and social positions."[12] In his biography of Rockefeller, Ron Chernow described what attracted the oil magnate to the plush location:

> With the spacious grandeur of a fine Victorian street, always busy with fashionable horses and carriages, the wide avenue had a double row of elms that created a tall, shady canopy overhead. The imposing homes were deeply recessed from the street, their trimmed lawns and shapely shrubbery providing buffer zones between the houses and their distant front gates. Since few houses were separated from adjoining houses by fences, the street sometimes gave the impression of being a single, flowing park, with elegant homes standing in an unbroken expanse of greenery.[13]

The small stretch of road from downtown to Fifty-Fifth Street that comprised "Millionaire's Row" was deemed so precious and privileged that the city forced horse-drawn public transportation to divert to northern streets in order to avoid disrupting the beauty of the avenue from being tainted by such unsightly objects.[14]

By 1900, more than 260 homes lined Euclid Avenue between downtown and Ninetieth Street, but the famed boulevard would soon endure a rapid decline, thanks to the encroachment of commercialism and a progressive mayor who failed to heed the elite's demands for isolation. Residents of Euclid Avenue not only fought and lost the battle to allow electric streetcars passage on their boulevard, but their concerns for their imminent demise were compounded by the advancement of commerce. In 1915, the Nickel Plate Railroad constructed an overpass across Fifty-Fifth Street, effectively cutting the Euclid Avenue in two.[15] The stretch between Ninth and Fifty-Fifth Streets, once deemed a lush and isolated location, quickly transformed into a busy thoroughfare for public transportation, causing many of the original "Millionaire's Row" residents to sell or abandon their homes in favor of newly established suburbs further

east of downtown. The elite's decision to flee Euclid Avenue immediately devalued properties, allowing more businesses to purchase land and construct shops where mansions once stood, thus fueling a downward spiral of property value that would continue for decades.[16]

With the elevated railroad obstructing the view of downtown, residents east of Fifty-Fifth Street found themselves literally on the wrong side of the tracks as their homes were devalued further (since they were not considered part of the original "Millionaire's Row" west of Fifty-Fifth Street). Families that had once enjoyed peace and quiet among their sculpted gardens now endured rising levels of automobile exhaust, bustling noise from streetcars and from shoppers perusing the expanding number of stores, and increasing smog levels from the many factories situated directly south. Euclid Avenue residents, however, perceived a far more distasteful invasion approaching from the south: the construction of minority housing that slowly encroached upon the once-exclusive boulevard. According to historian Jan Cigliano in her fascinating work *Showplace of America*, "the center of the developing black ghetto was around the Thirtieth Street and Central Avenue, just two blocks south of the [Euclid] Avenue, where a budding red-light district was also taking shape with its profusion of speakeasies, decaying lodges, and gambling houses."[17]

By the time that the Play House was founded in 1915, Euclid Avenue was in the beginning years of its decline, yet the theatre's first offerings were presented in a house on the Eighty-Sixth block—located in the middle of an area plagued by economic and social uncertainty. A question arises: Why did this group establish their theatre in a location deemed questionable by suburbanites who would normally be relied upon to support artistic endeavors and when they easily could have chosen a theatre downtown, which was commonly seen as the entertainment center of the region?

The answer is first and foremost practical. Weeks after the group formed their organization, the founding members began soliciting support from their friends and other like-minded individuals. At a dinner party held by Julia and Francis Drury in their lovely home located on the northwest corner of Euclid Avenue and Eighty-Seventh Street, one Play House enthusiast happened to sit to the right of the host and proceeded to describe the various plans and goals of the new theatre collective. Persuaded and excited by the new arts group that would incorporate art, dancing, music, and theatre, the Drurys immediately offered their support by letting the group use the Ammon House, an unused domicile located across Euclid Avenue from their formal residence.[18] Francis Drury owned the majority of the 8600 block south of Euclid Avenue as he intended to construct a lavish

garden for his wife. He planned on demolishing the few structures on this property—the Ammon House, a barn, and a garage—but allowed the Play House to utilize the vacant residence for performance purposes until construction began. Thus, the theatre received its appropriate moniker, having literally begun in a house with the aim of offering a home for the exploration of new ideas in theatre and art.[19] Even though a house seemed like an odd location for a theatre, it was a practical decision in the sense that they had nowhere else to go. However, after looking at the biographies of the major figures involved with the Play House's origins, the decision to utilize the Ammon House is emblematic not only of the founders' place in society, but also how the city in return would have viewed their endeavors.

IDENTIFYING THE PARTICIPANTS AND THEIR CONNECTIONS

The story behind the gathering of supporters in the Brooks' house begins with the touching efforts of a loving husband to entertain his invalid wife. As an electrician for the Colonial Theatre, a vaudeville house located two blocks north of Euclid Avenue in downtown Cleveland, John H. O'Neil constructed a small model stage upon which he could experiment with lighting effects. Although only three-feet wide, his presentations greatly amused his wheelchair-bound wife Angelina, prompting O'Neil to produce numerous lightshows while also pursuing his goal of experimenting with lighting technology and aesthetics. It was not long before these presentations caught the attention of John and Angelina's son, Raymond—a theatre critic for the local morning paper *The Cleveland Leader* (figure 1.1). Assisted by his friends, Raymond created small cardboard figurines and mounted shadowgraphs featuring dancing and singing.[20] Enchanted by the new approaches to design on display in his family's house and uninspired by the conventional productions offered at the Euclid Avenue Opera House, O'Neil realized the need to explore new ideas and theories in theatrical production. Three years after his father debuted his miniature stage, Raymond travelled abroad in the summer of 1914 to visit the theatres of which he had read and heard so much. Fascinated by symbolist works mounted by Max Reinhardt and by the Moscow Art Theatre, O'Neil became a devout believer in the theories and practices of Edward Gordon Craig, especially the utilization of a cyclorama, the creative authority of the master artist, and the replacement of actors with marionettes. Upon his return, O'Neil and his friend Henry Keller constructed a small cyclorama

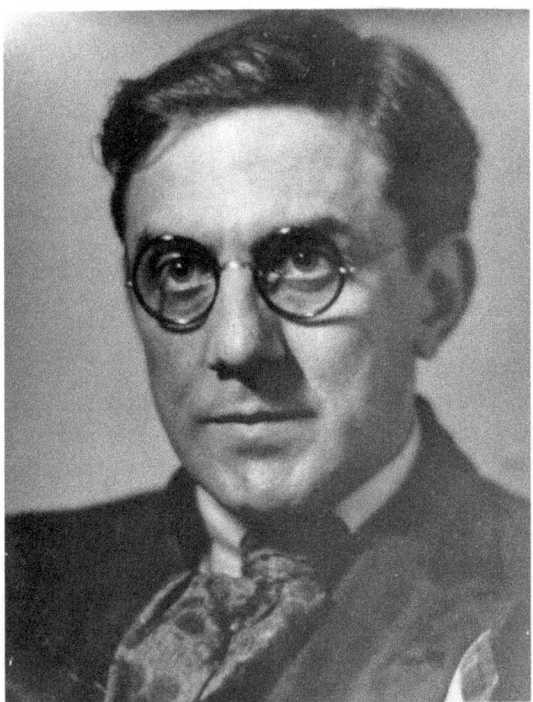

Figure 1.1 Raymond O'Neil, the first director of the Play House (Courtesy of Cleveland Play House Archives, Kelvin Smith Library, Case Western Reserve University.)

to fit within his father's miniature stage, allowing him to create stunning presentations that quickly became a topic of conversation among their small circle friends.[21]

That this refashioned model stage in the O'Neil household prompted a group of individuals to gather in the Brooks' home is well known, but it is *who* became involved that is the untold story of the founding of the Play House. Unfortunately, the extant simplistic descriptions of this initial meeting fail to provide any explanation why these particular individuals were invited, and no publication since has sought to discover how the composition of this group symbolized the institution's place within the Cleveland arts scene. New research reveals that two groups—a political organization and an artistic movement—played an instrumental role in bringing together the supporters of the new art theatre, and the political

and cultural marginalization of these two groups by mainstream Cleveland society dictated the perception of the Play House in its earliest years.

Those who viewed the presentations in the O'Neil household shared their enthusiasm for Raymond's work, spreading interest in its aesthetics and ideals to other like-minded individuals. One of Henry Keller's students who viewed the presentation spoke of the miniature theatre to sisters Grace and Ida Treat (the former would attend the Brooks meeting while the latter would marry Raymond O'Neil). Intrigued, the Treat sisters travelled to the O'Neil home and watched the brief display, becoming "spellbound" and determined to gather more spectators to delight in O'Neil's achievements. The next day, Grace Treat proceeded to the headquarters of the Woman's-suffrage Party, an organization for which she served as a political activist and advocate.[22] Grace Treat had become a public figure for the suffrage movement beginning with her 1913 request to Cleveland Congressman William Gordon, seeking support for the creation of a committee to explore issues concerning women's suffrage. A few months later, Treat and other suffragists drew attention to their cause when they occupied East Cleveland City Hall night after night in hopes of persuading members of a Charter Commission to vote for an amendment favorable to women's rights. In the fall of 1915, it was at the Woman's-suffrage Party headquarters where Treat first described O'Neil's theatrics to fellow activists, including two friends: Minerva Brooks (the chairman of the party who accompanied Treat nightly in her East Cleveland efforts the previous year) and Katharine Angell.[23] The influence and contribution of these two extraordinary women—Brooks and Angell—remains largely ignored by the simplistic accounts of the founding of the Play House, even though both were present for the initial meeting at the Brooks' home.

In retrospect, the success of her husband Charles S. Brooks as an author and playwright overshadowed the important contributions that Minerva Brooks made to the creation of the Play House. Nevertheless, it is clear that Minerva Brooks was a force to be reckoned with both in the Play House and in Cleveland society. A dedicated feminist in addition to her status as a socialite familiar with "Millionaire's Row," she was not afraid to ruffle the feathers of the political and societal establishment. When the "Antis"—the Ohio Association Opposed to Woman's Suffrage led by Mrs. John M. Gundry of Cleveland—opened offices on Euclid Avenue, Minerva Brooks was despondent to see many of her high-society acquaintances join their ranks. Unafraid of the consequences of speaking her mind in "polite society" and offending her neighbors, she voiced her disappointment that "the homes along Euclid Avenue are, for the most part, strongholds of Anti-Suffragists."[24] Such

aggravations were shared among many supporters in the suffragist cause. "No one knew better than the suffragists the long years of work and struggle they must contribute to their cause before it could triumph," historian Aileen S. Kraditor notes in *The Ideas of the Woman Suffrage Movement*. "No one knew better than they (although the antis knew it too and frequently reminded them of it) that one of their greatest obstacles was the indifference of the majority of women to their own political equality."[25] Unfortunately for Minerva Brooks, the frustration of being an outsider in Cleveland society—as a suffragist and a politically liberal millionaire—was soon echoed by her short-lived involvement with the Play House.

Katharine Angell also struggled to have her voice be heard in Cleveland. A Winchester, Massachusetts native, she was engaged to Ernest Angell the summer before her freshman year at Bryn Marr. She married the Harvard law school graduate in May 1915 and moved to Cleveland shortly thereafter. One account of Katharine's time in Cleveland describes her life as "tiring but happy" while another suggests that she was lonely, joking that both she and Boston Red Sox Tris Speaker were "traded to Cleveland in the same year."[26] Eager to find ways to ingratiate herself with Cleveland society, Angell became involved in local theatre. However, she would not find her true professional calling until she moved back east, divorced Ernest Angell, married *Charlotte's Web* author E. B. White, and served as a writer and much-lauded fiction editor for *The New Yorker* for 35 years.[27]

Both Minerva Brooks and Katharine Angell were present at the suffragist headquarters on the day that Grace Treat enthusiastically described Raymond O'Neil's presentations, and both women asked Treat to arrange a special performance for them and their husbands. The Brooks and Angells responded enthusiastically to O'Neil's light show, but none more than Minerva. Listening to Raymond discuss Craig's theories about performance and production, her intense enthusiasm prompted her to immediately suggest a new course of action. Minerva declared, "I think we should form a little theatre group to produce plays in this new art form.... If I do the leg work in organizing it, will you, Raymond, be the boss—the director?"[28] Following Minerva's lead, the Angells and Charles Brooks also pledged their support to O'Neil who agreed to accept the position on the condition that he would be "free to handle it in his own way."[29] The Angells kept their promise of support not only by attending the meeting at the Brooks' house, but also by playing instrumental roles in the Play House's earliest endeavors—Katharine was one of the six puppeteers for the first Play House production, Maurice Maeterlinck's *The Death of Tintagiles*. Even though her husband was the organization's first treasurer,

Ernest's opportunities to volunteer for the Play House were limited because of the demands of his law career and also because he enlisted as a first lieutenant in the army in November 1917. Compared to his wife who viewed the theatre group as a distraction from her "lonely" life, Ernest's impact on the development of the new organization was minimal (perhaps donating his time to appease his wife more than any artistic inclinations of his own). Upon his return from the war, the Angells moved to New York. Ironically, for someone who had little impact on the operations and decisions of the Play House, Ernest Angell receives repeated attention simply because he attended the Brooks' meeting, causing his name to appear in the list of participants recorded by Flory.[30]

Whereas Minerva Brooks's involvement with the new theatre derived from a genuine interest in artistic exploration, the same cannot be said of her husband. For Charles Brooks, the impetus to support a new art theatre was more about opportunistic timing rather than his passion for theatre. After graduating from Yale in 1900, the Cleveland native returned home to assist in the family's printing business. Over the next 15 years, Brooks demonstrated enough business savvy to justify his being promoted to vice-president, but his heart was never in it. In 1915, at the age of 37, he retired from the business and dedicated himself to pursuing a literary career. While he quickly found fame as an essayist (his first collection of writings, *Journeys to Baghdad*, was published in 1915), he also looked for other literary and artistic challenges to inspire him, and he seized the opportunity to work with the new theatre company.[31] Although he left Cleveland in 1917 to pursue literary opportunities in New York, Brooks became vice-president of the Play House upon his return in 1921. He cleverly utilized the theatre as a means to produce his latest plays, including *Wappin' Wharf*, which premiered the same year that he returned.

In hindsight, it is emblematic of the time period that Charles Brooks has received more attention for his contribution to the foundation of the Play House than his wife. The reasons for this are numerous: being male and having assumed a leadership position, Charles Brooks became the public face for the institution (Minerva, like many other women at the time, failed to secure leadership positions); becoming a celebrated essayist and local celebrity, Charles frequently received more attention for his contributions, in part because of the premieres of his plays at the Play House; Minerva's interests developed toward dance performance rather than the legitimate theatre that became the focus of the Play House; and finally, the Brooks' divorce in 1925 caused Minerva to abandon her support for the Play House and return to Boston, where she died only four years later.

History needs to appreciate the astonishing efforts of Minerva Brooks and Katherine Angell in founding the Play House. Using their connections within the Woman's-suffrage Party to drum up interest in the new art theatre, they enlisted other women from this organization to play an instrumental role in establishing the Play House, whether or not they attended the gathering at the Brooks home or were recorded as a founding member. For example, Miss Myrta L. Jones was a devoted suffragist—she marched in numerous parades around the state, carrying banners reading "Women Vote in China; Why not in Ohio?" and her letters on suffragist issues were frequently published in the local papers (including one refuting Mrs. Gundry and her anti-suffragist claims).[32] Jones is perhaps the most overlooked contributor of all because she was the dinner guest who sat to the right of Francis E. Drury and informed him about the Play House, leading to his offering of the Ammon House.[33] In spite of the limited number of documents available to pinpoint personal relationships during this time period, it is clear that many of the earliest supporters of the Play House also championed suffragist causes and that Minerva Brooks, the Treat sisters, and others exploited their relationships within the Woman's-suffrage Party to raise awareness of and interest in the new art theatre.

The Brooks and Angells were not the only ones who wanted to ensure a successful meeting at the Brooks' home; following the presentation for the Brooks and Angells, Raymond O'Neil utilized his own connections to garner support for his becoming the director of the new institution. Whereas Minerva Brooks promoted the theatre within the suffragist party, O'Neil sought support from his friends and associates who participated in another collective: a small but dedicated group of artists encouraging a "new art" movement in Cleveland. Founded in 1911 for the purpose of "developing individual talent and awakening a general appreciation of art in Cleveland," the Kokoon Arts Club proclaimed itself to be the first formally organized effort in Cleveland to "break away from established art traditions."[34] The founders of the Kokoon Arts Club first restricted their membership in an effort to attract only serious artists, allowing no more than 30 members at a time (women were not allowed to join). Gender discrimination aside, the group successfully established a club for artists interested in pursuing avant-garde forms, and their public displays became popular (and press fodder) in the form of their "bal masques"—an annual celebration of the bohemian spirit in Cleveland and frequented by the community's artists, poets, actors, and musicians. These yearly events featured "unconventional costumes, exotic dances, opening processions, enormous props and clashing decorations, and unpredictable 'stunts' throughout."[35]

Unfortunately for the Kokoon Arts Club, the popularity of these balls quickly transformed the group from a selective collection of dedicated artists into a social club (more than doubling its membership in later years). Its ties to with the bohemian society became a frequent topic of conversation in Cleveland's social circles—not because the populace debated the merits and philosophies behind the "new arts" movement, but because patrons and supporters anxiously waited to see the exotic costumes. Press coverage of the Kokoon Arts Club's efforts primarily focused upon their social events, as exhibited in the description of the January 1913 "bal masque:"

> Cleveland art folk are awhirl with preparations for the bal masque to be given the evening of Jan. 17.... It is promised that the affair will be the most pretentious in matter of costuming of any mask dance ever given in Cleveland.... "The Kokoon club's bal masque will absolutely be the most elaborate thing attempted in Cleveland—bohemian in the very best sense of the word, with a program of unusual character, it will be setting down in the heart of Cleveland for one night a famous old world scene," is the claim the Kokoon club's president, Allen Earnshaw, confidently makes.[36]

It is clear that within a few years of its founding, the Kokoon Arts Club began to shift its identity away from a selective, process-oriented arts group to one that was willing to define its success through product and popularity, becoming a spectacle in the process.

The Kokoon Arts Club, however, is important not only to the history of the Play House because it established the model of a small, dedicated arts group with a limited membership, but also because one of the Kokoon Club's early participants played an influential role in the development of the new theatre organization: Henry Keller. While serving on the faculty of the Cleveland Institute of Art, Keller became an early participant in the Kokoon Arts Club, but as the "bal masques" became more about fashion and spectacle rather than artistic endeavors, Keller searched for new artistic outlets. Thanks to his friendship with Raymond O'Neil and their work together on O'Neil's miniature stage, Keller's interest in exploring theatrical arts fit perfectly with the endeavors of the Play House, and Keller's connections to the Kokoon Club opened doors for O'Neil and his supporters to gain notice within the arts community.

In discussing the creation of the Play House, the *Oxford Companion to American History* briefly mentions that "most of the original members were, curiously, painters rather than actors or other theatre people," but it (or any other account of the Play House's history) fails to offer any explanation

as to who these painters were and what was their connection to the new theatre.³⁷ The answer lies with Keller, who often encouraged his students to participate in his artistic explorations—not surprisingly, he invited students to view O'Neil's light shows, and several of them (including the Treat sisters) continued their support for the Play House. Keller, however, did not attend the meeting at the Brooks' residence, and no reason is given for his absence. However, Keller's and O'Neil's involvement in another "new art" endeavor provides the only link to the remaining participants at the initial meeting for the Play House—namely George Clisbee, Henry Hohnhorst, and Marthena Barrie.

While the Treat sisters might have been considered "painters" because they were enrolled in Keller's class, Clisbee and Hohnhorst made drawing and painting their profession. Both men worked for the local papers—Hohnhorst was an artist for the *Cleveland Leader* while Clisbee served as a newspaper cartoonist and eventually the art editor for the *Cleveland News*. Of the two men, Clisbee achieved greater respect in art circles, having his work published in numerous national magazines until he became an advertising executive in New York.³⁸ Hohnhorst, on the other hand, was noticed more for his singing than his sketches.³⁹ The two men, however, joined a host of other artistic-minded individuals to perform at the Hatch Galleries on April 27, 1915, in a rare exhibition of futurist performances called *La Nuit Futuriste!*, promoted as "noninstitutional, nonsectarian, nonuplift, and non compos mentis."⁴⁰ It is this event that provides the only evidence of any link between many of the founders of the Play House—Henry Keller and Raymond O'Neil sponsored the event, Keller designed the sets that were maneuvered during the performance by both Clisbee and Hohnhorst, and Ida Treat performed as Cleopatra.⁴¹

The *La Nuit Futuriste!* event featured a variety of performances including a shadowgraph, piano solos, fashion displays, and "rhythmic expressions." This last offering suggests the only connection to the final participant, whose name is not included in any other existing record or document: Marthena Barrie. As a dedicated follower of the Florence Fleming Noyes system of rhythmic expression, Barrie presented numerous dance programs at a variety of locations in Cleveland and offered classes for children to explore "artistic dancing and time."⁴² Barrie's link to O'Neil, Keller, or any other Play House founding member remains unknown; however, it is clear that she can be linked to the gathering at the Brooks' residence through artistic connections. This claim is corroborated by the fact that Minerva Brooks also began teaching interpretive dance at the same Noyes School of Rhythm in the early 1920s. Furthermore, Barrie would have been familiar

with the "rhythmic expressions" presented at *La Nuit Futuriste!* given her interest in the Noyes system of movement.[43]

Marthena Barrie symbolizes the challenge of exploring the contextual history of the Play House, primarily because so little is known about her—it is not known if she was a suffragist, if she had attended "bal masques," or if/when she ever viewed O'Neil's miniature stage. Her reported connections to the Cleveland art scene contrasted by the absence of any record of her involvement in Cleveland politics or the suffragist movement symbolizes the varied social dynamics represented at the Brooks' meeting. To understand fully the challenges overcome by the supporters in order to launch a new art theatre, it is important to remember that the meeting at the Brooks' home was a collection of individuals rather than an organized group. These persons arrived at the East 115th Street residence with diverse interests and experiences, yet they met with one objective in mind. While some of the early participants like Barrie terminated any affiliation with the Play House after this single meeting, the other members of this clan worked together for a common artistic goal, creating a sense of ownership by all of the contributors (a sentiment that prompted a huge rift in the coming years of the Play House).

MISFITS IN SEARCH OF A HOME

Raymond O'Neil and his assemblage of "businessmen and bohemians" aimed to mimic the independent theatres of Europe in their offerings, but the Play House also copied European arts theatres by resembling more of a private club than a public institution. Similar to the model established by the Kokoon Arts Club, the earliest endeavors of the Play House served the interest of its own members, and this approach made sense given how the Cleveland community viewed the participants of the new theatre. The few descriptions of the earliest years of the Play House fail to place the new theatre within the context of the community; instead, every published history of the Play House suggests that the institution's ability to endure is sufficient evidence of its receiving support. The omission of analyses in these histories, written by individuals affiliated with the Play House, implies that the theatre was a revelation to the community and that the cultured citizens of Cleveland immediately recognized its artistic value—nothing could be further from the truth. Having detailed the biographies of those involved with the beginnings of the Play House, it is also possible to understand how the new theatre would have been perceived by the

population *because* of those individuals' affiliations with the futurist and women's suffrage movements.

In the early 1910s, futurist fashion was all the rage in the local newspapers as journalists frequently reported from Paris and other cultural hot spots about its implementation in clothing design. In Cleveland, these fashion trends found their way into costume balls where patrons viewed the clothing as spectacle rather than an artistic statement that challenged the status quo.[44] While futurist influence in clothing may have been commonplace, other forms of futurist art were mocked routinely by critics and citizens alike in the local press. In nearly every evaluation of a futurist exhibition or performance, the response is negative and/or the opinions are filled with disdain, describing their movement as "atrocious" and labeling its followers "fools."[45] In one candid moment of bias, a local critic argued that futurism had "no value today and even less in the future [and it] does not satisfy the more serious art lover," and such viewpoints also were echoed by the public, as exemplified by a joke submitted anonymously and printed in the paper:

"Beg pardon, but why should you use so large a canvas as a brush wiper?"
"Are you alluding to that finished painting, sir?"
"Ah, I remember now. You are a futurist."[46]

To add insult to injury, the editors of the *Plain Dealer* went out of their way to denounce futurist works by reporting on failures outside of northeast Ohio, not only mocking a London production of *Richard III* by suggesting that a "blue-haired king" would call for his cubist horse, but also insulting an Italian futurist performance where the actors needed to dodge items thrown by the audience, including eggs, fruit, and even a dead cat.[47]

The fact that the public openly ridiculed the efforts of these futurists suggests that the *La Nuit Futuriste!* presentation featuring O'Neil, Treat, Keller, Clisbee, and Hohnhorst would not have been perceived as a major event in the Cleveland art scene. In fact, on the day of the premiere, their offering failed to receive any notice on the full-page listing of daily theatre performances in the local paper. Considering that the theatrical scene was dominated by the Euclid Avenue Opera House and that the legacy of Marcus Hanna encouraged the booking of visiting stars to provide the greatest entertainment value for audiences, the miniscule production of *La Nuit Futuriste!* was bound to be ridiculed, if not largely ignored, by the public. The fact that the Play House's founders were associated with

La Nuit Futuriste! meant that the public disdain for these artists' work translated into a stigma placed upon the Play House.[48]

More than the avant-garde offerings of the Play House, the new theatre also suffered from contempt derived from its reputation as an anti-Republican institution in an increasingly post-Progressive city, thanks to the individuals who had prior political and social relationships with public figures in Cleveland. For example, Grace Treat's public plea to encourage Representative William Gordon to support women's suffrage unwittingly backfired. Not only did the representative rebuff Treat's request to consider the issue of women's suffrage, but he also published his terse response to Treat in newspapers, announcing that he would fight any constitutional amendment that proposed giving women the right to vote.[49] Because of this public debate, Treat quickly became a prominent figure of the unpopular suffrage movement, but she was not alone.

The political environment in Cleveland following the 1914 election was changing as Republicans gained control of city hall, bringing an end to the Progressive era ushered in by former mayor Tom L. Johnson.[50] "By 1914, Cleveland had lost its enthusiasm for reform," write historians Carol Poh Miller and Robert Anthony Miller, and the transition to a more conservative social platform hindered the suffragist movement as "the Cleveland Suffrage League, which focused on gaining the vote in Ohio, worked diligently but unsuccessfully."[51] Eleanor Flexner's *Century of Struggle: The Woman's Rights Movement in the United States* finds that such disappointment was not uncommon, citing similar national results of the 1914 election: "In Ohio and Wisconsin the margin of defeat was much greater than the first Michigan vote.... Seven states voted on woman suffrage; only two, the sparsely populated and politically unimportant states of Montana and Nevada, were in favor. On the other hand grueling and costly campaigns were waged and lost in the two Dakotas, Nebraska, Missouri, and once again in Ohio."[52]

The struggle for widespread acceptance became more politicized in 1915, thanks to the "militant" tactics of the rival suffragist group, Congressional Union, which attacked both Republicans and Democrats.[53] This development forced the Woman's-suffrage Party to declare publicly their support for Democratic candidates, as exhibited by a telegram from Minerva Brooks published in the *Plain Dealer*: "Some of the strongest friends of the Ohio Woman Suffrage party are Democratic candidates for, or members of, congress, and Ohio suffragists do not authorize or support any political activity against them in Ohio."[54] With these and other statements made in the press, Minerva Brooks quickly became "widely known over the state

as an active worker in the cause of equal suffrage," writing several "newsy paragraphs" and editorials throughout Ohio.[55] She frequently forayed into the man's world of politics and was elevated to the level of minor celebrity when the women of East Cleveland finally attained suffrage in 1914. This modicum of success resulted in an article in the *Plain Dealer* that praised her beauty as well as her "mind that is as quick as lightening."[56]

Despite Minerva Brooks's best efforts, the Woman's-suffrage Party remained an unpopular organization, and a losing one at that. The populace of Ohio twice voted down attempts to provide suffrage—first in 1912, and by an even larger margin the year before the Play House's founding—and Brooks, Treat, and their supporters soon found themselves further on the outside when the conservative Republican party won the mayoral seat and control of the Cleveland city council in 1916, making the prospect of women's suffrage less likely.[57] To be a suffragist when the Play House was founded was to be a political outsider, and Brooks's willingness to challenge the conservative political leadership set her apart from many of Cleveland's elite society, thus furthering the stigma of the Play House as a home for suffragists and other liberal-minded individuals. The traditional history of the Play House ignores records that suggest that the founders of the Play House were considered to be on the fringes of mainstream society and politics.

The clan that gathered at the Brooks' residence in 1915 certainly was not only a collection of "businessmen and bohemians," but also of misfits and social pariahs, be it because of their unpopular political views, their unappreciated artistic efforts, or their undesirable social connections. The frequently promoted history of the Play House failed to place the organization's earliest events in a social and political context, and the repeated decision to omit any biographical information about the founders implies that these participants shared a vision for a theatre that would last a 100 years. The result of this lengthy exploration, however, is a different interpretation of the theatre's founding—that the individuals who founded the Play House were not a unified group with a vision, but instead unintentional visionaries. In her simplistic history, Flory states that the Play House was "conceived in youthful enthusiasm and dedicated to art, with high aspirations for community service," but it would be years before the institution garnered enough attention to perform any type of community service that would be both widely recognized and appreciated.[58] Although the theatre claimed to serve the community, the definition of "community" needs to be refined to reflect the limited amount of work performed by the Play House and those who supported it. The "community" interested in this new art theatre was not the larger community of Cleveland, but, instead,

those who followed E. Gordon Craig's artistic ideals; in other words, the founders and their supporters were more of a collection of amateur artists looking for an outlet for their creative endeavors, not popular acceptance.

The Play House began as a small collection of artists hoping to create avant-garde presentations unlike the work offered downtown that exhibited both the best and worst of Hanna's legacy with the arts in Cleveland—the best in that he gave money in support of the arts for the masses, and the worst in that he equated fame and popularity with artistry. The Play House became a sanctuary for individuals who found themselves relegated to the outskirts of society or dismissed as liberals and progressives. It is fitting, then, that the Play House began in an abandoned residence because it became a home for this group of misfits, and the home metaphor continued for many years as the group redefined itself. Soon, the Play House made efforts to expand—both artistically and culturally—in order to be a part of a larger movement in American theatre, but this idealistic group would find that the first years brought both highs and lows. The Play House would move into a large and permanent performance space, but what was once a united front quickly became divided as the businessmen and the bohemians clashed over Raymond O'Neil's artistic vision and leadership, resulting in the most significant change in the entire history of the theatre.

2. Averting Disaster and Ignoring Cleveland

In its discussion of the development of "Little Theatres" across the United States during the 1910s, the 2007 edition of the *Cambridge Guide to American Theatre* lists "Frederick McConnell's Cleveland Play House (1916)" as one of the first and greatest institutions in this movement.[1] This claim is certainly perplexing given the facts that McConnell did not join in the Play House until 1921 and that an examination of the Play House's activities in comparison to other theatres participating in the Little Theatre movement suggests that the legendary Cleveland theatre may not have been part of the movement at all. Such an assertion would contradict the established and oft-repeated history of the Cleveland Play House being founded as a Little Theatre, as labeled by numerous writers of the 1920s and 1930s, reinforced by the press (including *Time Magazine* in 1927), and retold by the Play House itself.

The fact is that the Cleveland Play House has long been considered a member of the Little Theatre movement because of circumstances—its founding in 1916 coincides with the height of the movement's development between 1912 and 1918, dates provided by Dorothy Chansky in her book *Composing Ourselves: The Little Theatre Movement and the American Audience*.[2] The challenge of determining whether or not the Play House should be considered a participant in the Little Theatre movement is dependent upon defining the term "Little Theatre." The issue is one of taxonomy, distinguishing between a "Little Theatre," an "art theatre," and a community theatre. While most scholars agree that "art theatres" attempted to emulate the work of European art theatres by producing the work of new playwrights and experimenting with new production values (as exemplified by the Play House's earliest attempts), differing opinions of the goals and aesthetics of "Little Theatres" and their distinctiveness from community theatres makes the formation of a specific yet applicable definition of a "Little Theatre" nearly impossible.

Unsatisfactory descriptions of the Little Theatre movement abound, including classifying these institutions as theatres that engaged "in dramatic production and which are animated by intrinsic enjoyment rather than by monetary gain" (a description that could apply to all nonprofit theatres in existence today) or purporting the vague notion that the Little Theatre movement was unique because its participants aimed to produce quality work (versus other theatres that strove to produce terrible work?).[3] Such insufficient generalities fail to classify properly the variety of theatres that existed in the 1910s, let alone those of the Little Theatre movement. For example, whereas many writers often confused the term "art theatre" with "Little Theatre" because both premiered new plays, others linked "Little Theatres" with community theatres because these small organizations provided performance opportunities for amateurs. Alexander Dean, author of *Little Theatre Organization and Management* offered the term of "second generation of Little Theatres" to describe the transition of many institutions from a "Little Theatre" to a community theatre.[4] Chansky, on the other hand, suggests that the Little Theatre movement encompassed "art," "little," and community theatres, making the issue even more confusing.[5]

Consensus exists among many scholars concerning the origins and timeframe of the Little Theatre movement. Influenced by the political and social changes sweeping the country as exemplified by reforms of the Progressive Era, these new theatres offered audiences "a chance to explore social issues and to resist the numbing lure of predictably scripted spectacle shows."[6] Dependent upon wealthy supporters, these Little Theatres offered new plays by Ibsen, Chekhov, Hauptmann, and other modern playwrights with the aim of presenting work that celebrated anticommercialism and experimentation, favoring social commentary and psychological realism over popular taste.[7] Hoping to improve American society, many of these early theatres aligned themselves with educational organizations or other cultural institutions including museums, orchestras, operas, and charities. Following the leadership of the Little Theatre in Chicago (1912), Winthrop Ames's Little Theatre in New York (1912) and the Toy Theatre in Boston (1914), the Little Theatre movement spread quickly with over 50 institutions established by 1917.[8] However, the inconsistent quality of work presented by these Little Theatres opened the door for criticism. Noted author Samuel Marion Tucker detailed the varying work and stability of these theatres and the movement:

> The quality of the productions vary so widely that it becomes immediately evident that these hundreds of organizations have little in common except the

term (utterly without meaning) of "Little Theatre." Some have fine playhouses of their own; some have no abiding habitation or city of refuge. Some have thousands of subscribers and are firmly founded in the community life; others live from hand to mouth. Some produce virtually every night; others only two or three times a season. Some produce fine plays, others mere "hokum."[9]

With the onset of World War I, however, many of these theatres faced financial hardships as the economy soured and monetary priorities shifted away from arts groups, forcing many of the Little Theatres to either alter their aesthetics or shut their doors.[10] The most commonly suggested date for the end of the Little Theatre movement coincides with the conclusion of the war in 1919, with Chansky characterizing the work of the 1920s Little Theatres as less "glamorous," less adventurous, and less well-known.[11]

While the Play House established itself in 1915 as an "art theatre," hoping to mimic the aesthetics of Edward Gordon Craig and numerous art theatres of Europe, the artistic, administrative, and economic decisions of the Play House between 1915 and 1921 fail to coincide with the aesthetics and timeline of the Little Theatre movement, suggesting that the Ohio theatre should not be considered a contributor to the movement and that its role in the development of American theatre needs to be reexamined. Furthermore, juxtaposing the development and activities of the Play House with other participants of the Little Theatre movement highlights the theatre's growing pains, and analyzing the Play House's actions within the context of the Cleveland community provides new insight as to why the Play House drastically changed its course in 1921 and why it was able to survive when so many Little Theatres failed.

If the role of a Little Theatre was to introduce audiences to the new style of playwriting produced in Europe's independent theatres, then the Play House failed miserably in accomplishing that task. The selection of plays during the six years of Raymond O'Neil's leadership was random and eclectic, to say the least. Whereas the Toy Theatre in Boston and Little Theatre of Chicago presented works by Shaw, Ibsen, Strindberg, and other internationally acclaimed playwrights, the most frequently produced playwright by the Play House was American poet Alfred Kreymborg, followed by Molière.[12]

Even though conventional play selection became a contentious issue for the Play House, one cannot fault the young theatre for not selecting plays similar to other Little Theatres because of Cleveland's unique history of supporting such work. When compared to other cities on her tour, the reaction of Cleveland theatergoers to legendary American actress

Minnie Maddern Fiske's production of *A Doll's House* indicates the public's acceptance of European playwrights. Clevelanders delighted at Fiske's return, not only excited by the opportunity to see the premier actress of the stage, but also to see a fully realized production. Supporters of theatre in Cleveland were well aware of Ibsen's work, indicated by the numerous articles in the local papers discussing his aesthetics and promoting the value of his plays.[13] When Fiske arrived in Cleveland, she found audiences and critics that were small but appreciative. This reception must have been a welcome change from Fiske's previous engagement in Pittsburgh, where the controversial ending of the play left audiences confused. While some Steel City theatergoers opted not to attend because they believed *A Doll's House* to be a children's show, others who witnessed the third act "settled down to wait for a fourth act and the penitent return of the wife. The house lights went up, and down, and up—and still they failed to take the hint. Finally, the stage manager announced bluntly that the play was over, and the audience went home grumbling at being done out of a fourth act and a happy ending."[14]

By comparison, Forest City theatergoers were more cosmopolitan and better educated as to the latest trends in playwriting and theatre production, and the positive response to Fiske's production of *A Doll's House* and other professional touring productions of modern European plays directly impacted the play selection of the Play House. Cleveland established a reputation as a welcoming destination for modern plays, as exhibited by the many tours and productions offered in Cleveland's downtown theatres in the ten years preceding the founding of the Play House. Cleveland audiences had the opportunity to enjoy not only the performance of Minnie Maddern Fiske in *A Doll's House* and again in *Hedda Gabler* but also other productions of Ibsen's work, including *Peer Gynt*, *Rosmersholm*, *Ghosts*, and film adaptations of *A Doll's House*.[15] In addition to Ibsen, Clevelanders also supported tours and local presentations of the plays of Maeterlinck, Gerhart Hauptmann, and George Bernard Shaw.[16]

With multiple opportunities to view work by Europe's leading playwrights, the Play House did not want or need to share the responsibility of other Little Theatres to produce these plays. However, whereas other participants of the Little Theatre movement defined themselves by offering an opportunity to view new and controversial works, the Play House struggled to define its identity through its presentations.[17] From its founding in 1915 until 1921, the Play House functioned as an "art theatre," working to satisfy its members' own artistic endeavors rather than catering to the wider public. Their work was initially only supported by a small membership,

but the theatre's quick rise in popularity challenged Raymond O'Neil's management abilities, leading to questionable artistic and administrative decisions and an abandonment of the "art theatre" aesthetics and offerings. This change, however, occurred in the 1920s, a time when scholars consider the Little Theatre movement to have waned.[18] Whereas many "art theatres" transitioned into Little Theatres, numerous Little Theatres likewise found financial stability as community theatres, but the internal battles of the Play House resulted in its direct transition from "art theatre" to community theatre, never pursuing the educational and cultural goals of the Little Theatre movement.[19] A quick summary of the history of the Play House during Raymond O'Neil's tumultuous directorship, placed within the context of Cleveland's cultural and financial struggles, reveals why the leaders of the Play House forced O'Neil to resign and forever change the direction of the theatre in order to survive.

THE HOUSE IN SEARCH OF A HOME (LITERALLY)

While Julia M. Flory's and Chloe Oldenburg's books sufficiently document the production history of the earliest years of the Play House, a brief summary of the events leading to the contentious yet quick growth of the Play House is necessary to understand fully the many influences that prompted the theatre's transition away from an "art theatre" in 1921. The six-year period encompassing Raymond O'Neil's tenure as director of the Play House can be divided into two distinct phases. For the first three years, O'Neil and his followers struggled to become an "institutional theatre," a term defined by former producing director of Actors Theatre of Louisville, Jon Jory, as "a theatre structure so strong that it survives generation after generation."[20] The last three years found O'Neil desperately searching for artistic and administrative stability as the membership divided into two camps that fought over the future direction of the theatre.

Following their decision to form the theatre, the founders of the Play House managed to mount three vastly different productions in the Ammon House—Maeterlinck's *The Death of Tintagiles* utilizing marionettes, a shadowgraph presentation, and a "rather soberly" staging of August Strindberg's *Mother Love* performed in the third-floor attic of the Ammon House (there was no admittance fee for *Mother Love* since it was "not a finished production").[21] Participants quickly organized other endeavors, including a dance troupe that explored Florence Fleming Noyes's system and a children's group available to members of the Play House.[22] The enthusiasm of the original members to offer a variety of

artistic activities was soon bolstered by a growing membership. The majority of documents from this period in the Cleveland Play House archives reveal a concerted effort to establish a selective membership process—who should be allowed, who is rejected and why, and how much membership dues should cost.[23] Even though the theatre was by no means considered hugely popular by the Cleveland community, the earliest efforts of the Play House generated enough interest in their work to warrant a membership growth from approximately 50 members to 125 members within a year.[24] Unfortunately for these supporters, their enthusiasm was tempered by the continual challenge to find a permanent home for the theatre. Shortly after their first season, Francis E. Drury informed the group that the Ammon House would soon be razed (as he had promised it would be) to make way for a lavish garden, yet he once again generously offered them another building: the barn located behind the house.[25]

The barn not only functioned as a theatre, but was also the home to newlyweds Raymond O'Neil and Ida Treat, who surely did not enjoy the fact that their personal bedrooms served as dressing rooms on performance nights.[26] Julia M. Flory provided a personal account of the unique and challenging space:

> A round stove in the center grudgingly gave forth a minimum amount of heat, and we sat on cushions on the floor. The stable had been built on sloping ground, so the stalls for the cow and horses were elevated about five feet above this big room, though adjacent to it. The separating wall was removed, and this upper area formed our stage, with walls painted with blue paint. During the day it doubled as the O'Neil's kitchen. This arrangement was entirely satisfactory, as the stage lights were always so dim and so blue that the background of range and sink were quite indistinguishable.[27]

The barn hosted a few ambitious productions, including William B. Yeats's morality play *The Hour Glass* and Anton Chekhov's farce *The Bear*, but no critical assessments of these performances remain. Perhaps the fact that these productions are not included in the Play House's official production history speaks to their amateur quality or to the embarrassment of having to perform in a cow barn, jokingly called "The O'Neil Institute."[28]

If the group was ashamed of their humble beginnings, then their fortunes would worsen before they improved. Drury informed the group that the stables also would soon be demolished, forcing Raymond O'Neil and the newly elected chairman of the board, Walter Flory, to quickly search for another new home.[29] A less-than-ideal site was located in the third-floor ballroom of a house, formerly owned by Mayor Tom L. Johnson.

Not only did these new accommodations mean that the Play House had changed locations three times within a two-year period, but also that its new "home" was more than 60 blocks away from its previous location on Euclid Avenue. Furthermore, the "studio hall" limited the kind of work the Play House could produce—with the absence of a traditional stage in the ballroom, O'Neil and his members shied away from attempts at legitimate drama and instead explored nontraditional offerings including dances and puppet plays.[30]

Long before the move to the ballroom and aware that their days in the barn were numbered, Flory thankfully initiated the process of locating a permanent home for the Play House.[31] They decided to purchase a small Lutheran church located at Cedar Avenue and East 73rd Street—the only home of the Play House without a Euclid Avenue address. This $7,000 solution demonstrated the persuasive leadership of board members Drury and Flory. Although the 125 members believed that the group obviously needed to find a new home, several participants were reticent about purchasing a building that required approximately $9,000 worth of renovations at a time when the country was on the march to war.[32] In order to calm any fears, Flory sought advice from Drury about whether or not it was wise to risk the financial stability of the growing organization during widespread economic uncertainty. Drury's response inspired the group:

> I have found when there is a group of young people who have undertaken a worthwhile enterprise and have shown determination to make it a success, it is never advisable to discourage their going forward, even in the face of great obstacles. You have youth and high ideals—a well-nigh invincible combination. My advice is to let nothing deter you in proceeding with this project.[33]

Thankful for Drury's advice and his generous contribution of $6,000, Flory and other members proceeded to secure their new home.[34]

It should be noted that Flory, as chairman of the board, asserted his leadership during the process of securing the financing for the new building and its subsequent renovation. He is the one who resolved to reduce the cost of renovations by using bricks and plumbing and other materials from the razed Ammon House, and he is the representative who visited numerous banks in order to find the best possible loan terms for the group. Flory gathered a dozen trustees and directed them en masse to the Citizen Savings and Trust Company where they collectively endorsed a note for the loan. Flory then initiated various fund-raising activities and personally monitored the monthly and yearly budgets in order to secure the financial health of the institution.

36 *America's First Regional Theatre*

Flory's decisiveness quickly established him as the economic and administrative leader of the Play House, and the membership's respect and admiration for his abilities soon led to a contentious battle over the leadership of the theatre. When the Cedar Avenue Theatre opened on December 21, 1917, with the pantomime *The Garden of Semiramis*, the entire membership beamed with pride at their new accomplishment (Figure 2.1). A new theatre featuring the capability to reproduce Raymond O'Neil's earliest lighting effects on a larger scale (cyclorama included) and an auditorium seating 160 (eventually 200 after a balcony was installed) launched the organization into uncharted territory, both artistically and administratively.[35] Before the construction of the Cedar Avenue Theatre, the Play House was a ragtag group, bohemian in spirit and much more willing to trust the artistic decisions of O'Neil. The growth in membership led to a burgeoning feeling of communal ownership over the new theatre and an increase in responsibilities and expectations placed upon the reluctant O'Neil. Because the new theatre was a result of the hard work of the trustees as well as the fund-raising efforts and personal pledges of the Play House supporters, the

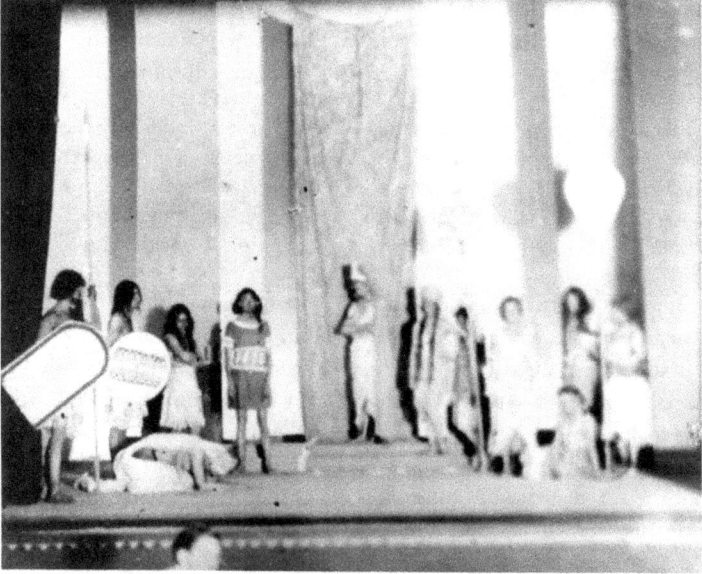

Figure 2.1 *The Garden of Semiramis* at the Cedar Avenue Theatre, the earliest-known (and unfortunately blurry) production photo in the archives (Courtesy of the Cleveland Play House Archives, Kelvin Smith Library, Case Western Reserve University.)

burden of responsibility for the direction of the Play House began to shift away from O'Neil and toward the board of directors.

While the new theatre marked a change in the level of professionalism of the Play House—becoming more and more of an "institutional theatre"—the opening of the new space also initiated the second phase of O'Neil's tenure as art director. Whereas the first three years found the Play House struggling to institutionalize, the second three-year phase exposed the extent of Raymond O'Neil's inability to manage the theatre, culminating in a hostile and decisive battle with an increasingly powerful board of directors. His ineffective leadership and contentious decisions resulted in an administrative change that not only altered the future of the Play House forever, but also directly impacted how the institution would define itself in an increasingly competitive arts scene in the midst of Cleveland's postwar economy.

BUSINESSMEN VERSUS BOHEMIANS

When O'Neil wowed his spectators with lighting effects on his miniature stage, he often followed his presentation with a brief discussion of the theories of Edward Gordon Craig. After touring Europe, O'Neil became a die-hard believer in the theories and aesthetics of Craig, especially the notions of the director functioning as a master artist and the concept of actors controlled like puppets.[36] In the early years of the Play House, O'Neil must have loved to see his dream of a Craig-influenced art theatre became a reality, especially after agreeing to take the job as director of the Play House on the condition that he would be "entirely free to handle it in his own way."[37] Initially, the founders of the group supported every decision O'Neil made and enthusiastically championed him as the guiding force of the new art theatre. All of that changed when Flory and other supports obtained the Cedar Avenue Theatre, causing the membership to increasingly expect O'Neil to be more accountable to the interests of the group rather than continuing to follow his own artistic inclinations. As O'Neil entered this second phase, he continued to emulate all aspects of Craig's character, even those that brought the British designer international disdain: as O'Neil's control and leadership was increasingly challenged, the embattled director mimicked Craig's tempestuous nature, becoming difficult to work with and demonstrating his inability to guide the theatre into the future.[38] O'Neil's final three years at the Play House were filled with skirmishes, tensions, and large numbers of members abandoning the group. A quick summary of these contentious years informs the challenges that O'Neil faced in three key areas: artistic productivity, administrative leadership, and economic management.

Numerous conflicts erupted between the combative O'Neil and various members of the Play House, but one event in particular elucidated the outstanding issues between O'Neil and the membership. Fulfilling its purpose as an "art theatre" and following the example established by the Kokoon Klub, the Play House provided local artists with many opportunities to present their work for others to enjoy, including piano recitals, dance performances, and painting exhibits. One supporter who was willing to share her latest drawings with her fellow members was Lucia McCurdy McBride. A proud Irish descendant and art collector, McBride also devoted much of her spare time to suffragist causes, local arts organizations, and efforts to reform public education in Cleveland.[39] An amateur artist in her own right, McBride offered to hang some of her etchings in the lobby of the theatre, allowing her many friends in the community to view her work. When she inquired to O'Neil about the possibility of a display, he responded with a letter on December 3, 1918, stating that the Art Committee would be meeting the following day and that he would inform her of their decision. After waiting more than a week for a response, McBride called O'Neil and was informed by his secretary (after O'Neil himself confirmed it) that her etchings would be hung that night or the next (in fact, they weren't displayed until December 17).[40] What soon followed marked the beginning of O'Neil's decline: for some unexplained reason, the director took down the drawings, upsetting McBride and angering many board members.

This action initiated a series of events leading to debate over who should control the organization—the director or the board—and the hostility between the two sides quickly escalated. Without ever admitting that he gave permission for the etchings to be hung (despite his assistant's confirmation), O'Neil wrote a terse letter to Flory attempting to explain his motivations for the action: "No member, whether he is president, art director, or anything else, has the right to use the Play House, as arbitrarily as you did, for the handling of an exhibit, the playing of a recital, or the giving of a play."[41] After three days of talking to those involved, Flory responded with a lengthy letter that began by chastising O'Neil: "I regret very much the position you have apparently assumed in this matter. I also regret that you have insisted on handling it by letter, as I believe that such matters are rarely solved satisfactorily when handled in such a formal manner. However, since you have written me, I feel it necessary to make a brief reply." At first, Flory agrees with O'Neil that no one person should control the organization, but then the author cites that his purpose in supporting McBride was not to circumvent the Arts Committee but, instead, to fulfill a promise that the Play House had made to one of its members. Flory

then proceeds to establish the timeline of events leading up to O'Neil's removal, repeatedly suggesting that O'Neil erred: O'Neil claimed that he sent McBride an explanation in the mail, but it was never received (Flory implied it was never sent); O'Neil claimed he also sent a copy of the letter to Flory, but it too was never received; O'Neil himself gave approval for the etchings to be hung, a statement that he refuted yet was confirmed by his own assistant; O'Neil claimed ignorance about the display yet informed another board member about the etchings being displayed; finally, O'Neil claimed that the drawings were relocated because the lobby was not a suitable viewing place, but he moved them to the basement out of anyone's view. Flory's letter concludes with a passage that reflects on the deteriorating relationship between the two leaders: "I am convinced that we have not acted towards Mrs. McBride...with the degree of good faith and consideration which is necessary if the Play House is to receive the measure of support by the people in this community which is essential for its ultimate success. I tried to make this clear to you in the talk which I had over the telephone when you hung up the receiver in the midst of the conversation."[42] Unfortunately, the archives do not contain a response from O'Neil (if one occurred), defending his position on any of these matters.

Several battles ensued between Flory and O'Neil, including a final showdown that turned public when the former proposed amendments to the constitution, including one that directly challenged O'Neil's authority.[43] The ensuing debate (detailed later in this chapter) so frustrated Flory that he resigned on March 3, 1919. The Play House quickly fell into disarray, its failings summarized in one of its own official publications: "In 1920, the organization disintegrated and ceased to function except in a casual and desultory way."[44] Widespread dissatisfaction eventually forced O'Neil to resign two years later, allowing for the return of Flory and Charles S. Brooks to leadership positions within the Play House.[45]

O'Neil might have stayed longer or chosen to endure more opposition, but the internal turmoil within the Play House combined with the social and cultural developments in Cleveland made it nearly impossible. O'Neil's failures in three key areas—artistic productivity, administrative leadership, and economic management—doomed any hopes of the Play House maintaining its status as an "art theatre" or becoming a participant in the Little Theatre movement. By charting O'Neil's faulty decisions in these three areas, it is possible to see how his eventual resignation not only derived from his lack of leadership, but also from external forces and events occurring in Cleveland. These contextual events emboldened the theatre's board of directors to fight for the future of the Play House.

Artistic Productivity

When the Play House originated, its small membership was content to produce a limited number of presentations, primarily because each member was required to dedicate substantial amounts of energy and time to mount these works. However, when the Cedar Avenue Theatre opened, members raised their expectations for both the number of performances and the opportunities to participate—after all, what good was building a large theatre if it was not utilized to its utmost potential? Granted, the theatre mostly offered recitals, marionette shows, and lectures, but the productions of plays were few and far between, causing the membership to become more and more dissatisfied. The numbers justify the growing discontent: in the year the Play House opened the Cedar Avenue Theatre, O'Neil managed to offer only four stage productions, and the following year only six.[46] After feeling pressure from the board, O'Neil declared that the 1920–21 season would feature 12 shows, but he was unable to fulfill that promise, directing only six shows before his abrupt departure in February. Julia Flory's reaction symbolized that of many members: "Then, at what should have been the peak of the season, the stage was dark for two months."[47] Given his inability to direct the required number of shows for his organization, O'Neil's resignation was proof that he withered under the pressure from the board and the large membership.

When the Cedar Avenue Theatre opened, O'Neil needed to seize the opportunity to establish his new theatre as an artistic force in the community, but, instead, he let it flounder by refusing to present more plays, thereby allowing other groups in Cleveland to attract audiences with their competing productions. O'Neil failed to realize that the time was ripe for his group to entice audiences to its new theatre, first and foremost because the productions in downtown Cleveland had diminished in both quantity and quality, thanks in part to the decline of the road shows. Despite the decreasing number of professional productions, leaving Cleveland audiences hungry for theatre, O'Neil did nothing. Not only did he fail to seize the opportunity to attract new audiences to his new theatre, but he also ignored the public's enthusiasm for theatre exemplified by the consistent discussion of and support for theatrical endeavors that appeared in local newspapers. While the Play House sat idly by, the efforts of two other organizations helped launch a cultural shift in Cleveland that created and established numerous competing arts institutions.

Created in 1869 and quickly becoming one of the great public institutions in the country, the Cleveland Public Library began actively

supporting drama in the late 1910s. One group that took advantage of the Cleveland Public Library's wealth of materials was the Cleveland Center of the Drama League of the Americas, founded in 1915. The Cleveland Center and its 200 members focused on two goals: to bring in numerous guests artists to lecture on a variety of topics and to produce children's theatre.[48] While Raymond O'Neil was fighting his board and struggling to produce four shows for his increasingly dissatisfied membership, the Cleveland Public Library and the Cleveland Center of the Drama League of America worked together "in some sort of circular manner in which the support and interest fostered the growth of both. At any rate...the environment for theatre in Cleveland was such as to offer a potential for vigorous growth."[49]

Another amateur theatrical group wisely capitalized on the growing thirst for drama. Founded in the same year as the Play House and "designed to aid a neighborhood community, in this case a predominantly black neighborhood in and around E. 38th Street, by providing a wide range of motivational activities to the underprivileged," the Playhouse Settlement (now known as Karamu House) served as a one of Cleveland's many settlement houses.[50] Unlike other settlement houses that offered athletic games and exercises as an outlet for disadvantaged youths, founders Russell and Rowena Jelliffe (who attended a few of the earliest Play House meetings at the Brooks' home) believed that theatre could be utilized to bridge the racial boundaries in Cleveland, and their theatrical efforts began with an integrated production of *Cinderella* in 1917.[51] Like the Hull House of Chicago, the Playhouse Settlement quickly became "a Little Theatre with sociological aspects" by offering works that addressed the racial discrimination suffered by blacks, including Ridgeley Torrence's *Granny Maumee* and Lulu Vollmer's *Sun Up*.[52]

With the number of groups offering discussions and/or productions of modern plays increasing, the opportunity for the Play House to carve out its aesthetic niche became more difficult the longer that O'Neil preferred to restrict the work of the Play House. Unfortunately for O'Neil, artistic relevance was not the only challenge he faced; soon his administrative shortcomings would be exposed when compared to other cultural organizations thriving in Cleveland as well.

Administrative Leadership

As the Play House grew, it quickly became apparent to many supporters that Raymond O'Neil was not a capable administrator. Not only did he

fail to fulfill to his promise to produce a larger number of shows, but he consistently refused to respond to Walter Flory and other board members concerning management issues. The bickering over the McBride etchings initiated a series of events that resulted in a divided membership, public criticisms, and a battle over the role of the board of directors that eventually led to Flory's resignation. An exploration of these events not only reveals O'Neil's ineffective leadership and its effect on the growth of the Play House but also, by placing these developments in the context of cultural events surrounding the Play House, the severity of O'Neil's actions combined with his ignorance and unwillingness to resolve conflict, which suggests that O'Neil deserved his fate.

O'Neil remained aloof throughout his entire tenure at the Play House. His decision to leave for days at a time without explanation initially was viewed as worrisome and strange but not problematic (he was an artist, after all). Flory, ever the practical man, failed to understand O'Neil's decisions to isolate himself, and numerous letters from the Cleveland Play House archives document Flory's repeated attempts to coax O'Neil into conversation. At the same time, as his letters to O'Neil accumulated through the years, Flory's exasperation became more evident in his writings, especially one letter tersely written on a Saturday morning in July 1917:

> Several of us tried to reach you at various times Friday afternoon and evening, and I have also made four attempts this morning to reach you. I have been informed at your father's house that they have not heard from you since yesterday and have no idea as to where you are... You have had sufficient experience in attempting to get together groups of people to know that unless you have a fixed time it is impossible to arrange meetings, for you cannot wait until the last minutes and then expect to get them all together at the spur of the moment.[53]

Perhaps the last line of Flory's letter best summarized of the deteriorating relationship between O'Neil and the board of directors: "I am not angry, but I am certainly in earnest."[54]

Matters did not improve once the Cedar Avenue Theatre opened, and O'Neil's tendency to remove himself from managerial decisions became an impediment to the organization. Julia M. Flory remembers O'Neil's frequent refusal to communicate: "He didn't like to be pinned down to definite commitments. He refused to talk to the president or other officers. He dropped out of sight, was unavailable. He would disappear for days at a time and no one could find him. After *The Dumb Messiah* [December 1918], he was completely incommunicado for several weeks."[55] With the

board's growing frustration and the increasingly dire financial situation (to be discussed later in this chapter), actions had to be taken.

Following the McBride controversy, Flory proposed two amendments that he believed would alleviate the administrative burdens on O'Neil. Once approved, his proposals would enlarge the board in size and give the board greater responsibility (or power, as O'Neil saw it) to manage the affairs of the institution. Like E. Gordon Craig, O'Neil lashed out at Flory and his amendments, claiming that the board was incapable of understanding his artistic vision and methodologies. The debate divided the membership with those loyal to O'Neil criticizing the board for their attempt to seize control of an artistic endeavor while many (not all) of the members of the board of directors argued that changes were necessary to maintain the success of the institution. This battle came to a head on the evening of March 3, 1919, at a meeting of the active members of the Play House. Knowing that these amendments would be debated and voted upon, O'Neil made sure to have his supporters present in large numbers. The evening's most dramatic moment, however, was not the voting process or even then result, but the events that preceded it. Walter Flory stood before the gathering and read his "Report of the President of the Play House," a lengthy argument detailing the failings of O'Neil, the struggles that the organization faced, and the necessity of the proposed amendments.[56] At the conclusion of his report, Flory immediately resigned from his post and sat down. The shock and silence that followed were short-lived as numerous board members arose one by one to resign their posts, leaving only four members remaining on the board.[57] Within minutes, one of the four remaining board members, John Strong Newberry, was elected president, and the meeting continued with the discussion of the two proposed amendments, which were defeated. Flory claimed that O'Neil had "gathered together his chosen cohorts and had very much misled them as to the effect of the proposed amendments. They did little or no thinking and voted blindly as he had pledged them."[58]

O'Neil was now unopposed, and his continued inaction led to the burgeoning decline of membership over his final two years at the Play House. The archive is populated with letters of members opting to remove themselves from the institution, including founding members Grace Treat and Henry Hohnhorst. Plea after plea went unanswered as members abandoned the Play House, in part because of O'Neil's discriminative policies and also because of external influences. Not only did the meteoric rise of several arts organizations in Cleveland pressure O'Neil to deliver on his promises, but also their successes, compared to the Play House's struggles,

ultimately exposed O'Neil as a horrible administrative leader for the Play House.

In 1921, the director of the Cleveland Institute of Arts, Henry Turner Bailey, described the city as "entering upon the years of its early maturity. It is beginning to have a real interest in its own aesthetic future."[59] Bailey's remarks reflected the outpouring of support for Cleveland's new cultural institutions, namely the Music School Settlement (1912), the Cleveland Museum of Art (1913), the Playhouse Settlement (1915), the Cleveland Orchestra (1918) and the Cleveland School of Music (1920, later renamed the Cleveland Institute of Music).[60] In their book *Fine Arts in Cleveland*, Holly Rarick Witchey and John Vacha suggest that "the trustees of these institutions, many of whom served on more than one board, understood that unless the general public as well as coming generations were educated to understand the importance of music, art, and theater in civilization, the new institutions being formed in the city were simply self-serving entities."[61] Unfortunately for the Play House, this last comment aptly described O'Neil's perception of the theatre: a "self-serving entity" that ultimately enabled him to disregard the recommendations of the board and to ignore the cultural developments occurring in the city. A quick look at two of these competing arts institutions not only reveals the city's admirable dedication to the development of the arts, but their success also serves as a reminder of O'Neil's failure to capitalize on the community's enthusiasm for artistic endeavors.

The story of the creation of the Cleveland Orchestra in 1918 shares a few similarities with that of the Play House: both groups began as a vision of one individual, meetings were organized to ensure support, and their first performances were small in scale. Concerning administrative leadership, the marked differences between these two groups were made apparent by the wisdom and foresight of the leader for the Cleveland Orchestra, Adella Prentiss Hughes. A longtime supporter of symphonic music, she slowly and steadily built appreciation for orchestral music by securing performances for out-of-town symphonies and by introducing Cleveland audiences to the work of many famous composers, including Richard Strauss and Gustav Mahler. After meeting with an array of local supporters, Hughes and her group decided to form a small orchestra to perform at Grays Armory on Bolivar Road, and the Cleveland Orchestra was born. Hughes did not rest on her laurels; instead, she worked tirelessly to develop the organization in both quality and quantity. Within two years of its founding, support for the organization had grown such that the orchestra—now enlarged from 50 to 86 musicians—performed

14 local concerts and an additional 11 performances in Pittsburgh, Boston, New York, Washington, and other cities.[62] How the Cleveland Orchestra flourished so quickly reveals the differences in leadership between O'Neil and Hughes. Whereas O'Neil exploited the financial support of the membership so that he and a small, selective group of friends could continue their artistic endeavors, Hughes advocated a greater sense of inclusion and ownership of the group, realizing that she would need to convince others to join her in developing the institution. In his book charting the history of the Cleveland Orchestra titled *The Cleveland Orchestra Story: Second to None*, Donald Rosenberg praised Hughes for her ability to foster productive relationships that allowed her to delegate many of the administrative duties of her position and to rely on "a visionary board of trustees to assist her."[63] O'Neil, of course, was threatened by his board of directors instead of being appreciative of their efforts, an evaluation that ultimately led to the institution's decline.

The same year that the Play House provided its membership with performances in the Ammon House, the Cleveland Museum of Art opened the doors of its beautiful new building located in Wade Park (the land was donated by Jeptha Wade Jr. in 1882). Founded initially in 1882 as the Cleveland School of Art, this institution grew steadily throughout the years, becoming one of the largest arts organizations in the city, when the Play House just began its operations. The accomplishments of the Cleveland Museum of Art spawned educational endeavors through the creation of a program for children called the "Children's Museum" and a hugely popular course in art appreciation first offered to local college students in 1918. According to one historian, "Any doubts about the interest in the new museum and the visual arts were soon dispelled when 506 students and 97 auditors enrolled in the course."[64] The stunning growth of the institution is exemplified by the widespread interest in their educational endeavors—by 1922, the school affiliated with the museum featured a staff of 21 teachers who offered classes to children and adults and a number of degree programs (including graduate programs of study) for a student body numbering over 700 students.[65]

The progression of these arts organizations increased pressure on O'Neil to articulate his own plan for growth. O'Neil failed to realize the unique opportunities for support available within Cleveland, opting to remain isolationist and autocratic. Feeling the brunt of O'Neil's reclusive and ornery nature while also serving as witness to the growth of other art organizations were the members of the board of directors for the Play House, many of whom also served on boards of other arts groups. In 1916 alone, four

members of the board of directors for the Play House were also active members with the Cleveland Museum of Art (including Charles S. Brooks). Numerous Play House participants were supporters of the Cleveland Orchestra, including the Florys.[66] One can imagine the frustration felt by Flory and his supporters as they struggled to work with O'Neil, knowing what a healthy and productive relationship between a board of directors and an organizational leader could have provided to the future of the Play House. As they watched other arts organizations effectively entice new members, build a loyal membership, and produce quality works with wide appeal, Flory and the majority of the board of directors believed it was time for the Play House to operate in a more responsible manner. Following the lead established by the Cleveland Orchestra, Flory proposed that the power of the organization rest with the board of directors. Once Flory's amendments were voted down, it was clear that O'Neil would take the institution down a different path than the rest of the community's arts organizations—a path characterized by ineptitude, exclusivity, and self-indulgence.

Perhaps the greatest of O'Neil's flaws was his failure to recognize the necessity of fostering support for his institution in ways other than membership and monetary donations. The keys to the growth of these new institutions—which O'Neil either failed to see or foolishly opted not to pursue—was their consistent efforts in the area of education outreach. At the turn of the century, Cleveland were a city yearning for knowledge; according to the 1920 census, of the ten largest cities in the country, Cleveland had the largest percentage of children aged 7 to 13 enrolled in schools.[67] "Cleveland was not a literary center, not an art center, nor a city known for its fine local theatre," Wicthey and Vacha suggest in *Fine Arts in Cleveland*. "Cleveland was known, however, for its library and well-read citizens, and for the money it had to bring in the finest in professional performers. It gave back to these performers a rare commodity in the nineteenth century, a cultivated, educated, and responsive audience."[68] Despite the city's perception as an industrial town, supporters of the arts institutions (including the leading industrialists of the day) viewed the new museums and artistic offerings as an opportunity to enlighten the common man, and Cleveland's diverse citizenry took advantage by registering for night classes offered by the Cleveland Orchestra.[69] Furthermore, institutions like the Museum of Art and the Cleveland Orchestra both worked with local schools to not only publicize their endeavors, but also educate and train future supporters as well. The Cleveland Museum of Art hired a staff person to tour various schools and discuss art with students, and the museum made rooms available to schools if they wanted to hold classes

in the new facility. For the Cleveland Orchestra, one of its primary goals was to work with schools to improve their instrumental music programs, and Adella Prentiss Hughes worked directly with the superintendent of Cleveland's public school system to achieve this goal.[70]

By comparison, the educational efforts of the Play House were miniscule, selectively offering guest speakers and recitals by and for its own membership. The fault for the limited outreach lays with Raymond O'Neil, whose refusal to work with his own board inhibited any possibility of constructive discourse concerning how to enlarge membership and attract new supporters. O'Neil preferred to focus solely on the artistic aspects of his job, and before the opening of the Cedar Avenue Theatre, the tasks expected of him were within his skill set. However, in the final three years of his tenure at the Play House, his decision to dedicate himself solely to artistic pursuits hindered the ability of the Play House to expand and fill its new theatre. In his defense, O'Neil was a terrible administrative leader as he lacked the skills of an effective administrator—he was an artist who naively assumed a leadership role without any plan for success. His flaws in management might have been permissible if the Play House had remained an insignificant art theatre and had not built a new theatre at a time when support for the arts flourished in the community. However, the theatre was built, and O'Neil stubbornly refused to admit that he was over his head. Like Edward Gordon Craig, O'Neil viciously attacked those who criticized him, but this self-defense mechanism further isolated not only him from the board, but also the Play House from the community.

Economic Management

It is easy to summarize how the Play House got into financial trouble: by offering fewer productions to a stagnant membership, expenses quickly outweighed the revenues. This problem arose early in the Play House's history, evidenced in a letter from Flory to O'Neil dated June 13, 1918. In this document, Flory complains about O'Neil's continued absence from a board of directors meeting and states that the institution was $900 in debt with an expectation that their summer revenue would only cover one-third of that amount. Three months later, the board of directors sent letters to members whose dues were unpaid, asking them to send money because the institution was "face to face with several bills payable, (some of them antiquated) which it cannot pay."[71] The problem progressed to the point that Flory suggested it was necessary to crassly ask certain supporters with ill family members to pay their dues on time.[72] Of course, within a month,

Flory delivered his famed "Report of the President" in which he addressed the dire financial condition of the theatre. In 1919, the theatre's total operating cost was $8,721, yet income from admission fees only covered a little over 20 percent of these expenses, requiring the membership to contribute the remainder through yearly dues and financial gifts.[73] To Flory and other board members, the Play House needed to devise a financial plan if it was going to "maintain its self-respect and the respect of others."[74]

Flory was not alone in his argument for fiscal responsibility. In his 1926 book *Little Theatre Organization and Management*, drama professor Alexander Dean harshly criticized institutions that relied heavily on their membership. In an impassioned argument, he dismisses the tactics of Little Theatres that operated with the modus operandi of "art theatres" asserting that it was necessary for these theatres to become fiscally responsible. Dean's harshest criticisms are reserved for organizations exactly like the Play House:

> At the beginning of the Little Theatre movement...here was a new philanthropic organization to be supported by endowments and bequests of wealthy citizens. The Little Theatre was something which should not be forced to depend upon public support. The presence of this subsidy behind the first Little Theatres had its effect upon policy and direction. A source of financial income independent of the audience allowed the director to give plays which he wanted to present rather than those which any public wished to see. It divorced him from any consideration of the audience. It made the Little Theatre an experimental organization.[75]
>
> [But] too many directors in the community Little Theatres and schools expect money, equipment, interest and an audience to be served them on a silver salver, garnished with water cress, lemon and paprika. Fortunately, it doesn't come to us in our profession that way; I don't know of any profession in which it does. No one can succeed in any line of work who gets mad and won't play because he can't have it his own way. Yet many Little Theatre directors have proved they are poor workmen by blaming their tools.[76]

Not only was O'Neil too slow in learning this lesson, but he was also unwilling to fix any of the financial problems brought to his attention. At the beginning of his final season (1920–21), the debt for the Play House had risen to $1,200, yet O'Neil refused to address monetary matters, believing them to be too "sordid" for artists like him. Instead of working to enlarge the membership, he traveled to Europe.[77]

Contextualizing O'Neil's refusal to address the theatre's financial difficulties with the larger economic challenges facing Cleveland makes his

deliberate decision to inhibit the board of directors in its efforts to secure financial stability even more shortsighted and insipid. Members were leaving not only because of opportunities provided by other arts organizations, but also because economic hardships occurring in Cleveland from 1919–21 made it unwise to invest in an arts institution with no fiscal responsibility. How the leaders of these various arts organizations responded to the financial challenges explains why the Play House nearly collapsed while other institutions weathered the storm.

When Raymond O'Neil took control of the Play House from 1919 into 1920, the city of Cleveland was sliding into a "severe depression" that ended in 1921.[78] As a manufacturing city, the slowdown of a postwar economy hurt Cleveland as it adjusted to the new realities of lessened demands. The Cleveland Foundation's annual yearbook provided statistics for the economic downturn: "During 1920, the volume of business operations in Cleveland was reflected by bank transactions that averaged $30,000,000 a day. In 1921, commerce and industry had so contracted and slowed down that the average was only $21,000,000 a day."[79] The steel and iron industries were hardest hit when the economic slowdown caused the number of blast furnaces in operation between March 1920 and May 1921 to be severely reduced from 67 to 13.[80] Within the same timeframe, the number of employees working in 50 Cleveland-area plants was cut in half. Industries concerned with transportation and commerce made substantial cuts as well, but not always enough to survive. According to the *Cleveland Year Book*, "three times as many firms failed in 1921 as in 1920, and their liabilities were six times as great."[81] The city was undergoing an economic depression, causing many to leave the urban center and move to outlying areas in hopes of finding employment.[82] This location shift directly affected local schools: "In September, 1919, the Cleveland Public School System statistician noted that city school enrollments were far less than expected and reported that unusually heavy enrollments had occurred in Lakewood, Cleveland Heights, and other Greater Cleveland suburbs."[83] People took their money away from Cleveland, and those that remained were making less or were not as willing to donate it to arts organizations.

With these financial constraints, it was even more imperative that arts organizations worked harder to retain their membership during the postwar depression. The Cleveland Museum of Art, for example, struggled with a stagnant membership, decreasing their numbers in 1919.[84] While many supporters remained committed to the organization after moving away from the city, the need for these arts institutions to justify their existence and their worthiness to the community was paramount, and that

is exactly what the director of the Cleveland Museum of Art did. In its monthly bulletin to its members (another method of keeping their supporters engaged and involved), Frederic Allen Whiting bluntly addressed the economic difficulties facing the museum, detailing how the museum's income "is many thousands of dollars short of the budget approved by the trustees for operation for the current year. Every effort is being made to cut down expenses without curtailing services; but there will still be a considerable deficit at the end of the year unless the public responds liberally to the appeal of the Museum for help."[85] The Cleveland Orchestra also struggled to find financial stability given its small number of contributors (135) compared to orchestras in similarly sized cities like Detroit (700 supporters) and Minneapolis (360 supporters).[86] The leaders of the orchestra worked tirelessly to promote the cultural advantages that the orchestra provided and the amount of pride and recognition that it brought to the city. This marketing strategy resulted in contributions from "businessmen who had no personal interest in the music but realized that a symphony orchestra provided the community with a valuable cultural benefit."[87]

O'Neil, however, never made such overtures to the community to elicit support. He refused to work with his board to initiate a membership drive or to promote the work of the Play House as deserving of support. He failed to utilize the city's educational opportunities to help ensure community awareness. Instead, O'Neil antagonized the board, became exhausted by the responsibilities of the job, and failed to fulfill promises that he and the board of directors had made to their membership. With Cleveland's arts organizations competing for support in a city enduring a financial downturn and decreasing population, it was unthinkable that O'Neil failed to act on behalf of his institution, but this lack of effort and vision was simply who O'Neil was. O'Neil's problem was that his perception of the theatre and its purpose never changed, despite the group's growth in size and membership. He never altered his methodologies or his approach to management, and, like Edward Gordon Craig, his prioritization of his "artistic vision" over managerial and economic matters led to the near-collapse of the Play House.

THE NON-LITTLE THEATRE THAT O'NEIL LEFT BEHIND

Following the close of the eighth and final production of the 1920–21 season (four short of the 12 that O'Neil had promised), active members

received an envelope from the Play House containing two letters. The first was a brief notice from O'Neil written on February 22, 1921:

Dear Member:

> I am announcing my permanent retirement as director of The Play House at the close of my term in May.
>
> I am convinced that the necessary and inevitable evolution of the art theatre in America is from amateur to professional production. For this reason I leave The Play House to pursue work in this direction after my return from Europe.
>
> Very truly yours,
> Raymond O'Neil

The second letter, written by the president, Leonard Smith, instructed members to attend a meeting on February 28 in order to discuss O'Neil's resignation and the future of the organization (Figure 2.2). Members whose dues were not paid in full were not allowed to vote on any of the measures.[88]

Events developed quickly that were very telling of the direction that the membership of the Play House wished to go. The two presidents who served under O'Neil during his final three years, John Newberry and Leonard Smith, both became "utterly discouraged and ready to give up the whole affair," asking Walter Flory to resume the presidency. Flory declined due to demands of his law practice, but he suggested that Charles S. Brooks, who recently returned from New York, be approached to become a vice-president under Smith (who would continue as president). By May, both Flory and Brooks were once again on the board, and the Play House began its search for a new leader.[89]

Whoever would be chosen to take the helm of the theatre had a daunting task set before him—not only was the stage dark and the institution suffering financially, but the membership also was dissatisfied and confused about the theatre's purpose in relation to developments in American theatre. Thanks to O'Neil, the Little Theatre movement had passed the Play House by. While institutions like the Washington Square Players, the Hull House in Chicago, and the Toy Theatre in Boston reflected the ideals and endeavors of the Little Theatre movement in America, the Play House failed to produce any similar achievements.

The definitions of the three types of independent theatres in existence in the 1920s bear repeating to appropriately label the Play House, given its halting evolution. First, the Play House was established as an "art theatre," an institution with a limited number of members who "subsidized the theatre's activities and were themselves the only audience for

February 22, 1921.

Mrs. Edna Strong Hatch,
Cleveland, O.

Dear Member:

 I am announcing my permanent retirement as director of The Play House at the close of my term in May.

 I am convinced that the necessary and inevitable evolution of the art theatre in America is from amateur to professional production. For this reason I leave The Play House to pursue work in this direction after my return from Europe.

 Very truly yours,

 Raymond O'Neil

Figure 2.2 O'Neil's brief resignation letter addressed to individual members of the Play House (Courtesy of the Cleveland Play House Archives, Kelvin Smith Library, Case Western Reserve University.)

its productions."[90] Unlike the Play House, most of these art theatres were founded in the earliest years of the 1910s and had either closed or transformed into Little Theatres by the end of World War I.[91] Second, Little Theatres served a social purpose, hoping to educate audiences and provide new cultural experiences through the introduction of new and modern playwrights as well as consistent efforts in educational outreach. Finally, a community theatre offered opportunities for people from the entire community to become involved with the institution and enjoy works selected for a more "commonplace" audience.[92]

The inner workings of the Play House betray the fact that it was considered a member of the Little Theatre movement only because it operated during the same time period. Whereas Alexander Dean argued that "the Little Theatre, as a society fad, died during the war," the Play House remained an art theatre until O'Neil resigned in 1921. [93] The Play House never transitioned from an "art theatre" into a Little Theatre because it failed to pursue any form of educational outreach for the community, and its endeavors focused solely on satisfying a limited viewership, not engaging a larger audience. If the heyday of the Little Theatre movement occurred in the 1910s and ended by 1919, the Play House lagged behind in its development and never aimed to "raise the appreciations of its audience" as most Little Theatres did.[94] Raymond O'Neil's ineffective leadership prohibited the Play House from satisfying the expectations and purpose of the Little Theatre movement: Little Theatres aimed to explore social issues or to better American culture through the exposure to European playwrights; they challenged audience expectations through their production methods or the physical audience/performer relationships; and their work was anti-commercial, aimed to satisfy theatergoers' desire to see plays previously unavailable or considered too controversial for commercial producers. These elements were the core tenets of the Little Theatre movement, and the Play House did not satisfy a single one of them.

If O'Neil had not resigned, it seems likely that the Play House Board of Directors would have plotted his removal. Throughout his entire six years with the Play House, O'Neil never understood that as the theatre and its membership grew, the theatre owed more to the community. O'Neil disregarded the needs (and inclinations) of the city by failing to institute educational outreach programs. In addition to ignoring the successful efforts of the Cleveland Public Library and the *Plain Dealer* to increase support for dramatic activities in the community, O'Neil's disastrous leadership in all matters, artistic, administrative, and economic, prevented the Play House from transitioning into a Little Theatre, robbing the institution of an opportunity to carve out its niche in the Cleveland community. Instead, the dire financial condition of the organization and the need to immediately bolster its support through increased membership forced the Play House to transition directly from an "art theatre" to a community theatre, beginning a long period where the Play House accomplished little in the way of artistic ingenuity.

Ironically, O'Neil's inaction may have saved the Play House by distinguishing it from the Little Theatre movement. Instead of being tied to an ideal or a specific social cause that often limited the audience base, the

Play House as a community theatre enjoyed greater flexibility and, therefore, survived where other little theatres failed, including the Toy Theatre of Boston (which became a movie house in 1957), the Provincetown Players (which ceased operations following the Great Depression), and the Washington Square Players (which pursued professional endeavors when it evolved into the Theatre Guild).[95] O'Neil's avoidance of responsibility and resignation from the theatre marked the beginning of a new era for the Play House—an intentional shift of focus where the theatre's greatest accomplishments derived from community outreach efforts rather than artistic achievements.

His tenure may have been short-lived and other participants from the time might be more fondly remembered, but it is hard to argue that anyone has had as much impact on the history of the Play House as Raymond O'Neil. Given the board's need to ensure financial stability, O'Neil unknowingly forced the Play House into becoming a community theatre, defining its role and its purpose for the next 60 years.

3. Learning Curve

When O'Neil left his post in May 1921, the theatre's board of directors was quietly working to find a replacement, creating a search committee consisting of Walter Flory, Charles Brooks, and Frank Mulhauser. The fortuitous arrival in Cleveland of two respected figures in American theatre provided an opportunity for the committee to seek advice from individuals very much in touch with the current state of American theatre. George Pierce Baker, playwriting teacher and creator of the legendary 47 Workshop at Harvard University, took his group on tour in the spring of 1921, landing at Cleveland's Duchess Theatre for a two-night engagement.[1] During their brief stay, Brooks not only enticed Baker to give a lecture at the Play House, but also asked his good friend to supply a few names of potential candidates for their vacant leadership position.[2]

The second visitor travelled to Cleveland specifically to meet with the Play House's board of directors. Thomas Wood Stevens, whose theoretical approaches to the training of theatre artists brought him acclaim as the dean of the School of the Theatre at Carnegie Institute of Technology in Pittsburgh, was impressed by the Play House's facilities and strongly recommended one individual for the position: his former student Frederic McConnell.[3] A native of Nebraska, McConnell led a varied life before committing himself to a career in the theatre, having attained a law degree and served in the military (he was a prisoner of war in Germany during World War I). Upon his return from service, he dedicated himself to the theatre arts, working with leading figures in the American theatre, including Sam Hume, at a variety of theatres around the country, including the Arts and Crafts Theatre in Detroit.[4] Persuaded by Stevens to consider the position available at the Play House, McConnell agreed to visit Cleveland in June while en route to California. During his brief stop, McConnell watched a performance of three one-act plays, a production that members decided to mount following O'Neil's recent departure. According to Julia Flory, the cast were eager to please McConnell and worried that their performance and production would not be enough to impress the director.

There is no record of McConnell's thoughts concerning this one performance; however, he must have enjoyed it because he not only accepted the position, but also married the leading actress of the show, Katherine Wick Kelly.[5]

In O'Neil's final year, he promised to produce 12 shows, and thanks in large part to a membership determined to stage works despite O'Neil's lack of support, the theatre managed to offer eight presentations. When McConnell announced his intention to mount eight productions, the board greeted his promise with justifiable skepticism. By the end of his first year as artistic director, McConnell had produced 12, marking the first time in the Play House's history that the theatre delivered on its promise to present a specific number of plays.[6] The difference between the two men and their ability to fulfill their promises was a matter of hubris. Whereas O'Neil selfishly considered his aesthetics and his skills as superior to his cohorts, McConnell relied on the assistance and judgments of two other men to help shape the future of the Play House. As part of his agreement to take the directorship, McConnell asked the board to also approve the hiring of two assistants: K. Elmo Lowe and Max Eisenstat.[7]

Like McConnell, Lowe (often simply referred to as "K") led a multifarious life before dedicating himself to theatre—the native Texan worked as a journalist, a dental assistant, a shipyard electrician, and a milkman before studying under Sam Hume at the Greek Theatre (where he first met McConnell). Lowe and McConnell met again at Carnegie Tech, and a lifelong friendship developed that greatly benefitted them in their work in Cleveland. The respectful sharing of ideas between the two men is exhibited in a private letter exchange where McConnell proposed opening the season with poet Edwin Arlington Robinson's *Van Zorn*. In response to McConnell's July 4 letter, Lowe demonstrates his comfort level with McConnell by freely sharing his opinions. On July 9, 1922, however, Lowe unleashed a diatribe in a handwritten letter:

> What can have been your phycology [*sic*], your method of logic, your taste of your desire to announce *Van Zorn* as your opening production I don't know. Its intentions may rank it as deserving to be sandwiched into an experimental season somewhere, but surely not as an opener. It surely isn't good theatre, good thinking or good writing. The poor man has something to say I guess but he can never say it to me in the theatre, he'd much better keep on being a poet.[8]

By the end of the letter, Lowe had calmed himself down: "Excuse the *Van Zorn* explosion, but really shouldn't the opener be a little more of a

comedy?"⁹ In his response dated July 14, McConnell justifies his appreciation of the play yet is persuaded by Lowe:

> Your two letters are at hand, written from Chicago both of them redolent with verisimilitude of your very peculiar self, and enjoyed and appreciated beyond words to tell.... I am not committed to the play and your strong criticism helped me to waver. We won't do it as an opener. If the light doenst [sic] get any clearer we don't do it at all, altho [sic] I am strong for the idea of doing a new man who has written a play that is different from anything I have ever read.¹⁰

The play was never produced by the Play House.

This willingness to listen to others' opinions not only signifies a drastic shift in leadership from O'Neil's tenure, but also details the camaraderie between the two men. McConnell presented himself as "business-like" and "matter of fact" in his dealings with the board, yet those who knew him best also praised his dry sense of humor.¹¹ In a fond remembrance of the director, past-president of the board of directors Chloe Oldenburg recounted a "legendary story" frequently told by company members: "A young actress at the Cedar Avenue Play House said: 'Mr. McConnell, this chair is awkward to sit on.' 'Remember my dear,' replied McConnell, 'it isn't the chair that's awkward!'"¹²

Lowe was a living contrast to McConnell, both in temperament and physicality. Known for his matinee idol good looks, photos of the assistant director were frequently stolen from the theatre lobby. A successful actor in his own right, Lowe was "mercurial, vital, and warm and was generally loved by his colleagues for his thoughtfulness" and his jovial sense of humor.¹³ In addition to his talents on the stage, Lowe received frequent praise as an impassioned public speaker and an expert storyteller, tools that served him and the theatre well when tasked with promoting the theatre to social clubs and other community organizations.¹⁴

As the third member of what was frequently referred to as "the Triumvirate," Eisenstat sprung from more humble beginnings, having arrived in America at the age of two from his native Russia. Growing up in Pittsburgh, he was interested in attending college close to home, so he enrolled in Carnegie Institute of Technology, where he planned on becoming an engineer.¹⁵ Evidentiary of Lowe's persuasive speaking skills, he convinced Eisenstat to abandon his prior studies in engineering and, instead, develop his skills as a lighting designer, stage carpenter, and production manager.¹⁶ Eisenstat's experience with engineering benefited him in Cleveland where he single-handedly designed light boards for the Play

House, increasing the theatre's national reputation by possessing the most "flexible" switchboard in the country.[17]

The arrival of these three men from Carnegie Institute of Technology marked a significant shift in the operation of the Play House. One of McConnell's first directives was the dismantling of O'Neil's precious cyclorama, a move that not only symbolically erased O'Neil's artistic imprint of the Play House, but also announced the new regime's intention to transition the Play House from an art theatre into a community theatre.[18] The removal of the cyclorama served as a gesture to the community that one man's aesthetics and dictates would not dominate every production or affect the operation of the institution. McConnell believed in "a soundly, democratic organization," and he proposed an initial season "intended to appeal to a wider audience and to offer wider scope for the acting talent of Cleveland."[19] In contrast to O'Neil's methodologies and unfair casting, McConnell directly appealed to the community for support: "Before coming to Cleveland, I obtained the names of a number of capable actors and actresses who, though living in Cleveland, have never been seen on the noncommercial stage here, and I am also extending a general invitation to others to join the Play House forces."[20] With the cyclorama gone, the performance space became more expansive, and the theatre opened its doors to the community.

The hiring of the "Triumvirate" also led to an immediate yet monumental achievement. Before accepting the position, McConnell argued for a yearly salary for himself ($3,500) and his two associates ($1,200 each).[21] Even though O'Neil had received a yearly salary for his work, McConnell, Lowe, and Eisenstat were the first "trained" men hired by the theatre on a yearly salary.[22] While it may be a nuanced distinction, the board's commitment to hiring three professionals transitioned the theatre from an amateur to a professional status (figure 3.1). Historian Joseph Welsey Zeigler noted the significance of McConnell's hiring, stating that the Play House was "one of the very few [art/little theatres] to change to professional status...making the Play House the first American regional theatre of any size, scope, and continuity."[23]

Prompted by Brooks and Flory in numerous letters of correspondence to the new director, McConnell and his team immediately initiated a strategy to popularize the Play House within the community.[24] To this end, acting opportunities were made available to all community members as opposed to paid members, leading parts were rotated among actors so as not to "sacrifice" amateurs, and the educational programs afforded to students and community members helped expand the staff and production capabilities.[25]

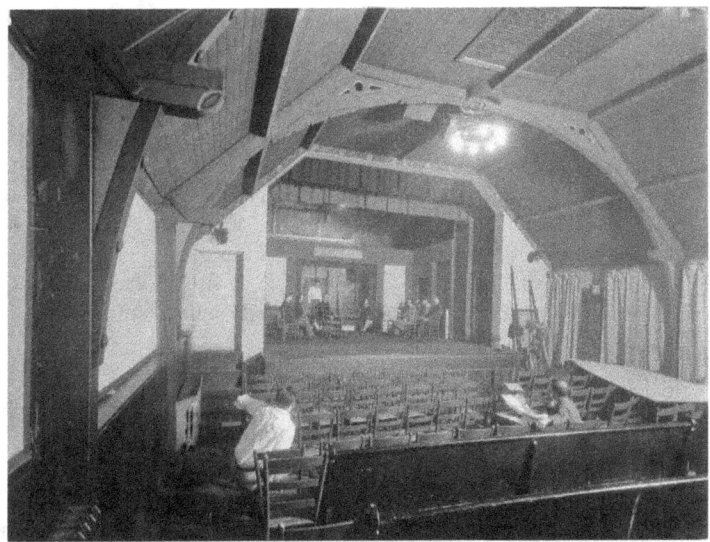

Figure 3.1 Rehearsal in the Cedar Avenue Theatre. Sitting in the audience (left to right) are K. Elmo Lowe and Frederic McConnell. (Courtesy of the Cleveland Play House Archives, Kelvin Smith Library, Case Western Reserve University.)

McConnell seized upon the opportunity to increase community involvement as a means of fulfilling his bold agenda: the formation of a resident company of actors and technicians, the establishment of a school for inexperienced actors, and a "new and more fully equipped theatre."[26] To his credit, these goals were all achieved within a decade, but the existing histories of the Play House focus on McConnell's artistic work more than his other endeavors. Descriptions of productions and the actors and actresses who graced the stage are adequately documented in Flory and Oldenburg's books. However, these two works do not give sufficient credit to two other remarkable achievements of the Play House during this time. The establishment of educational outreach endeavors, which featured a landmark children's theatre program, and the formation of a new fund-raising model for community theatres both assisted in the fulfillment of McConnell's agenda.

"STEAL OR BORROW A CHILD!"

In a letter dated December 13, 1922, president of the board of directors Charles S. Brooks sent a letter to Play House subscribers detailing the

financial debts of the theatre and announcing upcoming productions. In this report, he dedicates a paragraph to the promotion of an unofficial production (not part of the subscriber's season):

> During this same week, beginning the day after Christmas...there will be given a marionette play for children and for other fold whose bears are not too stiff. The Play is produced by Mrs. Walter Flory, and it will recount the amazing adventures of Aladdin and his search for the magic lamp. There is a cavern of jewels, a storm on a mountain top, and a genie who is an inch taller than the other dolls. Steal or borrow a child! Pick up a dozen as you come along! Or if your neighborhood is empty, dress yourself in curls and childish ginghams! Buy a lollipop and turn back the years![27]

Brooks failed to mention that his enthusiasm for the project derived from the fact that he wrote the script, and his support for the project symbolized a growing commitment from Play House members to expand educational outreach endeavors. Ironically, puppet shows would be the least celebrated of all the early educational undertakings of the Play House, yet when placed in the context of efforts of other arts organizations in Cleveland and around the country, they are a remarkable accomplishment.

While the outreach activities of the Play House may have been extraordinary within the field of professional theatre, the motivation to arrange such events came from external influences. The time was right for the theatre to join citywide efforts to support education outreach and promote the arts within the local public school system. Because of the continued influx of minorities into the Cleveland area, unions began to take hold in many of the city's factories. This growing labor organizations change gave rise to another brief "Progressive Era" and culminated in Cleveland hosting the Second National Conference for Progressive Political Action in December 1922.[28] Responding to new Progressive statewide mandates that required public schools to provide education for disabled persons in conjunction with a move by Cleveland schools to encourage educational experiences outside the classroom (primarily vocational), arts organizations in Cleveland heeded the call by offering special programs for local school systems.[29] Once again, the Play House followed the lead of the Cleveland Orchestra and the Cleveland Museum of Art by adapting their ideas and programs to establish its own model for educational outreach programs.

Cooperation between Cleveland's nonprofit arts organizations and the public school system began with the opening of the new Cleveland Museum of Art in 1916 when director Frederic Allen Whiting hired Mrs. Emily Gibson to be the first director of educational programming. Upon

her arrival in January of that year, she immediately contacted schools and libraries, talked with administrators and members of the community, and promoted the museum as an educational opportunity within the Cleveland area.[30] The museum went to extraordinary lengths to provide educational opportunities for local school systems, hiring several full-time teachers to conduct tours for visiting school children or to travel and lecture in different schools around the city.[31] Groundbreaking in its own field, the Cleveland Museum of Art was one of the first art museums in the country to allow children to draw in the main galleries, and also institute a policy of "open classes" where children could attend free lessons on Saturday or wander around the facility in hopes of finding individual inspiration.[32] In their book *Educational Work at the Cleveland Museum of Art*, which details the museum's educational programming, Thomas Munro and Jane Grimes summarized the popularity of the museum's efforts in the context of the city's "Progressive Era" mentality:

> Cleveland is an extremely cosmopolitan city, and the museum classes express this fact in every way, especially in the free classes for non-members' children. Many of these come from underprivileged levels of the population. Some of them consider museum experience so valuable that they walk for miles in winter weather, to attend the open classes. On occasions, in recent years, when the city was completely paralyzed by bad snow storms, students somehow got to the art museum for lessons. The museum has done its best to encourage these students and aid them with whatever small financial help it can secure.[33]

Formal agreements followed with various school systems, including Cleveland Heights and Shaker Heights ensuring their access to the museum by making annual grants in order to establish a definite schedule for its students. With many members of the Play House Board of Directors also serving on the museum's board and becoming aware of the increased patronage from both students and their parents, the successful efforts to entrench the institution within the community did not go unnoticed.[34]

A second arts organization jumped on the bandwagon, providing another model and further pressure for the theatre to follow suit. The director of the orchestra's educational program, Lillian Baldwin, implemented what became nationally known as "the Cleveland Plan." Similar to the art museum's offerings yet untried by orchestral organizations, the plan aimed to provide students with access to concerts, supported by postshow discussions and lectures. Unlike the Museum of Art, which aimed to discover new talent, the Cleveland Orchestra's goals were much simpler: student appreciation for music by "putting them in touch with feelings that could be expressed in

no other way."³⁵ In addition to offering concerts to public schools beginning in 1921, utilizing public radio to provide instructions for music lessons, and organizing a citywide music memory competition, the Cleveland Orchestra followed the model established by the museum and offered age-appropriate classes for all students between the fourth and twelfth grades.³⁶ According to historian Donald Rosenberg, "Thousands of children—sometimes up to 40,000 or 50,000—were immersed in symphonic repertoire each year. The interest spilled over to their parents, many of whom enrolled in adult music-appreciation courses."³⁷ Increases in attendance in these educational programs also directly influenced support for the newly founded Cleveland Institute of Music, the city's first professional conservatory.³⁸

Given the number of Play House members who served on multiple boards, it is not surprising that the impetus for the creation of programming for children at the theatre would come from three such members. Unlike the other arts organizations that made educational programming central to their founding, the trio from the Play House initiated educational programming in response to community need. With McConnell's shift toward mainstream entertainment and away from the "art theatre" offerings of O'Neil, the marionettes featured in many of the Play House's earliest performances (and favored by O'Neil and Edward Gordon Craig) fell into disfavor with the new director. One woman, however, channeled her passion for puppetry into a new endeavor: the newly formed Puppet Player's Guild, a small but dedicated group within the theatre.³⁹ Mrs. Ernest A. (Helen) Joseph fell in love with puppetry during O'Neil's tenure, so much so that she studied the form outside of Cleveland and eventually wrote a book on the subject.⁴⁰ She enlisted the help of Mrs. Charles H. Prescott who first fashioned puppets in a simple effort to amuse her children, but later gained recognition through her popular puppet shows performed at the Cleveland Museum of Art. With Julia Flory designing the sets, these three women banded together to utilize their skills and offer a fundraiser for Park School, an institution founded by several women who also financially supported the production. On the mornings of November 25 and 26, this offshoot of the Play House presented *Hansel and Gretel* at the Circle Theatre (the Play House was opening Eugene O'Neill's *Beyond the Horizon* on the same day, making the Cedar Avenue theatre unavailable).⁴¹ The performances drew rave reviews from audiences and theatre critics, allowing the group to plan a series of productions throughout the year with the support of McConnell and the entire Play House.⁴²

Despite receiving praise, *Hansel and Gretel* did not rival the attention given by the local newspapers to another marionette production that

happened to be performed on the same date and at the same time. Performed in the famous Hotel Statler in downtown Cleveland, the "second musicale" puppetry show primarily served as a social function, with press reports noting who sat with whom instead of offering descriptions of the show.[43] The difference of intention between the two productions was obvious: the "second musicale" was a means to an end (entertainment for the ladies who lunch) whereas the Puppet Players' Guild mounted a serious, respectful work celebrating the art of puppetry. The creators of the *Hansel and Gretel* production certainly deserve praise for their commitment to excellence, but they also warrant recognition for unknowingly achieving a landmark accomplishment in theatre history. The Puppet Player's Guild became so popular that they converted an empty storeroom in the Cedar Avenue Theatre into a permanent performance space for their puppet shows, becoming the first permanent marionette theatre in the United States.[44]

It is impossible to pinpoint which theatre in the United States offered the first children's theatre production and when it was mounted. There are records of theatres founded with the sole intention of offering shows for children dating back to the nineteenth century, and several of these organizations toured with their productions to nearby towns. Historians of children's theatre appear confused concerning the differences between Little Theatres, community theatres, and professional theatres, with many writers failing to specify production dates, often listing productions as having occurred "in the 1920s." The decline and closure of these theatres has also contributed to the absence of sufficient documentation for production dates. For example, Nellie McCaslin's *Historical Guide to Children's Theatre in America* attempts to analyze children's theatre productions presented by Little Theatres. The only institutions that McCaslin references clearly are children's theatre groups, that is, The Children's Theatre Guild of New Orleans, The Junior Repertory Theatre of Minneapolis, and the Indianapolis Junior Civic Theatre.[45] Furthermore, the scarcity of information on these theatres makes it impossible to verify production dates. Jed H. Davis and Mary Jane Larson Watkins's *Children's Theatre: Play Production for the Child Audience* cites settlement houses as the producers of some of the earliest children's theatre work, but then the authors also claim that community theatres produced similar work; further complicating the matter, the institutions referenced are obscure and production dates are rarely provided. Lists of theatres producing children's plays are provided, but it is never made clear in what order (if any) they are listed.[46]

It is nearly impossible to ascertain specifics concerning the development of children's theatre in America. There are, however, two absolutes that

can be verified: first, the Junior League played an instrumental role in the development of children's theatre across the country, and second, the Play House was an unknowing pioneer of its kind. The Association of Junior Leagues of America's involvement with children's theatre began in 1912 when members began visiting hospitals and settlement houses to introduce children to puppetry and storytelling.[47] In 1921, the Junior League initiated a program dedicated to the production of children's theatre, featuring members performing their own work in rented theatre spaces.[48] By the end of the decade, more than 50 Junior Leagues across the country were offering productions for children, and this activity continued well into the 1970s when members began performing less and, instead, opted to sponsor non-League productions.[49] It should be noted that the Junior League played a role in the development of children's theatre in Cleveland as well: girls of the Junior League served as ushers for the Puppet Players Guild's performances, and several of the declared "patronesses" from the Junior League were also devoted members of the Play House.[50]

As for the Play House, it is impossible to determine whether or not its November 1921 production of *Hansel and Gretel* was the first children's theatre production offered by a professional theatre. What can be verified is that the Play House produced the first children's theatre show of any currently operating theatre. The longest-running children's theatre in the country is assumed to be the Children's Theatre of Maine, but its first production was mounted in 1923, two years after the Play House mounted theirs.[51] In other words, because of its longevity, the Play House can claim the title for longest-running children's theatre program in the United States.

According to historian Roger Bedard, editor of *Spotlight on the Child: Studies in the History of American Children's Theatre*, the history of children's theatre should not be characterized by a list of who performed first; instead, he argues, historians ought to analyze the lasting impact of a specific accomplishment.[52] With this standard, the Play House production of *Hansel and Gretel* deserves recognition. This group's inaugural marionette production spawned numerous puppet performances for children throughout the years. In fact, McConnell was so impressed by the presentations and its wide appeal that he proposed that the theatre offer a second season of marionette shows as a means to develop audiences. In a letter dated October 31, 1924, McConnell attempted to persuade Charles Brooks to support this new endeavor:

> The season will be designed primarily for a children's audience—a field which, I believe, exists in Cleveland and which is as yet practically undeveloped. It

seems quite within our scope to develop this field of children's entertainment and, for the time being, this may be one way to enter into this field. The emphasis now will be on marionettes and puppets and this, so far as the creation of an audience is concerned, will be the beginning of a children's theatre as an adjunct to our general enterprise."[53]

In addition to *Hansel and Gretel* and Brooks's own *Aladdin*, the surprising support for children's theatre within the Play House soon sparked an interest in larger educational programs.

Utilizing its peer arts organizations as models, the Play House quickly moved to integrate itself within the community through educational outreach programs, often seizing the opportunity to publicize its efforts. By September 1922, McConnell introduced the Play House Scholarship Fund, which enabled Russell Collins, a recent graduate of Carnegie Institute of Technology, to perform in several shows. McConnell also initiated an apprentice program in which two teens or young adults from the Cleveland area were trained by the theatre staff.[54] "They worked for one or two seasons in various departments of the theatre," historian William B. Clark noted. "No tuition was charged and no salaries were paid; however, scholarships were sometimes awarded."[55] Within a year, the theatre was touring productions to Oberlin College and Lake Erie College, leading to the creation of the Play House School of Theatre in 1927, which provided college students and theatre professionals the opportunity to study at the theatre as well.[56] That same year, the Play House became affiliated with Cleveland College, allowing the staff of the theatre to provide lectures to students while also offering them "firsthand experience in working with stage equipment, costuming, lighting, and scenery."[57]

The culmination of these theatre educational endeavors came in 1934 with the establishment of the Play House Children's Theatre (later renamed the Curtain Pullers), a program created by Esther Mullins.[58] Producing "plays for children with children as actors," Mullins sent letters to the principals of numerous Cleveland-area schools, asking them to select two of their most talented students and allow them to attend the Play House School of Theatre free of charge.[59] While the legacy of the Curtain Pullers most often refers to the discovery and training of famed actors Paul Newman and Joel Grey, the steady growth of the group is a testament to the quality of its work and the dedication of the Play House staff to ensure its success. As evidence of its growth, Clark notes that the Curtain Pullers "produced eight plays [in 1934–35], giving one to three performances each. Within a few years, five hundred students between the ages of six

and eighteen were attending the Saturday morning classes.... Admissions to Curtain Pullers productions in the late nineteen-thirties averaged about five thousand each year."[60]

The educational outreach efforts of the Play House not only helped promote the theatre throughout the community, but also paid dividends many times over. Beginning with its landmark production of *Hansel and Gretel*, the Cleveland theatre followed the example set by other Cleveland arts organizations by working with public schools to offer educational opportunities to the public. Despite initially mimicking the efforts of the Cleveland Orchestra and the Cleveland Museum of Art, the educational programs offered by the Play House quickly became the model for other community theatres around the country, allowing the Play House to firmly establish a national reputation—not because of its artistic products, but because of its administrative work. This commitment to the community benefitted the theatre greatly in the 1930s when support for the organization reached new levels (discussed in the next chapter). However, the growth of the children's theatre program was not without growing pains—before the educational outreach programs could reach their full potential, the theatre had to address its limitations.

WHEN THE FAT RAT SINGS...

A private party was held on the evening of April 4, 1927, and guests were invited to wear funeral attire. The black-bordered invitation read "Died April 3rd, 10:30pm," marking the end of the previous night's offering of George Bernard Shaw's *Arms and the Man*. Serving as the final performance in the Cedar Avenue Theatre before the opening of the Play House's new facility, the membership and staff of the theatre decided to hold a wake to "bury the old place and all of its inconveniences, its noisy ventilator, its leaky roof, its backstage mice."[61] As part of the festivities, the "funeral director" introduced songs, including one which featured sections performed by the ventilator, the backbreaking chairs, the leaky roof, and the large rat who "ran over your feet" backstage.[62] This group had reason to celebrate because six nights later, on April 9, the Play House officially opened its brand new facility—a two-theatre complex located at the intersection of 86th and Euclid Avenues, the location of their first performances in the Ammon House.[63]

In his 1922 report to the board of directors, McConnell first addressed the need for a new building: "The possession of a new building, while important, is substantially secondary to the perfection of out technic [*sic*]

and the establishment securely of the fact that we have a public. Proof of these two things will produce the necessary assistance toward the projection of a new building."[64] Within two years, McConnell had proven that there was a public clamoring for theatre as annual attendance skyrocketed from 4,000 to 40,000 in his first two years.[65] A balcony was added in an attempt to allow for patrons, but the growth of the Play House had proven too swift for the small Cedar Avenue Theatre to contain. When the Cedar Avenue Theatre opened in December 1917, the company struggled to mount six to eight productions a year, but under McConnell's direction and with the addition of revivals and marionette shows, the Play House was now producing nearly 20 shows a year and using the facility six nights out of the week. The theatre frequently turned patrons away due to limited seating.[66]

Thanks to Walter Flory and Charles S. Brooks, an aggressive fundraising plan resulted in a groundbreaking ceremony on June 1, 1926, and, within a year, Clevelanders celebrated the opening performance of Sam Benelli's *The Jest* on April 9, 1927.[67] This new complex, believed to be the first multi-theatre complex belonging to a community theatre, drew rave reviews from national publications including the *New York Times*. The larger of the two theatres allowed for 500 patrons to view a proscenium arch approximately 40 feet by 40 feet. Profits from the larger audiences in this theatre, named after Francis Drury, would support productions in the smaller theatre named after Charles S. Brooks. This 150-seat theatre was considered the "experimental" space, aiming to provide opportunities for new play productions and other bold artistic endeavors. Unfortunately, this idea of the Brooks Theatre as a home for experimentation was shortly lived, thanks in part to the Great Depression and the need to conserve money. Nevertheless, these two theatres were products of the visionary leadership of the Play House and were in use until the Play House sold the facility in 2010. The architectural details are sufficiently provided in Flory's and Oldenburg's books, yet while these two books celebrate the accomplishment of the two-theatre complex, what these histories fail to explore is the important process of how these buildings came to fruition within the context of other arts organizations around the country (figure 3.2).

The Play House could not have erected a new building without contributions from countless individuals, hundreds of donors, and hours upon hours of volunteer labor from the staff, but four individuals in particular deserve special recognition for making the dream a reality: Frederic McConnell, who prompted Walter L. Flory to consult Francis Drury, and Charles S. Brooks who oversaw the project to its completion. As for

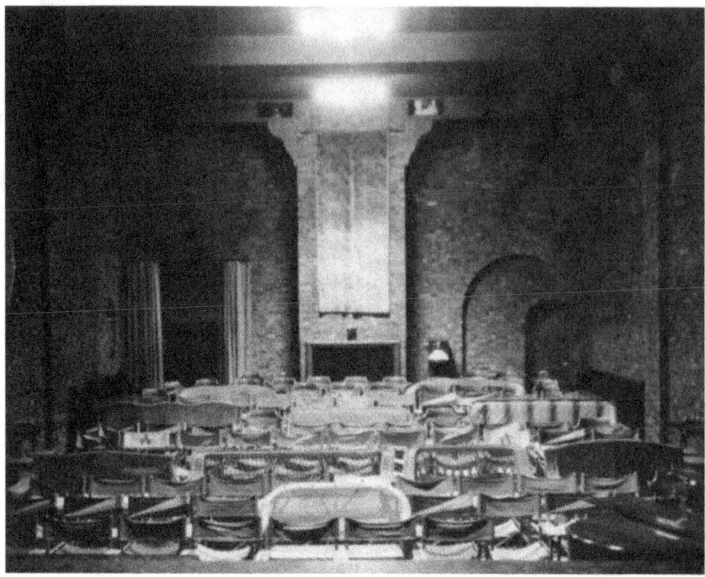

Figure 3.2 Auditorium seating for *After Quiet Pleasures* in the experimental Brooks Theatre. Photograph by Gordon Connor. (Courtesy of the Cleveland Play House Archives, Kelvin Smith Library, Case Western Reserve University.)

McConnell, his success in popularizing the theatre within the community generated a larger audience base and, in turn, an extensive list of potential donors. McConnell's ability to provide quality, mainstream entertainment played a crucial role in the Play House's ability to raise money. According to Flory, "McConnell's combination of good taste and good judgment, integrity and appreciation of business obligations soon established The Play House on a firm, reliable basis in the community."[68] Realizing the need to build a new facility, lawyer Walter Flory consulted with Francis Drury, the same individual who had not only offered the struggling group the use of his Ammon House, but also the one who encouraged the group to build the Cedar Avenue Theatre. Once again, Drury proved instrumental in providing the Play House with a home, agreeing to donate the land that had once been his private garden located on East 86th Street to the theatre on one condition: the Play House needed to initiate a fund-raising campaign to pay for the construction costs of the new building.[69] The task of fund-raising fell to Charles S. Brooks, who surpassed their initial fund-raising goal of $75,000 with a stunning total of $170,000 in donations.[70]

While Brooks's success and Drury's generosity deserve recognition, it was a decision by Walter Flory that made the task of building a new theatre different from previous undertakings. Not only had Flory been a founding member of the theatre, but he had also acted as the organization's legal advisor since its inception, and, with the push to construct a new building, Flory proposed a novel idea: the creation of the Play House Foundation. The formal mission statement for the Play House Foundation defines its purpose as "promoting and encouraging charitable and education activities, including the advancement of art, literature and science, and to acquire, hold, and dispose of real and personal property for such purposes"; while this description is rather verbose, the motive for creating the foundation is found in the final duties listed in this statement.[71] This nonprofit corporation served as a holding company, concerning itself with building construction and maintenance in addition to renting the land and building the Play House. By enabling the foundation to own the land and building, the financial responsibilities of fund-raising and facility management would not jeopardize the theatre's operating and production budgets.[72] The foundation was incorporated on May 22, 1925, and four days later, the first meeting was held in the Drury home that resulted in two important decisions: the foundation officers agreed to engage an architectural firm to draw plans for the new theatre; and Charles S. Brooks agreed to spearhead the fund-raising campaign for the new building.[73] It was to the Play House Foundation that the Drurys donated their land (in addition to their generous $15,000 donation to the building fund), and it was the foundation that secured a $100,000 loan for construction.

The formation of the Play House Foundation deserves recognition because it was the first foundation specifically established to support a professional/community theatre in the nation. The notion of a foundation supporting the arts was not new—the early years of the twentieth century saw foundations established by Andrew Carnegie, John D. Rockefeller, numerous Guggenheims, and other benefactors, but support for the humanities from these foundations lagged far behind other fields, receiving approximately less than 2 percent of all grants monies.[74] A 1931 survey by the Twentieth Century Fund catalogued $52 million in foundation grants that year, with less than $1 million dedicated to the arts, meaning that arts organizations could not rely on these charitable organizations for money and that theatres needed to locate funding from other sources. In order to provide financial security, many philanthropists established regional foundations to support specific arts organizations, including the Julliard School, Metropolitan Opera, Longwood Gardens, and many other

museums and schools.[75] These foundations served as models for the Play House Foundation, leading Flory to propose the idea of the first foundation to support an individual theatre not affiliated with a school. However, the recent struggles of another foundation also motivated Flory and his cohorts to act on their own.

Established in 1914 by Frederick H. Goff, the Cleveland Foundation is recognized as the nation's first "community trust," where citizens and companies donate directly to the fund and income is distributed "under supervision and control of a distribution committee of citizens selected for representative character and knowledge of charitable affairs."[76] This foundation supported school programs as well as arts organizations, including the Cleveland Orchestra and the Cleveland Museum of Art.[77] Facing competition from the fund-raising arm of these two organizations, Flory knew that decisive action needed to be taken if the theatre was going to persuade community members to support his Building Fund, but the struggles of the Cleveland Foundation made the establishment of the Play House Foundation a necessity. By the end of 1924, the Cleveland Foundation found itself in a "precarious financial situation" with income from the endowment providing only $15,000 in distributable funds, meaning that the Play House could not rely on the Cleveland Foundation to play a major role in its fund-raising efforts.[78] Knowing well that the theatre's status in the community was not on par with the other two major arts organizations in town, Flory's bold decision to form a foundation not only enabled businessmen to lead the fund-raising efforts without much interference from the artistic leadership of the theatre, but also served to protect the organization in light of recent financial struggles experienced by the Cleveland Foundation (in case the financial support could not be raised and financial contracts not fulfilled, the Play House would still be able to mount its productions).

If the Cleveland Foundation had not endured severe financial struggles the year before the Play House Foundation was established, Flory might have collaborated with the Cleveland Foundation instead of branching out on his own, likely leading to a longer fund-raising process. Of course, the leadership of the Play House Foundation had no way of knowing about the upcoming hardships caused by the Great Depression, but the decision to pursue an aggressive fund-raising plan (as opposed to one reliant upon established foundation practices and organizations) forever altered the history of the Play House, allowing it to build its new home before the stock market crash of 1929—to have waited longer would have meant a likely delay in the building of a new theatre complex and missed opportunities

to promote the theatre's more-traditional work in the city of Cleveland and around the nation.[79]

In addition to the Play House Foundation, a second group formed during the 1920s proved instrumental to the growth of the theatre: the Women's Committee Board of the Play House proved an invaluable organization for the theatre, completing many tasks normally performed by the paid employees, saving the theatre and its staff time, money, and hassle. This group not only provided suppers for the actors and for post-production strikes, but they promoted their productions to dozens of social clubs throughout Cleveland, organized play-reading sessions open to the community (an example McConnell learned from the many library and amateur drama groups throughout Cleveland), and also sold specially-priced tickets to students around the city.[80] In addition to hosting social events, the Women's Committee Board coordinated volunteering activities and a lecture series, oversaw the distribution of student tickets within public schools, and also formed a "play reading sub-committee" which searched for new material worthy of the Play House stage.[81] The size of the Women's Committee Board—their annual meetings often boasted over one-hundred attendees—allowed the group to assume greater responsibility for the day to day operations of the theatre, and their commitment to the organization helped keep the theatre financially sound. As former president of the committee, Oldenburg's praised for their efforts:

> They were invaluable public relations agents in the community and nourished the concept of the Play House "Family" with their "strike night" suppers, after theatre parties, and, later, the hot dinners served the staff on days of double performances. When some of the students were cut off without funds during the bank crisis, members of the Women's Committee rushed over every evening with a hot meat dish. As conditions worsened, the fellowship between the Play House company and the volunteer corps kept this struggling groups of artists together and producing.[82]

Although the objectivity of Oldenburg's history of the Play House is hindered by her unabashed praise and selective recollections, she does make an astute observation concerning the value of the Women's Committee Board during these Depression-era years. Austere budgets and McConnell's decision to favor traditional fare (as opposed to experimental work that defined O'Neil's directorship) resulted in little artistic ingenuity, allowing the formation of this volunteer group to represent the greatest accomplishment of the Play House in the 1930s. The Women's Committee Board's extraordinary efforts and contributions might not have added to the coffers of the

theatre, but it did save the Play House untold thousands of dollars which, during the Depression-era, allowed the theatre to remain in operation while so many other participants of the Little Theatre movement closed.[83]

The responsibility of selling tickets assumed by the Women's Committee Board proved less daunting because of the large number of attractive mainstream works staged by McConnell between 1927 and 1937, resulting in increased subscriptions. While McConnell occasionally selected more serious, contemporary plays like Ibsen's *The Wild Duck* and *Hedda Gabler* or even Elmer Rice's *The Adding Machine* (mounted with minimal expressionistic design), these works were not considered risky because Cleveland audiences were already familiar with the work of Ibsen. McConnell further drove the Play House away from Raymond O'Neil's original intentions by keeping the latest European playwriting and production trends far away from the Play House. Instead, Cleveland audiences were treated to a healthy dose of classical plays mixed with contemporary comedies, and, given the financial strain gripping the nation, patrons were pleased with the lighter fare. During the Depression years, subscriptions grew and then plateaued, fluctuating between 1,100 and 1,500 subscriptions a year with annual attendance estimated between 100,000 and 120,000 (peaking for the 1935–36 twentieth-anniversary season).[84]

The 1920s were by far the most important years in the theatre's long history. This period began with a theatre near collapse and ended with an institution thriving both financially and artistically (in terms of quality of product, not aesthetics). Most deserving of respect and recognition are the several bold initiatives taken by the leadership during these years: the transformative decision to hire professionals from outside the theatre as opposed to promoting local artists from within; the wisdom of the "Triumvirate" to know how to improve the public perception of the theatre; the appreciation of all contributors to the Play House, resulting in increased support and participation in new groups like the Puppet Player's Guild; the dedication to pursuing educational outreach programs as a means of enlarging its audience and promoting its work within the community; and the move to protect the artistic work of the theatre through the establishment of the Play House Foundation.

While the arrival of McConnell and his eventual successful transformation of the theatre is an extraordinary accomplishment, the theatre's unsung hero during this decade is Walter Flory. Having played a part in the majority of these decisions, Flory's guidance in all these matters helped revitalize the theatre and greatly reduced the burdens upon McConnell during his earliest years at the theatre. Over time, as the Play House

became more entrenched within the Cleveland community, his influence waned as he primarily worked with the Play House Foundation; nevertheless, it is without a doubt that the survival of the Play House owes a large debt to Flory. In addition to his contributions detailed in this chapter, it is also crucial to remember his pivotal role in helping the theatre survive O'Neil's disastrous directorship, convincing members to realize O'Neil's ineptitude, and keeping the theatre afloat during and after O'Neil's final years in Cleveland. Flory articulated his vision for the future of the Play House long before McConnell arrived, and it is to his credit that he not only worked tirelessly to ensure the viability of the institution, but also allowed McConnell and the many other participants in the theatre to both share the burden and take the credit for the accomplishments. Eventually, Flory's vision for the theatre's prominence within the Cleveland community would be realized, but the Play House first had to endure an outbreak of violence that threatened to divide the community.

4. "Catch These Vandals!" ✧

The early morning hours of September 27, 1937, were peaceful and quiet as the residents of East Cleveland slept, unaware of the mischief about to unfold. In the first hours of that Friday morning, a large, dark sedan crept up East 86th Street toward the north side of the Play House. A fuse was lit. Someone hurled a small object over the theatre's brick edifice, and the car sped away. The dynamite exploded at approximately 2:30 a.m., ripping a four-foot hole in the roof of the scene shop, shattering windows of nearby buildings and waking residents throughout the neighborhood, including some reports that the blast was heard over ten miles away in Shaker Heights.[1] The Play House's ten-year-old home was under attack.

The discord that prompted this act of vandalism and the hullabaloo that followed is the subject of this chapter. In the few written histories of the Play House, the bombing of the theatre has been regarded as an unfortunate yet unimportant event, unexamined in the context of history and glossed over as a pivotal moment in the institution's development. The more recent of the two Play House histories, John Vacha's fascinating history of theatre in northeast Ohio titled *Showtime in Cleveland* briefly notes the overwhelming support that the Play House received as a result of the attack, dedicating six sentences to the subject and reaffirming the narrative promoted by the theatre.[2] Similarly, the subjective *Leaps of Faith* written by former board president Chloe Warner Oldenburg dedicates only two small paragraphs to the bombing, briefly providing an overview of the event and focusing heavily on the theatre's role as a victim.[3] Thanks to the passage of time and the narrative perpetuated by those closely affiliated with the institution, this important event in the history of the Play House has been misunderstood and ignored. An analysis of the context surrounding the bombing of the theatre does not alter the fact that the violence enacted upon the arts organization was cowardly and despicable. However, the notion that the Play House provided absolutely no motive or that the leadership was blindsided by the violent tactic reveals a lack of awareness of the trending violence in Cleveland.

Over the course of the recorded history of the Play House, an event like the 1937 bombing has received little notice because the culprits were never found and the indefensible act caused little damage. Furthermore, the community quickly rallied around the institution, resulting in the condemnation of the failed intimidation tactic and allowing the theatre's season to proceed on schedule. This incident, however, deserves greater scrutiny in order to discover for the first time a reasonable motive behind the bombing. A closer examination of events involving labor organizations in and around Cleveland provides an understanding as to why this extreme act occurred. Also, an analysis of the unified public response that followed the attack reveals that the bombing not only produced the opposite effect for which it was intended, but also indicated, with the outpouring of support, that the Play House had finally cemented its place within the Cleveland community.

FROM CONSTRUCTION TO DESTRUCTION

With the beautiful new Play House facility opened and audience expectations raised, Frederic McConnell turned to his close advisors to determine the artistic future of the theatre. As the number of participants in the Little Theatre movement dwindled throughout the 1920s and into the 1930s, theatres like the Play House returned again and again to commercial fare to secure financial stability. In an article for *Theatre Guild Magazine*, Cleveland theatre critic William McDermott summarized the institution's decision to favor public tastes over artistic inclinations:

> When it sails blithely into an experimental play that may have merit but not enough ordinary theatrical vitality, the Play House can lose money as prettily as any other theatre. This dependence upon a relatively large and representative audience has naturally had an effect on the repertory of the Play House.... In one respect, that restraining hand of general public taste has probably been artistically helpful. The Play House has never gone arty, never wandered in the wilderness of pretty little plays, or lost touch with the common, average, reasonably cultivated theatrical taste.[4]

This criticism stung McConnell and K. Elmo Lowe, and a debate ensued over the purpose of the Play House and how it served the community. While McConnell and Lowe both yearned for theatre to serve as "a catalyst in a society where reforms were badly needed," they wisely set aside their artistic ambitions in the face of the souring economy during the 1929 stock market crash and the ensuing Depression years that followed.[5] Even though they mounted several premieres and works featuring controversial content

during the ten-year period following the opening of the new complex, most of these plays were not well received by critics or audiences. An example of this backlash against non-populist fare took the form of a letter in the *Plain Dealer* where C. M. Streator criticized the Play House for including the controversial and (un)timely play *Red Rust* by Comrades Kirchen and Ouspensky in its 1931–32 season when the country was "struggling against Bolshevism."[6] While this specific criticism may have resulted from unwarranted paranoia, a further comment about the Play House from Streator reflected the stigma about the institution that McConnell was working hard to overcome: "I can recall when it was a nest of 'parlor-socialists,' of pseudo-artistic 'hangers-on,' who busied themselves (chiefly) with extolling the virtues of German and Russia at the tops of their discordant voices. I very well remember hearing a prominent Clevelander then very much in evidence on the acting staff make the statement that a Soviet form of government was the only one worth having."[7] This complaint, of course, harkens back to the original perception of the Play House as a home for misfits and those on the fringes of society, and even though nearly 20 years had passed since the theatre was founded, it was clearly necessary for McConnell to continue working toward firmly establishing the Play House as an integral part of the Cleveland community through its popular offerings and social activities.[8]

To be fair, the Play House's slow but steady development resulted in a respectable number of achievements, including positive notices in both the *Theatre Guild Magazine* and *Theatre Arts Monthly* and the ability to pay off its $100,000 mortgage within nine years.[9] Despite its increasing audiences and financial stability, the Play House had become a popular community theatre, but not an institution that was recognized as integral to the fabric of the city.[10] It is impossible to know if the theatre could have maintained its financial stability during World War II when many smaller theatres around the country failed, but the explosion in September 1937 changed everything (figure 4.1).

The criminal act was the culmination of years of strife between the Play House and Local 27, the Cleveland-area chapter of the International Alliance of Theatrical Stage Employees (commonly referred to as IATSE). Even though the culprit(s) were never identified, blame fell squarely on Local 27—an accusation which the leaders of the chapter vehemently denied. While the motivation and affiliation of the perpetrator(s) remained an issue of dispute (at least from the union's perspective), the events leading up to the explosion are well documented by the local press and court records. The Play House's first interaction with unions was remarkably uneventful: in 1929, two years after the opening of their new facility, Actors Equity contacted members of the Play House acting company to ask if they would like to join, but the invitation was unanimously declined.[11] As the

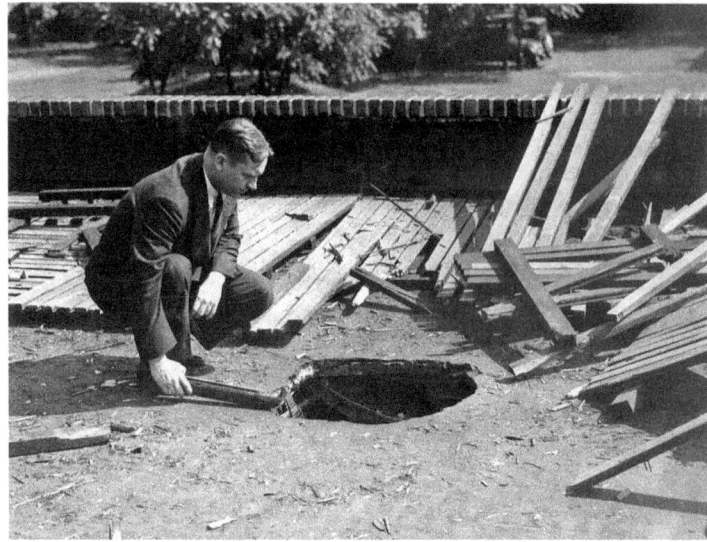

Figure 4.1 Cleveland's safety director Eliot Ness examines the hole in the roof caused by the firebomb. (Courtesy of the *Cleveland Press* Collection, Michael Schwartz Library, Cleveland State University.)

theatre continued to prosper, little was heard from unions until January 5, 1937, when Local 27 installed new officers who prioritized the unionization of the Play House.[12] Four months later, union president John B. Fitzgerald and business manager William Finegan proposed to the trustees of the Play House that the theatre hire five union members, each with a weekly salary of $60.[13] On August 10, the Play House rejected the union's proposal, and board president Laurence H. Norton and artistic director Frederic McConnell explained their reasoning:

> They gave as the chief, if not the sole, reason for their request a desire to provide jobs for unemployed members of the union. Along with this request they frankly warned us that this was to be regarded as merely an initial step, an "entering wedge," to use their own words, and it would be their constant endeavor to effect further unionization.
>
> No one connected with the Play House has ever expressed a desire to join the stage hands' union, and the union expressly stated that it would not take any person on our staff into its membership. On the contrary, the union stated as its main objective the obtaining of more jobs for present members and the barring of new applicants. No issue of unionism or collective bargaining was

raised. We were simply asked to provide five members of the stage hands' union with jobs in the Play House.

The board of trustees of the Play House, after giving the matter consideration, unanimously declined to accede to this request and so advised the union by formal communication dated August 10, 1937, setting forth therein the reasons for its decisions.[14]

In response, the union leadership declared that it would initiate the process of having the theatre designated as an "unfair" workplace.[15]

Despite the threats and increased tensions, the union refused to react impulsively, opting instead to discuss the issue with its membership over a series of meetings. One meeting occurred on the evening of Thursday, September 23, only a few hours before the explosion. Details concerning what happened in this meeting remain a mystery. Even now, when contacting IATSE, every request to research their archives has been ignored, and any attempt to talk to an IATSE official (at the local or national level) about the incident has been rebuffed. Attempts to explore police and fire records of this event have proved fruitless, especially since many of these records, ironically, were destroyed in the fire. Documents involving Elliot Ness (who served as Cleveland's safety director at the time and officially helmed the investigation) have gone missing or are not available to the public. There is, however, one quote from Fitzgerald in a newspaper article that provides the only insight to the meeting:

> Our executive committee met last night [September 23rd] to discuss the situation at the Play House, and I had suggested another meeting with the directors of the institution in an effort to carry on negotiations. At our meeting, I suggested that we send a half-dozen or so men to the Play House when it opened—not as pickets, but as observers. It was my idea that these men would watch the crowd there in an effort to get names of any friends of labor who might be attending. I suggested that we send a letter to all such persons asking them to support us in our campaign and to stop going to the Play House until union stage hands were employed."[16]

Fitzgerald also called the trustees of the Play House his "friends" and stated that the union officials were as shocked by the explosion as everyone else. In fact, Fitzgerald learned of the blast when solicited for a reaction by a local reporter, immediately asking, "What? A bombing?"[17]

The attack appeared to be motivated by the conflict with the union, but it is entirely possible that the union officials had no prior knowledge of this event. Anyone familiar with the history of violent intimidation tactics such as bombings knew that they rarely succeeded when carried out

against public institutions or nonprofit groups. Considering the fact that the union believed the local newspapers to be antiunion in their reporting and editorials, why would anyone in Local 27 sanction an act that would lead to increased public scrutiny and police involvement?

To understand fully the motivation behind the bombing of the Play House requires a multifaceted analysis involving the growth of unions in northeast Ohio, the rise of radicalism in unions, the effects of the Wagner Act (officially the National Labor Relations Act that allowed unions to form in the workplace) and its implementation across the country. Further consideration needs to be given to the recent strikes against "Little Steel" that erupted into violence and resulted in deaths in Ohio, the unionization of other theatres across the country and of other nonprofit organizations in Cleveland, the apparent bias in the local press against unions, and the developing battle for the public perception of unions as either pro- or anti-American organizations. Many of these issues have never been explored in conjunction with the attack on the Play House; instead, the bombing is described by the press and remembered in established histories of the theatre as a random and unjustifiable act of violence. While the latter description certainly is true, a first-ever examination into the leadership of the Play House suggests that the act was not random at all, finally providing an explanation as to why the theatre became such an important symbol ripe for attack.

THE EXPECTATIONS OF LOCAL 27

Few in the local press cared to investigate Fitzgerald's statement about his relationship and his goals with the Play House—there is not one mention or interview with any Play House board member to validate his "friendly" relations, nor does there appear to be a single attempt to verify Fitzgerald's claims that he hoped to simply picket the theatre (and not resort to violence). In one article, the reporter believed that Fitzgerald was genuinely surprised when informed about the bombing, but this fact was relegated to the tenth paragraph of the story and not given any further consideration in any article.[18] Every newspaper in Cleveland immediately discredited Fitzgerald's statements, providing insight into the antiunion attitudes of the press, and the bias exhibited by these reporters and editors allowed the news cycle to focus upon assigning blame rather than trying to understand why the event may have occurred. The Local 27 leadership tried to frame their argument as one of fairness in a statement published in early October: "We at all times knew and at this time recognize that the Play House is an organization 'not for profit' but we also know from the experiences of many

other 'not for profit' organizations... that the mere fact that an organization is created and exists as a 'non-profit' organization does not preclude that organization from having satisfactory and pleasant relations with organized labor."[19] These arguments fell on deaf ears as the following day's *Plain Dealer* offered an editorial criticizing the union for its continued efforts in picketing without a single reference to the union's claim (Figure 4.2).[20]

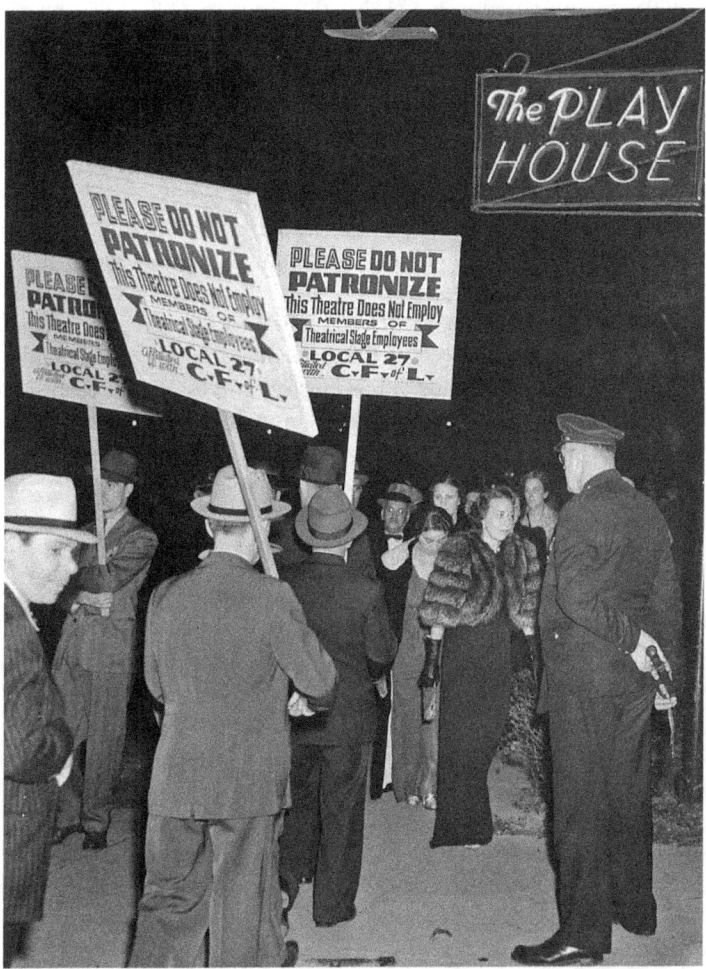

Figure 4.2 Members of Local 27 picket outside the Play House. (Courtesy of the Cleveland Public Library.)

The press's rush to judgment resulted in a large oversight in reporting of the actions and intentions of Fitzgerald and his union: newspapers published the Play House's response to the bombing, which explained in convincing detail why the theatre refused the union's heavy-handed request, and the press accepted the theatre's interpretation of the union's proposal at face value without ever considering the possibility that the union's proffer was intended to be seen as an initial negotiation tactic. Once the union's demands—to hire five full-time stagehands at a weekly salary of $60—are compared to the finances of the Play House, which in turn are compared to other Cleveland arts institutions and to other theatres around the country operating on a similar budget as the Play House, it is impossible to view the demands from Local 27 as a serious proposal.

The tactics utilized by Local 27 derived from the struggles experienced by IATSE during the first decades of the twentieth century as the changing economics and audience trends proved hard for many stagehands.[21] Movie theatres replaced vaudeville houses, and the Little Theatre movement and the following rise of community theatres relied upon volunteerism, meaning that consistent employment was difficult to find outside of road houses that booked touring productions. Given these economic realities, union members and their local chapter representatives pursued a strategy of attempting to gain a foothold in producing organizations by making large demands. In its own history of the organization titled *100 Years of Solidarity*, the leadership of IATSE explained the wisdom and necessity of this bargaining tactic:

> What they [the theatre owners and the producers] could not appreciate or accept was that these workers believed they had to strike while the iron was hot—that is, get the most out of the work while they could because they were likely to have a long time off between productions. Until the problem of sporadic employment could be resolved, conflict between producers and workers would continue unabated.[22]

This admittedly desperate attempt for employment is exemplified by the approach taken by Fitzgerald and the Local 27.

The proposal submitted by Local 27 to the Play House was representative of this "get the best terms they could up front" mentality. The demand for the theatre to employ five full-time employees was ludicrous given the limited economic means of the institution, and several indicators bear out this assertion. Concerning salaries, the Local 27 proposal argued for positions to be paid $60 a week whereas pro-Play House critic McDermott suggested that stagehands routinely earned $75 a week plus overtime.[23] Given

these figures, the total financial cost to the theatre of hiring five stagehands at this rate would amount to approximately $14,800, almost 15 percent of the theatre's approximate annual budget and one-third of the institution's entire budget for salaries.[24] When compared to reports that less than one-third of the 85 staff members at the Play House received any salary, and of those few earned "more than $1200 annually," the 1,233 percent increase proposed by Local 27 was ridiculous, especially given the lasting effect of the Depression years when the Play House drastically cut costs and reportedly slashed the budgets of their shows from $200 to "an unenviable low of $15."[25] Hoping to contain costs further, the Play House in the 1930s shortened its season and encouraged its own employees, including members of the "Triumvirate," to supplement their salary by finding employment elsewhere (often in the form of summer stock or taking extended leaves-of-absence during the season for higher-paying gigs, including K. Lowe who appeared in the new play *Broomstick* on Broadway).[26] The union's awareness of these cost-cutting measures combined with the Play House's inability to pay reasonable salaries give credence to the notion that Labor 27's exorbitant demands were not meant to be taken as an ultimatum but, instead, as an opening salvo in negotiations.

If there was any expectation that the Play House could afford an increase in staff and salary, such a possibility was promulgated when the theatre paid off its $100,000 mortgage. Even though the Play House threw a party to celebrate this achievement and invited the press to cover the "burning of the mortgage," this accomplishment created the false perception that the institution was thriving financially, but other well-known factors proved that the Play House would have been unable to sustain the financial burden recommended by the local union, making the proposal less credible. Details made public in the *Plain Dealer* and the *Cleveland Press* explain how the institution accomplished this remarkable feat:

> The present campaign was in response to the grant from the Rockefeller Foundation on the condition that local sources match the foundation's offer of $38,000. The grant was influenced by the success of the Play House in co-coordinating its theatrical activities, personnel and equipment with a program where teachers, students and future leaders in the theater may obtain practical experience and training in theater art.[27]

It should also be noted that the articles iterated that any additional money raised during the campaign would not be used for salary increases but, instead, for capital improvements and the hiring of guest artists.[28]

Comparing the Cleveland Play House's finances against other theatres to determine if the hiring of union stagehands was feasible proves difficult because most theatres failed to weather the financial assault of the Depression and because the label "Little Theatre" changed during the 1930s, often referring to any nonprofessional theatre that was interested in doing new work (an extremely broad and flawed definition). Whereas many of the original famous Little Theatres folded prior to the Depression—the Chicago Little Theatre in 1917, the Washington Square Players in 1918, the Provincetown Players in 1929, and the Toy Theatre rechristened the Copley Theatre Stock Company in 1916—the few theatres that did survive failed to fit a uniform group. The Pasadena Playhouse began as the Community Playhouse Association of Pasadena and "had encouragement" from Hollywood actors including Charlie Chaplin, Will Rogers, and Mary Pickford; Chicago's Hull House Theatre received support as part of settlement house; and the Play House, of course, shifted from being an art theatre into a community theatre.[29] To confuse the matter more, conflicting lists of Little Theatres were provided in various publications, some of which listed the Play House and the Pasadena Playhouse as Little Theatres and some which omitted them without providing an explanation for the same.[30]

Regardless of the variety of ways that these theatres received financial support, one fact does unite the Play House with the Pasadena Playhouse and other semiprofessional theatres founded in the 1920s and 1930s, such as the Pittsburgh Playhouse (1934) and the Goodman Theatre (1925): none of these theatres were under contract with IATSE.[31] It would be many years before most theatres became union houses thanks to Actors Equity, not IATSE. The fact that Local 27 could not cite any authoritative examples to support its position made their proposal unsubstantiated as well as unrealistic. In support of the Play House's argument, the Cincinnati Little Civic Theatre employed union labor, but it quickly accumulated over $5,000 in debt.[32]

Given the absence of precedence for Local 27 to demand that the Play House employ its stagehands, what inspired the decision to pursue negotiations? While there are several external factors that may have influenced Fitzgerald's course of action (discussed in detail later in this chapter), the theatre's prior interaction with Actors Equity served as an impetus for IATSE to view the Play House as ripe for unionization. In 1929, Frederic McConnell's decision to invite Ben-Ami to return to Cleveland and perform in Leonard Andreyev's drama *He Who Gets Slapped* seemed an inspired choice given the popularity of Yiddish theatre in Cleveland as well as Ben-Ami's desire to work in "a professional art theatre."[33] The plan

backfired, however, and the hiring of Ben-Ami generated several problems. First, McConnell was contradicting his purported philosophy concerning the hiring of professional actors, frequently promoted as his "no star" policy that favored community involvement over national recognition.[34] While the popularity of Ben-Ami quieted most critics within the Play House, other theatres in Cleveland immediately cried foul. Even though the Play House credited Ben-Ami as a "guest player," Robert McLaughlin, a manager of a smaller stock company, complained to Actors Equity member on the basis that the actor should not be allowed to perform in a "competing house" when other theatres in Cleveland had to abide by Equity regulations—a clear violation of the rule that Equity actors were not allowed to perform with non-Equity casts.[35]

While the controversy faded once *He Who Gets Slapped* opened, the notion of the Play House as an institution not playing fair with unions persisted. The perception (without justification) was important: here was a theatre that was allowed to claim amateur status yet employed an administrative staff and now professional actors; here was an institution that claimed to be struggling to make ends meet yet opened a new facility and expanded its administrative programs; finally, here was a theatre that was allowed to ignore union regulations and thrive where other local companies were penalized for attempting the same maneuvers. Despite having reasonable justifications in order to proclaim each of these perceptions to be false, the Ben-Ami event thrust the Play House into an unintended fray—into the middle of a battle over the purpose and value of unions. This intense debate was being waged in Cleveland and throughout northeast Ohio during the 1930s, and the bombing the Play House in 1937 served as the culmination of tensions between industry and labor union forces, with the famed theatre suffering the consequences of an antiunion perspective.

THE CONTEXT OF 1937

While IATSE developed animosity toward the Play House over the Ben-Ami dispute, it is important to remember that this controversy occurred in 1929, and it is highly unlikely that the Local 27 leadership patiently waited for eight years until they found the right time to strike. Eventually, the Ben-Ami tension dissipated and little was heard from Local 27 until a four-month period in 1937 highlighted by the Play House's rejection of IATSE's petition and the bombing. This drastic and unexplained action prompts

a simple question: why take this radical action at this point in time? If bombing (or even the threat of bombing) was a routine tactic for IATSE and/or Local 27, it would have made sense for the labor organization to intimidate the Play House in 1929 instead of letting the organization further establish its position as a nonunion house. Something changed in the years between 1929 and 1937 that provoked the brash and unjustifiable violence, and that change was felt across the country, beginning in 1935 with a landmark piece of legislation. New York senator Robert F. Wagner introduced the National Labor Relations Act (commonly referred to as the Wagner Act) in early 1935 hoping to close the loopholes that had allowed industries to refuse negotiating with any other labor groups besides the unions established and managed by the company itself.[36] Furthermore, the Wagner Act allowed for collective bargaining and protected employees if they formed a union outside of the workplace (an action that previously led to widespread firings).[37]

The impact of this act, signed into law by Roosevelt in June 1935, immediately bolstered the power of labor unions across the country. In his study of American labor titled *State of the Union*, historian Nelson Lichtenstein articulated the substantial benefits for labor unions:

> The law was a radical legislative initiative because it was designed to put in place a permanent set of institutions situated within the very womb of private enterprise, which offered workers a voice, and sometimes a club, with which to resolve their grievances and organize themselves for economic struggle. It guaranteed workers the right to select their own union by majority vote, and to strike, boycott, and picket. And it enumerated a list of "unfair labor practices" by employers, including the maintenance of company-dominated union, the blacklisting of union activists...and the employment of industrial spies.[38]

Even though labor unions heralded the Wagner Act as a monumental achievement, many corporations continued to ignore its dictates, believing that the law would be found unconstitutional.[39] This refusal to acknowledge the Wagner Act led to strikes around the country as labor organizations fought against the often heavy-handed tactics of industry, most notably union busters, smear campaigns, and the stockpiling of guns and tear gas.[40]

Strikes increased dramatically between 1933 and the Supreme Court's affirmation of the Wagner Act in 1937.[41] According to labor historian Robert Bruno, over 10 thousand strikes involving more than 5.3 million workers occurred during this period, many of them in northern Ohio.[42] By 1937, tensions in the region had escalated thanks to massive strikes at the

General Tire and Rubber Company in Akron and the Electric Auto-Lite Company in Toledo, let alone additional strikes in neighboring states.[43] One conflict in northeast Ohio in particular drew national attention, and the resulting violence and deaths greatly fuelled the outrage felt by labor unions in Ohio and made them even more determined.

The "Little Steel" Strike of 1937 began in Cleveland when steel workers voted to strike against a group of three independent steel producers—Republic Steel, Youngstown Sheet & Tube, and Inland Steel. Ohio governor Marvin Davey encouraged negotiations in hopes of averting a strike, but talks were repeatedly thwarted by Republic Steel and Youngstown Sheet & Tube's outright refusal to "recognize the [worker's] committee as representatives of its members."[44] In anticipation of conflict, these companies began stockpiling ammunition. For example, Republic Steel created a heavily armed police force to protect its property, having "purchased 7,855 tear and sickening gas grenades and shells, 105 guns for firing gas shells, 247 revolvers, 142 shotguns, 75,650 rounds of ammunition, and 400 magazines for rifles."[45]

Confident in his ability to defend his factories and boastful of his anti-union stance, Republic Steel chairman Tom Girdler initiated hostilities by expelling over 1,000 union supporters from plants in Massillon and Canton, Ohio. Workers throughout the Republic Steel company took note. On May 30, a crowd of over 1,500 striking workers, women, and children gathered to march on Republic Steel's South Chicago plant. Singing anthems and chanting pro-labor cheers, these marchers proceeded to the factory where they were met by a double line of 500 police officers who moved into position to protect the plant. The confident singing of the marchers quickly faded as the leaders of the march walked up to the police formation and asked to form a picket line outside the factory. The accounts of what happened next vary from different sources: some claim that a standoff occurred and violence erupted slowly while other eyewitnesses suggest that the police quickly began attacking the group with their Billy clubs, hitting women and children as well.[46] Then, without explanation, police drew their revolvers and began firing into the retreating crowd.[47] In total, over 200 shots were fired, leaving ten marchers dead and hundreds wounded. Police began rounding up marchers, detaining them without administering medical assistance to the injured, including women and children. A Senate subcommittee that investigated the event determined that "the Chicago police and Republic Steel Company had coordinated a premeditated violent attack on peaceful protesters," but no one was ever indicted for the deaths that occurred on that Memorial Day.[48]

Ohio was not immune to acts of violence involving "Little Steel" as six more striking workers were killed on picket lines. In Youngstown (approximately 70 miles east of Cleveland), police opened fire on a group of women gathered to celebrate "Women's Day" at the picket line, injuring 42 women and children. Furious at the police provocation, strikers continued threatening police, but the only result was the death of two more workers.[49] Responding to the growing violence, Governor Davey brought in the National Guard to keep the peace and to establish martial law in Youngstown—a move optimistically perceived by the Steel Workers Organizing Committee (SWOC) as a protection for the strikers.[50] Instead, the National Guard "acted as local law enforcement [and] arrested at least 160 unionists and conducted night raids on the homes of union supporters, resulting in the jailing of whole families."[51] In a move seen as a betrayal of the labor forces that helped propel him to victory, Davey ordered the National Guard to protect the "Little Steel" plants in Ohio to ensure access to the factory for non-striking workers, reducing the effectiveness of the picket lines.[52] When organized labor appealed to Roosevelt for assistance, they were told bluntly that the strike was a political liability and "a real headache," which made the union leaders abandon their aspirations.[53]

In addition to affecting neighboring cities, violence occurred in Cleveland, but the result was not as intense in a city that proved more supportive of labor organizations, preventing Republic Steel from bullying and abusing the strikers at will. Mayor Harold Burton's priority was to preserve order, and he did so by preventing Republic Steel from using an airfield to fly in workers for their plants, yet he also encouraged the deployment of National Guard troops to protect local Republic Steel property. Mayor Burton's goal of maintaining the peace lasted until the National Guard was eventually removed and violence quickly ensued. A front-page article in the July 27, 1937, *Plain Dealer* described the events:

> At least 60 persons were injured, shots were fired, tear gas bombs were thrown and more than 100 automobiles damaged in wild fighting between striking steel workers and non-strikers at the Corrigan–McKinney plant of the Republic Steel Corp. that started just after dark last night and raged until after one this morning. Headquarters of the Steel Workers Organizing Committee at 4336 Broadway S.E. was wrecked in the battle that was a continuation of sporadic fighting that had gone on all day yesterday and had resulted in the killing of a C.I.O. striker and injuries to about twenty more persons.[54]

By the end of July 1937, dozens of strikers in Ohio and around the Great Lakes had been killed, hundreds had been wounded, and the "Little Steel"

strike was failing, thanks to the protection offered by the National Guard. Nevertheless, the SWOC's decision to strike indicated their determination to continue the fight, even at the expense of public opinion and loss of life.

The spring and summer of 1937 in northern Ohio were volatile times for labor relations—the Memorial Day Massacre included unnecessary violence at Ohio plants, strikes continued in Akron and Toledo, several deaths occurred in Youngstown, and police clashes in downtown Cleveland, all of which contributed to increased hostilities between the unionists and the captains of industry. The slow but steady failure of the "Little Steel" strike might have demoralized local steel workers, but belief in the importance of and need for unions remained strong.[55] Encouraged by the Supreme Court's affirmation of the Wagner Act in April, the swelling tide of violence involving organized labor continued throughout the summer of 1937, but the perception of fighting "Little Steel" as a losing cause possibly prompted labor leaders to search for other campaigns. Might the bombing of the Play House be related to this growing hostility toward industry leaders? A first-ever examination into the leadership of the Play House suggests that the act was not random at all, finally providing an explanation as to why the theatre became such an important symbol for someone to attack.

THE WHO'S WHO OF THE "COMMUNITY" THEATRE

As part of the widespread effort to blame the entire Local 27 organization (rather than pro-union radicals acting on their own) and to discredit the union as an anti-American group, the coverage of the event by the Cleveland media mirrored national trends by consistently sympathizing with antiunion forces and rarely providing balanced coverage. This slanted journalism developed after the passage of the Wagner Act in 1935, with the mainstream press covering union activities and strikes "in ways that still worked to marginalize workers."[56] In 1938, journalism critic George Seldes noted that the commercial press frequently "suppresses or buries, or distorts" news stories favorable to labor organizations, often refusing to publish a "considerable body of news" that might serve to assist unions.[57] The local press never explored why the Play House became a target of violence as opposed to other businesses that battled unions but did not suffer from dynamite attacks. Instead, the city's leading newspapers published columns that aimed to outrage the public, vilify the union, and cast the leaders of the Play House as individuals caught off guard by such violence.

For example, under the title "Catch These Vandals!" the *Plain Dealer* editor and friend of many Play House trustees, Paul Bellamy, penned an Op-Ed piece intended to articulate the impeccable nature of the Play House leadership, suggesting it was outrageous that a union would think to assault these exemplary individuals.⁵⁸

A closer look at the leadership of the Play House, however, suggests that these individuals were the very reason why the theatre was singled out for an attack. The board of trustees consisted of 15 men and women, nine of whom had expressed antiunion opinions or worked for companies that supported or committed antiunion activities. In Bellamy's editorial, he cites four individuals: board president Laurence H. Norton and three trustees. The editor praised Norton as a "former state senator and president of the Board of Education," but Bellamy neglects to point out that Norton used these positions of power to curb union influence. During his time on the school board, Norton's votes reflected his Republican Party's antiunion positions, consistently fighting against the City and County Truck Driver's Union and the teachers' union, refusing multiple times to increase salaries and labeling the letters sent by the union leadership to the school board "impudent, containing a direct threat."⁵⁹

Two of the three trustees also mentioned in Bellamy's editorial also were very familiar with unions—both Walter L. Flory and Thomas L. Sidlo worked for law firms that publicly denounced labor organizations.⁶⁰ As a founding member of Thompson, Hine and Flory, the trustee and founding member of the Play House was guilty by association when members of his law firm routinely attacked the Wagner Act in public forums.⁶¹ For his part, Sidlo first argued against the legitimacy of unions in high school and later published opinions in support of "compulsory arbitration," restricting a union's right to strike.⁶² Beyond these men mentioned by Bellamy, other trustees also expressed antiunion views: Not only did Vice-President Alexander C. Brown publish his arguments criticizing labor unions' intrusion into the workplace, but there was a strike against his family's company also that resulted in bloodshed; Mrs. John B. Dempsey's husband penned letters articulating prejudice against minorities who often benefited from union representation; Robert A. Weaver's refusal to increase wages for workers at his Ferro Enamel & Supply Co. Corporation prompted a strike two years earlier; and Leonard C. Hanna Jr.'s family's mining company endured a four-month strike in the spring of 1932.⁶³

Given the numerous trustees' connections to industry and their antiunion history, especially following the 1935 passage of the Wagner Act, it is stunning that no written history or local press explored the possible

relationship between the bombing and the predominance of antiunion sentiments in the Play House leadership. Led by individuals who consistently fought with labor organizations, the theatre could have been viewed as a symbol of antiunionism, meaning that the bombing was a reaction to the representatives of the community's industry and legal institutions, not to the theatre's refusal of Local 27's request. Proof of this can be seen in the timing of the attack—if the bombing was retaliatory, then it would have occurred a month earlier when the theatre first rejected Local 27's proposal. Instead, the blast erupted hours following a meeting when the leadership opted to continue working with the trustees. The bombing, therefore, should be interpreted as a reaction to the union leadership's decision and as a signal to the trustees of the theatre.

In addition to being an inexcusable act of violence, the bombing of the theatre was an extremely irrational act—whereas unions fought companies over the status of dozens if not hundreds of employees without resorting to bombings, a larger explanation is needed as to why the Play House was attacked over five employees. The answer lies both with the likelihood of radicals being involved and the perception of the Play House as an institution led by individuals known for the antiunion activities. The Local 27 leadership, aware of the powerful connections between the trustees of the Play House and the community, understood that an unjustified act of violence would elicit more sympathy than would intimidation. Because dialogue with the theatre was continuing, the defensive statements of the Local 27 president are logically sound, meaning that the bombing was unexpected and counterproductive to their cause.

IMPACT OF THE BOMBING ON THE PLAY HOUSE

The years preceding World War II are not remembered for any particular production or artistic achievement at the Play House but, instead, for the theatre's growing educational outreach initiatives, the shared notion of the theatre as a "family," and the theatre becoming more ingrained within the Cleveland community. This concept of the Play House as a "family" revived the familiar sentiment expressed by the original founders who helped contribute to the purchasing of the church in 1917, but the extent to which the Play House leadership was forced to depend upon volunteers to maintain the company's existence only enlarged the concept of shared ownership/responsibility of the theatre. While this reliance upon the goodwill of the community certainly benefitted the theatre during the hard times, this communal "family" later became the theatre's greatest

encumbrance. This concept of the Play House as a "family" is central to understanding the media's unified condemnation of the 1937 bombing and their quick attempts to assign blame. Their shock and disgust that someone would attack an organization that represented the entire community (a debatable claim) served as the basis for their outrage, almost as if the union was filled with heartless individuals who failed to appreciate the noble endeavors of the theatre.[64]

The battle over public perception/public opinion was routinely lost by the unions, and Local 27 was no exception. Throughout their existence in American history, labor unions have fought the charge of being "anti-American" organizations, often linked with communism and an anti-capitalist agenda. In his fascinating book *There Is Power in a Union*, historian Philip Dray explains, "Employers leveled charges of foreign radicalism against labor with devastating effect. Business lobbyists such as the U.S. Chamber of Commerce and the National Association of Manufacturers learned to play on such fears by invoking cherished American ideals of individualism, personal freedom, and liberty."[65] While some unions did align themselves with the Communist Party in the 1930s in a joint effort to protect the interests of the working class, the majority of unions eschewed such radical parties and hoped to work within the American political system (by voting for Roosevelt and members of the Democratic Party).[66]

The attack on the Play House revived the accusations that Local 27 and IATSE were "anti-American" in their interests, and the Play House seized upon the opportunity to exploit this sentiment to their benefit. In its playbills following the dispute with Local 27, the theatre appealed to the patriotism of its community by claiming to "fight for the American way" in a written commentary that reads like a politician's stump speech:

> The Play House, in common with hundreds of other community and university theatres, is forwarding the challenge of American democracy and exposing the evils which seek to undermine it. Here, in these theatres is a forum close to the heart of democratic government. Here, in a practical and demonstrative way, voice constantly is given to the progressive idealism of American thought and feeling, to the instinct for democratic freedom and social justice, and to the all-pervading liberation of the poet's soul. These are attributes that will bar from our soil that dictatorship of force and intimidation that now clutches the world and in its wake threatens the destruction of all that we cherish.[67]

It was shrewd but wise for the leadership of the Play House to advance its own interests by positioning itself as a victim of an unprovoked attack and as a representative not only of the community, but of the entire country.

Much to the Play House's satisfaction, editorials in the local newspaper echoed this concept of the bombing as an assault on the community and its citizens. "Any attack on the Play House is an attack that strikes home to people as deeply as if their own houses had been shattered," wrote critic William McDermott. "The public disgust and resentment that must inevitably be aroused will not help to put union stagehands to work. This bombing, indeed, puts public feeling fiercely on the side of the Play House."[68]

This sentiment continued to drive the press coverage to the point that *Plain Dealer* editor Paul Bellamy argued, "This union could better employ its time right now helping Eliot Ness uncover the perpetrator of the bombing than by picketing an unoffending public institution dedicated to culture and education."[69] This opinion is not only typical of the many attacks launched at the union, but also tells of how the bombing changed the public's perception of the Play House. Within a matter of days, descriptions of the theatre in the press transitioned from a "non-profit organization" to a "public institution" that deserved to be immune to labor disputes.[70] The immense outpouring of support for the Play House, not only from government officials and the press but also from the Cleveland citizenry, finally allowed the Play House to claim a central role in the community on par with the other established cultural institutions. While an editorial in *The Cleveland News* labeled the theatre "a Cleveland civic institution" comparable to the Cleveland Museum of Art, an editorial in *The Cleveland Press* furthered this notion by proposing that the theatre "should have been immune from any labor difficulties."[71] In response to the bombing, the mayor boasted of the theatre's value to the community: "The attack upon the Play House is an attack upon the people of Cleveland. Those in charge of this...enterprise have been making a great contribution to Cleveland for which the community is and should be deeply indebted to them."[72] This newfound support not only helped the Play House last through the financially straining years of World War II when many remaining Little Theatres failed, but also allowed the theatre to pursue bolder artistic projects, most notably expanding its new play production endeavors in an effort to achieve national recognition. Right or wrong, the public outcry over the bombing at the Play House changed the perception and value of the theatre to the community, and the absence of analysis exploring the motivating factors behind the violent act exemplified how the priority of the day was not finding the culprit, but assigning blame.

5. Catering to Cleveland

In the midst of the vast archives of the Play House sits a grey box labeled "A313." While the items held within this container do not provide information about the daily business of the Play House or its financial and artistic dealings, the box is incredibly informative about the theatre during the war years. Inside A313 rests a small, leather-bound notebook, no bigger than paperback novel but distinctly expanded because every page has an index card attached by a paper clip. Opening the cover reveals this book to be the "Play House Log of Participation in World War, 1940 to 1945"—a journal maintained by a staff member to meticulously keep notes on each Play House member or participant during the war.[1] Each page in the journal has a corresponding envelope also within the box. Many of the documents kept within the Cleveland Play House archives are brittle and worn with age, but the contents of these envelopes have been well preserved.

One envelope labeled "Rauch, Don" reveals a great deal about this individual and the Play House during war time. Two black and white photographs depict Rauch proudly posing in his army uniform—one snapshot taken standing outside a civilian home after his enlistment and another more formal picture displaying his "wings" after successfully graduating from flight school in Greenville, Mississippi. According to the log book, Rauch enjoyed some form of affiliation with the theatre between September 1938 and May 1940, but documents could not be located to verify his position within the theatre. Despite his good looks, he never acted on stage, or at least never appeared in notices or reviews for the theatre's productions, and it can be assumed that he studied or worked on the technical side of theatre as his letters were addressed to Max Eisenstat (Figure 5.1).

These letters provide a unique understanding of the value of the Play House to the men of Cleveland during the battles of World War II. A May 11, 1942, letter from Rauch expresses his thanks to Eisenstat for sending him programs of recent shows, leading to an acknowledgment that he felt "homesick for the Play House."[2] After transferring to Mississippi in

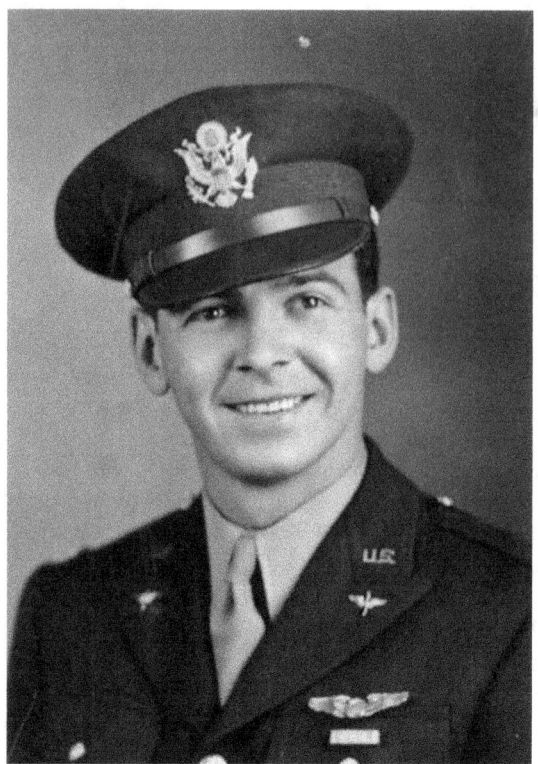

Figure 5.1 Airman Donald Rauch in a photo sent to the Play House (Photograph by Paterson's Studio. Courtesy of the Cleveland Play House Archives, Kelvin Smith Library, Case Western Reserve University.)

November of the same year, Rauch penned a letter thanking a Play House staffer for sending him an article about productions. He mentions how he hears rumors and news about the Play House in passing from other Cleveland natives, giving the impression that the theatre is a frequent topic of conversation abroad for Rauch and his friends, but Rauch strikes a melancholy tone when he realizes that "there isn't much left of the staff that I knew there."[3] A few months later, Rauch's letter is more sentimental, evidenced by its being addressed to "Dear Gang." Having moved from base to base in preparation for his role as a dive bomber, he clings to the familiar and appreciates being sent programs and articles about the theatre, prompting Rauch to write, "It was nice of you to remember. I think

of you all so often and plan to come back some day for sure. In looking over the program, there were a lot of names missing and I wonder where they are."[4]

In the midst of his training, Rauch found time to get married. Nestled behind the letters and pictures in the envelope is a wedding announcement: "Mrs. Arthur Carr Sherman announces the marriage of her daughter Barbara to Donald J. Rauch to be held in Radnor, Pennsylvania in October 1943."[5] Little is heard of from Rauch until the theatre received a letter from China dated December 17, 1944. Written for "Maxie," the letter reads as if Rauch has grown weary of his travels and assignments and longs to return home. In this letter, the lengthiest of the collection, he complains of sitting and waiting for news from home while his friends have fun in Italy. Throughout the correspondence, he begs to learn about his former Play House friends:

> Long time no hear from. Which is no one's fault but my own. You don't know my address. Now do you. How about dropping me a line?
>
> Are there any of the old gang left there any more? Do you have Cornleigs address? I'd like to get in touch with him again. I'm pretty much away from everyone here and haven't heard from the Playhouse [sic] in a long time.... I'm going to come back and pay you all a visit one of these days.
>
> How's McConnell? And is Kay [Elmo Lowe] still around, and Leslie, and Rolf? Golly, it seems such a long time since I have seen or heard anything of anybody. If you've got a couple old mouldy [sic] programs hanging around, put them in an envelope and send them my way....
>
> Drop a line soon, Maxie. I'll be waiting to hear from you.
>
> "Hello" to all
>
> Don
>
> P.S. Merry Christmas, too. I'm probably a little late. Are you going to have a New Year's Party? I remember the one during *Liliom*.[6]

This letter was the final correspondence from Donald J. Rauch received by the Play House. On February 22, 1945, he was reported missing over China.

The journal and the envelopes are a fascinating yet sobering read—a glimpse into the lives of individuals long forgotten but who contributed to both the war effort and the theatre. N. S. Elderkin Jr., for example, studied at the graduate school at Western Reserve University, and his early affiliation with the Play House is not detailed. The log book documents his enlistment into the army in 1942, followed by his tours in Algeria and

Italy before returning home in September 1945, allowing him to perform at the Play House in *Wings over Europe*.[7] Elek Hartman left the Play House School in September 1942 to enlist, joining a paratrooper unit training in Fort Benning Georgia before shipping out to Ireland. Hartman survived the June 6, 1944, invasion of Normandy as well as the invasion of Holland three months later, and he finished his service by spending four months engaged in the "Occupation of Germany." Upon being discharged, he immediately returned to the Play House to study theatre.[8]

From the collection of 82 envelopes and the hundreds of letters and documents contained in box A313, it is evident that not only were the servicemen dedicated to the Play House, but the theatre was dedicated to them as well. To reinforce his dedication to the men who left the theatre to serve, McConnell placed a handwritten note on the theatre's call board: "Upon recommendation of the Director, the Play House Board of Trustees resolved that it will be Play House policy to rehire all members of the Play House staff who resign to serve in the United States armed forces and wish to resume their Play House engagement upon release."[9] One of the first to leave was Sol Cornberg who served as the theatre's technical director since 1930. Many of his technicians soon followed, meaning that the skill level of the technicians plummeted as the nation marched to war.[10] To supplement the departure of trusted friends and colleagues who the theatre employed as artistic staff, McConnell hired guest directors and guest actors, beginning with Western Reserve University professor Edwin Duerr to helm the 1942 production of Maxwell Anderson's *The Eve of St. Mark*.[11]

Locating adequately trained staff was only one of the problems that McConnell faced. The fact is that no model existed to guide McConnell during these wartime years because the Play House remained one of the few professional Little/community theatres in operation. Furthermore, the level of the Play House's dependency upon the community both in funding and participation made the theatre unique. The Pasadena Playhouse, comparable to the Play House in size, organization, and reputation, enjoyed adequate funding from its bevy of Hollywood supporters.[12] Chicago's Goodman Theatre received financial assistance from its parent organization, the Art Institute of Chicago, and companies like the McCarter Theatre received money due to their affiliation with an academic institution.[13] The Play House, however, was reliant solely upon its ticket revenue and any generous gifts from its members, resulting in the deepening of the symbiotic relationship between the theatre and its community during these trying times.

The dearth of manpower forced McConnell to search for new talent and new plays, and the theatre benefitted greatly from inviting new actors,

artists, and technicians to participate in the Play House's wartime productions. The departure of enlisted servicemen allowed for greater community engagement as an influx of citizens temporarily replacing actors and technicians helped the Play House defray costs and maintain sufficient audience attendance. Acknowledging his theatre's indebtedness to and dependency upon the generosity of the public, McConnell moved the institution further away from its art theatre roots by acquiescing to the community's interests and tastes. This decision resulted in a brief period of the theatre catering to Cleveland, including noble and extraordinary efforts by the theatre's staff to mirror the anxieties and passions of the Cleveland citizenry through the presentation of quality, relevant art. McConnell's desire to engage the community with timely works is best reflected in his play selections of the early war years. Lesley Storms's *The Heart of the City*, a play about actors surviving the London bombing raid, received rave reviews, as did a host of other topical plays, including Clare Booth's anti-Nazi satire, *Margin for Error*, Elmer Rice's *Flight to the West*, and Maxwell Anderson's *The Eve of St. Mark*, the first play produced in America that referenced the current war.[14] While other productions did not utilize the war as subject matter, the Play House often promoted their shows as a reflection of the nation's wartime mindset. "The girls—bless their hearts—seem to have solved the war man-power problem in theatrical circles…" wrote critic Glenn C. Pullen. "*Nine Girls*, the Play House's popular mystery-melodrama set in a sorority house, is another case of a play that gets along nicely without the benefit of men."[15]

McConnell's most interesting play selection during the earliest years of World War II derived from a chance encounter, and the resulting production of *Heavy Barbara* allowed the Play House to promote its dedication to the war effort while also offering Clevelanders an opportunity to witness a unique work of theatre. The two Czechoslovakian comedians who created the satirical work quickly became frequent fixtures in the local papers as their well-publicized story of survival overshadowed the play and production. Jiri (George) Voskovec and Jan Werich met in law school at a Prague university, but boredom from their studies drove them to write and perform in a revue for their peers (Figure 5.2). This impromptu amusement was an immense success, and their friends demanded a second showing the following night for a wider audience of friends. Night after night, Voskovec and Werich performed their revue to increasing crowds, prompting them to rent a theatre where they performed the show for over a year. Soon the two men founded a theatre of their own, the Liberated Theatre of Prague, which quickly became "a monument of Czech culture and one of the outstanding theatres of Europe."[16]

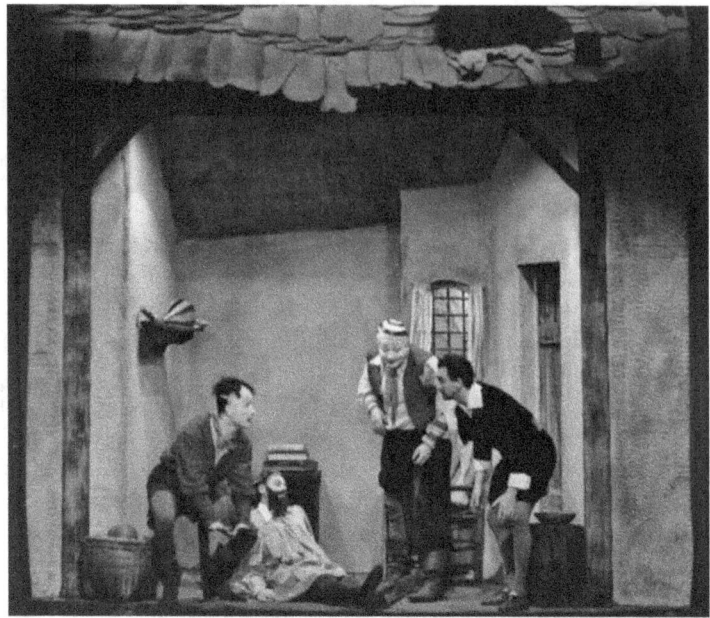

Figure 5.2 Production photo of *Heavy Barbara* starring Voskovec and Werich in their clown attire (Courtesy of the Cleveland Play House Archives, Kelvin Smith Library, Case Western Reserve University.)

In addition to directing and performing in every show while also managing the business affairs of their theatre, Voskovec and Werich wrote 26 plays, many of them satires on communism, fascism, capitalism, and democracy. One these works, *The Ass and His Shadow*, angered Adolf Hitler to the extent that he denounced the theatre in his radio programs and in speeches. Hitler reportedly sent many letters of protest to the Prague officials, asking them to censor and/or close the theatre, but the popularity of the Liberated Theatre caused Hitler's pleas to be ignored.[17] Unfortunately, the Czechoslovakian government bowed to German threats and signed the Munich Agreement on September 29, 1938, establishing Czechoslovakia's policy of appeasement to Germany and spelling imminent doom for the Liberated Theatre.[18] Initially, the theatre was refused a permit to perform, but Voskovec and Werich felt obligated to their 90 employees to proceed with their planned November opening. Their staunch refusal to oblige resulted in the immediate closing of their theatre (the first theatre

ever banned in Czechoslovakia), soon followed by threats of Voskovec and Werich's internment in concentration camps.[19] The two men left for England and then the United States, hoping to find success on Broadway; however, New York producers wanted Voskovec and Werich to conform to the style and content of a vaudeville act, a sacrifice the two actors were not willing to make.[20] Struggling to garner support for their work, Voskovec and Werich found a modicum of success touring the country and playing for Czech audiences.[21]

Before Voskovec and Werich fled Europe, Herbert Klein, a Cleveland documentarian, viewed their work at the Liberated Theatre and mentioned the duo to McConnell and Lowe. Intrigued by the descriptions of their "free, spontaneous and inventive" style of clowning, McConnell travelled to the Czechoslovakian National Hall in southern Cleveland to watch Voskovec and Werich perform for a native audience. McConnell invited the duo to tour the Play House, and the Czech actors fell in love with the Euclid Avenue theatre.[22] "They were immediately impressed by the similarity between the work being done by the Play House and the type of thing they had been doing at home," boasted *Plain Dealer* editor and Play House supporter Paul Bellamy. "They decided then that they wished to produce their first play in America at the Cleveland theater. Thanks to Director Frederic McConnell, the voice of these men, stifled in their native land, will again be raised in a country dedicated to freedom in the arts."[23]

With McConnell's decision to feature Voskovec and Werich in the 1938–39 season, the Czech actors not only became immediate celebrities, but also embodied the willingness of the Cleveland theatre and its community to support the war effort. The local press documented every detail of Voskovec and Werich's stay while also celebrating the hospitality afforded to the comedians. Cleveland newspapers inundated their readers with enthralling descriptions of their long train ride to Cleveland (18 hours), their discovery of and love for the *Popeye* cartoon strip, their confusion with American phraseology, their wives' favorite snail recipes and other favored refreshments, and many other exposés of a trivial nature.[24] Typical of the local coverage, one article described their first encounter with a new fruit while also managing to mock the nation's enemy:

> Known around New York as "the uncanceled Czechs," these two delightful visitors are having a grand time in our midst, adding to their knowledge of American customs. The other night at a party they had their first taste of nectarines, and asked curious questions about the delicious fruit. Told that they

were a cross between a peach and a plum, Mr. Voskovec remarked that they'd never be allowed in Germany. "They aren't of pure race," he explained.[25]

For its part, the Play House seized every opportunity to remind the public of the theatre's efforts to welcome the foreigners. A two-page spread in *The Cleveland Press* documented the Play House Women's Committee's opening night reception for Voskovec and Werich, featuring numerous pictures of notable attendees and accompanied by descriptions of the various gowns worn by the women of high society.[26]

The American premiere of *Heavy Barbara* was a success for the theatre both critically and financially, and it served as the crowning achievement of the early war years. With *Heavy Barbara*, the Play House capitalized upon its growing support from the community to take an artistic risk with the Czech actors. In turn, McConnell's genuine dedication to assisting these refugees served as the motivation to invite Voskovec and Werich to his theatre while also demonstrating to the community how the theatre reflected the community's concerns. The fact that the theatre benefitted greatly from the continuous publication of articles about the duo only added to the success that McConnell initially envisioned: a work of relevance and artistic quality that would define the type of work that the Play House would offer during the international conflict. Ideally, the theatre would become the leading cultural *and* community organization in the city, and the many actions of the Play House staff and supporters exemplified this aspiration. The theatre not only sacrificed revenue by offering benefits for local charities engaged in supporting the war efforts, but the theatre assisted in the American Red Cross's War Fund Drive, promoted the sale of war bonds by creating a play to benefit the Greater Cleveland War Savings Committee, donated costumes to the Russian War Relief for civilians and prisoners of war, utilized its staff to create radio programs for the Cleveland War Chest Campaign, and offered discounted tickets to servicemen.[27] The theatre's status as an amateur organization allowed it to alter its performance schedule without union oversight, enabling the theatre to support the war effort by offering "special performances at 12:30a.m., special Sunday matinees, and 'late, late' Saturday night performances to accommodate factory workers in Cleveland."[28]

For McConnell, his relentless drive to assist in the war effort deserves admiration. In addition to his many duties at the Play House, he attended numerous USO conferences on camp entertainment, working to ensure that many arts organizations in Cleveland and around the country offered entertainment for servicemen.[29] In the US Coast Guard's publication *The*

Welfare Bulletin, McConnell's decision to offer free tickets to servicemen was described as "most generous and welcome."[30] To his credit, McConnell believed in the value of theatre during times of conflict, thanks in part to the struggles he endured and witnessed as a prisoner of war:

> It was my reluctant destiny during the latter phase of the last war to be interned in Germany. There I saw what a conflict will do to a nation of people, in the way of material depravation and spiritual dead-end. I saw, also, some of those forces that helped preserve civilization. One of these was the theatre.... The theatre speaks best in periods of momentous living. Such is our life today. The theatre finds strength in the presence of popular need. We should keep it strong and prepare now for the continuance of that strength in the dubious years that lie in wait.[31]

Unfortunately for McConnell, his prophecy quickly became reality as the latter years of the war proved extremely difficult for the theatre both artistically and economically, yet the alterations made in 1942 by McConnell and the theatre's trustees not only enabled the Play House to survive the war, but these production and financial decisions also dictated the course of the theatre for the next 50 years.

THE YEAR THAT CHANGED THE THEATRE

In the early 1940s, two factors drastically impacted the financial health of the Play House: first, suburban flight created greater economic disparity between the downtown area and the increasing number of suburbs. For the theatre and all other arts organizations, the decentralization of the population would continue to be a major problem for decades as audiences moved further away from the various institutions.[32] Problems for the theatre were compounded by the significant number of men deployed out of town or shipped overseas. Roughly, 160 thousand men were called to service from the Cleveland area, meaning approximately 18 percent of potential theatergoers were no longer able to attend.[33] With these men withdrawing from the workforce, the loss of steady wages forced many patrons to become more selective with how they spent their entertainment dollars, leading to the closure of several community theatres in Cleveland and around the country.[34] Furthermore, the departure of men answering the call of military service caused frequent turnover throughout the entire organization. For example, two of the three actresses in the acting company departed for various periods of time to visit their husbands abroad, and the

number of apprentices working for the theatre plummeted from twelve to one between 1940 and 1943.[35] The theatre, however, found it difficult to compensate for the additional expenses of temporary staff when the federal government imposed 10 percent amusement taxes in 1941 and again in 1944, resulting in higher ticket prices without any additional revenue.[36] In addition, following the attack on Pearl Harbor, wartime inflation resulted in a 10 percent increase, meaning that production and administrative costs skyrocketed quickly.[37]

By 1942, the Play House was in financial peril as the theatre faced its first deficit since the Depression. McConnell and his board pursued three courses of action to remedy the problem for both the short- and long-term health of the theatre. First, the trustees generously donated money to cover the present deficit, alleviating the theatre of the immediate crisis.[38] In order to prevent another deficit the following year, board president Robert A. Weaver publicly announced the Security Fund campaign in July 1942, hoping to raise $30,000 in four weeks. In a savvy public relations move, two different sets of materials were disseminated. In an appeal to the entire community, the theatre sought donations to support its educational and community programs (as opposed to its production budget). In numerous newspaper articles, Weaver emphasized the importance of the theatre's outreach efforts to the community: "It has given more than a theatre program, however. It has contributed a useful and ever-widening civic and educational program. It has been the only theater in the country to maintain a tuition-free theater school, a children's theater, a playwright clinic, to issue special-priced student tickets and give aid to social services and other civic agencies."[39] The local press and public officials once again rallied to the theatre's cause: in the *Plain Dealer*, an article announcing the campaign printed Weaver's statement in full, all nine paragraphs, and *The Cleveland News* printed the story on the front page.[40] Mayor Frank J. Lausche (the former judge who ruled in favor of the theatre's picketing ban) joined the editors of all three local papers to speak on behalf of the theatre at the campaign's formal launch on August 1, 1942.

Weaver's public statement played upon sentiment and community goodwill in the hope of soliciting funds, yet letters obtained from the Cleveland Play House archives and sent by Weaver to subscribers and members of the theatre's Citizen's Committee (charged with raising the money) stressed the financial hardship that war had placed on the theatre while also making the clear distinction that this campaign did not result from the recent deficit: "The campaign is necessary because the war presents problems of cost at the theatre that make it impossible to continue to support the non-revenue

producing part of the theatre program from its operating income based on low-priced admissions. This is not a campaign to meet a deficit but, rather, to insure the theatre's traditional policy of supporting itself."[41] This letter proves disingenuous in that it not only ignores the theatre's reliance upon the board to eliminate the deficit, but also attempts to cite lower tickets prices as the problem rather than declining attendance. Furthermore, despite Weaver's declarations of the value and necessity of these programs to the community, the theatre cancelled its Shakespeare Festival the following year when it became more profitable to extend the regular season into the summer.[42] Not wanting to seem crass after raising money to save programs like the Shakespeare Festival, the Play House announced that the summer festival was cancelled due to tire and gasoline rationing.[43]

The cancellation of the Shakespeare Festival resulted from the second course of action taken by McConnell and his board to ensure the financial security of the theatre: altering the season in order to increase admissions. The plan was surprisingly simple, yet its success would have long-lasting implications (aside from the festival cancellation). First, the number of matinees offered would be dependent upon the success of each production. In lieu of offering a scheduled matinee every Saturday, the new plan relied upon flexibility as some shows would offer a matinee only if demand at the box office necessitated it. Second, in hopes of increasing admissions and, in turn, the percentage of capacity sold, the length of each run was shortened.[44] Historian William B. Clark Jr. described the reasoning behind McConnell's alteration: "At the heart of the plan . . . was an increase in the number of productions offered in the course of the Drury season. It was reasoned that if the poorly-attended fourth and fifth weeks of a production were to be replaced by the well-attended first and second weeks of a new production, then total admissions would rise. This would require intensive rehearsal and preparation by the company, but was looked upon as an economic necessity."[45]

Such a plan would succeed provided that the theatre presented productions that the community wished to see, and McConnell ensured that that would be the case. Serving as the third course of action taken by McConnell and his board, a clear shift in programming occurs in 1942 with the decision to present more popular, "escapist" works instead of the more experimental fare offered during the earliest years of World War II.[46] Gone were the days of celebrating the brave artistic endeavors of the theatre and inviting artists like Voskovec and Werich to establish a residency in the Play House—now they aimed to contribute to the community not by offering new theatrical experiences and/or educating its patrons about the latest production trends

in theatre, but, instead, by becoming a popular institution where the community could come together during stressful times.

The reason for shift toward populist fare is multifaceted. First and foremost, the new schedule would only succeed if the productions were well-attended, causing McConnell to select plays that appealed to a wider audience. This plan found immediate success when McConnell presented more comedies, namely Moss Hart and George Kaufman's comedy *George Washington Slept Here* and Booth Tarkington's Broadway hit *Clarence*. Both of these productions enjoyed numerous sold-out performances, prompting McConnell to publicize their success in an effort to increase demand.[47] *Clarence*, a comedy in the smaller Brooks Theatre, also exemplified the negative implications of McConnell's new plan. Despite emphasizing the play's success in New York and praising it as a vehicle for many famous actors (including Alfred Lunt, Helen Hayes, and K. Elmo Lowe), *Clarence* failed to sustain large audiences, so McConnell shuttered the play after its third week.[48] McConnell had planned to create a revue for the Brooks, but because he was worried about production costs compared to the potential audience for a revue (not a known quantity compared to the recent string of popular shows presented in the Drury), he shelved this idea to save money, leaving the Brooks Theatre dark from January to May.[49] When the Euclid Avenue complex opened in 1927, the smaller Brooks Theatre was considered to be central to the fulfillment of the Play House mission, providing a space for theatrical experimentation and the staging of new plays. The new criteria for success, however, reduced the role of the Brooks Theatre to a subordinate effort rather than a fundamental activity of the theatre.

Nevertheless, McConnell and the board kept to their revised plan, and their adaptability reaped great rewards in January 1943 with the opening of Joseph Kesserling's *Arsenic and Old Lace*, which was still running on Broadway and had toured at the downtown Hanna Theatre earlier in the year.[50] By the end of its sixth week, the production surpassed all attendance records at the Play House for a single show, yet the show continued to run for an additional three weeks. In all, more than 25 thousand tickets were sold for *Arsenic and Old Lace*, accounting for over 20 percent of the season's 115 thousand admissions, boosting the audience capacity from 63 percent to 77 percent in one season. McConnell's new plan allowed for the extension of the run of *Arsenic and Old Lace*, forgoing the summer Shakespeare Festival in order to secure more money. This decision was the first blatantly clear example of the Play House operating in direct opposition to its original purpose where community involvement and artistic exploration dictated the season, not financial reward.

A second reason for the shift toward popular play selections derived from the success of the recent Security Fund campaign and the obligation felt by the theatre toward the community. Reflecting the concerns of the community was no longer a priority for McConnell; instead, he arranged a season that reflected the *tastes* of the community. McConnell's decision to emphasize lighter fare mirrored the growing optimism in the country, in large part because "the tide of the European War had turned against Germany with the defeat of Stalingrad, inflation was in check, yet money was relatively plentiful."[51] Unlike O'Neil who refused to alter his production methods to acknowledge the generosity of the community, McConnell aimed to appease the growing number of patrons by increasing the number of productions (both in length and in number of productions). As a result, the company was expanded as well in order to allow for the casting of a larger number of roles. McConnell wanted to reward the community following the successful Security Fund campaign by giving them what they wanted—less experimental work and more popular fare. Even the shows that were seen as risks were tempered in order to appeal to a wider audience (as will be discussed later in this chapter).[52]

The final factor that supported the shift toward populist fare also derived from the war. With the large number of original members and staff away from the Cleveland area, the theatre was forced to hire younger, inexperienced actors, crew, and staff for their daily operations. These individuals joined the Play House to obtain practical training or simply to find steady employment. This younger company represented a new generation at the Play House that was not beholden to the original mission statement of the theatre; they were "younger, more pragmatic, and more mobile," resulting in increased interactions with college theatre programs in Cleveland and around the country.[53] Whereas the membership of the Play House in the 1920s would have rebuked McConnell's attempts to favor commercial theatre over experimental endeavors, the new company members supported the move toward popular fare, and, in conjunction with the increased number of productions and more patrons willing to spend money on entertainment, McConnell found himself at the helm of a runaway train.

MCCONNELL'S "OPEN STAGE"

With the money pouring in and audiences expecting lighter entertainment, McConnell quickly found himself in a predicament. He never wavered in his dedication to presenting new plays, but his audience was becoming

accustomed to being fed a steady diet of accessible, commonplace play selections. McConnell struggled to maintain a new play program that satisfied the agenda intended for the Brooks Theatre, and to his credit he produced several new plays each year. However, with over 130 plays having premiered on its stages, it is striking that the Play House never established a reputation as a home for new playwrights.[54] This failure stemmed from two important developments that occurred shortly following the conclusion of World War II: McConnell's questionable determination to continue expanding the Play House, and the theatre's inability to participate in the blossoming regional theatre movement.

The established history of the Play House records the period after 1942 as an era of great creativity. From 1942 to 1960, the theatre presented 20 world-premiere plays and also constructed a new theatre with a revolutionary design. Converting a church into a theatre provided McConnell with an opportunity to explore an "open stage" marked by an audience wrapped around a large apron, the first of its kind in the United States. Brooks Atkinson, theatre critic for the *New York Times*, attended the opening production of *Romeo and Juliet* and offered praise for the design:

> [McConnell] has remodeled it into a unique amphitheatre after the design of old Roman and Elizabethan models with a proscenium arch so huge that it is practically eliminated. Mr. McConnell...has entirely succeeded in dispensing with the conventional "peep-hole" stage and its boxed-in playing area. There is no curtain separating the audience from the platform stage.... It restores the relationship of audience to stage that existed before the conventional box stage dominated the drama. It can liberate production and play-writing from some of the arbitrary restrictions that have become basic in most work for the stage. In fact, the relationship of audience to stage is so normal that a playgoer hardly has time to realize that it is novel and revolutionary.[55]

It is often publicized that this new theatre—located at the intersection of Euclid Avenue and 77th Street, ten blocks west of the Books and Drury Theatres—demonstrated the visionary genius of McConnell, but records from the archives contrast the simplistic history as recorded by the press and other official histories of the theatre. For the first time, the complicated story behind the creation of the 77th Street Theatre reveals how the new theatre might not have been constructed if not for questionable circumstances and how it may have hindered the growth of the theatre more than it may have helped.

Following the implementation of McConnell's 1942 plan, annual attendance continued to skyrocket, increasing from 115 thousand in 1942

to 144 thousand in 1945—an attendance record that would not be broken for 35 years.[56] Like many directors of regional and community theatres, McConnell viewed the financial security as an opportunity to expand his theatre's facilities. He had first proposed the idea of a new theatre in a 1937 memo to the theatre's board of directors, arguing that the Brooks should remain an experimental space and that a new theatre would allow the Play House to produce a greater number of popular works that would attract more patrons.[57] The uncertainty of the war, however, postponed this idea until McConnell's 1942 plan provided increases in revenue, and the director again pressed for the creation of a third theatre.

The first public announcement of the Play House's intention to expand appeared in the October 1947 article "Old Church is Eyed by Head of Play House," explaining that the large hall and its ample seating capacity would "solve many of the theater's expansion problems."[58] Documents from the Cleveland Play House archives, however, reveal that discussions about the 77th Street building began a year earlier and often resulted in fierce debates between McConnell and the board of directors. Local press releases and publicity materials from the Play House suggest that the purchase of this space resulted from the natural growth of the theatre whereas the truth is another story. Answering why and how the Play House acquired this building and detailing McConnell's process of creating the noteworthy design exposes the contentious inner workings of the theatre and demonstrates how financial concerns dictated artistic product in the new theatre for many years.

Formed to explore the artistic and financial ramifications of expansion, a new Play House Building Committee concluded that the construction of a theatre on East 86th Street proved impossible due to the theatre's inability to secure sufficient land for parking; documents from May 1946 also unveil the committee's serious concerns over construction costs.[59] In addition, trustees and members of the committee criticized McConnell for his determination to enlarge the theatre's operations. Following McConnell's assertion that the theatre could borrow and/or raise an additional $200 thousand to afford new construction, past president of the board of trustees Leonard C. Hanna scoffed at this proposal in a letter to Walter Flory, then president of the Play House Foundation:

> I still feel that we are getting on reasonably well as we are and that there should be a very good reason for us to go further. I don't want you to surmise from this that I disapprove but only that I feel that we should not necessarily be responsive to any impulse to just GROW. Mac speaks quite casually of our

raising another $150,000 and borrowing $50,000. The reaction of such ones as I have talked to is one of amazement that we could consider the necessity of such a project.[60]

In his reply, Flory agreed by citing the Cleveland Community Chest's inability to reach one-third of its fund-raising goal. Then, responding to McConnell's financial proposal, Flory established some limitations on fund-raising ("It is doubtful if we could raise $75,000") and financing ("I would not favor our borrowing more than $50,000"). Undaunted, McConnell submitted letters to both Hanna and Flory justifying his optimism for the theatre's ability to raise such a large sum, but he still found himself being "blocked" by board members who demanded cuts in construction costs and repeatedly questioned the need to expand.[61] The two sides seemed at an impasse, unsure how (or even if there's need) to proceed. It would take a massive change of plans to reinvigorate the push to expand. That change arrived in October 1946 due to the racist and elitist fears of Euclid Avenue residents.

The subject of purchasing the 77th Street building first appears in a letter dated October 2, 1946—a full year before the notice appeared in the *Plain Dealer*—in which Flory informs Hanna of the possible sale of the building. Not only does his note contain the first mention of a sale price (initially suggested at $75,000 but eventually purchased for $52,000), but it also exposes the racist motivations of a group of Euclid Avenue residents known as the 7710 Euclid Corporation. "You may remember the Christian Science Church on the southeast corner of Euclid Avenue and East 77th Street," Flory wrote to Hanna. "When it was recently vacated, a group of Cleveland people purchased it for $60,000 to prevent it falling into the hands of a colored congregation."[62] It is both fascinating and troubling to consider that McConnell's "open stage" on 77th Street might never have been realized if not for the purchasing power of a coalition of wealthy citizens fearful of minority intrusion. Furthermore, it is worth noting that the motivation to prohibit the black congregation from moving to Euclid Avenue is emblematic of the obvious tension between blacks and whites concerning property ownership that would eventually erupt into violence during the Hough Riots of the 1960s.[63]

Flory was convinced that the purchase of the 77th Street church was worth exploring; however, the 7710 Euclid Corporation of the theatre refused to budge from their asking price, prompting Play House Building Committee member M. L. Sloan to inform McConnell and Flory that the "77th Street venture, for the moment, appears to be out of the picture" because the asking price was too steep.[64] In response, Flory a sent

letter to Hanna detailing how the acquisition of the church might be possible without borrowing a large amount of money. "If we could obtain a gift of the vacant land to the east of the church from the Warner and Swasey estates, this project might take on a much more attractive aspect," Flory suggested. "I am endeavoring to ascertain the possibilities of such gifts."[65] Flory persuaded two leading industrialists, Ambrose Swasey and Worchester Warner, to donate approximately 50,000 square feet of land from their estates to the theatre, giving the Play House more frontage space on Euclid Avenue and property that stretched to 79th Street.[66] Flory eventually secured additional funds that helped make the purchase possible, namely $31,000 from the city of Cleveland for the expansion of Euclid Avenue in front of the church (that never occurred) and a $25,000 grant from the Rockefeller Foundation.[67] Despite the deals that Flory had negotiated, the Play House Building Committee and several trustees still balked at McConnell's desire to expand. McConnell's letter to Draz in December 1947 is noticeably downbeat: "At a recent meeting of the trustees it was decided that the Christian Science Church building was of no value to us and that the only condition upon which we were justified in purchasing the property was its land value.... As a result, the whole project has been abandoned."[68] The failure to acquire the church also meant that the gifts of land from the Swasey and Warner estates and that the grant from the Rockefeller Foundation would not be secured.[69] After a year during which Flory negotiated for gifts and grants beneficial to the Play House and during which McConnell had composed hundreds of letters and drawings analyzing every minute detail of a conversion process, from the angle of the auditorium rake to the size and cost of fire curtains, it was a shared belief that the hope for expansion was at an end and McConnell's exciting plans for an "open stage" would not come to fruition.[70]

What happened between late December 1947 and late March 1948 remains a mystery due to a significant gap in the archives, but someone or something caused a drastic shift in the dealings between the Play House and the 7710 Euclid Corporation. "I am pleased to inform you," Flory wrote in a March 29 letter to David H. Stevens of the Rockefeller Foundation, "that an agreement has been reached by which the Christian Science Church property on Euclid Avenue and East 77th Street will be acquired immediately by The Play House Foundation" for $52,000—$17,000 for the building and $35,000 to cover the existing mortgage.[71] With the gifts from the local Swasey and Warner Estates combined with both the Rockefeller grant and the money from the city to purchase additional land, the total cost for the Play House Foundation to purchase nearly two acres of land was $29,000.[72]

In a press announcement, McConnell claimed that "no immediate plans for remodeling are being considered"—a blatant falsity.[73] Energized by the purchase, McConnell again began working on designs with architect Frank Draz, but financial problems encountered by the theatre dampened the trustees' enthusiasm for the project (Figure 5.3). With consumer prices having risen 22 percent since the end of the war, patrons began to budget their money more closely, leaving less money for entertainment. In 1948, the theatre witnessed a reversal of audience gains with the 1948–49 season resulting in the lowest number of admissions since the Depression. Increased production costs and preparations for converting the theatre forced an increase in ticket prices, but with fewer ticket sales, the loss of revenue meant that the theatre quickly fell into dire financial straits, relying once more upon generous public contributions to cover the theatre's considerable operating debts (a problem that occurs quite frequently in the Play House's history).[74]

In what should have been a triumphant moment for the theatre—the acquisition of a new space to build a revolutionary theatre—archive documents reveal a leadership consistently worried about the financial ramifications of their decision. Confirming an admission by McConnell that the church "was not as in good condition as we thought, for possible alteration and conversion," the cost of renovating the 77th Street building was

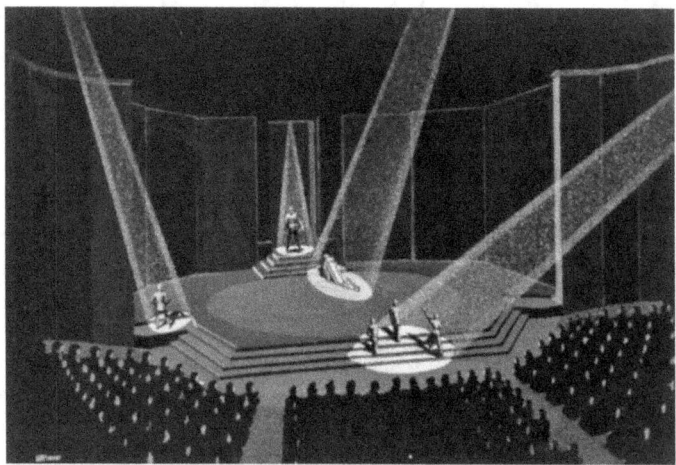

Figure 5.3 A sketch of the proposed 77th Street Theatre audience and stage (Sketch by W. McCreary. Courtesy of the Cleveland Play House Archives, Kelvin Smith Library, Case Western Reserve University.)

now estimated at nearly $200,000.[75] Trustee F. T. McGuire penned letters to over 1,200 previous donors, "urging contributions to the annual Operations Assistance Fund," asking for $10,000 to cover immediate debts.[76] By the end of the 1948–49 season, when admissions dropped to 104,000 (compared to 144,000 in 1945), Flory and his trustees realized the immediate need to initiate another fund-raising campaign and contemplated hiring an outside organization to assist in collecting donations for the New Theatre Building Fund.[77] The financial panic continued into 1950 when bills totaling $27,000 were due, yet the theatre's New Building Fund had raised only $15,000. To compensate, the theatre increased its mortgage note from $85,000 to $100,000 in order to acquire an additional $15,000 to pay off its debts.[78]

Similar to 1942 when McConnell enacted his plan to boost revenue by increasing attendance, the years encompassing the 1949–51 seasons became crucial for the theatre. Ticket prices were reduced for the first time in the theatre's history in an effort to attract former patrons and new audiences to the theatre.[79] Admissions increased during this two-year period—thanks in part to more productions (17 shows in three theatres in 1949–50 alone), the city's fascination with the opening of the new 77th Street Theatre, and McConnell's decision to move further away from experimental works in favor of popular fare and classic plays. The 1950–51 season finished with the third-highest number of admissions in the theatre's history, buoyed by the 11-week run of Garson Kanin's comedy *Born Yesterday*. As a further reward for McConnell's shift to more-populist offerings, the annual Operations Assistance Fund raised $30,000 during the 1950–51 season (nearly $20,000 more than expected), and the theatre concluded its season without a deficit for the first time in several years.[80] The financial gains may have been cause to celebrate, but McConnell's push to expand to three theatres became an unexpected financial burden on the theatre which, in turn, affected artistic decisions. The opening of the 77th Street Theatre reinforced a problem created by the implementation of McConnell's 1942 plan and, ultimately, hindered the Play House's ability to play a leading role in the growing regional theatre movement.

RISK AND RELEVANCE

In its promotional materials, the Play House frequently describes itself as the nation's oldest regional theatre; while this may be factually accurate, the Play House was not an early participant in the regional theatre movement. Joseph Zeigler's *Regional Theatre* elucidates this point when

he describes the movement as "a network of professional groups located in major cities around the country" and proceeds to list 11 different towns, but not Cleveland.[81] The Play House was America's first regional theatre because it was founded in 1915, yet it failed to participate in the regional theatre movement that occurred in the 1950s and 1960s.

The regional theatre movement began in 1947 with Margo Jones's establishment of Theatre '47 in Dallas, soon followed by Nina Vance with the Alley Theatre in Houston and Zelda Fichandler with the Arena Theatre in Washington, DC. Jones, often credited with creating the regional theatre movement, articulated her goals and motivations in her book *In the Round*, published in 1951 and received as a how-to manual for developing regional theatres:

> A permanent repertory theatre with a staff of the best young artists in America; a theatre that will be a true playwright's theatre; a theatre that will provide the classics and the best new scripts with a chance for good production; a theatre that will enable Dallasites to say twenty years from now, "My children have lived in a town where they could see the best plays of the world presented in a beautiful and fine way."[82]

Zeigler provides a different set of criteria, suggesting three tenets of a regional theatre: a community of artists who form a family, a governing board of directors, a charismatic leader to give the theatre "spirit, direction, and inspiration," and a commitment to the decentralization of American theatre.[83] Unfortunately, the Play House failed to satisfy two of these criteria, and where it failed explains why the Play House became less relevant during the development of the regional theatre movement.

The concept of "decentralization" as it pertains to the American theatre refers to the development of new works outside of Broadway, no longer viewing New York as the determinant of success, but, instead, aspiring to assist up-and-coming playwrights develop their craft at a variety of theatres around the country. A devotion to the discovery and development of American playwriting was the hallmark of the regional theatre movement as theatres introduced audiences to new voices writing for a new kind of American theatre (rather than the traditionally large, proscenium Broadway house). If the goal for regional theatres was to unearth new talent in their own communities, then the Play House certainly satisfied that criteria as they continued to offer staged readings and occasional premieres of local playwrights, beginning with Charles S. Brooks. The problem for the Play House was that McConnell judged the success of a new play by the product rather than the process. For most regional theatres, the writer

was given great freedom to develop his/her work as he/she saw fit, establishing the notion of a "playwright's theatre" rather than that of a director. To allow for a new play to fulfill its potential, the theatre staff needed to include someone with dramaturgical experience and familiarity with adapting to each playwright's individual needs and goals. While the Play House staff certainly included men familiar with adapting and rewriting scripts (namely K. Elmo Lowe and McConnell), their work primarily functioned to make plays accessible and acceptable to Cleveland audiences. For example, Lowe's work with Voskovec and Werich's *Heavy Barbara* mainly resulted in translating the work for a Cleveland audience rather than assisting them with their development as writers.

The misguided goal of cherishing the product rather than the process greatly impacted one famous playwright's experience in Cleveland. In 1943, Margo Jones was hired to direct the world-premiere production of then-unknown playwright Tennessee Williams's *You Touched Me*.[84] Jones found herself in uncharted territory at the Play House—she was the first female director in the theatre's history, and her determination to explore a new directing style caused McConnell and others great distress as they worried about the public reception of the new play. Upset with Jones's "loose directorial style" and her refusal to accept his edits to the scripts (without the playwright's consent), McConnell took over the rehearsal process, allowing her to remain in the auditorium but removing her from her creative position. According to Margo Jones's biographer, Helen Sheehy, "McConnell took charge in the last week of rehearsal, telling the actors where, when, and how to move. Outwardly gracious and accommodating, Margo sat in the auditorium during the final week of rehearsal swallowing her anger."[85] The play received lukewarm reviews, with critic William F. McDermott praising the production rather than the play, suggesting, "The play needs tidying up."[86] Jones eventually found success with the play when she took it to the Pasadena Playhouse, which allowed her to reinstate the cuts and employ her own directing style, resulting in much stronger reviews.[87]

Examples of plays like *You Touched Me* floundering in the development process are littered throughout the Play House's history. The theatre produced three additional new plays in 1943 with an eye toward Broadway, yet each one failed to find life after Cleveland. Norris Houghton, in his study of American theatre, described the bind in which the Play House found itself: "No first-rate dramatist was interested in writing for the Play House; in nineteen years the theatre staged only sixteen full-length new plays; the Play House suffered from a lack of new blood; and there was no definitive theatrical style."[88] In the 84-year history of the Play House at 86th

Street or Cedar Avenue, only three plays have had any significant impact outside of Cleveland, yet only one is still performed on American stages today. In 1946, as part of McConnell's determination to provide popular entertainment, the Play House presented the world premiere of William Wister Haines's *Command*, a gripping war drama exploring the stress upon commanders of an Air Force unit as they knowingly send men on missions that may result in loss of life. The play provided the Play House with its first national success—the play moved to Broadway where it was retitled *Command Decision* and eventually was released as a motion picture starring Clark Gable. The second play, Donald Freed's docudrama *The United States vs. Julius and Ether Rosenberg* received glowing reviews, and the play also found its way to Broadway where it was recast and renamed (now called *Inquest*).[89] The third play that garnered national attention, Paul Zindel's *The Effect of Gamma Rays on Man-in-the-Moon Marigolds*, transitioned from the Play House in the 1969–70 season to New York where it received the 1971 Pulitzer Prize for Drama. While the promotional materials for the Play House list this production as a premiere, the Alley Theatre first produced the play five years earlier. The Play House deserves credit, however, for mounting the production that secured a transfer to Off-Broadway.[90] While a few other plays traveled to Off-Broadway or other regional theatres, the Play House's inconsistency with development affected its reputation; two plays in nearly 100 seasons of theatre does not represent a good track record for discovering and developing new works. In other words, the Play House failed to satisfy the criteria as a "playwright's theatre."

In McConnell's defense, it seems unfair to criticize him for failing in new play development at a time when the standards and practices for the training of dramaturgical staff and developing new playwrights were not as commonly accepted as they would become during the regional theatre movement of the 1960s. At the same time, it is fair to criticize McConnell's decisions that made his theatre incapable of adapting to the changes and goals championed by Jones and the regional theatre movement. Because of McConnell's 1942 plan and his 1950 decisions to emphasize popular play selections, the Play House set itself on a path distinctly separate from that of the regional theatre movement. By frequently appealing to the public for funds to cover its deficits and to build new performing spaces, the Play House catered to its audience base by routinely selecting plays to reflect the interests and tastes of the community. This strategy initially proved successful early when new play selections like *Command* or *The Eve of St. Mark* addressed issues relevant to all Americans coping with the effects of wartime, but the risk of topicality faded as McConnell favored escapist entertainment.

As stated earlier, the decision to construct the 77th Street Theatre contrasted the current trend of the regional theatre movement to build smaller, experimental spaces, especially theatre-in-the-round configurations made popular by Jones and a host of other directors. These smaller spaces dictated reduced production costs and, in turn, required a smaller number of patrons to make the production financially viable. In this model, a regional theatre could produce any type of play with fewer worries for financial loss—the risks taken with producing untested scripts was compensated by a balanced season featuring a traditional work or a classic play. This template allowed theatres to develop new plays without concerning themselves with audience responses (a small percentage of a regional theatre's patrons consistently supported new plays, ensuring an audience for the production and lessening the risk even more).

McConnell, however, went big, building the 462-seat amphitheater, which required large audiences on a nightly basis in order to break even. If the Play House experienced drops in revenue and/or attendance from either the Drury Theatre or the 77th Street Theatre, McConnell made the choice of sacrificing the expense of mounting less revenue-generating shows in the Brooks Theatre, namely new plays.[91] While McConnell argued for the artistic value of his "open stage," the ingenuity was lost by the Play House's inability to remain relevant on a national level. This slight offended McConnell as he repeatedly boasted of his theatre's innovation; in 1960, McConnell bragged about this theatre's accomplishments:

> Interest in the open stage has been heightened by recent events. The new Dallas Theater Center, conceived by Paul Baker and designed by Frank Lloyd Wright, has completed its first season. Plans of the Lincoln Center for the Performing Arts call for a repertory theatre with a flexible stage, making possible the presenting of plays in free rein in front of the proscenium. Meanwhile, the Play House, which has been a pioneer in the field of the open stage, has just concluded a revealing ten-year demonstration of its practicality.[92]

He continued his argument philosophically, arguing against the proscenium arch as an outdated device and labeling it a hindrance to American playwrights. This statement is contradicted by the fact that McConnell relegated the premieres of new plays to the Brooks Theatre, a traditional proscenium theatre.[93]

McConnell's resentment was justified—the Play House has not received fair credit for the revolutionary design of its "open stage." The features of the 77th Street Theatre have been copied countless times across the world and can been seen as the inspiration for countless other regional

theatre's performance spaces, including the Alley Theatre, Actors Theatre of Louisville, Arena Theatre, and countless others (not to mention the Olivier Theatre of the National Theatre in London). Given the hours upon hours that McConnell spent meticulously perfecting the design of the new theatre, it is not surprising that he wished for the Play House to receive its share of recognition. Following both the conclusion of the tiresome process of building the 77th Street Theatre and his 1950 decisions to sacrifice artistic endeavors to ensure consistent revenue, McConnell requested a change in his role with the Play House. In 1950, he sought and received approval from the board of directors to appoint K. Elmo Lowe as the producing director. According to Oldenburg, "Though McConnell retained the title of director and would continue to make general policy and help in the selection, scheduling, and casting of plays, he disengaged himself from the daily activities of theatre production and the programming of acting and technical personnel."[94] This decision proved instrumental: not only did McConnell's lesser role prevent the theatre from fulfilling the last of Zeigler's criteria (that the theatre must be guided by a tireless, inspiration leader with a singular vision), but his abandonment of his post marked a change in the "family" dynamic for which the theatre frequently was praised. The replacement of the theatre's earliest members with younger staff and talent combined with the increasing influence of the board and the patrons over the direction of the theatre signified the end of an era.

LOSING THE WAR

While America was fighting overseas, the Play House was fighting to stay alive financially and artistically. The Play House may have won a few battles during the 1940s, but it lost the war by abandoning its commitment to experimental works that aimed to introduce new ideas and artists to the community rather than conforming to trends emanating from Broadway. While the Cleveland theatre did achieve several notable accomplishments during this decade, the decisions made by McConnell and his board of directors altered the course of the theatre forever. McConnell's decisions can be judged only by their effects upon the theatre and how they prepared the theatre for the future, but it is clear that McConnell's directives hindered the theatre's ability to participate in the regional theatre movement and, in turn, lessened its relevance on a national level. McConnell cannot be faulted for his inability to predict the future of the American theatre and the growth of the regional theatre movement, but he deserves criticism for giving into the temptation that has caused the undoing of many

directors: the relentless desire to expand. Many theatres closed when they could no longer afford to pay for larger facilities and the staff needed to support it, or, in the case of the Play House, McConnell's push to grow physically hindered the theatre's ability to grow artistically.

At the beginning of the war, when financial strains began to impact the Play House's daily operations, McConnell's admirable determination to assist the community through morale-building productions or through activities to support the war effort never distracted from his goal to provide productions of artistic merit. In fact, his decision to bring in Voskovec and Werich exemplifies his willingness to take a risk in order to satisfy the mission statement of the theatre while also appealing to the concerns and interests of the community. As the war progressed and budgets tightened, McConnell's leadership inspired the staff and supporters of the theatre to make sacrifices in order to keep the theatre alive for the benefit of the community. In addition to the 12:30 a.m. performances to accommodate factory workers, the staff accepted stew lunches (often cooked by the actors) as compensation for lower wages.[95]

The first battle for the Play House came in 1942 when McConnell's decision to implement the plan helped the theatre regain its financial footing, yet it also redirected the institution away from its original mission. Once McConnell and his board were rewarded with the wild success of *Arsenic and Old Lace* and the immediate and impressive spike in attendance, the theatre changed forever. This is the period of time when, for whatever reason, McConnell decided not to champion the aesthetics that had made the Play House so unique compared to many other community theatres around the country. It is legitimate to justify McConnell's 1942 plan with the notion that the lean years of the war made them become more money-conscious, but the prioritized pursuit of revenue created two irreversible trends: first, the larger audiences meant larger expectation from the trustees and a larger sense of ownership from the community; and second, McConnell failed to persuade the board (or simply opted not to persuade them) to return to the theatre's mission statement of consistently discovering and developing new thought-provoking, relevant works.

Another battle was fought in 1950 with the opening of the 77th Street Theatre when the need to organize several fund-raising campaigns led McConnell again to cater to public tastes to ensure audience support. In addition to solidifying the move away from the Play House's original mission, a second shift occurred when McConnell delegated some of his authority to Lowe, giving the new artistic director and the board greater control over the direction of the theatre. Again, McConnell's unwillingness to

fight is curious, as if he simply had grown tired of fighting with the board of trustees. By 1950, he had his "open stage," which he certainly viewed as his crowning achievement (and explains why he wrote a passionate notice promoting his theatre's revolutionary contribution). Nevertheless, McConnell's 1950 decisions cemented a change that hindered the growth of the theatre: instead of art driving financial decisions, it was clear that finances would dictate art.

McConnell's 1942 and 1950 decisions and their long-lasting effects caused the Play House to lose the war over its potential. By following the almighty dollar, the theatre unintentionally sacrificed its ability to contribute to the regional theatre movement. Saddled with substantial financial responsibilities and an audience increasingly expectant of entertainment suited to their tastes, the idea of the theatre as a family transitioned into a theatre of owners. The community, which had repeatedly given so much money to save the theatre, felt a sense of ownership over the institution and, therefore, expected to have a greater say in its affairs and selections. While this development certainly was not destructive—in fact, from a financial standpoint, it helped ensure fiscal health as a larger number of supporters established a deeper connection with the theatre—it could lead to financial loss and administrative upheaval if leaders within the theatre chose to present works not embraced by the community. An example of this conflict would be seen 40 years later when the Play House tried to reflect national trends as opposed to the preferences of the Cleveland community.

Despite these criticisms, the Play House could be considered the envy of most professional regional theatres in the 1950s—it enjoyed a large subscription base and an esteemed place within the community. It presented a few new plays (though with little success), and enjoyed facilities unlike most regional theatres that operated in discovered spaces. Furthermore, the Play House deserves credit simply for surviving during a strenuous time when no model existed to serve as a guide or comparison. Its nearest competitors benefited from consistent external funding sources whereas the Play House was more audience-dependent for its revenue, making the Cleveland theatre's survival all the more noteworthy. In this context, the fact that the Play House was able to thrive and expand is remarkable and worthy of recognition, and the theatre was willing to ride its wave of success throughout the 1950s and into the 1960s. However, the infamous events within the city of Cleveland in the mid-1960s forced the Play House to evaluate its relationship with its immediate community in addition to its responsibility to the city of Cleveland during times of racial strife.

6. Escaping No-Man's-Land

The city of Cleveland's history is filled with infamies that have tarnished the city's reputation on a national scale, from unimaginable accidents like the burning of the Cuyahoga River in 1969 to the horrific explosion of the East Ohio Gas Company in 1944 that left over 130 people dead. One moment that captured the national spotlight occurred in such close proximity to the Play House that Superintendent Elijah Ford was forced to defend the theatre by standing with his shotgun alongside the National Guard on the rooftops of the theatre, protecting the building from "the pimps, the prostitutes, and the thieves."[1] The Hough Riots, documented in newspapers around the country as an event marked by burning houses and violent clashes between police and residents of the neighborhood, resulted from a culmination of political and social decisions that widened the disconnect between the urban ghetto and the other residents of Cleveland now situated in the suburbs. While the Play House was in no way directly involved with the Hough Riots or could ever be blamed for the outbreak of violence that erupted, it continued to reflect its community not only through artistic endeavors, but also by mirroring the attitudes and actions of the city with its attempts to follow trends occurring in the regional theatre movement. For example, the theatre ignored a portion of the Cleveland community as part of a financial strategy utilized by theatres around the country; similarly, the city's efforts to improve itself at the expense of the urban population, however, provoked the shameful violence and inexcusable deaths. An exploration of the administrative and economic decisions of the Play House in the 1960s compared with the policies and actions of city leaders and government officials reveals both a theatre and a city struggling mightily to redefine themselves while hoping to remain relevant on a national level.

THE HOUGH RIOTS AND THE ITS EFFECTS

A single glass of water. It is hard to conceive of six nights of violence, four deaths, over 300 arrests, and 531 reported arsons resulting from a dispute

over a single glass of water. Of course, the complete history of what sparked the riots is far more complex, replete with racism, oppression, economic disenfranchisement, and government incompetence.

Following the automation of farming in the 1940s, jobless African Americans moved north seeking work, many settling in the urban neighborhoods of Cleveland. The construction of the Willow Freeway (now Interstate 77) forced the destruction of numerous properties in the Central neighborhood, causing the African American residents to move further north to find cheap and affordable housing in Hough.[2] The effect of this migration resulted in a drastic demographic shift. In 1950, blacks were only 4 percent of the Hough population, but that figure quickly rose through the decade. By 1960, the population of Hough was 73 percent black, and this percentage rose to nearly 90 percent by 1965 as white residents fled the area.[3]

Living conditions in Hough deteriorated rapidly as the neighborhood became the city's most populated area. "The neighborhood would become overcrowded," one scholar noted, "eventually, it would not be able to support itself, and it would break. The economic, political, and social, and geographic [sic] factors responsible for Hough's decline, irritated by a lapsing post-war economy give rise to a cyclical dynamic taking the neighborhood on a downward spiral. The combination of deterioration and division in the community would irritate each other until Hough could take no more."[4] In his study of the 1966 riots, Marc E. Lackritz noted that the Hough area housed approximately 45 people per acre compared to other Cleveland neighborhoods that hosted anywhere from ten to 35 people per acre.[5] According to one estimate, Hough contained 30 thousand people per square mile, comparable to modern-day Brooklyn and Queens, New York, but without the high-rise buildings. Hough was primarily two-story homes crammed with people and interspersed with small business establishments.[6] One of these small businesses that catered to local clientele was the Seventy-Niners Club located at 79th Street and Hough Avenue, which was owned by two brothers, Abe and Dave Feigenbaum, who assumed ownership of the bar when their father was killed while sitting in his car not far from the club.[7] The club had a history of tense and inflammatory relations with the residents, including an attempt to set fire to the brothers' car a few months before the riot.[8]

While the Feigenbaums denied provoking members of the Hough community to riot, most accounts tell a story of minor events snowballing into a massive violent reaction. On Monday, July 18, Dave Feigenbaum was working at his bar when a local prostitute named Louise entered the premises, seeking donations for a fund-raiser to benefit Margaret Sullivan, a

recently deceased prostitute whose heart attack left behind three children.[9] Feigenbaum ordered Louise to leave, but initially the woman refused. The conversation soon turned hostile as the two hurled insults and vulgarities at each other. To make matters worse, Feigenbaum reportedly "muttered something about serving Negroes."[10] Later that same day, a black man walked into the bar to purchase a pint of cheap wine, but he also requested a glass of water. The Feigenbaums described this man as a "wine-head"— one who buys a pint to avoid purchasing wine by the glass and then proceeds to dump the water and drink the wine from the cup. The bar owners later cited state law that prohibited them from serving anyone who purchased take-out alcohol, but the manner in which they refused the man a glass of water caused the riot.[11] According to bar patron Dennis Hilliary, Dave Feigenbaum told the barmaid, "I have told you and I'm not telling you again, serve no niggers no damn water."[12] Upon hearing this, the man who had been refused the glass of water immediately shouted to his friends in the bar that he had been refused. He stormed out the front door, but returned quickly to post a sign made from a paper bag which read "No water for Niggers." Word of this refusal of service quickly spread, and within minutes a crowd had gathered outside the club. The Feigenbaums called the police and the fire department, and also decided to defend their property by standing outside armed with a pistol and a rifle.[13]

The Feigenbaums blamed the riot on the police, claiming that they could have stopped the riot by arresting those people who they have seen looting stores and vandalizing buildings. The brothers also denied inciting the riot with their refusal to serve the black man a glass of water, and they never acknowledged how their racist language may have angered local residents.[14] What is certain is that when the police arrived, the protest erupted into a full-blown riot.[15] The crowd spread and continued to grow throughout the night as residents reported incidents of rock throwing, looting, arson, and sniper fire. As firemen arrived to put out flames, crews were frequently hit by rocks and bottles and sometimes their hoses were cut. Rioters also attacked police and their cruisers, slashing tires and smashing windows. Soon, gunfire from snipers hiding in nearby homes began raining down upon both police and bystanders. The arrival of the National Guard assisted in calming some of the violence, but the tension remained for six uneasy nights. Finally, Cleveland mayor Ralph Locher declared the riots over and released the National Guard, but the destruction in the Hough area was evident. According to one patrolman, "I was in London in the bombings of World War II—that's what it was like here last night and that's what it looks like this morning."[16]

The Hough riots are replete with horrific tales of violence, many documented in the local papers and in oral histories taken in depositions. Given the level of destruction associated with the event, one would think that the city government would take great pains to conduct a thorough investigation of the riot in order to learn from its procedural mistakes and in hopes of preventing similar riots from occurring in the future. Unfortunately for the residents of Hough and the city of Cleveland at large, the response of the local government was insipid and laughable, if not outright incredulous. City councilmembers avoided admitting that the riots derived from years of neglect by their own city government and, instead, offered a host of excuses to explain the violence. For example, Councilman Leo Jackson claimed that "thugs" organized the riots as part of a "struggle for leadership of the Negro community."[17] Cleveland Chief of Police Richard R. Wagner supported this assertion by arguing, "This violence was organized, and those behind it studied the laws very carefully and then just as carefully evaded the scope of their coverage."[18] A fellow councilman not only suggested that the riots were precisely timed to occur when the National Guard would be unable to mobilize quickly (the unit ordered to quell the riots had lent their convoy trucks to a division operating in Michigan), but also proposed that smaller skirmishes on Superior Avenue in June were, in fact, a "dry run" for the Hough riots.[19]

Such delusional assertions found their way into official government records. On July 25, Judge Thomas Parrino summoned a 15-member grand jury for special session to act as the "conscience of the community" and to discover the true causes of the riots.[20] The very next day, following a bus tour of the Hough neighborhood to assess the scale of the damage (because none of the jury members lived in the area), former editor of the *Cleveland Press* and foreman of the Grand Jury Louis Seltzer declared that the Grand Jury "saw enough to realize the violence was organized and planned because of specific targets singled out for looting and burning."[21] The Grand Jury proceedings were directed by Seltzer from the beginning to suggest a coordinated effort led by Communist and/or Black Panther influences, citing "clubs" in the area that were used for bomb-making and the dissemination of guns. On August 9, the Grand Jury issued its report, featuring a preface that articulated its central assertion: "The outbreak of disorder was both organized, precipitated, and exploited [*sic*] by a relatively small group of trained and disciplined individuals at this business."[22] The report commended the work of the police and the National Guard, warned of increasing Communistic threats, blamed single mothers and "common-law" relationships for encouraging the abandonment of responsibilities,

and avoided assigning blame to city officials despite their years of ignoring the plight within the neighborhood. In fact, Seltzer's report accused Hough civic leaders of failing to prevent the riots.[23] Along with other city officials, Mayor Locher supported the jury's findings, declaring, "This Grand Jury had the guts to fix the approximate cause—which had been hinted at for a long time—that subversive and Communist elements in our community were behind the rioting."[24]

To say that both Seltzer's ludicrous assertions and his refusal to assign any responsibility to city officials or the police riled the Hough community would be an understatement. State legislator Carl Stokes labeled the jury's report "whitewash" and criticized the jury for deliberately absolving the city of any liability.[25] Even the city's own community relations director Bertram Gardner publicly stated his belief that the report reflected an effort by "the white community to escape responsibility for the conditions which caused the riots."[26] Angered by the conclusions of the grand jury, the leaders of the black community responded to Seltzer's report by creating their own public hearing in the form of a biracial citizen's review panel.[27] Consisting of representatives from various community organizations, the Citizens Committee for Review of the Grand Jury Report invited testimony from any member of the public who wished to testify, including the mayor and other city officials who were issued personal invitations. This hearing lasted three days and resulted in a report which argued that the ignorant and incompetent actions of Cleveland city officials contributed to the conditions that caused the Hough riots.[28]

The city found itself divided, both racially and geographically. Once again, the Play House found itself caught in a no-man's-land, catering to a suburban audience while residing in an urban setting. The local government's role in establishing the conditions that supported the riots reflected a citywide neglect of the area, whether intentional or unintentional. In the years before and after the Hough Riots, the Play House faced its own administrative and economic problems, and while their corrective efforts helped the theatre rediscover its identity, the decisions and policies enacted by the theatre and its patrons unintentionally mirrored the foolish and unfortunate actions of the city in how it moved to avoid the growing problems developing in the Hough area. Charting the Play House's continuous search to determine its role within the city and in the national landscape of regional theatre illuminates how the theatre's actions reflected the city's indifference toward the Hough community while also revealing the institution desperate for an identity and still in search of a "home."

UNREST WITHIN AND AROUND THE PLAY HOUSE

After examining the archives of the Play House, one would never imagine that the violence that erupted in Hough occurred only two blocks north of the Play House's two theatres. The Seventy-Niners Club was less than one-quarter mile away from the front doors of the 77th Street Theatre, and the stores surrounding the 86th Street Theatres suffered from vandalism and looting. Despite the scale of the destruction and its proximity to both locations, references within the archives to the Hough Riots or the National Guard are scant at best. In fact, the disturbances in Hough are never mentioned in any of the minutes for either the meeting of the board of directors or the Men's Club. It is possible that this shocking omission might reflect a secretary's decision not to record unpleasant discussions in the official history of the Play House; however, for a theatre that prided itself in serving the needs of the community, both in artistic product and outreach, the avoidance of any discussion concerning the riot is both stunning and telling.

The disconnect between the theatre and the riots symbolizes the theatre's lack of support for the Hough area. The Play House attempted to operate with a business-as-usual mentality during the turbulent 1960s (as evidenced by the minutes of administrative meetings), but this decade proved difficult not only for the neighboring community, but for the theatre as well. In an effort of self-preservation and to find its "home" (both within the community and in a new facility), the Play House ignored its surroundings and focused on its own needs, much in the same vein as the city of Cleveland did toward the Hough neighborhood. The Play House's actions/inactions toward the Hough community can be categorized into three themes/issues, which are also specified by the Citizens Committee for Review of the Grand Jury Report as causes for the Hough riots. This parallel serves not only to pinpoint how the city's inactions contributed to the environment that generated the violence, but also to demonstrate how the theatre repositioned itself away from its prior role as a community theatre in hopes of transitioning into a professional regional theatre. Much like Hough, the theatre risked the loss of its identity and place within the city.

The two decades encompassing the 1950s and 1960s proved to be a period of great instability. If the new postwar leadership reflected a new direction, thanks in part to the absence of two members of the "Triumvirate," then this new period marked the end of that influence. Between 1954 and 1967, the Play House grieved the losses of Walter L. Flory, beloved actor Rolf Engelhardt, Max Eisenstat, and Frederic McConnell, not to

mention Raymond O'Neil.[29] Serving as the last of the "Triumvirate" to work for the Cleveland theatre, K. Elmo Lowe was named McConnell's successor in 1958, and he remained the theatre's artistic director until he retired in 1968.[30] During these turbulent years, marked by frequently shifting moods of optimism and pessimism, Lowe faced a plethora of challenges, successes, and even temptations that caused the theatre to further abandon its original mission statement. For example, the 1952–53 season featured both notable accomplishments such as increased annual attendance (135 thousand), national exposure via *Life Magazine* article, and the appointment of Frederic McConnell as a judge for a national playwriting competition in Hollywood, and also some frustrating setbacks. Exploiting their success, McConnell and Lowe attempted to return to the theatre's roots by staging 26 weeks of performances in the Brooks Theatre, half of which were considered "experimental productions." Unfortunately, the Korean War impacted attendance and ticket prices (similar to World War II), resulting in drastic cuts the following year, most notably the closing of the Brooks Theatre for the entire year.[31] Any hopes of reopening the Brooks Theatre to stage new plays vanished when further financial hardships forced the board to relinquish control of the Brooks Theatre and rent the space to outside organizations.[32]

For every success, there was a challenge: years after the complimentary article in *Life Magazine*, the Play House penned letters of protest to *Time Magazine* and the Ford Foundation after being omitted from a list of notable regional theatres around the country.[33] Also, Tyrone Guthrie and Oliver Rea submitted a proposal to the board of directors wherein the Play House would become a classical repertory theatre under their control, but the board flatly rejected the proposal as an attempt to "take over" the theatre.[34] In addition, the reception of a $130,000 grant from the Ford Foundation—the first ever to a theatre—allowed the Play House to train and eventually employ professional actors (most notably Alan Alda and a young Jon Jory), yet their appearance on the stage quickly forced the Cleveland theatre to submit to Equity contracts and rules which, in turn, increased their production costs.[35] Finally, the Play House premiered Eugene Freed's *The United States vs. Julius and Ethel Rosenberg* in 1969, drawing immense praise from the public and enticing *New York Times* critic Clive Barnes to visit Cleveland to view the production before it traveled to New York. Unfortunately, League of Resident Theatre (LORT) contracts at the time prohibited profit-sharing agreements (a commonplace practice in contemporary regional theatre), eliminating any chance of a financial windfall for the theatre.[36]

The combination of all of these events and numerous others created an environment of uncertainty within the Play House—strategies for returning to the original mission statement supporting experimental fare had failed, yet attempts to build upon popular successes were stifled as well. Endeavors to increase the quality of performers and heighten the theatre's reputation resulted in increased financial burdens placed upon a theatre whose standing in the national landscape was diminished; consistent leadership and pride for the theatre's history became secondary to the institution's need to survive and replace departing staff. In its struggle to reclaim its identity and reestablish both its national reputation and its standing with local audiences, the Play House pursued a series of self-preservationist actions without consideration as to how they affected its immediate community. The three problems to which the theatre responded were the same as those cited by the Citizens Committee for Review of the Grand Jury Report as the causes of the riot. Although the Play House did not deliberately neglect its nearby neighbors, its actions paralleled the citywide abandonment of the Hough area.

Fear of Crime

For years, the Play House worked to become an integral part of the community, but now it was forced to battle its immediate neighbors in order to retain its audiences. Whereas Euclid Avenue was once the most fashionable and wealthiest street in the city, by the 1950s much of the area had fallen into decay. In his book *Cleveland: Confused City on a Seesaw*, historian Philip W. Porter described why the area deteriorated: "Large numbers of uneducated blacks, whose jobs as cotton pickers in the South had been eliminated by automation, had moved into Hough-Wade Park, doubling up with relatives; and by the mid-fifties, this whole section was fast becoming a slum, and badly needed urban renewal."[37] As the decade progressed, the problems increased, thanks in part to the city's negligence. Many of the larger homes in the area were being subdivided, yet the city did little to enforce housing code violations, causing "run down houses, crime, and blockbusting" to saturate the Hough area.[38] Enabled by the city's lack of oversight and enforcement, these conditions were cited by the Citizens Committee for Review of the Grand Jury Report as primary causes for the Hough Riots.

The numbers and severity of crimes continued to rise throughout the 1960s as murders, racial attacks, and arson became commonplace in Hough.[39] While not located in the Hough area (only the northern side

of Euclid Avenue was considered to be part of Hough), the Play House did border the neighborhood that brought problems related to ghetto life. Patrons attending a performance at the theatre turned onto the Play House property off of 86th Street, passing in between the theatre and a series of apartment buildings known as the Drury Hall Apartments. According to Elijah Ford, these run-down dwellings were a hotbed of prostitution run by three pimps named Eddie Ratcliff, Blood, and Pie, and their nightly business affected theatergoers' ability to park in the Play House parking lot. Theatre patrons, often dressed in elegant attire that might attract unwanted attention from the local residents, feared for their safety among the streetwalkers and pimps trolling the nearby streets and adjacent lots. After hearing complaints and learning of refusals to attend future performances, Elijah Ford came to the rescue: "I got them out of there.... I put a fence up, a chain-link fence, and I got into a scrap with a couple of the pimps, but I took care of them."[40] While Ford solved a logistical problem, he alone could not blunt the growing fear felt by patrons about travelling into town to attend the theatre.

The deteriorating conditions within Hough and the frequent reminders from the local papers as to the attacks on white Clevelanders in the area directly affected attendance at the Play House. According to previously unreleased documents from the Cleveland Play House archives, administrative leaders frequently expressed their concerns over the theatre's proximity to the ghetto. In 1963, Lowe himself acknowledged the problem in his report to the trustees, claiming that the theatres' "locations tend to discourage rather than attract audiences."[41] Kenyon Bolton expanded upon Lowe's worries, adding "We are losing our footing in the community, and we are losing out because of the location."[42] By June 1964, the discussions about the theatre's vicinity to the Hough neighborhood featured a more ominous tone as evinced by this summarization in the minutes of a board meeting: "There was a discussion as to the urgency of leaving the present locations, and it was answered that there was a serious need because of the neighborhood which has effected [sic] attendance noticeably."[43] As the problem worsened, the theatre leadership felt so besieged by problems caused by local residents and by the sustained threat to attendance that Bolton spoke of the future of the theatre in dire terms. According to the minutes of the September 1965 meeting of the trustees, Bolton warned of a bleak future:

> Mr. Bolton stated that our immediate problem, however, is survival in our present location. He commented on the deterioration of the neighborhood,

that people who had been coming to the Play House for years were now unwilling to come into the area, and that we were in an unfavorable situation from audience stadnpoint [sic] as well as our young people's living quarters. This increased resistance from our potential audience to come into this neighborhood seriously affects our being able to meet our budget. There must be ways and means found to combat this situation so that the Play House not only survives but progresses...[44]

This foreboding persisted after the riots and into the late 1960s with trustees expressing fear of being firebombed and considering possible locations in the event of a disaster caused by the "danger in the neighborhood."[45]

Fearing for both its safety and its fiscal health, the Play House needed to make changes in order to limit its deficits (which were becoming routine), but the changes that were made unfortunately hurt its standing within the immediate community. Similar to the inaction of the local government to address the social ills within the Hough area, the Play House made several alterations that hindered its ability to connect with local residents and reassert its position as a vital member of the community.

Decreasing Community Involvement and Changes in Demographics

Facing uncertainty in audience attendance and in its fiscal health, the Play House desperately searched for new tactics of attracting patrons to the theatre. For many regional theatres across the country, the answer came in the form of Danny Newman. Described by the *New York Times* as "perhaps the most prodigious public relations man in the history of the nonprofit arts," Newman created aggressive campaigns to build audiences through subscriptions rather than relying on single-ticket purchases for revenue.[46] Among his many tactics—including the sharing of slogans among theatres and discounting subscriptions—it was Newman's "hard sell" tactic that swept through America's regional theatres and also found a home at the Play House.

The principle behind Newman's "hard sell" forced a change in how those theatres marketed themselves to the community. Instead of casting a wide net over the entire community, Newman argued that only 3 percent of the population would become subscribers and that theatres should concentrate their marketing campaigns on this smaller group of citizens. "In Newman's mind, attempts to attract a broad cross-section of the population were not only too costly but also foolhardy," Joseph Wesley Zeigler summarized in his book *Regional Theatre*. "They simply would not respond,

he said. His was a purely elitist approach to building audiences; he was seeking the upper middle class."[47] Critics charged that Newman's tactic of repeated mailings to a smaller demographic resulted in homogenous audiences, and artistic directors began to feel constrained by the types of plays often selected in order to satisfy the patrons from the "carefully-chosen mailing lists."[48]

Regardless of the criticism, it is no surprise that regional theatres and other arts institutions employed Newman as a consultant to help increase their subscriptions, and his impact on the development of American theatre is astounding. According to Zeigler, theatres who utilized his techniques enjoyed approximately 75 percent growth in their subscription rolls in the first years.[49] His work earned praise from nearly every institution that he assisted: "Danny is the godfather, the founder of the feast," lauded the Goodman Theatre's executive director Roche Schulfer in an interview. "He invented the method that allowed theatres to prosper across the country."[50] Trish Pugh Jones, former Manager of Patron Services at Actors Theatre of Louisville, credited Newman with the increase of subscriptions than enabled Jon Jory to implement his new play festival into the regular season, ultimately becoming the Humana Festival of New American Plays.[51]

When the Play House hired Newman as a consultant in 1963, the hope was that his tactics would not only increase ticket revenue, but also entice wealthier patrons to donate to the institution. Newman described his selective targets, boasting, "The campaign will be aimed at doctors, lawyers, teachers, artists, and other professional people as well as other art lovers and opera, symphony and pop concert goers."[52] Despite the selective nature of Newman's "hard sell" approach, Lowe justified the hiring of Newman as a means of making his staff's efforts more efficient. "In the past, while some shows have been playing to capacity houses, others have run with the theatre three-quarters empty," Lowe stated in an interview with the *Plain Dealer*. "This means that part of our energies are wasted. With the economics of the situation solved, we would be able to do much more in the way of distinguished drama."[53]

The Play House set a lofty goal based upon the recent successes of other regional theatres under Newman's guidance; for example, the Goodman Theatre's subscription list jumped from 1,900 to over 10,000 with Newman's assistance. Lowe and his staff launched the largest subscription drive in the theatre's history with hopes of increasing their subscription list from 4,300 to 15,000. The results were mixed. According to records and board meeting minutes from the Cleveland Play House archives, the

theatre never attained the support and financial windfall that other theatres enjoyed. Initially, the subscription drive resulted in immediate success with subscriptions increasing to 5,241 within a few months and to 6,088 by January 1964.[54] The modest increase in subscriptions (compared to what was expected) resulted in the theatre running a deficit following the 1964–65 season, and, not surprisingly, the numbers of subscribers dropped to 5,633 following the Hough riots.[55]

One year following Newman's arrival in Cleveland, a trustee remarked that the audiences "appeared to be composed to a large extent of students, doctors and nurses, and the like." This observation mirrored the desired audience articulated by Newman in his first interview with the *Plain Dealer*, suggesting that although the subscription drive may not have succeeded in terms of volume, Newman's tactics were successful in attracting his favored demographic to the facility. Furthermore, the increased patronage of upper-middle-class citizens directly benefitted the Play House Club, the theatre's popular dining club established in the 77th Street Theatre in 1960.[56] Lowe admitted altering the play selections of the larger theatre, resulting in "a good deal of popular fare" at the 77th Street Theatre in hopes of attracting members to the "poor man's Union Club," not only for meals before and after shows, but in hopes that the Club would become a popular site for businessmen also to meet for lunch (which it did).[57] Thanks to upper-middle-class patrons becoming more aware of the theatre's performances as well as its new social club, membership steadily increased and provided the much-needed revenue to offset other operating expenses. The impact of Newman's tactics can also be observed in the increased number of social fund-raisers held by the Women's Committee, including a Masked Ball held in January 1964 that hosted 1,600 guests (at $35 a ticket) and set records for a Play House fund-raising event.[58] The following year, records were broken again when the Women's Committee hosted the Fiftieth Anniversary Ball. While Newman's push for subscribers may not have put patrons in the seats, the theatre received increased revenue, thanks to Newman's hard sell at upper-middle-class citizens who supported societal functions if not performances.[59]

Descriptions of these lavish social occasions and the establishment of a dining club, which contrasted with the living conditions and the crime occurring two blocks north of the 77th Street Theatre, reveal a disconnect between the Play House and its immediate community. It is important to emphasize that the actions of the Play House, while intentionally disregarding its immediate community in favor of attracting wealthier patrons, was not reflective of its attitude toward the community. The outreach

programs of the Play House echoed local efforts within the Hough community to address social problems, but both the theatre and the civic organizations were hindered by limited funding and increasing apathy by the citizens of Cleveland, resulting in a lost opportunity to improve the lives of Hough residents and potentially curb the tide of violence. The waning support for public education caused a decline in student enrollments in the Curtain Pullers program. The number of participants in the program had been dropping off since its peak in 1946 when more than 750 children enrolled in the theatre's school programs; by 1961, free classes in "creative dramatics" attracted less than 400 students.[60] Two statistics deserve notice: first, the number of fellows and apprentices steadily decreased during the 1960s, meaning fewer opportunities for local residents to study at the Play House. Second, the theatre's determination to market itself to the suburbs is reflected in the attendance of its student matinees. With increased frequency, the schools attending the theatre on a regular basis were from suburban (i.e., wealthier) districts while inner-city schools failed to attend. For an institution battling deficits, it was logical for the theatre to complement its "hard sell" tactics by using the matinees as a means to attract students of a similar demographic (and ideally their parents) to the theatre. The theatre never prohibited Cleveland students from attending its matinees or participating in its program—it is simply a fact of economic disparity that suburban children were more disposed/enabled to attend the offerings at the Play House. Lowe and his staff worked to involve the Hough community to the extent that their finances would allow, but oftentimes these efforts yielded poor results. Changes in the Play House's outreach endeavors reflected the new push toward attracting upper-middle-class patrons, yet the theatre's attempts to remain relevant within the local community were admirable, if not minimal.

White Flight and the Devaluation of Property

Rising crime and deteriorating housing conditions plagued Hough and its surrounding neighborhoods, but when the city received federal money for urban improvements, Cleveland city officials made a disastrous choice: to ignore the area most in need of assistance. Instead, in an attempt to revitalize downtown Cleveland and attract new corporate interests to the area, Cleveland city officials led by Mayor Tony Celebrezze used funds provided by the Federal Urban Redevelopment Program to develop a portion of downtown known as Erieview, a lakeside area extending from East 6th Street to East 18th Street, north of Chester Avenue and south of the

lake.[61] Claiming the development as a priority and the future of Cleveland business, Celebrezze hired internationally acclaimed architect I. M. Pei to design a master plan for the area involving "low buildings accented by vertical towers" and a large reflecting pool.[62] The centerpiece of this development, a 40-story office building known as Erieview Tower, opened in 1964, and five more buildings opened within the next decade.[63] By 1972, "over $220 million of construction had been committed to Erieview," and the decision to pour extensive amounts of money into this area has been a cause of great debate and criticism.[64] Cleveland historian Philip W. Porter argued that this downtown renewal project made Cleveland "much worse off now than before Erieview."[65] The new development "destroyed Euclid Avenue... as the main, fashionable, nationally-famous shopping center of Cleveland" because the new offices were too far away from the shops and restaurants on Euclid Avenue, meaning workers had to abandon the rapid transit system as a means of transportation and no longer passed by the stores in Tower City or along Euclid Avenue.[66]

The greatest criticism of the Erieview project derived not from its impact on downtown Cleveland, but from how it affected other areas of Cleveland, especially Hough. Erieview was a priority and "claimed all of the city's energy and attention, while other parts of the city were generally neglected."[67] Instead of addressing the needs of the Hough neighborhood, the Celebrezze/Locher administration cited the University–Euclid area as its second development priority; in fact, according to reports from the Cleveland City Planning Commission, the development of an urban renewal plan for the slums of Hough ranked sixth on the commission's list.[68] The deliberate decision to ignore the plight of the ghetto combined with the redevelopment of other areas of Cleveland accelerated the demise of the Hough area. When seizing dilapidated properties via imminent domain in the interest of urban renewal, the former residents evicted from their homes in the name of progress (along with those moved because of new interstate construction) found cheap housing in the Hough area, sparking a jump in population density and a decline in housing conditions. For example, while Hough contained only 7 percent of the city's population, its residents "provided nineteen percent of the welfare cases for the entire county."[69]

Unfortunately for the University–Euclid project, administrative red tape caused the development of the area to be mired with delays. Porter described the flaws of the University–Euclid proposal as "sketchy and incomplete; there seemed to be no plan for the whole area."[70] The city's failure to manage these projects in a timely fashion drew a public rebuke

from federal officials, warning that the Cleveland was taking on too many projects at once.[71] Unable to wait for the city to detail its own renewal plan, privately funded expansion initiatives by University Hospitals and Western Reserve University forced these two institutions to purchase land on their own in order to begin construction.[72] With the city focusing all of its attention on these two projects—one downtown and the other in University Circle—once again the territory in the middle became a "no man's land." If the city had focused its time and money on the deteriorating conditions in Hough, its "collapse into complete slums would not have come so fast, nor the aftermath of problems been so tragic."[73]

The continued neglect of the Hough area affected its residents in numerous ways. In addition to the infusion of poor, uneducated blacks into the neighborhood, Hough also experienced "white flight" as many of the wealthier residents fled when property values began to decline. White-owned businesses remained, and many of the absentee landlords were the former residents who attempted to make money despite their severely devalued property. These landowners who had invested in the once-predominately Jewish middle-class neighborhood had now moved to safer suburbs, and those who remained stayed because of the cost of moving out to the outlying areas.[74] Hollow promises from city officials for urban renewal development failed to inspire investment as more and more businesses attempted to abandon the area, including the Play House.

When the Play House decided to build its 77th Street Theatre in 1947, it was a conscious decision to invest in the area; in fact, the location of the new theatre resulted from "white fight" (as opposed to "flight"), a initiative of local white residents intending to stay in the area who were fearful that a black congregational church of Euclid Avenue would lessen their property values. Thirteen years later, the Play House became mired in discussions concerning the search for a new home, and once again two familiar options presented themselves: downtown Cleveland and University Circle.

Throughout its history, the Play House has repeatedly considered moving either downtown where the national touring shows attracted large audiences or to University Circle where many of Cleveland's cultural institutions resided. From outside influences to its own board members, the consistent suggestion to move the theatre never abated during its entire stay at Euclid Avenue, giving the impression that it did not "belong" at that location. A mere ten years after the opening of the 77th Street Theater, the impetus to move again derived from a surprising assertion made by Frederic McConnell: he declared that the theatre needed to "work for a single plan in a better place."[75] There are two stunning revelations in this

statement: first, only ten years after working tirelessly to design and build his "open stage" theatre, McConnell once again exhibited his desire to expand by abandoning the 77th Street Theatre in favor of new construction. Second, McConnell acknowledged the troubles in the surrounding neighborhoods by suggesting that the theatre find a new home in a "better" place, likely downtown or in University Circle.[76]

It is not surprising, then, that conversation advocating another search for a new home quickly dominated administrative gatherings. At a meeting of the board of trustees on January 5, 1960, the primary topic of discussion was the Guthrie–Rea proposal, but in the midst of considering the conditions set forth by the two men involving a move to a new theatre space, board member John H. Kerr suggested that Leonard C. Hanna Jr.'s foundation might financially support a move to University Circle. The issue was dropped as the Guthrie–Rea proposal was roundly rejected, but the topic became a frequent point of debate in future meetings.[77] Within five months, lengthy discussions with representatives of Western Reserve University and University Circle resulted in serious negotiations for the Play House to move, but one sticking point remained unresolved: the existence of a dining facility as part of the theatre. The University Circle representatives stated that they were constructing a "staff club" and demanded the Play House use that facility. The Men's Club of the Play House scoffed at this proposal, causing a stalemate in negotiations that delayed the proposed starting date for construction to September 1963.[78]

By 1963, negotiations with Western Reserve University remained at a standstill, described by trustee William A. Polster as "not encouraging" because "Western Reserve has its own problems which must be settled, and is unwilling at the moment to discuss Play House collaboration."[79] In addition to the repeated call for the Men's Club to forgo their dining club, other problems developed when University Circle leadership acknowledged two major problems: there was no land currently available for the construction of a new theatre facility, and Western Reserve University's fund-raising efforts (expected to contribute to the relocation project) was dedicated to securing money for its new medical school.[80] For the remainder of 1963, the board of trustees repeatedly explored options for moving east to University Circle, including land that might be available along Euclid between 102nd and 107th Streets.[81] A survey of the land commissioned by the theatre, however, revealed that the ineptitude of the city's urban renewal plans created uncertainty concerning the theatre's ability to develop the area in a timely fashion, thereby making it too risky for the theatre to consider.[82]

Desperate to find a new location, Lowe announced in 1963 that not only had he been contacted by Inner Belt Association about a possible move to Erieview, but an official also had foolishly promised him that they would be able to move within a year. The deliberations exploring a possible move to Erieview were never as involved or prolonged as those with University Circle representatives, primarily because the flaws of the Erieview project became frequent fodder for the press and the area offered little interest to Play House officials.[83] Furthermore, a November 5, 1963, defeat of a bond supporting the Erieview project reflected the public's lack of confidence concerning the future of the lakeshore development, which immediately impacted private financial commitments as well.[84] Following the problematic Erieview development, the Play House Board of Trustees acknowledged that they were faced with four problems simultaneously: first, the city's urban renewal plans were deeply flawed and that any development might take up to ten years before a move could be made; second, monies from federal and local foundations for urban development had either dried up or been eliminated; third, conditions in their current location were worsening, requiring the theatre to spend more money on extra security and lighting as a safety precaution; fourth, despite the widespread criticism and ineffective management of the Cleveland Urban Renewal Commission, the announcement that the city planned to "destroy" the area around and including the Play House on Euclid Avenue as part of a future development project meant that the theatre could not sell its property at a price that would contribute to a new facility.[85] Even if the trustees had found a new home for the theatre, the complicated logistics of acquiring the land and receiving funding meant that Lowe and his company were trapped inside their current House for the time being.

The push to flee the Euclid Avenue location gained new momentum in 1965, thanks to dialogues with new potential partners, including the Cleveland Clinic (concerning land availability) and the Musical Arts Association, regarding the possibility of establishing an arts center akin to the Lincoln Center (this idea was quickly abandoned).[86] However, the trustees of the theatre once again looked west to the downtown area as a new proposal offered renewed hope for relocation:

> Discussions with Fenn College and Euclid Innerbelt representatives were held on several occasions. Great interest was expressed in having the Play House in this area both as an adjunct of center-city rejuvenation and as a nucleus for a cultural complex.... This involved the complete re-building of a large section of the near downtown east side, so that this new university will lie between

Erieview on the north and St. Vincent renewal area on the south, where a new campus for 15,000 at Community College will be created. This area will adjoin the downtown business area at 18th Street.... Included in these ultimate plans are teaching programs in the humanities and arts which closely relate to the Play House, and they expressed definite interest in having the Play House in this area and working out their plans with a view towards developing a working arrangement between the institutions.[87]

An outgrowth of the YMCA's educational program in the 1880s, Fenn College faced new financial hardships in the early 1960s from competition with Cuyahoga Community College.[88] Instead of closing, Fenn College officials worked with city and state governments to create a new four-year public university to be known as Cleveland State University.[89] The new campus hoped to accommodate 20 thousand students within ten years and eventually up to 40 thousand students. On September 1, 1965, a new wooden sign was unveiled outside Fenn Tower, officially declaring the opening of the new state university.[90]

The opportunity presented by Cleveland State University initially appeared more feasible than any of the earlier proposals, and the possibility of being affiliated with a university led to increased interest among the board members. Excitement increased when the Cleveland Development Foundation announced the creation of a $100 million commercial complex as part of the $300 million Cleveland State University urban renewal plan.[91] These new plans would have placed the Play House next to Playhouse Square, but another bond issue defeat at the hands of voters in 1966 halted further discussions.[92] Soon after plans with Cleveland State University stalled, discussions with a new school quickly gained traction. Dr. Robert W. Morse, president of Case Institute of Technology, suggested that the Play House relocate to the newly amalgamated Case Western Reserve University and "do away with Eldred Hall and start to rejuvenate the Drama Department and move into an area with a graduate school in theatre."[93] Morse and Case Western Reserve University continued to press the trustees, and the discussion became more serious as the theatre debated paying for another feasibility study to explore the cost of a move to University Circle.[94] However, one of the four problems that the Play House simultaneously battled eventually became too much to overcome as funds once available for urban renewal were now depleted. The feasibility study surprisingly suggested that the proposed location next to Playhouse Square between 17th and 18th Streets would best serve the theatre, but such a move would cost the theatre over three million dollars, making it

impossible. Initially, two-thirds of this cost would have been paid by urban renewal funds, but such support was no longer likely.[95] Holding onto hope, Case Western Reserve University continued to press for an affiliation, but its continued difficulty in finding a suitable location for a theatre (except on the outskirts of the university) failed to inspire confidence that a resolution could be reached. It was at this point in the theatre's desperate search for a new home that the Play House received some interesting news from local councilmen.[96]

Throughout the theatre's persistent efforts to join the "white flight" of the Hough neighborhood, a few voices urged caution. In the various minutes of the board meetings now available in the archives, the records reveal that board members began questioning the necessity of moving, either out of dedication to the neighborhood or out of concern regarding the financial risk. A pivotal moment occurred a few months before the Hough riots when Alan L. Littman resigned from the board due to the "projected program [that] demands financial support and gifting which exceeds the capacity of our community."[97] His letter suggests that the board was looking to expand beyond the immediate needs of both the theatre and the community. His concern for the community sparked a growing pessimism as board members questioned with greater frequency the motivation behind the relocation effort. Two months after Littman's resignation, the Report of the Relocation Committee read at the trustees' meeting suggested, for the first time since the "white flight" trend began in 1960, that the Play House ought to consider remaining at their present home:

> The neighborhood certainly is one in which the Play House can only be a victim of the tides of the times. Regardless of the fact that in other cities, where similar outbursts have occurred and have quieted down, life does seem to go back to normal, and will go back to normal in Cleveland. There will be some people who will be fearful of coming into the area, and it's going to take a good deal of conscientious, positive selling on the part of all of us to see that our friends and former supporters of the Play House continue to give support during these difficult times.[98]

After years of criticizing the city government and attempting to abandon the neighborhood desperately in need of support, the argument articulated in the Report of the Relocation Committee was the first call for the Play House to recognize its responsibility toward the immediate community, harkening back to the theatre's earliest days when it served as a home for all Clevelanders who shared a common spirit of exploration and creativity.

It is impossible to know if the Play House would have moved if either of the proposals from the two competing universities had proved feasible. If voters had approved either of the bond issues, it is likely that the Play House would have relocated to downtown Cleveland, and the future of professional theatre as well as that of Euclid Avenue would have been altered immeasurably. The fact that the Play House remained in the area provided constant reminders to its patrons of the economic disparity existing in Cleveland. The fact that the Play House, as an institution cherished by its wealthy and influential supporters, might be threatened by racial violence in nearby neighborhoods possibly encouraged other communities to commit to making a difference in the Hough community. The growing concern for the residents of Hough became evident at a board meeting in 1968 when local councilmen announced, for the first time, an increased likelihood that the area would (finally) receive funds for urban development programs.[99] For the first time in years, the Play House found its future more certain, and even though it still considered the possibility of relocation, the recent success of Lowe's *The Tempest* at the Cleveland Arts Festival combined with the 1967 election of Carl B. Stokes, the city first black mayor, exemplified a new citywide determination to assist inner-city residents.[100]

THE END OF AN ERA

Change can be violent, and the events of 1968 proved this adage to be true as the summer of 1968 will live in infamy as a period of distress and discontentment, both locally and nationally. Uncertainly spread across the country following the assassinations of Martin Luther King Jr. and Robert F. Kennedy, and the much-publicized political turmoil in Chicago gave rise to youth disenfranchisement. On a local level, Cleveland unfortunately endured another violent summer when the Glenville Shootout erupted in July 1968.[101] Despite Mayor Stokes's best efforts, redevelopment programs did not affect residents quickly enough to curb the growing influence of Black Nationalists in the Glenville neighborhood. Fred "Ahmed" Evans led a revolt against the police, using guns purchased with money given to him from Stokes's own "Cleveland: Now!", a $4 million community project, privately funded by Cleveland businesses. Evans later was convicted of murder and sentenced to life in prison.[102] Once again, references to the Glenville riots are scant in the theatre's archives.

Turmoil of a different scale was being felt within the Play House in 1968. In addition to LORT's refusal to let the theatre profit from the

Broadway run of *The United States vs. Julius and Ethel Rosenberg*, 1968 marked the beginning of K. Elmo's Lowe's final season at the Play House. The last member of the "Triumvirate" was departing, completing a slow transition to new leadership throughout the Play House. Much like the city in the 1960s, the theatre faced a pivotal question: What course of action would brighten its future? The city opted to support a risky endeavor when favoring Erieview over other programs that would have been less worthy of national attention but more beneficial to maintaining the health of the city. With Lowe's departure, the Play House faced a similar decision: Should the theatre plot a new course and risk its community support for national recognition, or should the theatre remain conservative in its leadership and select someone who continued to reflect the values of the community? For decades, the Play House worked tirelessly to reflect the concerns and tastes of its community, but during the 1960s, the theatre mirrored the actions of the city's politicians and business leaders which unintentionally created a divide between the theatre and its neighbors. Change was inevitable, and major decisions needed to be made. For the time being, the Play House resisted change by retaining its home on Euclid Avenue, but there was too much work to be done for Play House to survive. The Cleveland theatre needed to get its own House in order.

7. The "Endangered Theatre" ❦

For his book *Beyond Broadway: The Quest for Permanent Theatres,* Julius Novick traveled around the country, viewing productions at a variety of regional theatres. His 1968 publication offers limited resources for historians in that the bulk of his writing recounts his personal reactions to different plays and presentations rather than utilizing research to make substantial comparisons between repertory companies and the various challenges they faced in the late 1960s. Nevertheless, he visited the Play House on two occasions during which he recorded his responses to Neil Simon's "quite good" *Barefoot in the Park,* an "excellent" *Who's Afraid of Virginia Woolf?,* a "vacuous" adaptation of Molière's *School for Wives* titled *The Amorous Flea,* and an offering of *The Tempest* presented "without imagination or insight."[1] Despite Novick's delight in providing pithy insults, he does pause from his reviews of the Play House's productions to address a concern he has for the theatre's future:

> The Play House is now a somewhat geriatric institution; it is the only resident theatre faced with the problem of a staff that is slowly dying off. Mr. Lowe himself, acting and alert though he is, was born in 1899. The Play House has the advantages that often come with an advanced state of maturity: wealth, experience, a certain kind of solid proficiency, an institutive knowledge of what can safely be done. But it also has the great disability that comes with age: timidity, conservatism, a tendency to continue in the same groove.[2]

After arguing that any theatre's "highest function" should be "to challenge and stimulate its audiences," Novick concludes his criticism by evaluating the work of the Play House against his self-declared standard, resulting in his labeling the theatre "an egregious failure."[3]

With the resignation of K. Elmo Lowe in July 1969, the board of trustees had a unique opportunity to address Novick's critique. The board faced two options when hiring a new leader: promoting someone from within the institution that would cater to the tastes of the Cleveland community and whose familiarity from the acting company appealed to local audiences

(and ideally entice more patrons) or welcoming an outsider whose reputation derived from accomplishments on the national stage, hoping that his/her arrival in Cleveland would instigate a new spark of creativity and support for more daring works. This divide existed for all regional theatres attempting to strike a balance between ensuring audience support through mainstream fare while also contributing to the future of American theatre through the development of new plays and playwrights. Theatres located in larger cities, like the Goodman Theatre in Chicago, the Manhattan Theatre Club in New York City, the Alliance Theatre in Atlanta, or the American Repertory Theatre in Boston enjoyed a larger audience base, making it easier to take the financial risk of producing a new play. In cities the size of Cleveland, for example, Milwaukee, St. Louis, etc., the risk of producing new work was much greater, often relegating any new play production to a smaller theatre in hopes of reducing the reliance on audience support.

By the late 1960s, the call for discovering and supporting new American playwrights became the mantra of the regional theatre movement (and only more so in the 1970s following the creation and immediate success of the Humana Festival at Actors Theatre of Louisville), and the Board of Trustees of the Play House sought a leader from the middle of the spectrum—someone who understood Cleveland yet was also sensitive to the national trends developing within American theatre. In addition, Lowe sought to establish a training program at the Play House similar to the Guthrie Theater's Theater Workshop, and he hoped to find a candidate who would support his new endeavor. Not surprisingly, the person who fit these criteria had been on the Play House staff and had been recruited by Lowe. When William Greene announced his decision to leave the Guthrie after a four-year stint (the last two as the head of its workshop program), seven theatres offered him immediate employment.[4] He accepted Lowe's offer to move to Cleveland to run the new TheatreLab, a series of classes available for all Play House actors that taught theatre history as well as "psychodrama and calisthenics."[5] Greene also brought a resume of acting and directing both abroad and on Broadway, and his willingness to work under Lowe's tutelage enabled a seamless transition when Lowe announced his resignation and personally chose him as his successor only one year after Greene's arrival.

Unfortunately for the theatre, while the transition may have been smooth, the next few years proved incredibly rough. Whereas only two men had served as executive director for the previous 48 years, tragedy and conflict caused the Play House to hire three executive directors in two

years. This brief period, from 1969–71, set in motion a chain of events that dictated the artistic, administrative, and economic course of the Play House for the next 36 years. During this time, the increasing power of the board of trustees—a common occurrence in regional theatre—resulted in several instances of the board overreacting to problems that the theatre encountered. Two decisions in particular—the construction of the massive theatre complex and the hiring and firing of the theatre's most controversial artistic director—reveals the ineptitude of the board as it negatively impacted the artistic endeavors of the theatre and hindered the Play House's ability to remain relevant on a national level.

TWO TUMULTUOUS YEARS

William Greene had ambitious plans for the Play House: developing new playwrights by asking them to write specifically for Cleveland audiences; increasing the number of tickets sold at a reduced price in hopes of enticing younger patrons to the theatre; attracting more professional directors to the Play House; hiring Hollywood stars for limited engagements; and, turning the theatre into a year-round operation through the addition of summer shows.[6] Despite his interest in "jobbing in" celebrities to attract audiences, Greene reassured the acting company and the community that his status as a newcomer did not spell doom for the resident actors. "I haven't been hired to fire everybody," Greene stated in an interview with the *Plain Dealer*. "Like Thomas Jefferson, I don't believe in tearing down fences until I know why they were built."[7] Instead of eliminating staff, Greene made a significant hire within a few months of his arrival: despite rumors in the press that Greene would assign popular company actor Richard Oberlin to a managerial position, Greene continued to broaden the national stature of the theatre by hiring his friend from the Guthrie Theater, Rex Partington, to serve as associate director.[8]

Greene's inaugural season was both an artistic and commercial success, offering a balanced selection of Peter Shaffer's *The Royal Hunt for the Sun* and Peter Nichols's *Joe Egg* contrasted by productions of Mary Chase's *Harvey*, a second Shaffer play *Black Comedy*, and the premiere of Paul Zindel's Pulitzer Prize–winning *Effect of Gamma Rays on Man-in-the-Moon Marigolds*.[9] The astonishing success of *Marigolds* outweighed the one blemish on the season, the premiere of a new play by Norman Wexler, who served as the theatre's first playwright-in-residence since Charles S. Brooks.[10] The season was progressing well and the theatre was enjoying

both success and stability: the productions were well-received, the theatre was expanding artistically, its new executive director transitioned into the leadership role without a hitch, thanks in part to "consultant" Lowe, and plans to dedicate the Brooks Theatre once again to experimental work were being formulated.[11] Unfortunately, any optimism that the company, staff, and leadership of the Play House may have felt about the season and/or the theatre's future immediately disappeared on March 12, 1970. William Greene decided to work from home on Wednesday, March 11, and that was the last that anyone saw him alive. Attempting to contact his friend, Rex Partington arrived at the executive director's home on Thursday only to discover Greene's lifeless body, the result of a suicide.[12]

Greene's sudden death sent shockwaves throughout the theatre, and the board moved swiftly to restore order in the midst of the season. In a quickly convened meeting of the executive committee of the board of trustees, two important decisions were made: Rex Partington was promoted to the position of Acting Director through the end of the season, and a committee was formed to begin searching for a new executive director. Stunned by the sudden death of Greene and believing Partington to be similar in mind and mission, two months later Greene's longtime friend was selected to become the fourth executive director in the theatre's history.[13] Described as a "spiritual brother of Greene," Partington announced that he would continue Greene's mission for the theatre, including the cultivation of a younger audience through cheaper tickets, touring, and the continuation of the TheatreLab.[14] Hopes for continued success under Partington, however, quickly faded when the 1970–71 season began. After a "powerful" production of *Three Penny Opera*, audiences were treated to a lackluster Noel Coward play (which closed early due to lagging ticket sales) and a production of *Endgame* that local critic Peter Bellamy described as "the most atrociously dull assortments of gibberish ever foisted on the public in the name of art."[15] If Partington was afraid that his productions were boring audiences, then he did not need to worry for long because his next offering caused a great deal of excitement. In fact, this controversial production not only provoked an overreaction by the board of trustees, but also instigated a debate about the role of boards in dictating artistic products.

Publicity photos from the archives give no indication of what made *Lysistrata* so offensive to audiences and critics; in fact, the photos featuring actors in period costumes and exaggerated makeup look as if they could be taken for any classic Greek comedy. The reaction to Aristophanes's sex-strike comedy fell into two camps: those who seemed outraged by the

lewd dialogues and provocative staging and those who defended the interpretation. The most vocal opponents of the production were the critics from Cleveland's two main newspapers. Both Tony Mastroianni of *The Cleveland Press* and Peter Bellamy of the *Plain Dealer* condemned the production for overexaggerating and highlighting the vulgar material of the play. "The play's element of bawdiness has been emphasized to the exclusion of everything else," Mastroianni wrote. "This is an anti-war play, but it's difficult to find the message in all the sniggering and archness."[16] Bellamy responded in a more personal manner: "My beloved Play House in the past forty years, to my certain knowledge, has offered some plays that didn't work, and some distinguished plays that weren't popular, but never has it descended to such layers of vulgarity and cheap emphasis on the crotch."[17] The powerful influence of the Cleveland critics quickly became evident to the Play House when schools began cancelling matinees and patrons refused to attend or purchase tickets. In an unparalleled move, the board of trustees closed the production after three days.[18] The theatre quickly staged Robert Anderson's *I Can't Hear You When the Water's Running*, considered to be a "sure-fire" box-office success, but attendance for the comedy proved disappointing as well.[19]

The few patrons who saw *Lysistrata* agreed that the play was crude. "It's a bawdy piece, and I think maybe the bawdry wasn't done right. Some of the bawdy effects were accented instead of just passed over," recalled company actor Richard Halverson. He also remembered the scandal that followed: "It closed after a week, but people who saw it dined out on that for about a month afterward. 'Oh, you saw *Lysistrata*? What's it like? Come to dinner.' [It was] sort of a scandalous thing."[20] In retrospect, two facts became apparent: the two local critics exhibited shameful ignorance concerning the content of the play, and the board's overreaction to the criticism proved detrimental to some of the staff.

Concerning the former, both reviewers claimed that the Play House production turned the "delightfully" risqué play into crude entertainment—Bellamy prudishly lamented the loss of an "anti-war comedy" in favor of "expressions which remind one of dirty words written on a sidewalk."[21] Mastroianni chastised Douglass Parker's translation for "dirtying up" the play in order to appeal to audiences.[22] The fact that both critics were shocked by the vulgar content of the play reveals how little they know about *Lysistrata*. Perhaps familiar only with early twentieth-century translations that censored the dialogue, contemporary editions provide a more faithful translation of the text by revealing how crude the dialogue truly was in Aristophanes's original text. Famed translator Donald Sutherland

explains: "Only recently has a direct translation of his [Aristophanes'] raw wording become legal in print, but his effect on the modern reader may well be one of great innocence—or of fantastically misplaced elegance."[23]

Partington unfortunately opted not to fight Bellamy and Mastroianni's judgments, agreeing to close the show after three days. Not surprisingly, the critics boasted of their accomplishment, especially Bellamy as the *Plain Dealer* smugly offered a note of congratulations to the management of the theatre for their "wisdom to cancel" the show, suggesting that to continue the run would have been "in poor taste."[24] Not every supporter of the theatre agreed with the decision—several patrons viewed the move as one of censorship rather than the protection of financial interests. One vocal subscriber, local attorney Albert I. Borowitz, penned an angry letter to the editor (unpublished) blasting both Bellamy for his uninformed criticisms and for compelling the board to close the show. "*The Plain Dealer*'s editorial congratulating itself on compelling the Play House to close *Lysistrata* bears witness to an act of cannibalism perpetrated by one great Cleveland institution upon another," Borowitz writes. "Time and again we are treated in your pages to intemperate and harmful attacks based not on deficiency in acting or style but on the critic's unfamiliarity with the dramatic literature with which the Play House is dealing."[25]

In an unusual move, Rex Partington defended his decision to close the production via the press, stating in a letter published the day after *Lysistrata*'s closing that the production was cancelled solely for economic considerations as opposed to the controversial content. Nevertheless, the majority of his letter defends the interpretation and the production while offering an occasional snide remark about the local reviews: "A better understanding of Aristophanic humor would make it clear that this translation is bawdy and lusty but certainly neither vulgar nor in poor taste. If anything, it is a watered-down version of the original Greek text.... The majority of audiences who saw the few performances presented, those people who chose to make up their own minds rather than take the work of the critic, were not offended."[26]

In a meeting of the board of trustees held five days following the closing of *Lysistrata*, the good news of increased subscriptions and income was overshadowed by the heated discussion over Partington's choice of production. The executive director claimed that teachers enjoyed the play and that they only canceled their school reservations due to increased pressure from parents and the general public. After defending his selection of the play as "artistically proper," Partington then attacked the local critics and the impact that their opinions had on both the public and the board of

long-standing "community theatre" appeal yet continue to work toward greater national recognition. The Play House faced new challenges, namely increased competition on both the national and local landscapes. Whereas the Cleveland theatre used to be one of the few resident repertory theatres in the country, the craze for urban redevelopment combined with generous grants from the Ford Foundation, the Rockefeller Foundation, and other charitable groups allowed for the building of new theatre centers across the country. According to historian Gerald M. Berkowitz, "Private, government, and foundation money also created multi-million-dollar homes for the Alley Theatre, the Arena Stage, the Mummers Theatre, and the Milwaukee Rep; indeed, more than 170 theatres and art centers were built between 1962 and 1969, with more than 60 percent of all private, government, and foundation support for the performing arts devoted to construction."[41] Of course, the Play House had attempted to follow suit with their efforts to relocate to University Circle and to Cleveland State University, but the incompetence of city officials combined with the dire needs dictated by the Hough and Glenville neighborhoods prohibited the theatre from collecting funds necessary to build a new performance facility. The regional theatre movement was bourgeoning, with institutions receiving national press for their modern performance spaces (to be discussed later in this chapter) while also receiving national acclaim for discovering new playwrights and sending plays to New York. The beacon that was the Play House was now fading on the national scene, and it needed to do something.

By the early 1970s, the Play House faced increased competition on a local level as well, thanks in part to the growth of other local groups with a specific mission that rode the wave of support for the establishment of new theatres in the 1960s. In addition to Arthur Lithgow's Great Lakes Shakespeare Festival (1962) and Dobama Theatre (1960), an effort to refurbish the abandoned theatres of downtown's Playhouse Square District continued throughout the 1970s.[42] Supported by the newly formed Playhouse Square Association, Ray Shepardson attracted audiences back to downtown Cleveland with his production of *Jacques Brel Is Alive and Well and Living in Paris*, a musical revue which ran for over two years, becoming the longest theatrical run in all of Ohio.[43]

As competition increased in the community and other regional theatres stole the limelight away from the storied institution, the question of how to respond to these external pressures was posed to the Play House. Two different resources provide two radically different scenarios, yet both are accurate accounts of events during Oberlin's tenure as artistic director.

In her book *Leaps of Faith*, Chloe Oldenburg charts many of the accomplishments of the theatre, but after she was appointed chairman of the Future Planning Committee and ultimately made president of the board of trustees during the 1970s, her recounting of the theatre reads more like a love letter to the institution, where the theatre rarely commits a single misstep—all the social activities were stunning successes, most productions were praised by critics and audiences alike, and the decision to build a new theatre complex was a well-supported endeavor. Those who know Oldenburg praise her as a devoted fan of theatre and one of the Play House's biggest supporters, and her book presents a version of history that has gone unchallenged since it was published in 1985, and it is also impossible to invalidate her optimism and her account of events given that she was present at the time. However, new documents released from the Cleveland Play House archives and interviews with theatre staff members paint a different picture, one that reveals that Oldenburg's history is only one side of the story.

Oberlin's first two seasons suggested that the Cleveland theatre was on the rise again. Following his first full season (1971–72), the theatre ended with a surplus of $3,517 thanks to exhaustive efforts of the board who raised over $200,000 for the theatre's Sustaining Fund.[44] This new financial security played a role in the board's decision to reject another proposal to move downtown into Playhouse Square, a decision recommended by Oldenburg's Future Planning Committee. This subcommittee also suggested that a land-use study of the theatre's properties be conducted, marking the first move toward consolidation under Oberlin's tenure.[45]

Even though the two-complex arrangement eventually became a financial burden, it was simply a way of life for company actors. Company member Halverson described the task of performing in both spaces in a single night: "There were several times that I would finish Act One in the Drury—I remember playing one of the first seasons we did here, *The Potting Shed*—and then I would run [eight blocks] down the street to 77th to appear as a juror in *Inherit the Wind*. But I didn't think anything of it, and now at my age, I don't think I would do it.... But nobody minded. I can't remember anybody complaining about it."[46] Halverson also recalled that few directors and designers were able to adapt productions to the "open stage" concept, resulting in flawed productions and numerous complaints from fellow actors who "never felt comfortable" in that theatre.[47]

In addition to any artistic concerns, the 77th Street Theatre became increasingly problematic for the Play House when the building began to show its age. In one of Oberlin's first board meetings, he presented his

"Plans for Renewal of the Play House" that described a host of problems: falling plaster in the lobby, thanks to a leaky roof (estimated $10,000 to repair), new doors throughout the building, new seats in the auditorium (over $20,000), a new lighting board ($14,000), new curtains and sound equipment ($6,000), and a new furnace (cost not approximated).[48] In her book, Oldenburg opts not to chart the demise of the 77th Street Theatre, instead giving the impression that the move to a single three-theatre complex was an easy and logical decision. However, documents from the archives reveal that the theatre found itself in much more of a precarious financial situation than previously known, yet the board relentlessly pushed ahead with its drive to construct a new theatre. The reasoning behind the decision to consolidate its facilities and the design and functionality of the resulting building serves as commentary on both the theatre's standing locally as well as nationally and the growing influence of a powerful board in determining the theatre's future.

To his credit, Oberlin accomplished a great deal during his tenure: increased subscriptions, numerous new play productions including premieres by Arthur Miller and Ken Ludwig, consistently good reviews for the majority of productions, an increase in staff, and, of course, the opening of a new facility in 1983. While Oldenburg's official history charts the many generous grants that the theatre received, she glosses over the financial problems facing the theatre. In its June 1976 application to the Cleveland Foundation seeking funds to begin the process of consolidation of the two theatres, the Play House's financial troubles are stated plainly: "For nearly twenty years, the Play House Board of Trustees has been concerned with the difficulties and substantial costs caused by operating in two locations.... In the face of inflation, it is a major problem to maintain two separate theatres at different sites with attendant dual costs for operation, upkeep, security and parking."[49] Despite the dire tone in its application, the board proceeded to explore expensive construction in the face of problematic financial developments. For example, the theatre missed its projected subscription rate by nearly 50 percent in 1976, resulting in budget cuts and a proposal to establish a cabaret and "cash bar" in the Brooks Theatre in order to make money.[50]

The board members' decision to consider expansion and thereby increase the theatre's operating expenses instead of addressing the institution's worrisome financial health reveals the board's ignorance of changes in foundation granting policy and its willingness to overlook pitfalls in order to continue its pursuit of expansion. What is stunning in examining the various minutes of the board of trustees meetings is the disconnect

between the financial problems faced by the theatre and the board's determination to engage in new construction, planning not only to add a new dining facility but to construct a massive proscenium theatre (Figure 7.1). In fact, what appears to motivate the board's persistence is not any artistic necessity, but, instead, a need to find a new home for the Play House Club. The growing membership and the unsatisfactory facilities at the 77th Street Theatre made the relocation of the Club a top priority for the board to the extent that discussions of acquiring a new location dominated several board meetings.[51] This push by the board to potentially risk the financial future of the theatre in order to prioritize its social services highlights the imprudence of the theatre's leadership, especially when examined within the context of changing financial trends for nonprofit organizations. For example, the Play House received numerous grants worth hundreds of thousands of dollars to assist with its operation expenses in the early 1970s, but by the latter part of the decade, many foundations stopped giving money to cover many regional theatres' annual debts. The Ford Foundation shifted their funding away from operating expenses to financial planning, rewarding

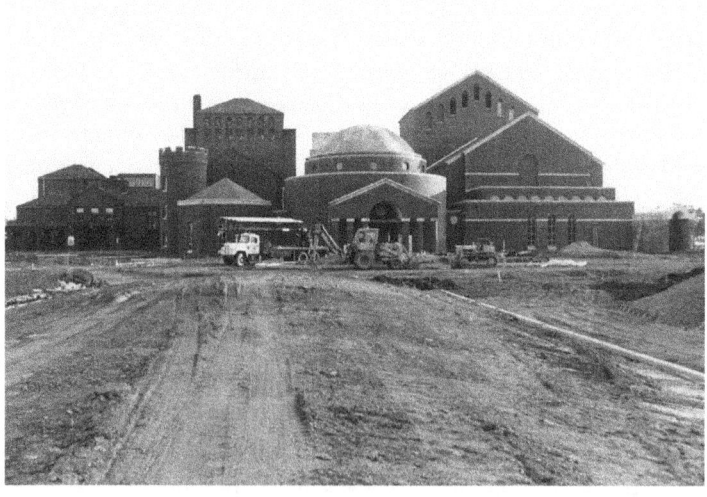

Figure 7.1 The Cleveland Play House complex under construction. The original Brooks and Drury Theatres are to the left of the rotunda. (Courtesy of the Cleveland Play House Archives, Kelvin Smith Library, Case Western Reserve University.)

arts organizations that exhibited "sound management practices." According to Berkowitz, "The hope was that theatre and other arts organizations, if never able to support themselves, would develop solid infrastructures that enabled them to function on the money available from other sources."[52]

Other financial comparisons available to the board should have made them rethink their flawed financial priorities. Utilizing financial information from other regional theatres published in Theatre Communication Group's *Theatre Profiles 3*, the board of the Play House should have been alerted to the institution's reliance upon outside funding and its lacking audience support, both of which were major causes for concern. Regarding the former, the Play House depended upon grants and gifts (unearned income reported as $477,167) to cover approximately 46 percent its operating budget (listed as $1,028,753).[53] The Play House's reliance on unearned income was disproportionate to other regional theatres with comparable operating budgets, most notably Actors Theatre of Louisville (24%), Milwaukee Repertory Theatre Company (30%), the Alley Theatre (31%), and the Dallas Theater Center (35%). Another cause for concern was how (or if) the theatre could remedy the imbalance. Analyzing the percentage to which each theatre played at its capacity revealed that the Play House lagged behind each of these theatres as well, achieving only 69 percent of capacity compared to other marks set by the Alley (76%), Actors Theatre of Louisville (98%), Milwaukee Rep (96%), and the Dallas Theater Center (77%). If anything, these figures should have served as a clear signal that the Play House not only was too reliant upon outsider funding, but that it also struggled to attract a sufficient number of theatergoers to offset any potential losses in grant monies.[54]

Despite the overwhelming amount of cautionary evidence, the board pressed forward with the project to build a new facility.[55] By any measure, their financial estimates for the expansion were ludicrous: the initial proposal suggested that the project could be completed in two years (the fall of 1978) for only $3 million.[56] Ultimately, the new theatre opened in 1983, but the entire project was not finished until 1995 with the opening of the Schubert Library in one of the complex's towers.[57] The total cost of the construction ran well over $13 million.[58] In an interview with the *Christian Science Monitor,* Play House Foundation president George Kirkham spun their lack of foresight as a positive, suggesting that if they knew from the beginning that the total cost would escalate to over $13 million, then it would have been impossible to proceed with the construction.[59] In hindsight, that may have been best.

The design of the Bolton Theatre prompts another question and criticism of the board: Why construct a third proscenium theatre? Judged against the

standard set forth by *Theatre Facilities: Guidelines and Strategies*, a facility-impact study published in 1981 by the Milwaukee Repertory Company that utilized information and designs from numerous theatres to provide a sourcebook on how to design for contemporary American regional theatre, the Bolton Theatre failed miserably as an endeavor to satisfy artistic objectives.[60] The majority of regional theatres around the country expanded in order to adapt to the developing trends in American playwriting. Thanks to smaller performances spaces and the increased use of arena theatres or flexible performance spaces, playwrights frequently fashioned their plays in accordance with the minimalistic production values often suggested by smaller, intimate seating arrangements. Instead of providing a flexible space that would have attracted a variety of playwrights to pen plays for the theatre, the board decided to "go big."[61] In this sense, the board's decision to construct a third, larger proscenium theatre hindered the Play House's ability to remain relevant on a national scale as it struggled to provide quality opportunities for playwrights. What playwright would want to write a play for a massive stage, knowing that very few regional theatres would be willing to spend the money on a risky, second production? Conversely, what playwright would want to send a play to the Bolton Theatre knowing that its physical space dictated the performance style and limited any emotional impact that the audience would potentially feel? Obviously, the members of the board of trustees either cared little for these concerns or were naïve as to the needs of the theatre.

The end of the 1983–84 season marked a change in the financial forecast for the theatre. "They had a huge uptick in subscriptions for one season [when the Bolton Theatre opened], and then they plummeted right back to where they were because everyone came in and went [unimpressed]," former acting artistic director Roger Danforth explained.[62] The problem was that the theatre's operating expenses shot through the roof, having grown from $2.2 million to $3.2 million, a 45 percent increase.[63] During this economic downturn, the board searched for ways to rejuvenate interest in the theatre, and the blame soon fell upon Oberlin. The removal of Oberlin initiated a new scrutiny of the board and their decisions. Several staff members suggested that Oberlin was "stabbed in the back" by the board and possibly his successor William Rhys. Albers recalled the firing of Oberlin with great disdain, stating, "They [the board] didn't do it well....And they didn't treat Obie well. This was a man who gave—and died shortly after his this [departure]—gave his life [to the theatre]. He devoted his life to the Play House, and they treated him badly."[64] Mounting criticism of the board of trustees was not a problem encountered solely by the Play

House; in many regional theatres around the country, changes in the board sparked controversy and concern for the future of many institutions.

With the inability to rely on funding from foundations to cover expenses, a notable shift occurred in the makeup of many of the board of trustees for nonprofit arts organizations. Needing to increase giving through its members and their directors, board members were now sought out for their financial connections and individual wealth rather than their dedication to the mission statement of the theatre. A power struggle often ensued: in their founding, many regional theatres simply followed the lead of their charismatic leader, as exhibited in the generous yet understandable leeway given to Zelda Fichandler, Nina Vance, Jon Jory, Tyrone Guthrie, and many others. However, the 1980s brought about changes in leadership as many of the artistic directors of the nation's most reputable regional theatres retired after serving their institution for two or three decades.[65] Boards were now charged with having to find replacements and new sources of income, and oftentimes these boards exploited the absence of an established leader to assert their power by redefining "success" for the theatres (in financial terms rather than artistic). Berkowitz suggested that this change resulted in artistic directors becoming employees instead of partners and that the addition of bankers and real estate investors on these boards increased the demand for "reliable returns on an investment."[66]

The new board members greatly impacted the artistic product of many regional theatres, as detailed in Suzanna Andrews's article in the *New York Times Magazine* titled "The Board Is Taking Center Stage." Andrews explored the impact of the changing composition of the board upon the artistic efforts of the Manhattan Theatre Club, a theatre known for discovering and producing new plays. New board members, unimpressed with the financial risk involved with producing new plays, fought to change the kind of work presented in the theatre, leading to a lengthy, soul-searching discussion about the mission of the theatre contrasted against current economic realities.[67]

For the Play House, new board members promoted a new definition for success: to improve the national reputation of the theatre. However, they were saddled with crippling debt as the financial status of the theatre worsened each year. Months after being appointed, acting artistic director William Rhys was forced to suspend the famed Curtain Puller program in an effort to curb expenses, but this course of action unfortunately was becoming common as many regional theatres eliminated programs in order to survive the economic downturn that crippled the country. "Ancillary activities—tours, education programs, children's theatres,

and the like—began to fall by the wayside," Berkowitz reported, "and in many cases the number of plays in a season or the length of each run was reduced."[68] Despite appointing a new leader, the Cleveland Play House Board of Trustees still had its priorities confused, as evidenced by the summaries of its discussions. For example, following the presentation of reports detailing massive salary cuts (up to 10%) and the possibility of its General Operations Fund running out of cash within a few months, the Play House Board of Trustees' discussion turned to the topic of securing money for new construction projects, namely the completion of the rotunda and the building of a library in the tower. It is astonishing that the board, despite being saddled with rising debt and substantial increases in its operational expenses, pursued funding for a part of the facility that had no contribution to production whatsoever. Such determination (especially in the face of budget and salary cuts) confused the staff as well. "I remember that they finally raised the money to complete Phillip Johnson's thing," Danforth recalled, "and I thought 'What does this have to do with producing theatre in America?'"[69] The misguided priorities of the board, so concerned with status (in the form of a national reputation) and surface (the completion of Johnson's building), combined with the poor financial state of the theatre provoked the trustees to search for a new artistic director, even though Rhys had little to do with the institution's deteriorating finances. Whether coincidental or another insensitive move by the board, the new artistic director was announced while William Rhys was out of town.[70]

SEARCHING FOR NATIONAL RECOGNITION

By all accounts, the search for a new artistic director conducted by the board of trustees was both thorough and well-designed. First, letters were sent to 30 current artistic directors at leading regional theatres, requesting a list of people who they would recommend for the job. From these responses, a shorter list of 12 candidates was created, and board members visited each one at his or her place of work. Following this step, the search committee reconvened and invited their top five candidates to visit the Play House for another interview with the board and to tour the facility and the city. Finally, on May 19, 1987, the board of directors concluded their two-year search by voting to appoint Josephine Abady as the theatre's first female artistic director.[71]

While a few reports suggest that the hiring of Abady caused "considerable internal turmoil" on the board, she ultimately received a unanimous vote of approval, and her extensive professional experience made

her an obvious choice for the position. In addition to serving as associate director of the Manhattan Theatre Club, Abady received praise for her success in operating the Berkshire Theatre Festival where she erased the theatre's $150,000 deficit, enlarged the facilities, and attracted near-capacity crowds.[72] In fact, Abady's name appeared on "almost every one" of the list of names submitted by artistic directors, making her a favored candidate who possessed many connections to professional theatre.[73] Her selection signaled a declaration from the board concerning the direction that they wanted the theatre go. While the most successful directors of the theatre had all been internal hires, the methodology of the search conducted by the board reveals their determination to hire the first true "outsider" since Frederic McConnell in 1921. The board was looking outside of Cleveland—not only for its leader, but also for its future.

The hope of the board was that Abady's connections would help the theatre reclaim its national prominence, but how exactly remained a point of contention during her entire tenure in Cleveland. Abady wanted to entice audiences to the theatre by bringing celebrities to Cleveland to star in productions that would travel onto other theatres (and eventually Broadway); however, there was one problem that she needed to address first, and it became a decision that haunted her during her entire time at the Play House. Abady intended to "job in" actors from New York and Hollywood for her productions, making the resident company no longer necessary. After only five days on the job, Abady set about dismantling the company, but the manner in which she announced her decision became legendary in Cleveland. Company actors and designers were called into a meeting in the Brooks Theatre where Abady was expected to discuss the future of the company and the theatre. Accounts of this meeting published in newspapers offered a lengthy explanation from Abady as to the future of the theatre. "I feel that the theatre is an endangered species in this country...," Abady was quoted as saying. "All of us have a responsibility to change that, before we become extinct. It seems to me that to make exciting theatre you need a rich mix of actors, designers, directors, as well as scripts."[74] Abady also reportedly expressed great sympathy for the members of the company, stating, "It's not easy to tell people who have given twenty years or more of their lives to an institution that changes will be made." As a sympathetic gesture, she promised to meet with these performers and designers to discuss their possible inclusion in future productions.[75]

Those who were in the meeting, namely company members, provided a different description of the event than what Abady reported to the newspapers.[76] According to company member Catherine Albers, Abady entered

the Brooks and sat on the top step at the front of the stage. Without introducing herself or thanking them for coming to the meeting, Abady made her announcement. Albers recalled, "She said, 'I have one thing to say to you: you're fired.' And then she said, 'Everybody.'"[77] After letting the artistic staff know that they would each receive two weeks' pay in accordance with union contracts, she stated that they could each meet with her individually to discuss their future with the theatre. For those who did, the meetings were surprising and insulting, being told that more talented people could be found in New York. Longtime company member Halverson was told that they were "in a rut" in Cleveland and that they should travel to other theatres to establish a more successful professional career.[78]

After more than 60 years, the resident company was no more, and the public let their displeasure be known. Letters to the Editor appeared in local newspapers, attacking Abady and the theatre for their terrible decision, and patrons protested by complaining to board members or refusing to renew subscriptions.[79] The decision to disband the company is still discussed today with such disdain that it is difficult to imagine that anyone could have supported Abady at the time. While Abady's brash personality certainly did not win her many supporters in Cleveland, she did find one important defender: local theatre critic Marianne Evett. Evett had chosen to focus less and less on the productions at the Play House in favor of promoting the more risky, experimental fare being presented at smaller theatres in Cleveland. Obviously, this lack of press coverage irked the public relations and marketing staff of the Play House, but Evett offered copious praise for the new artistic director and repeatedly penned articles encouraging the public to support Abady's new direction. "The real issue is not whether the Play House continues to have a resident company," Evett argued, "but whether it will give Cleveland audiences high quality, varied entertainment (real entertainment can delight your mind as well as your feelings)."[80]

In the debate over the wisdom and handling of Abady's announcement, one voice was noticeably silent: that of the board of directors. It should not be forgotten that her appointment reportedly caused "considerable internal turmoil," and that those board members put off by her prideful, confrontational manner apparently joined the chorus of those patrons lamenting the death of the resident company. However, new interviews and documents from the archive reveal that the board was unquestionably cowardly during this time period and enabled an atmosphere of hostility through their silence. The board members' apparent refusal to publicly support Abady's decision is a confusing one since it was well established that she

would dismantle the resident company upon her arrival. In fact, all five final candidates for the Artistic Director position believed that the resident company needed to be disbanded, so it would have occurred regardless of who was chosen (perhaps some of them might not have been as brash about it). The board gave Abady their support for ending the resident company, but only behind closed doors.[81] A public explanation from board members that Abady's decision was inevitable and supported by the board of directors would have generated a discussion about the current economic challenges facing regional theatres (most of which had disbanded their resident companies as well) and also allowed Abady to enjoy greater support from the community during her first year in Cleveland.[82] However, trustees let Abady take the brunt of the criticism, as if they were powerless to control the new artistic director. This lack of support was not only cowardly, but also detrimental to the theatre as Abady immediately became a polarizing figure within the community.

A possible reason for this lack of support may be a coincidence of timing. Abady was hired in May, but in July, elections yielded a new board comprising 45 percent new members, meaning that a large contingent of the board of directors did not participate in Abady's hiring or approve of her intentions.[83] This turnover in leadership allowed for a shift in the board's focus—no longer would they be as concerned with the reaction of the Cleveland community. According to some company members, these trustees simply wanted to meet visiting Hollywood stars, caring little for artistic production and only for social recognition. Others like board president Richard Hahn and his successors were accused of placing too much emphasis on the bottom line, criticizing any artistic endeavor that resulted in too much financial risk. Granted, it is common for artists to complain about the budget-tightening measures enacted by boards, and one cannot fault Hahn for fulfilling his responsibility as president of the board of trustees to make sure that the theatre was a financially solvent organization. Nevertheless, this July board meeting marked the moment when the Play House Board of Trustees prioritized national acclaim over hometown respect. This shift perhaps explains why the board did not defend Abady's decision to the community—they really did not care what the community thought.

If Abady and the board wanted national recognition, then their first year proved a resounding success. Announced as a preseason production, Abady presented Ed Asner and Madeline Kahn in Garson Kanin's comedy *Born Yesterday* before it embarked on a national tour.[84] Ultimately, the production landed on Broadway in January 1989 (with the Play House listed as a producer) where it played for nearly six months.[85] This production

initiated a parade of celebrities performing at the Play House during Abady's tenure, including Howard Hessman, Marlo Thomas, Daniel J. Travanti (from the award-winning television drama *Hill Street Blues*), and David Schramm (from the television sitcom *Wings*) among others. Unfortunately for the Play House, no other production achieved a similar level of acclaim on the national stage; a 1990 staging of Ivan Menchell's *The Cemetery Club* (originally produced at Yale Repertory Theatre) made to Broadway, but it ran only 56 performances.[86]

In addition to Abady's demand that the quality of all productions needed to improve, she also suggested that the reputation of the Play House among theatre professionals around the country needs to change. To address this problem, Abady intended to attract higher-caliber designers and actors to Cleveland by increasing the salaries of the entire staff to be more in line with salaries offered at other leading regional theatres.[87] Expecting their growth to continue, the board of trustees created several documents in March 1990 detailing a five-year plan for the theatre, highlighted by capital improvements, international tours, three active theatres, the development of new plays, and (listed last) a theatre education program for children.[88] Thanks to the increased attention and glitzy stars visiting their hometown, Abady and the theatre enjoyed moderate success in their first two years together. However, the big stars, the New York designers and their demands, the cost of housing all these outsiders, and the increase in salary and size of staff meant the operating expenses for the Play House skyrocketed, but it seemed that no one cared.

When the long-range plans were analyzed and compared against the budgets of other regional theatres, however, a very sobering picture began to develop, one which depicted a difficult road ahead for the Play House. Studies conducted in September 1990 and January 1991 reveal how far behind audience and financial support for the Play House were when compared with other regional theatres, namely the Seattle Repertory Theatre, South Coast Repertory (Costa Mesa, CA), Arena Stage (Washington, DC), and the Old Globe (San Diego, CA). The Play House trailed each of these theatres in subscriptions, single ticket sales, and contributed income by a substantial margin, yet projections held that their expenses soon would match these other theatres.[89] In order to compensate, it was clear that increased income in the form of ticket sales and subscriptions were necessary if Abady intended to pursue her artistic endeavors. The question then quickly became *how* to raise ticket sales.

The economic news for the Play House quickly turned from bad to worse as the 1990s progressed and the nation suffered an economic

slowdown. A divide between Abady and the board of directors became evident in a February 22, 1992, meeting where the artistic director, in the face of growing deficits, continued to call for an increase in the production budget. "To remain vital, we must have an expanded budget so that we can expand our repertory...," Abady demanded, "and become internationally known as one of the leading regional theatres in the country."[90] From this point on, Abady repeatedly criticized the board for not raising enough money, clearly holding the perspective that it was the responsibility of the trustees to locate funds to support her artistic vision. According to Berkowitz, Abady was not alone in her convictions. "By the 1980s, there was a generation of theatre artists and administrators who had grown up knowing nothing but subsidized theatre, and some of them fell into the psychological trap, considering subsidy their due," Berkowitz argues. "This 'entitlement' mentality led too many companies to the casual assumption that the money would always be there, so that the case for support need not be presented more than perfunctorily."[91] Board members rejected this charge, complaining that they were too heavily burdened financially and that Abady needed to give some consideration to altering her plans.[92]

The disagreements between Abady and the board quickly soured when the theatre began running deficits again. Managing director Dean Gladden realized that the management team had been inflating expectations for ticket sales and income for years in order to support the increased budget.[93] By March 1993, the chair of the Finance Committee, Tom Good, declared, "The forecasted deficit is intolerable. We would be starting next year $200,000 behind last year. Our working capital is $500,000 short of working capital needed." Then, Good concluded with a shocking assessment: "We must make up past deficits, or we may not be in business."[94] One month later, Abady was informed that continuing deficits would force her to make further budget cuts and abandon several of her endeavors, including international tours. "It always comes down to funding," board member Boake Sells reported. "The theatre does not have enough money to do what she wants to do."[95]

When the season ended with an approximate deficit of $270,000, board members began to assert themselves more and more, fearing for the future of the theatre. In response, Abady's confrontational nature began to rear its ugly head. In one meeting, trustees explored the idea of declaring the Play House an "endangered theatre," a label given to theatres that ran a 10 percent deficit that allowed for the struggling institution to hire more non-equity actors. Being designated an "endangered theatre" would have greatly tarnished the reputation of both the Play House and Abady, so the

idea was tabled. Growing weary of demands upon her to make further budget cuts, Abady pushed back against the board. She started by suggesting that the trustees needed to be educated about the role of regional theatre in the community and how the Play House should not be considered a "hit factory."[96] Contentious debate over Abady's play selections deepened the adversarial relationship between the director and the board, with Abady demanding that she be allowed to produce more controversial scripts while the trustees became increasingly dismayed over the deepening deficits.[97] In one heated moment, Abady announced that she was tired of listening to criticism concerning her play selections, despite the fact that her play selections contributed to a decreasing subscription rate and fewer ticket sales.[98]

Only two months into the 1993–94 season, the theatre was already running $511,000 behind its projected budget, and battle lines would soon be drawn over one production: James Goldman's historical drama *The Lion in Winter*.[99] When Abady announced her first season, she had made another choice that had upset several patrons—she retired the annual production of *A Christmas Carol*. "She didn't want to get caught in the trap that a lot of regional theatres are in that they have to make a lot of money on *Christmas Carol*," Danforth recalled, "[and] I think her idea was to retire it for a year or two and then come back with a new production. But what she didn't realize was the minute we nixed it and announced that we weren't going to do it, Great Lakes picked it up like that [*snaps*], and we lost that cash cow. So then what are you going to do at Christmas? Because the Christmas show is an *event*, and you have to make it an event."[100] Abady frequently proposed doing the musical *Peter Pan* as a major December production, but the trustees balked at the projected costs. Thanks to the lost revenue and the growing dissatisfaction with the season's offerings of the Play House (to be discussed later in this chapter), the board of trustees was extremely disappointed when Abady selected *The Lion in Winter* as the 1993 holiday production. Danforth theorized why she picked such a curious play: "Yes, it is set in Christmastime, but let's face it—*The Lion in Winter* isn't a Christmas play... Part of Josie's reasoning was 'Well, if you won't let me have what I want, then we'll do this. It's small and it'll save money.' It made decent money, [but] it didn't make what past Christmas shows had done."[101]

The Lion in Winter closed on Sunday, January 2, 1994, and a meeting of the executive committee was held three days later at the Union Club in downtown Cleveland. During this 90-minute meeting, the decision to offer *The Lion in Winter* as a Christmas show was roundly criticized, yet Abady

continued to push for a production of *Peter Pan* for the following season, suggesting that it was the board's responsibility to increase subscriptions to afford the expensive production. Several board members balked at her proposal, informing her that the theatre was unable to fund such a lavish production. Boake Sells suggested that "an agreement between the artistic, administrative and financial people" be reached in order to determine future holiday shows. In other words, the board demanded increased influence in the play selections, instructing Abady to have to the season ready for the board's "consideration" within four weeks. The meeting concluded when the executive committee voted unanimously to merge the struggling Play House Club with the theatre, which also resulted in the theatre adding to its moniker, officially becoming the Cleveland Play House.[102] This development was a further insult to Abady, given her previous criticisms of how "the Club's leaders and the Men's Committee have always resented" the changes that Abady brought to the theatre.[103] By the meeting's end, Abady might have been upset or discouraged by the executive committee's criticism of her play selections, but, according to friends, she had no expectation of the swift action that occurred over the next five days.

The story of how and why Abady was fired has become a matter of great speculation and controversy, primarily because neither the board of trustees nor the board president, Robert Blattner, ever provided a sufficient explanation for why Abady's contract was not renewed or how such a decision was reached among the board leadership. The sudden decision to not renew Abady's contract shocked not only the staff of the theatre, but also several board members. The fateful executive committee meeting had been very brief, yet the growing dissatisfaction with Abady's work was never discussed with the full board or with Abady herself. Sells and Blattner, however, reportedly "acted to prevent any organized board opposition" with Blattner announcing that no further votes would be taken regarding Abady's employment.[104]

The timeline of events is shrouded in mystery: the executive committee meeting held on Wednesday, January 5, concluded with an executive session (no staff from the theatre was allowed), and on Monday, January 10, Abady was fired. What happened between these two dates is cause of great speculation and debate: Did more bad financial news cause the board to overreact? Did Abady's refusal to compromise and criticisms of the board create a groundswell of support for her ouster? The board reportedly had offered an extension on her contract before the holidays, but did Abady's desire to postpone these discussions (in order to deal with the recent death of her mother) upset board members?[105] An explanation has yet to be

provided as to what changed/developed between January 5 and 10 that caused the board to reverse course.

The January 11, 1994, press release announcing the executive committee's decision offers nothing but praise for Abady, with Blattner lauding, "Josie brought new life to the Play House and to Cleveland. Earned and contributed income has grown over sixty percent since she arrived. We will miss her creative abilities very much."[106] Abady, however, complained publicly about the board's decision, revealing that Blattner and Sells asked her to sign a press release stating that she had decided not to renew her contract, but she refused. "They have not been civil about this," Abady claimed in an interview with *Backstage*. "I think this happened because our theatre has a deficit this year...and they decided to blame me. This is one scared bunch."[107] Blattner shot back, claiming that money was not a factor in their decision but he also cited that subscriptions had decreased by 3,000 over the past two years.[108]

Letters from Abady's defenders poured into the Cleveland Play House, including letters from John Guare, Herb Gardner, Daniel J. Travanti, Joel Grey, Emily Mann, and artistic directors from several regional theatres. These letters expressed shock and dismay at the board's actions, begging them to reverse course and maintain the reputation of the Cleveland Play House. Tazewell Thompson, artistic director of Syracuse Stage, threatened to withhold grant monies from the theatre because of its unwillingness to reward her efforts of increasing minority attendance.[109] According to reports, Blattner never showed any of the letters in support of Abady to the other board members.[110] On the other hand, it was suggested by one former staffer (who wished to remain anonymous) that Abady called her supporters and asked them to write letters protesting her dismissal.[111]

The absence of a sufficient explanation led to great speculation and accusations against Boake Sells and Robert Blattner. Two allegations charged that the firing was motivated by gender bias and by the board's racial intolerance. Concerning the former, Abady herself frequently claimed to be the victim of gender bias. When she fired the resident company, she claimed, "I do believe if I were a man coming to take over a corporation—it's done every day—nobody would have said anything about the changes."[112] Marianne Evett, *Plain Dealer* critic and staunch defender of Abady, suggested that the board would have reacted differently to the financial problems if the artistic director were a man. A member of the executive committee who wished to remain anonymous attempted to deny the gender bias claim, but unfortunately couched the criticism with an inappropriate remark, stating, "I don't know why Josie is behaving so

irrationally over this and is saying things that just aren't true. Gender was never an issue.... Perhaps she is under a great of stress since the death of her mother. She hasn't looked good lately."[113]

The second, more substantiated charge leveled against the executive committee concerned the board's apparent discomfort over the changing demographics of Cleveland Play House audiences. Multiple former employees (who wished to remain anonymous) suggested that the board did not approve of Abady's play selections that catered to minority audiences. In an interview, Abady recalled a conversation with a board member: "I remember one woman who, during the opening of my second season, stood beside me and looked out across the lobby and said, 'I don't recognize most of these people.' I said, 'Don't you think that's wonderful?' And she gave me a withering look that told me that she didn't think it was so wonderful."[114] Evett argued on behalf of Abady that Cleveland's community was "an ethnic and religious mosaic made up of young and old, black and white, rich and poor. The theatre's repertory should mirror that diversity, and its programs should make that repertory accessible."[115] Dean R. Gladden, managing director of the Cleveland Play House during Abady's tenure and her successors, took pride in their efforts to attract minority audiences to the theatre. "We drastically integrated the audience," he stated proudly. "I think the total audience base increased to twenty-seven percent African-American. It was a huge change, and it was a purposeful change to make the theatre more reflective of the community. This change was not received well by a portion of our patrons."[116] Examples of board members displeased with the influx of minority audiences and plays abound, from tales of board members refusing to attend August Wilson's *Fences* to supporters giving their tickets to their servants. Giving voice to the objections of the board, Blattner reportedly argued that Abady's "productions were not reaching the kind of audience we wanted to reach"—a statement interpreted by members of Cleveland's African American community to mean that they were no longer welcome at the Cleveland Play House.[117]

Former company member Albers, however, strongly rejected suggestions that Abady was fired because of her gender or her efforts to diversify the audience. "That is such bullshit," Albers stated. "She did it to herself. She made herself—that brashness that she prided herself on. She never tried to win anybody over.... And she spent all this frickin' money! The amount of money spent on shows was mind-boggling, and they started that financial decline with her very first show! You can't blame that on somebody else, because you're the artistic director. You're the one making the final decisions."[118] Gladden agreed, labeling the suggestion that

she was fired because of the inclusion of minority audiences and productions "a non-issue."[119] The financial argument remains the most plausible reason Abady was fired, and the hasty decision to not renew her contract reveals the lack of foresight and understanding that the board had for the business of theatre. Board members complained that Abady's play selections were not selling enough tickets because her plays featured too many unhappy endings. Blattner himself reportedly demanded for more "plays that offer hope, that make you feel good about yourself," yet Abady's seasons featured commercial works like most of regional theatres, including *Harvey, You Can't Take it with You, The Misanthrope,* and *The Philadelphia Story*.[120] Board members apparently did not complain about these particular offerings—only the newer plays and the ones selected to attract minority audiences.

In a recent interview, Gladden staunchly defended Blattner, Sells, and the board, reiterating that the leadership handled the situation as best that they could given Abady's determination to cause a ruckus.[121] Despite their best intentions, the executive committee handled the entire situation abysmally, attempting to use financial losses to justify the firing of a person with whom they simply did not get along. Arguments faulting Abady for running a deficit were ludicrous given that the theatre had balanced budgets for four of the previous six years and that the majority of regional theatres across the country were operating with deficits given the struggling economy.[122] Furthermore, the deficit of $142,000 represented only 2 percent of the theatre's $6.785 million budget, a miniscule number compared to other struggling theatres.[123] If artistic directors were to be fired for operating with a deficit of 2 percent, there would be constant turnover in America's regional theatres. The sudden firing received national attention, and almost every publication faulted the board for overreacting. Chris Jones of *Variety* reported that board members were scared by the recent closing of the Players Theatre Columbus and demanded that the theatre's financial debts be resolved immediately.[124] The *Village Voice*'s Porter Anderson likened Abady's firing to a moment when "the American regional theater gets gang-raped once more by lay trustees" whom he also described as "cowardly" and "feckless."[125] In his insightful summary of the event, Tony Chase of *Theatre Week* cast the decision as "a sad tale in which a board comprised of business people decided that Abady's artistic goals were irreconcilably at odds with financial ones, and that was irritated by an artistic director who argued with them....A dedicated executive committee has unwittingly tried to solve a very real and important problem by railroading a solution that sends them backwards."[126]

"HAVE YOU PEOPLE GONE MAD?"[127]

The above quote is taken from playwright Herb Gardner's telegram to the board of trustees, and it typified the response of the professional theatre community. Blattner acknowledged that the sudden firing of Abady gave the Cleveland Play House a "black eye" as the overwhelmingly negative response to Abady's firing caught board members by surprise.[128] Furthermore, in a March 2013 interview, Blattner admitted that the board of directors failed to anticipate the criticism aimed at their press release that offered only praise for Abady and no justification for her removal. Asked if he would handle the entire matter, especially the press release, differently, Blattner responded, "Absolutely, yes."[129] Nevertheless, Blattner argued that it was the board's intention to act in a "gentlemanly" fashion, and Gladden staunchly defended the board's actions, suggesting that the board performed admirably in a difficult situation and that there was no course of action that the board could have taken which would not have upset Abady.[130]

Abady quickly found employment as the new artistic director of Circle in the Square Theater in New York. The theatre had not produced any shows for two years and hoped that Abady would again prove successful at enticing new audiences to the theatre. Unfortunately, Abady gave a repeat performance of her time in Cleveland, mounting productions featuring celebrities yet failing to maintain sufficient audience support (subscriptions dwindled to 3,000 compared to Manhattan Theatre Club's 20,000). After two years on the job, Abady was asked to resign from her position (she agreed).[131] Abady continued to direct around the country until she died in 2002, succumbing to her long and painful battle with breast cancer that had spread to her bones and brain.[132] A press release from the Cleveland Play House quoted then-artistic director Peter Hackett praising Abady: "Josie helped prepare The Cleveland Play House for the challenges of the 21st Century. She raised the level of professionalism of the company and opened its doors to new audiences and organizations."[133] In an obituary printed in the *Plain Dealer*, longtime trustee Richard Hahn stated, "The Abady years, from an artistic point of view, were the best the Play House has had in the past several decades."[134]

Those interviewed for this book provided varying theories on why Abady was fired, but they all agreed on one assessment: Josie Abady's personality contributed to her being let go. Frequently described as "brash" and "stubborn," even by her greatest defenders, Abady refused to work with the board or heed their recommendations (forgetting perhaps that

the artistic director technically works for the board of trustees), ignoring her supporters who quietly suggested to her that she become more amenable. Playing well with others, however, was not Abady's way. "To my mind, she had good, healthy fights with the board," Roger Danforth recalled, adding, "but I don't think a lot of people thought that they were good and healthy."[135] There are many examples of Abady's unwillingness to work with the board, but Gladden cited one moment in particular when the trustees asked her to reduce her international visits in order to conserve money and focus on the theatre's mainstage productions. Instead of following their advice, she planned a trip to Europe, blatantly disregarding the trustees' instructions. "She was not nice to the trustees," Gladden remembered. "[Abady] was pushing the limits a little too far and not understanding that you've got find a compromise between pushing the limit and keeping yourself financially stable."[136]

Given that the theatre was close to defaulting on loans and was considering accepting the demeaning status as an "endangered" theatre, one cannot fault the board for their financial conservatism. Many regional theatres closed in the 1980s and 1990s because "their repertoires were too adventurous for their audiences."[137] Even legendary director and Arena Stage founder Zelda Fichandler lost half of her theatre's subscribers by producing too much experimental work, prompting a quick return to Shakespeare and more popular fare after two years of declining audiences.[138] Berkowitz provides statistics for the number of theatres that closed, further justifying the trustees' fears of becoming an "endangered" theatre: comparable to the time of Abady's tenure, "a total of twenty-three companies closed down between 1987 and 1992, according to the Theatre Communications Group, and half of those remaining faced mounting deficits."[139]

A board fearing for the future financial health of its institution is completely understandable, and there are several instances when the Board of Trustees of the Cleveland Play House should have expressed grave concerns over the direction of the theatre. From Lowe's retirement to the announcement of Abady's firing, all through those years, the trustees of the theatre made numerous questionable decisions that hindered the theatre's ability to develop into one of the nation's preeminent theatres. The increasing overreaction of the board to various developments paralleled the trustees' growing influence. Before Lowe retired, the promotion of Greene followed by Partington suggests a desire to bring the best and brightest minds to the Cleveland theatre, but the overreaction to the public's disapproval of *Lysistrata* not only revealed that the board was unwilling to defend its artistic product, but that the trustees knew little about the plays

being produced. In a deliberate move to favor familiarity over national recognition, hiring Oberlin as artistic director appeased the community. With its decision not to press for national recognition by hiring a director of national stature, the board opted to attract attention to the Cleveland theatre through the hiring of a famous architect who knew little about designing a theatre. Unfortunately, the board's determination to build a poorly designed and unnecessarily large facility initiated years of financial strain that not only caused Oberlin to lose his job, but also added to the financial woes faced by his successors. The callous firing of Oberlin and the unfair treatment of his successor, Rhys, further demonstrated the growing influence of the board that was unable to recognize the problems caused by the actions of the board members themselves, yet unwilling to treat the employees with great respect. With Abady, the board's inability to provide a suitable reason for her firing proved the board's incompetence, repeatedly failing to understand the appropriate role of trustees or how to communicate effectively with the public in order to benefit the reputation of the institution.

McConnell and Lowe had not only followed the original mission statement, but also embodied it. Once they departed, the board continuously looked for an artistic director who would achieve the national acclaim that the former leaders had promised to the city by enticing large crowds to the theatre. Failing to find the savior it sought and increasingly populated with business leaders who knew little about theatre operations or national artistic trends, the board began to redefine the mission based upon its own preferences. To be fair, the Cleveland Play House was built and led by men who appreciated public tastes, and it is not unreasonable to expect that standard to be maintained. However, when the rule of the "Triumvirate" came to an end, the new artistic directors were familiar with the model established throughout the regional theatre movement where the artistic director was responsible for the artistic vision of the institution, and the city simply came to see what that individual considered to be worthy for the community. For theatres like Actors Theatre of Louisville, the Alley Theatre, the Guthrie Theater, and countless others, artistic directors established a level of trust with their audiences, allowing them to take greater artistic risks. For Rhys, Partington, and, to an extent, Abady and her successor Danforth, the board never allowed them to establish themselves in the community with the full support of the board. For example, when Danforth was pressured to take the job of acting artistic director, he was told that he would have the first six months of the following year's season to prove his ability to lead the theatre. Any hopes that he may have had for

being considered for the permanent position were quickly dashed by the board. "My first season opened on a Tuesday," Danforth recalled, "and two days later on a Thursday they told me that they had already given the job to somebody else."[140] The board's decision to quickly withdraw its support from an artistic director at the first sign of trouble was not uncommon as theatres across the country changed leadership in the 1980s and 1990s and as corporate leaders, without any regard for artistic ingenuity or creative processes, assumed control of nonprofit boards of trustees. In one of the more famous examples, "Joe Papp hand-picked JoAnne Akalaitis to be his successor as artistic director of New York Shakespeare Festival, presumably with full knowledge of her strengths and weaknesses," Berkowitz reports. "But the Festival board was less open and patient; citing a too-challenging repertoire and a failure to attract funding, they fired her after eighteen months."[141]

When the board members realized that they needed to take drastic action in order to become relevant in the national landscape of regional theatre, they picked Josephine Abady with the expectation that she would increase the quality of production and help bolster the national reputation of the Cleveland theatre. She certainly accomplished both, making her the second most important hire in the theatre's long history. However, simply because she achieved national recognition for the theatre does not mean that she was the correct hire. Given their lengthy and reportedly thorough national search, it is improbable that board members were ignorant of her brash personality and how it would clash with the more conservative nature of the board and the theatre's supporters. Someone as bold and determined to revitalize and reclaim the theatre's influence on the national and international stage was desperately needed, and, thanks to Abady, the Cleveland Play House once again became one of the most respected theatres in the country. However, as much as she was the right person for the job, she was the wrong personality. "She wanted to force things down the throat, I think, of Cleveland," Albers remembered. "She used her brash personality, and she used her choices of shows and the people she brought in to do those shows."[142] Among others, Gladden, who praised Abady's artistic vision and her time at the Cleveland Play House, echoed Albers' sentiments, regretfully stating, "She just wouldn't work with anybody."[143]

The hiring of Abady was a blessing and a hindrance, and her arrival forced the listless board to assert itself in such a way that it subjected itself to criticism and scorn from both the Cleveland community and the theatre professionals around the country. A weaker personality would have simply followed instructions from the board, and a weaker board perhaps

would have not addressed the glaring financial problems created by the artistic leadership. It was a disastrous relationship, but a necessary one for the theatre. The firing of Abady gave everyone a "black eye," but it was essential for the Cleveland Play House to remove itself from the risk of becoming "endangered" as the board realized its responsibility yet failed to act in a manner that appeased the theatre's supporters in addition to the local and national press. The theatre risked becoming "endangered" not only because of its financial troubles, but also because it was listless in its mission and leadership. The harsh criticism endured by the trustees over Abady's firing made them less assertive and pushed them to find the right person for the job—a visionary leader and a collaborative artist with an engaging public persona. Surprisingly, the answer to the theatre's problems would not be found just in *who* would lead them into the twenty-first century, but *where*.

8. A Place to Call Home ❦

Heavy storms rained down on Cleveland the week of November 6, 1994, but clear skies greeted board members on Saturday, November 12, as they ventured to the TRW World Headquarters in Lyndhurst for a special meeting of the Cleveland Play House Board of Trustees.[1] The retreat began at 9 a.m. with Bob Blattner expressing gratitude to the many trustees who were able to attend, followed by President Bob Newmark declaring the 1994–95 season to be a "year of stabilization."[2] The controversy surrounding the departure of Josephine Abady had faded over the past 11 months, and following Roger Danforth's temporary helming of the theatre after Abady's tumultuous tenure, Peter Hackett arrived in November 1994 from Milwaukee where he served as the resident director of the Northern Stage Company. In an article announcing his appointment, Chris Jones of *Variety* noted that Hackett had "never helmed an institution of comparable size," but this mattered little to the trustees who gathered to hear Hackett speak at the retreat.[3] Newmark introduced Hackett who immediately declared, "It's important for everyone to remember that every artistic decision we make is a financial decision, and every financial decision we make is an artistic decision. This is what 'doing theatre responsibly' means."[4]

Hackett's initial interviews with the press shed light on how the theatre might operate differently under a new artistic director (or if the board of trustees had learned any lessons from its prior experience with Abady). After calming fears of any potential disastrous repeat of previous tensions, Hackett proceeded to promote his agenda to both the press and trustees. At this November retreat, the new artistic director articulated six goals— two would become his greatest achievements, another two would inspire criticism and hinder his legacy, and the final two would be forgotten. Hackett's legacy in Cleveland is best defined by both an artistic and an administrative accomplishment, namely education programming and new plays. Concerning the latter, Hackett expressed to the board his desire to establish a new play program during his initial interviews, adding, "I think

that was why they hired me."[5] According to the minutes of the meeting recorded by Louise Slusser, Hackett expounded his vision for the new program in his very first board meeting at the TRW headquarters:

> We should begin a development wing in our own theatre. We must have control over these new plays. Playwrights' agents maintain a list of theatres to which they send plays... If the first theatre does not accept for production, then the script is sent to the second theatre on the list. The Play House needs to get on that list, and we should be at the top so that we get first option on the play. We need to encourage local playwrights who have scripts for us to consider.... Mr. Hackett would like to open the Brooks Theatre for this project. If successful in the Brooks, the play could be moved to the larger Drury or Bolton theatre the following year.[6]

While the Brooks Theatre did not reemerge as the home for experimental fare as was originally intended, the theatre did mount several new premieres, and Hackett's push for new play development yielded respectable results: Michele Lowe's *The Smell of the Kill* enjoyed a one-month stint on Broadway while other works, namely native-Clevelander Eric Coble's *Bright Ideas* and Randal Myler's jukebox musicals *Love, Janis* and *Lost Highway* enjoyed transfers to Off-Broadway.[7] While his success rate in discovering and developing new playwrights and new plays may not have been as substantial as other regional theatres during this period, Hackett should be commended for developing a new play program, if only to instill in his audiences' minds the value and necessity of taking risks with new plays.

A few moments following his proposal for a new play program, Hackett suggested to the assembled board members that the educational programs of the theatre be expanded. He praised the theatre's current endeavor—seven Ohio University students who participated in a graduate-level Lab Program—but he also suggested that the theatre could "do more."[8] One of the hallmarks of his tenure, however, was that it did not expand the existing program—it simply replaced it with a better one. During his tenure, Hackett argued for and implemented a new Master of Fine Arts program with Case Western Reserve University, but it should be noted that the program was not created by the artistic director. John Orlock, former chair of the Department of Theater at Case Western Reserve University proposed a program where 12 students would receive a full tuition waiver and a substantial stipend, enabling them to focus solely on their studies and be available to rehearse and perform in Cleveland Play House shows.

Unlike his push for new plays and educational programs, two of the six goals articulated by Hackett failed to come to fruition. The first of these proposals suggested that the Cleveland Play House should publish its new plays in an effort to gain international recognition (which never happened).[9] The second proposal, mounting a cabaret in the Brooks Theatre to attract younger audiences, occurred in 1996 but was a financial failure.[10] The remaining two goals presented by Hackett at the Board of Trustees Retreat were initially viewed as wonderful and thoughtful suggestions, and, when implemented, were met with a modicum of success. For Hackett's legacy, however, they proved problematic.

In an attempt to right a wrong of the previous administration, Hackett proposed an Associate Artists Program. According to the minutes from the retreat, "[Hackett] suggests a plan to name individual actors, both local and out-of-town, and 'Associate Artists' at The Cleveland Play House. These performers would feel that Cleveland is their home and return to our stages because they believe in The Play House, and they would soon be familiar to audiences."[11] The move disappointed those who supported the disbanding of the resident company, even though Hackett made it clear that this was not to be viewed as a resident company. However, several employees and other critics viewed the move as a return to the days before Abady when the hiring of local artists cheapened the product in favor of familiarity. In addition, this proposal validated for some the perception of the Cleveland Play House as a glorified community theatre. In his defense, Ron Wilson, chair of the Department of Theater at Case Western Reserve University who worked with Hackett to improve the MFA program, suggested that such criticism was unfair. "That's the irony of it," Wilson explained. "They were all very good, professional actors. He would bring in one or two actors in a show at most."[12] Nevertheless, the inclusion of local talent was interpreted by many as a desperate attempt to recover from the black eye provided by Abady, causing many to fear that the theatre was taking a step backward, retreating from its prior attempts to establish relevance on the national landscape. Furthermore, his repeated hiring of the same talent soon elicited criticism that Hackett played "favorites," a view held by many and frequently cited as a contributor to Hackett's flawed productions.

If there was ever any doubt, a rejection of Abady's policies and aesthetics was made crystal clear to the board when Hackett announced his play selection criteria. Once again, it reflected a new movement in the ever-swinging pendulum that vacillated between establishing a national reputation and appeasing the community. Hackett articulated his belief

that the theatre needed to "reflect the community that it serves," and this endeavor was most apparent in his play selections. For the 1996–97 season, Hackett announced that his primary criterion was attracting large crowds to the theatre through populist fare, citing that "six of the eights shows were plays that will draw this kind of audience."[13] Unfortunately for Hackett, financial limitations plagued the artistic director throughout his tenure in Cleveland. Data from the Cleveland Play House archives reveals how sparse the production budgets were compared to other theatre institutions. While comparing production budgets for sets, props, and costumes alone, time and time again, the Cleveland Play House spent only a fraction of what other regional theatres budgeted for their productions. For example, for its production of Brian Friel's *Dancing at Lughnasa*, the Cleveland theatre's budget was only 46 percent of the Goodman Theatre in Chicago. For Terence McNally's *Lips Together, Teeth Apart*, the Cleveland Play House budget was 50.3 percent less than that of Seattle Repertory Theatre. Even for smaller productions like Cheryl L. West's *Jar the Floor*, the Cleveland theatre managed to spend only 52.9 percent of a production of the same play at the Arena Stage. Perhaps most shocking was the production of *Having Our Say*, where the Cleveland Play House's budget was a paltry 20.2 percent of the production budget at the McCarter Theatre in New Jersey. For Hackett, the difference in financial support must have been stunning. At the Denver Theatre Center, the production of *Peter Pan* appropriated $73,000 for sets, costume, and props, whereas the largest production at the Cleveland Play House during the previous two years, an adaptation of *The Grapes of Wrath*, received only $27,751.[14]

When Hackett announced his resignation in December 2003, the theatre found itself, once again, in dire financial straits.[15] Kenneth Jones of *Playbill* predicted "His successor will inherit a debt and questions about the nature of the Play House's future mission and identity."[16] Furthermore, Hackett's attempts to offer more populist fare not only failed to provide financial security, but also provoked criticism, especially from those who supported Abady's more-adventurous play selections.[17] For example, former theatre critic for the *Plain Dealer* Marianne Evett labeled Hackett's offerings as "too mainstream, too willing to satisfy the board's tastes, which are traditional and conservative.... No regional theatre should be doing Neil Simon plays or *On Golden Pond*."[18] The new artistic director could not offer a clean break with past practices because of the theatre's substantial debts, but external events soon forced the theatre and its new leadership to take a drastic course of action in order to survive. The theatre would never be the same.

THE BEGINNING OF THE END

When the board of directors interviewed Josephine Abady for the leadership position at the Cleveland Play House, they asked her what she would do with the resident company. When Michael Bloom interviewed for the same position nearly two decades later, he was asked what he would do with the building. "Part of the process was my having to answer the question 'How would I use the building?'" Bloom recalled. "In other words, what other activities could I utilize the building for? I was kinda green, and I thought I would throw out some ideas. But then I saw the building, and I thought, 'Wow.... Why?'"[19]

Bloom's arrival, followed shortly by Managing Director Dean Gladden's resignation in 2006 and the hiring of Kevin Moore, marked the beginning of the end of the theatre complex at 86th Street and Euclid Avenue. When Gladden departed, the massive complex also lost its most-staunch defender. Gladden took pride in the 86th Street and Euclid Avenue complex, arguing that the facility could be turned into a performing arts center (the Museum of Contemporary Art became a tenant) and constantly explored ways for the facility to earn revenue. To generate revenue, Gladden convinced the Cleveland Clinic to rent both the parking lot during work hours and the entire third floor of the theatre building for storage, providing the theatre with $450,000 in annual revenue.[20] With an outsiders' perspective and a willingness to challenge the status quo, Bloom and Moore set a plan in motion to convince the board that abandoning the massive facility was the only way for the theatre to survive. However, a study completed under Gladden's supervision suggested that it was in the Cleveland Play House's artistic and financial interests to remain at their present location. A second concern was the board members' attachment to the building, namely their refusal to leave a building to which they had dedicated so much time and money. Moore provided an example of one influential board member's attachment to the theatre complex: "Chloe Oldenburg had invested so much in this theatre.... She was there [at the 86th Street theatre] since she was a little girl. There was a lot of that sort of sentimental human attachment to the organization, [and] you can't replace that kind of passion.... Unfortunately, it [also] clouded business judgments."[21]

This emotional attachment was best embodied by the theatre's continued operation of the Club. Several staff members (who asked not to be quoted) cited the Club as the board's key reason for holding onto that building. These staff members opposed the idea of a nonprofit theatre financially supporting a private, "elitist" entity, and several board members

agreed, suggesting that the existence of the Club sent an "isolationist" message to the neighboring communities.[22] Bloom was one of several leaders determined to close the Club. "One of the things that I said to myself when I got there was 'I'm closing that club,'" Bloom stated in a February 2013 interview. "The [importance of the] Club to the Cleveland Play House demonstrated how far from the mission of the theatre the Play House had strayed."[23]

Bloom's earliest efforts to garner support for a move "fell on deaf ears," and it seemed to many that the financial risks and a fear of the unknown would force the theatre to remain at its present location regardless of the increasing deficits and how it would affect both the annual budget and, ultimately, the quality of work being produced.[24] "We did some good work at the old building," Bloom recalled, "but, all told, it looked bad, and it was because of how bad, how ugly [the buildings] were, how dysfunctional they were, how old-fashioned they were. Even the best production looked mediocre."[25] Bloom was desperate to find a new home for the Cleveland Play House, but his arguments alone would not dictate the future of the theatre. Internal efforts by the superiors combined with external influences quickly changed the minds of hesitant board members. The timely convergence of these two events made the Cleveland Play House's search for a new home inevitable.

In order to combat the rose-colored glasses worn by several board members, Bloom and Moore endeavored to educate them about the building. The solution was incredibly simple: during one of the board meetings, Bloom, Moore, and Director of Production Joe Martin arranged for the members to take a tour of the facility. "On our tour with the board, we looked at places in the building that they had never been to before," Bloom recalled. "Broken windows. Leaks throughout the building. And when they came back, there was shock. They had no idea that the building was in the shape it was in."[26] Moore elaborated by describing how the walk-through combated the notion that the building was financially self-sustaining: "The condition of the building was just awful, with leaky pipes and things like that. There were sewage pipes that were cracked and sewage smells wafting through the offices. It was disgusting."[27] Board president Peter Kuhn remembered the effect that the tour had on the board members, stating, "I think that they were surprised at just how desperate the building condition was."[28]

Encouraged by the board's new awareness of the problematic facility, Bloom turned his attention to finalizing the closure of the Club, and he was aided by worrisome financial figures incurred by the restaurant.[29]

According to the minutes of a finance committee meeting from May 2007, the Club projected a $20,000 shortfall, prompting the entire board to seriously question the future of the operation.[30] One month later, a Task Force led by Bob Trombly delivered its recommendations for the Club to the board of directors at a special meeting. The report provided a simple assessment of the problem as it related to the theatre: "Ultimately, it was determined that The Cleveland Play House needed to get out of the restaurant business."[31] Proposals were accepted by several businesses who wished to take over the management of the dining facility, with Creative Cafes, Inc. winning the contract. The days of business lunches at the Club were over—the new restaurant (renamed Stages at the Play House) would only serve food before and after shows. In order to end the long-term financial liability of the Club, the theatre agreed to help eliminate the Club's current debts, listed at $558,000 by forgiving the $278,000 owed by the Club to the theatre.[32] As a result, the theatre incurred a "deficit estimated to be $700,000, including write-offs, for the fiscal year July 1, 2006 through June 30, 2007."[33] Despite the financial burden of the Club, Moore articulated its important role in the theatre's history: "The Club does remain a fond memory to this day, having hosted many important events over its 47 years. At its founding, it had the distinction of being one of the few all-comers clubs in Cleveland, welcoming women, Jews, and African-Americans decades before the Union Club and others changed their policies and opened their membership. While it was failing at the end, it did for many years play a vital role for the Cleveland Play House and the community."[34]

With the theatre facing difficult financial hurdles in its immediate future, more and more board members began entertaining the idea of a move to another location. Once again, the familiar debate reemerged of whether the theatre should move west to downtown or east to University Circle. Many board members favored a move to University Circle where the Cleveland Play House would not be in close competition with the Great Lakes Theatre Festival's new home, the restored Hanna Theatre. Furthermore, the majority of patrons for the Cleveland Play House lived on the east side of town, and a move in that direction and alongside the museums and orchestra hall made sense. To Mark Alan Gordon, the move east would have benefited the institution greatly: "To put the Play House with its peers of museums and the orchestra would have been probably the most brilliant idea in the world."[35] According to Gordon, not everyone on the Cleveland Play House staff was as excited by the prospect of moving onto a campus: "Nobody had the patience to work it out. And I really think

that that was not as sexy to Michael as moving downtown."[36] Ultimately, "Case was just too bureaucratic to deal with," reported Pendleton, and concerns of the school's emphasis on science and engineering meant that support for the new theatre might be lacking. "They had their own agenda which was legitimate," he continued, "I mean, we're not anywhere near the top of that list [of financial priorities] and we weren't going to get to the top of it. So we rejected that."[37] Still hoping to move to University Circle, the theatre also explored a partnership with Cleveland School of the Arts, but the Cleveland Play House board quickly concluded that the Cleveland School of the Arts and its support organization did not "have the substance to raise as much money as was needed.... The School of the Arts didn't have the horsepower."[38]

Discussions with Case Western Reserve University ended in May 2008, and shortly thereafter was when "all hell broke loose."[39] In quick succession, the theatre suffered a series of crippling financial losses in the midst of the economic crash of fall 2008: its summer theatre series lost $80,000; it failed to find enough donors to support a matching grant, resulting in the potential loss of an additional $100,000; its production expenses skyrocketed; and the Cleveland Clinic cancelled its parking lease in addition to its recent decision to stop renting space in the Cleveland Play House facility, a net loss of $450,000 of annual income.[40] The theatre was in such poor financial shape that Bloom and Moore made personal loans to the theatre totaling $125,000 so that the organization could cover its payroll. The harsh impact of the nation's struggling economy became evident in September when Kuhn reported that "the revenue news is all bad:" subscriptions were down, single ticket sales were down, and the theatre faced an additional $500,000 in forecasted debt. By November, the theatre needed to borrow more money as estimates of expected income fell from $8.3 million to $7 million, prompting Moore to describe the theatre's financial situation as "horrific."[41] The economic downturn hit the theatre hard, best exemplified by a January 2009 report from the Finance and Investment Committee that revealed that the theatre's "portfolio was $3.5 million, down from $7.7 million" as a result of $3.1 million of withdrawals to cover debts and approximately $1.3 million in investment losses.[42]

The recession combined with the trustees' new awareness of the dilapidated state of the facility encouraged the board to eagerly search for a new home. Ironically, despite the financial problems accentuated by the sluggish economy, Bloom credited the recession with provoking the board to take action. "Frankly, without the recession, I'm not sure that we ever would have moved," Bloom claimed. "As much as we made a good argument for

it, the recession made an outstanding argument for it.... I think that the move occurred because the board had its back to the wall, and we would have gone out of business had we not moved."[43] Pendleton agreed that the recession caused the board to support a new search as the need to move quickly became "obvious" to the theatre's leadership.[44] For the first time since its original members left the Ammon House, the theatre needed to abandon its home out of necessity. The challenge for Bloom, Moore, and the board of directors was not only to locate a suitable facility, but also to find an ideal space that provided financial stability and allowed the staff to focus on creative work as opposed to financial concerns.

Desperate for money and hoping to receive a lifeline, Moore and Kuhn met with representatives of the Gund Foundation, a local philanthropic institution which had once been very generous to the Cleveland Play House.[45] When Moore and Kuhn informed the Gund Foundation's Dave Abbott of their intention to sell the building, Abbott offered a crucial piece of advice that forever changed the future of the Cleveland Play House. Kuhn recalled, "Abbott said to me, 'You know, if you want to go to the Allen Theater, you better get going because that train is leaving the station.' So I called Michael Schwartz and Cleveland State because they were the conductors of that train."[46] Moore remembered the meeting and the brief discussion afterward: "We had a meeting in February '09 in Mike Schwartz's office, maybe thirty minutes long. And Peter Kuhn, Michael Bloom and I stood in the parking lot afterwards and said, 'Yeah, we should do this.'"[47]

The details of "this" were provided by Kuhn at a February 19, 2009, meeting of the executive committee. In the new collaboration called "The Power of Three" (including Cleveland Play House, Playhouse Square, and Cleveland State University), the Cleveland Play House needed to raise an estimated $18–$22 million to move downtown, much less than the amounts discussed with Case Western Reserve University and the Cleveland School of the Arts.[48] When Barbara Snyder, president of Case Western Reserve University, finally "made it clear" that the school would not collaborate with the Cleveland School of the Arts and the Cleveland Play House in the construction of a new facility, the theatre's move downtown was all but a certainty (as it remained the only viable option).[49] By April 2009, the news of the westward relocation was front-page news, and within a few months, the old theatre complex was sold to Cleveland Clinic for $13 million (with the understanding that the Cleveland Play House could lease the building for free while it constructed its new home.)[50]

Debate raged in Cleveland's theatre community about the wisdom and risk in the Cleveland Play House's decision. Many patrons of the theatre

refused to renew their subscriptions, citing that the additional ten-minute commute to downtown would be too much of a burden. When asked if he conducted a survey of his subscribers to learn what percentage approved of the move, Moore replied that he did not ask that question: "It didn't matter, because if we stayed where we were, we'd be dead anyway."[51] The level of risk assumed by Moore, Bloom, and Kuhn was astonishing in retrospect. They were turning their back on a location that housed 84 years of history, knowing that their decision to sell the building would upset many donors who had contributed thousands of dollars to keep the facility functioning. Also, the Brooks Theatre, one of the nation's oldest theatres in continual use and the oldest regional theatre facility still in operation, would now belong to the Cleveland Clinic and might be demolished. Furthermore, the move away from the east side of Cleveland meant losing part of its identity to Playhouse Square, a massive performing arts complex. The Cleveland Play House was a theatre whose legacy was its longevity, and given the theatre's struggles to become a major player in American regional theatre, its longevity had been its primary selling point. Nevertheless, Bloom, Moore, and the board of directors deemed the situation dire enough that it was worth abandoning nostalgia and any semblance of certainty in order to move downtown. To further educate the board and "to inform their decision-making as plans were being set in motion," Bloom and Moore arranged a trip for 20 board members to tour three Chicago regional theatres.[52] Following their visits to Steppenwolf Theatre, Looking Glass Theatre, and the Goodman Theatre, the differences between these companies and the Cleveland Play House became immediately apparent. "One of the things that was driven home to us," Kuhn recalled, "was that their focus on the art was what was driving them. And [we] were distracted by our facility."[53]

While some members of the community continuously questioned the wisdom of the move, the support from the board of directors proved resolute and is a testament to the relationship between the board members and Bloom and Moore. At no other time in the theatre's history would such an endeavor have been possible. Previously K. Elmo Lowe and Frederic McConnell never considered leaving the 86th Street complex due to community support for the theatre and its Club. Abady may have wanted to move, but her frequent battles with the board quickly quashed any support that she would have needed. Bloom and Moore, however, dedicated time to educating the board concerning the issues facing the theatre, "bringing new perspectives to the table, new information and ways of looking at things, and a willingness to challenge the status quo."[54] Bloom praised this

new "professional board," and he credited Moore with this transition. "I think the board has moved in a very positive direction," Bloom explained, "and...I can't stress this enough: I think it's because now there are people on the Cleveland Play House board who are on other boards, who know how a nonprofit should work, they know that the day-to-day operations are the purview of the staff, and that the fiduciary responsibility is theirs."[55] In essence, the time spent educating the board engendered to a respectful and productive relationship built on trust between Bloom and Moore and the board of directors. Bloom agreed, stating, "I know that they had not been told the truth in the past by certain artistic directors, and I said to them in the very beginning, 'I will always tell you the truth, and it may not be pretty.'"[56] The board trusted Moore and Bloom, and the duo made their argument for the new future of the Cleveland Play House. If the venture failed, the blame would fall squarely on Bloom and Moore. They were risking nearly a century of history.

Despite lingering doubts within the community about the theatre's future, the decision to relocate did have the backing of Tony Brown, *Plain Dealer* theatre critic who was considered to be unfairly harsh toward the Cleveland Play House and its artistic director.[57] "It might not be the best of all possible deals," Brown penned in a July 2009 commentary, "but then again, Cleveland is not the best of all possible worlds. The agreement signed last week to sell the Cleveland Play House property...looks like the best deal under the circumstances."[58] The decision to relocate to the downtown area brought new administrative and financial challenges to the theatre, and Moore, Bloom, and Kuhn hoped that the potential for artistic accomplishment would be worth the risk. The Cleveland Play House, however, was not the only business taking a risk by investing in downtown Cleveland; in fact, the Cleveland Play House once again reflected the concerns of the Cleveland community by contributing to a citywide effort to reinvigorate the urban core of the city. The city of Cleveland and its legendary theatre were taking risks in hopes of finding a future that would allow the city and its business to not only survive, but also thrive.

WHAT THE MOVE REPRESENTED

The recession of 2008 hit the city of Cleveland hard. A Brooking Institute report detailing the effects of the economic downturn and the eventual recovery concluded that areas in the Midwest, especially Ohio and Cleveland in particular, would feel the effects of the recession longer and deeper than the rest of the country.[59] Cleveland ranked thirteenth out of

all major cities for unemployment, and the housing market collapsed as prices fell 31.1 percent as the city quickly became the "epicenter of the nation's foreclosure crisis."[60] Mayor Frank Jackson recalled, "Cleveland was hit hard and hit early by predatory lending that resulted in foreclosure and abandonment.... [However,] we have an opportunity to reinvent ourselves and rebuild."[61]

Reinvent and rebuild is exactly what Clevelanders did when faced with the bleak financial outlook. "Clevelanders don't need a study to tell them that a hard-working region bled manufacturing jobs for the last twenty years," the *Plain Dealer*'s Robert L. Smith wrote. The region, however, was undergoing a "steady if painful transition from traditional manufacturing, like steel-making, to the advanced manufacturing of precision parts, chemicals and polymers—products competitive in the global economy."[62] Cleveland redefined itself, abandoning its century-long history as a steel town and diversifying its marketplace in order to remain competitive, hoping to avoid being susceptible to collapsing markets and changes in industry models. "We're still making lots of stuff, [but] the mix of what we're making here has changed noticeably," clarified Tom Waltermire, the chief executive officer at Team NEO, a business attraction agency.[63] Manufacturing accounts for 18 percent of the gross regional product, but industrial companies are now buying locally, reinvesting in the Cleveland economy. "They buy materials, power, trucking, logistic," Waltermire explained. "There's much bigger ripple effects."[64]

The rebound has been most evident in downtown Cleveland where city and county governments took risks by investing in new projects. Unlike the Erieview project that grew out of local politicians' desire to build a crown jewel with little thought about how it would affect the entire community, the city invested $465 million in a new convention center and Global Center for Health Innovation (previously known at the "Medical Mart").[65] Another $350 million has been earmarked for additional projects, most notably a $260 million hotel adjoining the convention center.[66] The new construction in downtown Cleveland (including a new Horseshoe casino) combined with the new job opportunities in the surrounding areas has produced a surprising effect on downtown—an increase in population. While "residents left Cleveland and Cuyahoga County in unprecedented numbers last decade, one group defied that trend assertively. Young adults, minorities in particular, moved in eye-opening numbers to some urban neighborhoods of the city and its inner-ring suburbs," according to census data.[67] In downtown Cleveland, "residential occupancy rates now stand over 95% and developers are eagerly looking to meet residential

demand."⁶⁸ In a report titled, "Not Dead Yet: The Infill of Cleveland's Urban Core," Richey Piiparinen declared Cleveland "the antithesis of a dying city" thanks to these young, educated, and professional residents.⁶⁹ Smith agreed with the assessment, claiming, "Twentysomethings are creating a new and potentially powerful housing pattern as they snap up downtown apartments as fast as they become available.... Neighborhood life is blossoming on blocks once dominated by office workers and commuters, and people are clamoring for dog parks."⁷⁰

The Cleveland Play House seized upon this trend by reinvesting in the urban core. "We were in no man's land," Bloom stated in an interview. "There is so much more energy downtown."⁷¹ *Plain Dealer* critic Tony Brown hoped the move would reinvigorate the areas, writing, "The community could be another step closer to having a bustling, rejuvenated section of downtown with the critical mass of people needed to attract new restaurants, retail space, offices and residential units to the empty storefronts and mid-rises along Euclid Avenue."⁷² Former board president Peter Kuhn echoed these sentiments when discussing the potential for growth in downtown Cleveland: "I'm really excited about this stuff. I think that casino is actually a good thing for getting activity into Cleveland.... I think the Medical Mart is going to be surprisingly good for Cleveland."⁷³ Kuhn also approved of the timing of the relocation, stating, "I'm pretty sure that if the Play House had gone to Playhouse Square when Playhouse Square was built, we wouldn't have the theatre complex that we have today."⁷⁴ Financial circumstances dictated the timing of the move, but the relocation downtown also reflected the city's new geographic realities. The western and southern suburbs of Cleveland had grown substantially over the past two decades, and the move to Playhouse Square provided the Cleveland Play House with an opportunity to market itself to suburban audiences who had not traveled across town to the previous location. "We're now not just an east-side suburban theatre," Bloom boasted in an interview. "We're Cleveland theatre."⁷⁵

WHAT THE MOVE PROVIDED

"Seven years I spent in purgatory," remarked Bloom when discussing the move downtown, "and now I'm in heaven." The transition from the deteriorating facility at 86th Street to the new spaces was a dream come true for Bloom, Moore, the board of directors, and the entire Cleveland Play House staff. Instead of utilizing one poorly designed proscenium (Bolton Theatre), one suitable proscenium (Drury Theatre), one charming yet

timeworn proscenium (Brooks Theatre), and a small, ill-designed and ill-defined space used as a black box, the new Cleveland Play House opened the first of its three dynamic theatres on September 21, 2011, with an adaptation of Bertolt Brecht's *Galileo*. Bloom discussed the advantages and challenges provided by the new Allen Theatre: "To be able to start designing a play with all possibilities open, and anything on the table, is pretty thrilling and liberating." Also the cast of 23 actors was "the biggest show we've done in decades. We're going to be able to offer Cleveland a more exciting vision of what theater can be, and a broader range of work."[76]

Of the Cleveland Play House's three new theatres, only the Allen Theatre is a restored space (Figure 8.1). Built in 1921 and designed by C. Howard Crane in a style inspired by Raphael's 1523 Villa Madama outside of Rome, the 3,080-seat movie house was transformed into a 514-seat intimate proscenium theatre.[77] The renovation called for the back half of the balcony to be walled-off, creating a hidden space that eventually could be utilized as another performance space. Similarly, the back portion of the orchestra seating was transformed into a "sumptuous" lobby, two VIP lounges, and a ticketing area, leaving a smaller number of seats and a much more intimate feel.[78] According to Joanna Connors of the *Plain Dealer*, the overhaul fashioned "a new, contemporary theater within the old Allen, while preserving its historic shell and dazzling vintage finishes."[79]

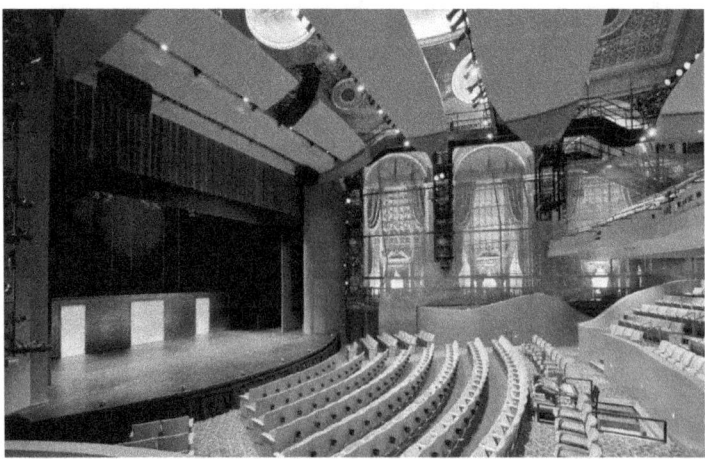

Figure 8.1 Interior of the new Allen Theatre at Playhouse Square (Courtesy of the Cleveland Play House.)

As part of the $30 million price tag, the Cleveland Play House benefited greatly from the construction of two new flexible spaces: the 314-seat Outcalt Theatre that opened in January 2012, and a 150-seat "lab" theatre that opened one month later, primarily utilized for Cleveland State University Department of Theatre shows as well as the CWRU/CPH MFA productions. These three spaces are connected by a long corridor that extends to the Playhouse Square parking structure, creating an optimal opportunity for the Cleveland Play House to promote its work to the Broadway Series' 27 thousand subscribers who pass through the Cleveland Play House facility.

The relocation of the Cleveland Play House, however, provided more than free advertising and artistic inspiration. The theatre was spending $1.2 million a year on maintenance at the 86th Street complex (15% of its annual operating budget), and hoped that its expenses would be cut in half.[80] Chairman of the board of trustees Alec Pendleton claimed that the effect was immediate: "We are spending more money on what's on the stage than we are on maintaining the stage."[81] More than the financial savings, Bloom stressed how the move impacted the focus of the theatre, stating, "What Kevin and I have done is essentially change the operation from a real estate-based company to a mission-driven organization."[82] In other words, the Cleveland Play House began functioning under a model similar to the Chicago theatres that the board members had toured three years ago. Kuhn elaborated on the benefit of being a tenant rather than owning the property, claiming, "There's wasn't anything going on that would indicate that we could afford to be a landlord. And, in fact, one of the problems with the building was the lease that we had with MOCA [Museum of Contemporary Art]...You don't want to be a landlord for a bunch of nonprofits. I mean, you want people who can actually pay [market-rate] rent."[83]

By becoming a mission-driven organization, the Cleveland Play House needed to find its niche in the midst of the massive Playhouse Square facility. As a result, the play selections became more daring and less populist than they had been at their previous location. In its first season downtown, the Cleveland Play House produced regional premiers including August Wilson's *Radio Golf,* Jeffrey Hatcher's *Ten Chimneys*, Sarah Ruhl's *In the Next Room, or the vibrator play,* John Logan's *Red*, and the world premiere of Ken Ludwig's comedy *The Game's Afoot* that became the largest single-ticket selling show in the theatre's history.[84] Bloom described the differences in programming for the two locations, explaining, "It's not a complete departure for us, but it is a resetting of our artistic vision.... It's

certainly the most adventurous and exciting season I've programmed."[85] With the Great Lakes Theatre Festival and the Broadway Series in the immediate vicinity, it was necessary for the Cleveland Play House to stake out its territory by offering works not presented by the other two entities. Moore celebrated the "uniqueness of premiere work that you can't get anywhere else" and how that has redefined the theatre's mission and its relationship to the community. "Regional theater is first and foremost a community service organization, with the service provided being the power of theater...," Moore stated. "If we're moving people, if we're doing plays like *The Whipping Man* [produced in the 2012–13 season] that nobody else in town could possibly do it at the caliber and level that we're doing, and having an impact on people's lives as a result, [then] that means we're doing our job."[86]

While becoming part of Playhouse Square certainly presented branding challenges to the Cleveland Play House (especially when Google searches for "Cleveland Play House" resulted in listings for the downtown arts complex and not the regional theatre), the relocation changed the landscape of Cleveland theatre, creating a more dynamic entertainment center for the city. Cleveland Play House's move downtown made the arts complex *the* place to go for professional theatre in northeast Ohio region. Bloom commented on the benefit of being a part of a larger facility, stating, "It's now an event when people come to our space. It feels more like an event rather than a convenience built around a parking lot."[87] Kuhn also praised the Playhouse Square organization and its ability to engage the community: "They may be the biggest landlord in the greater Cleveland area, and they are certainly the most effective in boosting the cultural presence of the city and making it an attraction. So I love being in here and being part of that, and we can be the Cleveland Play House. We've got an old name. We can make it work."[88]

When examining what the move downtown provided to the Cleveland Play House, the most notable effects are the discovery of the theatre's artistic niche, the potential financial respite, and the greater community exposure. In other words, the relocation of the legendary theatre has given the theatre a feeling of optimism and hope, a chance to continue its legacy. If the theatre had remained at 86th Street, it would not have survived the recession and would not have made it to its centennial anniversary in 2015. With the risk taken by the theatre's leadership, the theatre has been given its best chance to pursue artistic excellence in a city still suffering from the effects of the recession and decades of lingering economic shortfalls. In its search for financial stability, the theatre not only discovered its new

artistic purpose, but also finally found what it had been searching for: a home and a future.

COMING FULL CIRCLE

Despite all the debate concerning the relocation of the theatre, the Cleveland Play House building remains on Euclid Avenue. Playhouse Square is less than three miles away from the 86th Street Complex, directly west under the bridge at 55th Street that divided Millionaire's Row, past the main campus for Cleveland State University, and four blocks away from the proposed site for the theatre during the urban renewal discussions of the 1960s. The new Cleveland Play House also is close to the site where the Euclid Avenue Opera House once offered melodramatic, spectacle-based productions that prompted the group gathered at the Brooks' home to form the Play House. O'Neil and the original supporters might have scoffed at the notion of becoming a downtown theatre, but with the relocation, the Cleveland Play House was able to satisfy many of the artistic ideals articulated by the theatre in its infancy.

By producing edgier plays, the Cleveland Play House returned to its original goal of presenting work not typically produced in Cleveland theatres. The new flexible spaces are the only non-proscenium theatres in the downtown area, and the potential for greater experimentation echoes the original intentions of the Brooks Theatre while also attracting playwrights to pen plays for the flexible spaces. Having defined its artistic niche, the Cleveland Play House is able to offer premieres and other works not frequently seen in the region while also providing a home for audiences interested in more than populist fare.

In line with its original mission, the Cleveland Play House is satisfying another of its earlier goals by serving the community through community outreach. Under the guidance of Pamela DiPasquale, the education programming of the Cleveland Play House is thriving. The theatre not only offers matinees for students bussed to Playhouse Square, but the Cleveland Play House also coordinates with state education officials and local school districts to bring performances into schools throughout northeast Ohio, mimicking the actions of the Cleveland Orchestra. In addition to its classroom matinee touring program, the theatre offers teachers an opportunity to work with Cleveland Play House artists and staff to create a curriculum to assist students with reading and writing. Furthermore, with the "Power of Three" coalition and its partnership with Cleveland State University, the Cleveland Play House now works with undergraduates, meaning that the

theatre is involved in education at every level, from kindergarten through graduate school. For years, the education department of the Cleveland Play House floundered when artistic directors proposed its elimination as a cost-saving measure. The new Cleveland Play House reinvested in its education program, including an increase in staffing for the education department.[89]

Moving downtown also resolved one of the Cleveland Play House's longest-lasting problems: its continued residence in "no man's land." The theatre is now more integrated within the arts community and reaps the benefits of its central location by attracting audiences from all over the region. "Our west side attendance is up considerably," Bloom reported, and Kuhn further added that the population boom downtown has resulted in the Cleveland Play House's audiences getting younger, a significant shift that would be the envy of most professional theatres.[90] With increased exposure to the theatergoing public and its close proximity to downtown residents and Cleveland State University's 11 thousand students (who are eligible for $15 student tickets), it is no surprise that the audience demographics for the Cleveland Play House are changing.[91] For a theatre once reliant upon wealthy, older patrons from the eastern suburbs, the increase in younger patrons from all areas of the city is a remarkable accomplishment.

The quality of the artistic work produced by the Cleveland Play House at Playhouse Square also proves that the move was right decision. In May 2012, as part of its inaugural New Ground Theatre Festival, the Cleveland Play House collaborated with the Cleveland Orchestra to present playwright Tom Stoppard and composer André Previn's *Every Good Boy Deserves Favor*. Offered as a limited run for only three consecutive nights, the Allen Theatre's "play for actors and orchestra" was the first major professional production of this work in northeast Ohio since the Cleveland Orchestra's limited presentation at Blossom Music Center in the 1980s. This type of collaboration would have been unthinkable the previous year, but the decision to produce this massive work, if only for three nights, represents the new freedom felt by the theatre leadership and the potential for creativity and artistry provided by the new Cleveland Play House.

At the beginning of the inaugural season in its new facility, Bloom described his excitement when discussing the season's offerings: "'A new age is dawning and it's great to be alive' is a line from *Galileo*, the play kicking off our 2011–12 Season. It is a fitting sentiment for the rebirth of the Cleveland Play House."[92] More than a rebirth, the move downtown was a rediscovery of the spirit of the Cleveland Play House, reminiscent of the earliest days when its members produced work solely for its artistic

value. Later, the theatre exhibited a commitment to not only serving the community, but in becoming an integral part of the community by educating future audiences and eventually participating in the reinvestment of the city's urban core. Furthermore, the Cleveland Play House is benefiting artistically from its location in the center of the theatre community. According to Bloom, audiences support the move to produce edgier plays: "I actually find that our audiences are more interested in the more-challenging work, our core audiences—and that's a really great thing. We're doing *Venus in Fur* and *Clybourne Park* in the same [2013–14] season. We're definitely moving in the right direction."[93]

When it moved downtown, the Cleveland Play House did lose some subscribers who preferred the nostalgia of the 86th Street facility and/or believed that the additional driving distance was too far. Many of these people refused outright to support the theatre in its new home, but the loss of these patrons also represents a significant gain for the theatre. For decades, the Cleveland Play House suffered from a community-theatre complex, a sense of ownership by influential members of the community who had contributed to the renovation of the old facility and/or had participated in the defunct dining club. Any sense of ownership by the community was now obliterated when the theatre moved downtown. Whereas the Cleveland Play House had previously suffered from the self-imposed obligation to satisfy the community and its desire to achieve national recognition by hiring Hollywood stars or famous architects, the relocation to Playhouse Square is a declarative statement that artistic ingenuity and quality work will henceforth drive the mission. The move from "a real estate-based company to a mission-driven organization" saved the Cleveland Play House, and now any national recognition or community support will/should derive from producing quality plays. The duo of Bloom and Moore deserve an immense amount of credit, not only for working tirelessly to ensure a successful relocation process, but for also persuading the board of directors, the local philanthropic foundations, and the Cleveland community to support the move.[94] For a theatre whose legacy was its longevity, the abandonment of a facility that represents its extensive history in favor of new spaces in a performing arts complex was a substantial risk, and the effects are so far promising. The move has inspired a new sense of optimism and hope within the theatre's leadership and staff, believing that the Cleveland Play House has a future, now that it has found a new home.

Conclusion: The New "No-Man's-Land"

On the afternoon of May 23, 2013, an email was sent from a northeast Ohio listserv that sent shockwaves through Cleveland's theatre community. The opening paragraphs shared the news:

> Cleveland Play House (CPH) announced today that, with the May 19 finale of its 2012–13 season, Artistic Director Michael Bloom will close out his tenure with the theatre company.
>
> "I am proud to have been a part of CPH for the past nine years," Bloom said. "We have an exceptional team and an extraordinary organization producing top-quality theatre. It's a valuable asset for Northeast Ohio. Now that we've wrapped up the 2012–2013 Season, and planning for next year is complete, I feel comfortable moving on. And I know CPH is in good hands as it moves to its second century."[1]

The Cleveland Play House website was immediately updated to reflect Bloom's departure and Laura Kepley's promotion to interim artistic director.

The email revealed that Bloom resigned four days earlier, leading to conjecture and gossip concerning his release. However, unlike the absence of explanation and justification provided in the theatre's press release announcing Abady's contentious firing and her subsequent angry rebuttal, this separation was genuinely cordial. Bloom proved congenial by giving an interview to the *Plain Dealer* to confirm the mutual decision. "The timing is really good because we have accomplished much of what I'd hoped to when I came to CPH nine years ago," Bloom stated. "I feel our work has really positioned the theater for the future."[2] He also supplied an endorsement for Kepley, revealing, "I think the *world* of Laura, and that's one of the reasons why I'm able to leave at this time, because I think that she is poised to be terrific artistic director."[3]

With Bloom's departure, the leadership of the Cleveland Play House found itself in familiar territory and with another crucial decision to make: the board could promote someone who had proven success relating to Cleveland, or the executive committee could choose to pursue a more established director who would bring national attention to the theatre because of his/her reputation. However, the challenge of hiring an artistic director was different than in years past for the executive committee. During the earlier searches, the executive committee had debated whether or not the theatre should cater to the community or try to attain national exposure through the hiring of an individual. With the rededication to artistic products, this time the executive committee did not concern itself with aesthetics and play selections, but instead hoped to find someone who will be able to relate to the entire community. In other words, by removing the "community theatre" stigma (i.e., the sense of community ownership) that had plagued the theatre for decades, the theatre needed the community more than ever. To that end, Laura Kepley was formally announced as the ninth artistic director of the Cleveland Play House on September 23, 2013.[4]

Artistic directors of leading regional theatres across the country were effusive with praise for the selection. Oskar Eustis, Artistic Director of The Public Theater, labeled her appointment as "a day that we are going to remember for many years to come in the American theatre."[5] The numerous compliments from artistic directors addressed the dual goals that the Cleveland Play House has pursued for decades: achieving national recognition and becoming an integral part of the community. Concerning the former, Susan Booth, Artistic Director of the Alliance Theatre in Atlanta, claimed, "This is somebody who is destined to be a major leader of a national field." She also addressed the selection committee, predicting, "You've picked the way forward that is going to keep Cleveland Play House, vibrant, thrilling, and forward-looking for its next hundred years."[6]

Kepley is perhaps the most personable artistic director that the theatre has had since Oberlin, and her engaging personality was duly praised as well. "She's someone with enormous vision, enormous strength," offered Curt Columbus, the Artistic Director of the Trinity Repertory Company. "And yet, when you meet Laura, the thing that you'll get first and foremost is her sense of warmth, openness, and understanding."[7] Contrasting previous artistic directors who struggled or refused to relate to the community, Kevin Moriarity of the Dallas Theatre Center stated, "She is the best and brightest hope for the Cleveland Play House. Laura is a visionary artist—a warm and generous collaborator—and she understands that

great theatre is made in and of and for and with the community where it's located [sic]....Laura is the perfect leader to lead it forward into the next century."[8]

Bloom's prescient compliment, however, was not the only striking statement made in his final interview to the press, and the selection of Kepley as the next artistic director solved only one of the two most pressing needs of the theatre. At the end of Bloom's interview with the *Plain Dealer*, he provided one curious comment: "I'm very pleased to be leaving on a high note. I'm really proud of what we've done."[9] While the latter half of this statement does not need to be qualified, the first comment is questionable. Without a doubt, under Bloom's guidance and with the help of new facilities and engaging play selections, the Cleveland Play House has recently mounted some of its highest quality productions. However, to claim that the entire operation of the Cleveland Play House was "on a high note" is a bit disingenuous. Bloom was correct in that the artistic outlook was bright, but the theatre's economic status was an entirely different situation.

The financial condition of the theatre by May 2013 was dire as the theatre adapted to the new financial realities. At the 2012 Annual General Meeting held in the Second Stage, the Chair of the Financial Committee, Al Paulus, presented a report announcing a few positive economic accomplishments, namely that box office revenue had increased 8 percent (due mostly to single-ticket sales) and that funding of artistic and education programs had increased 17 percent, satisfying "the goal to bring more resources to mission-centric activities." However, Paulus's report also detailed the financial challenges for the theatre:

> Total contributions were down ten percent. Half of the decrease was due to the changes in CPH's special event structure. There was one joint event for "The Power of Three" as opposed to multiple events solely to benefit CPH. The other half of the decrease was in the corporate and individual categories which are sectors that were heavily solicited in "The Power of Three Campaign..." While an accounting adjustment will enable CPH to book a surplus for Fiscal Year 2012, the reality is that CPH's operations generated a deficit. There is a great deal of work to be done to build CPH's audience and donor bases moving forward.[10]

The increase in single-ticket buyers continued through the 2012–13 season, causing concern among the theatre leadership. "We maintained attendance," Moore explained, "but we traded subscribers for single-tickets buyers. We're selling a lot single tickets, but there are a few things to be apprehensive about that: one is the subscription is the most economical

way of selling a ticket. So a single ticket is the most expensive way of selling a ticket.... Single ticket buyers cost us more from the marketing point of view to get them there."[11] Moore fears that continued reliance upon single-ticket sales will make the theatre select shows for box office appeal rather than artistic merit—the same condition that plagued the theatre for decades in its former location.[12] These fears worsened when the theatre learned that its 2012–13 season ran a larger deficit than expected (approximately $600,000), leading to speculation that Bloom was fired (which proved untrue).

Further decreasing the theatre's revenue when it moved downtown, the number of subscribers opting not to renew proved to be higher than expected, losing approximately 15 percent of their subscription base. According to several board members, the greatest financial challenge for the Cleveland Play House is to raise its subscription level. "People don't understand how important subscribing to a theater series is," stated Peter Kuhn. "That it is the lifeblood of the regional theater. So if we can actually move from 4,500 subscribers to 9,000 subscribers, the Play House's future is assured and the quality of the production will be assured as well. If we can't, everybody's always going to wonder why didn't we go east where you could actually develop an audience."[13] There is a silver lining to this problem, according to Alec Pendleton: "Those single-ticket buyers are exactly the demographic we're aiming for. They're west side or south side. They're younger. We have exposed ourselves to a whole new audience."[14]

Despite changing neighborhoods, the Cleveland Play House finds itself in a new no-man's-land. The theatre has left the east side of Cleveland to reap the benefits of a central location, yet the audiences from the west and south suburbs (which the theatre desperately needs) have not yet supported the theatre in sufficient numbers to keep the institution financially stable. This point was proven when a poll was taken at the 2013 Annual General Meeting when board members were asked to raise their hands to identify in which part of town they lived. The clear majority of board members resided in the east, a handful were from the west, and none were from the south. How the Cleveland Play House taps into these markets and convinces people not only to purchase tickets, but to eventually become subscribers is the challenge facing the theatre as it moves forward. Granted, this is a challenge facing every regional theatre in America: How do theatres create/locate a theatergoing public among younger generation and/or in newer suburban communities with no tradition of supporting live theatre? The Cleveland Play House needs to find a solution to the subscription problem quickly before it caters to single-ticket buyers in its play selections.

To that end, the theatre launched a campaign to attract 4,500 new subscribers.[15] Only time (and play selections) will tell if it is successful.

Bloom, Moore, and the leadership promoted the relocation as an opportunity to improve the theatre's facilities and to rearticulate the new mission-centric focus of the theatre, but it also served as an opportunity to pursue a new business model. The theatre's 2013 strategic plan articulates the theatre's need to "create a sustainable financial model on a strong foundation of earned revenue."[16] According to the statement, five goals need to be met to ensure financial stability for the theatre, namely effective budgeting and responsible stewardship of the institutions finances, increasing the endowment, supporting holiday and summer fare in order to ensure quality programs during the season, exploring coproductions with commercial partners, and discovering new revenue streams.[17] This document reads like a commentary on past Cleveland Play House practices. The first goal demands "realistic budgeting," unlike past budgets that may have been inflated in order to enable artistic directors to pursue specific types of work. Furthermore, the desire to increase the endowment derives from years of withdrawing funds in order to cover debts accrued by the old facility.

The third and fourth goals, however, are forward-thinking proposals—objectives that the theatre immediately pursued upon its move to Playhouse Square. In an effort to generate more revenue and cut costs in its production budget, the Cleveland Play House launched new ventures with professional theatrical producers.. The first "commercially-enhanced" production in the new spaces was *One Night with Janis Joplin*, a huge success for the Cleveland theatre. "A commercial producer wanted to get the kinks out of the show," Pendleton explained, "so he put up most of the money, we produced it, and made a profit."[18] Coproduced with Arena Stage and One Night Productions, the summer 2012 show sold incredibly well, even though the majority of patrons believed that they were watching a Playhouse Square show as opposed to a Cleveland Play House production.[19] Moore detailed the reasoning behind the move to coproductions:

> When I did my analyses of what other theaters we admire are doing, there were a lot of co-productions and a lot of musicals. In the larger theatres, a lot of the co-productions seemed to be driven by artistic reasons rather than financial reasons.... It's when you choose to do a co-production purely for financial reasons, one that hurts your brand, that you risk your artistic integrity...Next year we're co-producing *Tappin' Thru Life* with Maurice Hines. We were so excited to have that on stage. We're co-producing it with the Arena and the Alliance, two theaters we deeply admire. Certainly we would not be able to

afford that project on our own. But we're thrilled to pieces that we have that project.... So I think you need to stick to a plan. There are right reasons [for co-productions]: extending the life of work, getting to do something you're excited about it... [and] building a stronger relationship with the national theater community among them.[20]

Whereas regional theatres look to receive royalties from future productions (or perhaps a Broadway run as was the case for *One Night with Janis Joplin*), Pendleton suggested that coproductions provide potential long-term benefits for the theatre. "If we're going to put on a play with five characters in it, maybe with the commercial tie we could put on a play with fifteen players," he explained. "And otherwise wouldn't be. So that would be a virtual circle that would attract a bigger audience, would sell more tickets and might subscribe next year."[21]

Despite the immediate financial concerns facing the Cleveland Play House, Moore and the board of directors remain optimistic about the theatre's future. In discussing the financial health of the institution, Moore provided a comparison between the company's final year at 86th Street and its new facility. "We haven't drawn on our line of credit in four years which is great," Moore boasted. "There was a year there toward the end on our time on Euclid where we spent over $400,000 in debt service alone.... That's the cost of a play."[22] Many board members believe that the theatre will find subscribers and that the pressing financial concerns will pass. Kuhn provided a realistic assessment for the theatre, stating, "My guess is that the theatre is always going to struggle some, but we have a chance to have this one not struggle so much."[23]

There are always going to be worries for the Cleveland Play House, as there are for every regional theatre in America. However, in its century of existence, the Cleveland Play House has weathered numerous financial crises, constructed a total of nine theatres, endured controversy with its productions and its artistic directors, navigated staffing challenges during a world war, survived repeated fire bombings from union radicals, and trained thousands of young Clevelanders through its schools. Most importantly, the theatre never stopped producing work. There is no doubt that the move downtown was the correct choice artistically: the theatre is enjoying a renaissance that most theatres will never be able to enjoy. By finding its new home and rediscovering its artistic purpose, the Cleveland Play House has the opportunity to once again become a leader in the regional theatre movement. Until 2008, the legacy of the Cleveland Play House was its longevity. Now, the theatre has the chance to redefine its legacy through

artistic accomplishments. Even though the Cleveland Play House has an astonishing record of premiering new plays, the fact remains that most of these works (regardless of their quality) were forgotten because they premiered long before the establishment of the regional theatre movement, meaning that these plays struggled to find another institution willing and able to produce new work.

The Cleveland Play House charted a brave, new course for theatre in America, providing examples of how to survive various predicaments while continuously searching for its place within the community. It is easy to forget that for the majority of its existence, the Cleveland Play House had no example to follow as peer institutions routinely folded around the country. The leadership was forced to discover its own path to success, becoming reliant upon the community (perhaps to its detriment at times) and establishing a unique relationship with the city of Cleveland unlike any other regional theatre in the country. When the Cleveland Play House moved downtown for the purpose of becoming a mission-driven institution, that sense of "community ownership" ceased to plague the theatre. It is ironic, then, that the Cleveland Play House needs support from Clevelanders more than ever, searching for supporters in the larger community and aiming to become a source of pride for all of northeast Ohio.

With the approaching centennial anniversary, the city of Cleveland will certainly celebrate its legendary institution, but theatre professionals across the country can also celebrate the centennial anniversary of regional theatre in America. Whether or not the Cleveland Play House makes it to a second centennial is impossible to determine, but the institution deserves an immense amount of respect for what it has contributed to the development of twentieth-century American theatre. In its continual search for identity, the Play House became the Cleveland Play House not only in name, but also in action and deed. Despite numerous missteps, the fact that the leadership of the theatre continuously aimed to serve the community and enrich their lives through the presentation of quality work deserves recognition. For decades, the Cleveland Play House's efforts had been distracted by a search for national recognition by linking itself with famous actors and architects, but even these misguided endeavors derived from an attempt to benefit both the city of Cleveland and its legendary theatre. The move downtown may not have been as celebrated nationally as the 1983 construction, but regional theatres have taken notice of the new Cleveland Play House and are anxious to see how the theatre thrives in its new home. The Cleveland Play House has provided a new model for other institutions to follow, according to Christopher Johnston in the

American Theatre magazine. "This ambitious plan isn't just a big deal for Cleveland," Johnston argued. "It's also on the radar of theatre managers and deal-makers from Oakland, Calif., to Newark, N.J., to Dallas to Philadelphia, all cities with expanding arts districts, who are watching this bellwether effort as a case of civic/arts partnership in action."[24]

How the relocation of the Cleveland Play House influences other companies to follow suit remains to be seen. What is certain is that the Cleveland Play House is now letting itself be inspired by its own work and its own aesthetics—reminiscent of the spirit articulated by the theatre's earliest members and supporters. No longer is the theatre searching for its place in the community or defining itself by its national reputation; instead, the Cleveland Play House hopes that the work it produces in its new facility will cause an influx of subscribers and for other theatres to look to Cleveland for inspiration and leadership. The Cleveland Play House endeavors to be the answer for playwrights searching for new opportunities; for actors, directors, and designers looking for inspiration and artistic freedom; and for patrons seeking engaging texts accompanied by the highest-quality production values. To that end, the Cleveland Play House's perpetual search for artistic accomplishment continues.

Notes

PREFACE

1. Kevin Moore, interviewed by the author, Cleveland, OH, April 28, 2010.
2. D. J. Lake, *Atlas of Cuyahoga County, Ohio* (Philadelphia, PA: Titus, Simmons, and Titus, 1874), 132.
3. J. A. Schweinfurth, "Residence of J. H. Ammon, Cleveland, OH," *American Architect and Building News, August 20, 1881* (James R. Osgood, 1880) 295.

INTRODUCTION

1. Scott Suttell, "Cleveland Play House Unveils Lineup for 2010–11 Season," Crain's Cleveland Business,, March 9, 2010, http://www.crainscleveland.com/article/20100309/FREE/100309828 (accessed March 19, 2013).
2. Cleveland Play House, "2011/2012 Season," Cleveland Play House, http://www.clevelandplayhouse.com/season/2011-2012 (accessed March 19, 2013).
3. Michael Bloom, quoted in "Cleveland Play House Announces 2011–12 Season" by Lisa Craig, Cleveland Play House Administrative Office Files, Cleveland Play House.
4. Cleveland Play House, "Overview and Mission," Cleveland Play House, http://clevelandplayhouse.com/about/overview-and-mission (accessed March 19, 2013).

1 BUILDING THE HOUSE

1. This chapter contains material from "A House in Search of a Home: A Contextual History of the Founding of the Cleveland Play House" by Jeffrey Ullom, *Ohio History Journal*, vol. 120 (2013): 70–91. Copyright © 2013 by The Kent State University Press. Reprinted with permission.
2. Joseph Wesley Zeigler, *Regional Theatre: The Revolutionary Stage* (New York: Da Capo Press, 1973), 12.
3. Julia McCune Flory, *The Play House: How It Began* (Cleveland, OH: Press of Western Reserve University, 1965), 5.

4. Carol Poh Miller and Robert Wheeler, *Cleveland: A Concise History, 1796–1990* (Bloomington: Indiana University Press, 1990), 100.
5. "Miss Charlotte Cushman," *Plain Dealer* (Cleveland), June 4, 1851, 2; "The Atheneum," *Plain Dealer*, July 18, 1853, 2; John Vacha, *Showtime in Cleveland* (Kent, OH: Kent State University Press, 2001), 53.
6. "An Opera House Burned," *New York Times*, October 30, 1892, 9; Vacha, *Showtime in Cleveland*, 44.
7. "The Opening of the New Opera House," *Plain Dealer*, September 7, 1875, 4; "Euclid Avenue Opera House," in *The Encyclopedia of Cleveland History*, edited by David D. Van Tassel and John J. Grabowski (Bloomington: Indiana University Press, 1987), 381.
8. Vacha, 50.
9. William Alexander Taylor, *The Biographical Annals of Ohio, 1902–1903* (The State of Ohio Handbook), 1903, 79; William Ganson Rose, *Cleveland: The Making of a City* (Kent: OH: Kent State University Press, 1950), 405, 449, 640.
10. "Theaters: *The Merchant of Venice*," *Plain Dealer*, January 25, 1900, 6; "A Play with Record," *Plain Dealer*, December 18, 1901, 4; "Amusements," *Plain Dealer*, March 22, 1884, 4.
11. Today, bus traffic dominates Euclid Avenue, given the October 2008 completion of the Metro Health Line that offers service from downtown to University Circle, passing by the Cleveland Clinic hospital on its route. "Cleveland RTA Honored for 'HealthLine' BRT," *Metro Magazine*, April 12, 2011, http://www.metro-magazine.com/News/Story/2011/04/Cleveland-RTA-honored-for-HealthLine-BRT.aspx (accessed May 14, 2011).
12. Foster Armstrong, Richard Klein, and Cara Armstrong, *A Guide to Cleveland's Sacred Landmarks* (Kent, OH: Kent State University Press, 1992), 5; Jan Cigliano, *Showplace of America: Cleveland's Euclid Avenue, 1850–1910* (Kent, OH: Kent State University Press, 1991), 2.
13. Ron Chernow, *Titan: The Life of John D. Rockefeller* (New York: Random House, 1998), 119.
14. Cigliano, 2, 312, 317.
15. Brad Crawford and William Manning, *Ohio* (New York: Random House, 2005), 82; Cigliano, 312.
16. Herbert H. Harwood, *Invisible Giants: The Empires of Cleveland's Van Sweringen Brothers* (Bloomington: Indiana University Press, 2003), 7; Cigliano, 317–20, 323–4.
17. Cigliano, 322.
18. Drury owned the eighty-sixth block south of Euclid Avenue as he planned to build an elaborate garden for his wife to enjoy.
19. Flory, 6–7.
20. Chloe Warner Oldenburg, *Leaps of Faith: History of the Play House, 1915–1980*, (Private publication by Oldenburg, 1985), 15; Vacha, 101; Flory, 2.

21. Flory, 4; Oldenburg, 15.
22. Flory, 4; Linda H. Davis, *Onward and Upward: A Biography of Katherine S. White* (New York: Harper and Row, 1979), 45; "Gordon to Oppose Suffrage in House," *Plain Dealer*, December 21, 1913, 4.
23. Davis, 45; Virginia Clark Abbott, *The History of Woman Suffrage and The League of Women Voters in Cuyahoga County, 1911–1945* (Cleveland, OH: League of Women Voters, 1949), 45.
24. Abbott, 32.
25. Aileen S. Kraditor, *The Ideas of the Woman Suffrage Movement, 1890–1920* (New York: Columbia University Press, 1965), 258.
26. Davis, 17, 44–7. Angell was an avid Red Sox fan, and she frequently took her children on walks near League Park, the home of the Cleveland Indians; ibid.
27. Katharine S. Davis and Elizabeth Lawrence, *Two Gardeners: A Friendship in Letters*, edited by Emily Herring Wilson (Boston: Beacon Press, 2003), xi; Davis, 1, 47.
28. Minerva Brooks, quoted in *The Play House: How It Began* by Julia McCune Flory (Cleveland, OH: The Press of Western Reserve University, 1965), 4.
29. Flory, 4.
30. Davis, 44–6.
31. "Brooks, Charles Stephen," *The Encyclopedia of Cleveland History*, http://ech.cwru.edu/ech-cgi/article.pl?id=BCS1 (accessed March 21, 2011); Florence Milner, *My Acquaintance with Charles S. Brooks* (New York: Harcourt, Brace, 1932), 3–4.
32. "Ohio Suffragists to Gather Here This Week," *Plain Dealer*, November 18, 1915, 6; Abbott, 25, 32.
33. Flory, 7.
34. "Kokoon Art Klub Runs Riot in Oils," *Plain Dealer*, July 22, 1911, 3.
35. "The Kokoon Arts Club," *The Encyclopedia of Cleveland History*, edited by David D. Van Tassel and John J. Grabowski (Bloomington: Indiana University Press, 1987), 597; "Kokoon Club Will Move," *Plain Dealer*, December 14, 1913, 13.
36. "Hoop La! Cleveland Artists at Play," *Plain Dealer*, January 12, 1913, 51.
37. Gerald Martin Bordman and Thomas S. Hischak, "Play House," *Oxford Companion to American Theatre* (Oxford: Oxford University Press, 2004), 134.
38. Flory, 2; "'Kliz' Illustrator Dies: G.H.H. Clisbee was Former Art Editor of *Cleveland News*," *Plain Dealer*, December 6, 1936, 16; "Showman Here on Trail Dad Broke," *Plain Dealer*, February 3, 1930, 18.
39. "Music and Musicians," *Plain Dealer*, June 28, 1903, 32; "Music and Musicians," *Plain Dealer*, December 29, 1907, 29.
40. "Oh Joy! What a Gay Time They'll Have," *Plain Dealer*, April 15, 1915, 12. The title of the production is listed differently in two different articles, as "*La Nuit Futuriste!*" and the simpler "*La Nuit Futurist.*" For consistency, I have chosen the former for all references in this work.
41. Lora Kelly, "Splurge? Yes-siree! Futurists Made It," *Play House*, April 28, 1915, 1.

42. Grace Goulder, "They're Seals and Seedlings Now," *Plain Dealer*, December 26, 1915, 38; Grace Goulder, "Society Arranges Two Dramas Here," *Plain Dealer*, April 12, 1916, 9.
43. "Brooks, Minerva Kline," *The Encyclopedia of Cleveland History*, http://ech.cwru.edu/ech-cgi/article.pl?id=BMK (accessed March 21, 2011).
44. "Peeks at Garments at Futurist Ball," *Plain Dealer*, April 28, 1915, 3; "Poiret Girl of Future May Seem Shocking Now, but She'll Be Comfortable and Eugenic, Then," *Plain Dealer*, October 18, 1914, 58.
45. "Course; Atrocious Futurist," *Plain Dealer*, March 15, 1914, 42; G. K. Chesterton, "Is New York Drifting to a Tragic Future?" *Plain Dealer*, July 26, 1914, 34.
46. Karl K. Kitchen, "All about Awful Art," *Plain Dealer*, March 24, 1913, 6; "Plain Deals," *Plain Dealer*, May 29, 1914, 10.
47. "Plain Deals," *Plain Dealer*, February 11, 1914, 6; "Sea Dog 'Hardens' Italy's Princeling," *Plain Dealer*, June 10, 1914, 10.
48. Flory, 9; Oldenburg, 16.
49. "Gordon to Oppose Suffrage in House."
50. Phillip W. Porter, *Cleveland: Confused City on a Seesaw* (Columbus: Ohio State University Press, 1976), 7–8.
51. Miller and Wheeler, 112.
52. Eleanor Flexner, *Century of Struggle: The Woman's Rights Movement in the United States* (Cambridge, MA: The Belknap Press of Harvard University Press, 1959), 259, 267–8.
53. Nell Irvin Painter, *Standing at Armageddon: The United States, 1877–1919* (New York: W. W. Norton, 1987), 248; "Militants Wreck Suffrage Merger," *Plain Dealer*, November 15, 1915, 5.
54. "Deny Ohio Women Will Help Move to Fight Democrats," *Plain Dealer*, September 15, 1914, 1.
55. "Suffrage Leaders Chosen by Party Here," *Plain Dealer*, February 2, 1914, 7.
56. "Leader of Suffrage Party in County Has Charming Personality, a Quick Mind and Statesmanship," *Plain Dealer*, May 24, 1914, 76.
57. *The History of Women's Suffrage*, vol. 6, edited by Ida Husted Harper (J. J. Little and Ives, 1922), 512; "Cuyahoga County Republican Party," *The Encyclopedia of Cleveland History*, edited by David D. Van Tassel and John J. Grabowski (Bloomington: Indiana University Press, 1987), 322.
58. Flory, 8.

2 AVERTING DISASTER AND IGNORING CLEVELAND

1. Richard Moody and Don B. Wilmeth, "Community theatre/Little Theatre movement," *The Cambridge Guide to American Theatre* (Cambridge: Cambridge

University Press, 2007), 178. This same error is repeated in *The Historical Dictionary of American Theatre Modernism* (2008) by James Fischer and Felicia Hardison Londré.
2. Dorothy Chansky, *Composing Ourselves: The Little Theatre Movement and the American Audience* (Carbondale: Southern Illinois University, 2004), 4–5.
3. Clarence Arthur Perry, *The Work of Little Theatres* (New York: Russell Sage Foundation, 1933), 9; Alexander Dean, *Little Theatre Organization and Management* (New York: Appleton, 1926), 1.
4. Dean, 10.
5. Chansky, 6.
6. Ibid., 4.
7. Constance D'Arcy Mackay, *The Little Theatre in the United States* (New York: Henry Holt, 1917), 1, 7.
8. Ibid., 15; Chansky, 4–5.
9. S. Marion Tucker, "Progress, Problems and Prospects," *Conference on the Drama* (Pittsburgh: Carnegie Institute of Technology, 1926), 128.
10. Ben Blake, *The Awakening of the American Theatre* (New York: Tomorrow Publishers, 1936), 6.
11. Dean, 36.
12. Charles S. Brooks, "The Play House," *Theatre Arts Monthly*, edited by Edith J. R. Isaacs (New York: Theatre Arts, Inc.), vol. 10, no. 8 (August 1926), 521–2; Mackay 14–5. In the Play House's defense, the Provincetown Play House also produced two plays by Kreymborg during the same period, yet they also produced many Eugene O'Neill plays. Ibid.
13. Whereas many critics in other cities warned their readers of the controversial content in Ibsen's plays, the enthusiasm of the *Plain Dealer*'s theatre critics is evident in the titles of their articles: "A Great Norwegian Reformer" and "Ibsen's Dramas: The Author's Conversion from Romanticism." As further proof of Cleveland's awareness of Ibsen and his intentions, these articles were both printed in 1890, six years before Mrs. Fiske's return. "A Great Norwegian Reformer," *Plain Dealer* (Cleveland), June 2, 1890, 1; "Ibsen's Dramas: The Author's Conversion from Romanticism," *Plain Dealer*, April 21, 1890.
14. Archie Binns, *Mrs. Fiske and the American Theatre* (New York: Crown Publishers, 1955), 24, 59.
15. "Advertisement: Seat Sale Thursday," *Plain Dealer*, January 13, 1907, 14; "Amusements," *Plain Dealer*, April 28, 1908, 8; "Exiled Actress Here," *Plain Dealer*, March 31, 1910, 2; "*Pillars of Society*," *Plain Dealer*, September 15, 1910, 4; "Will Play in Ibsen Drama," *Plain Dealer*, December 6, 1914, 4; "Advertisement: Stillman Theatre," *Plain Dealer*, June 10, 1917, 44.
16. "Good Old Fashioned Fairy Story is Told in Beautiful Dramatic Form," *Plain Dealer*, February 18, 1912, 43; Archie Bell, "Sarah Bernhardt and Mrs. Leslie Carter are Features at Theatres," *Plain Dealer*, November 13, 1910, 32; Archie Bell, "Hauptmann's *The Sunken Bell* for Special Local Matinee," *Plain Dealer*,

March 26, 1911, 34; "Woman's Page: Society Clubs," November 6, 1912, 11; "Mr. Mansfield's Repertoire," *Plain Dealer*, April 20, 1897, 6; "Society Events," *Plain Dealer*, May 14, 1912, 11.
17. Mackay, 5, 21;
18. Chansky, 6; Dean, 36.
19. Dean, 10.
20. Jon Jory, quoted in "Actors Theatre's First Ten Years: From Rags to Riches" by William Mootz, *Courier-Journal* (Louisville), May 26, 1974. Jory, who guided the small theatre to international acclaim, also described "institutional theatre" as a goal for Actors Theatre of Louisville early in his tenure. Ibid.
21. Julia McCune Flory, *The Play House: How It Began* (Cleveland, OH: Press of Western Reserve University, 1965), 10.
22. Ibid.
23. "Letter to Mr. E. F. Lenihan," April 5, 1918, Correspondence boxes, CPH Archives, accessed June 11, 2011. All future references to documents found in these archives will be labeled "CPH Archives."
24. Maude Truesdale, "A Cleveland Group Puts Art on the Stage and Makes the Box Office its Test," *Plain Dealer*, February 17, 1924, 86; "Seventy-Fifth Anniversary of the Play House" (Cleveland, OH: Play House Promotional Publication, 1990), 3.
25. Truesdale, "A Cleveland Group Puts Art on the Stage and Makes the Box Office its Test"; Drury 10.
26. Oldenburg, 16–17; Julia M. Flory, 12.
27. Julia M. Flory, 12.
28. Rice Hershey, *The Play House: Sixty Years of Professional Resident Theatre* (Cleveland, OH: Play House Promotional Publication, 1975), 22; Oldenburg, 164.
29. Walter Flory replaced Charles S. Brooks who left with Minerva to live in New York.
30. Julia M. Flory, 14–5.
31. Lora Kelly, "Cleveland's Little Theater," *Plain Dealer*, May 13, 1917, 53.
32. Ibid.; Oldenburg, 17; Julia M. Flory, 15–6. The government would declare war on Germany within a month.
33. Frances E. Drury, quoted in *The Play House: How it Began* by Julia M. Flory, 16.
34. John Vacha, *Showtime in Cleveland* (Kent, OH: Kent State University Press, 2001), 102.
35. Oldenburg, 18; Holly Rarick Witchey and John Vacha, *Fine Arts in Cleveland: An Illustrated History* (Bloomington: Indiana University Press, 1994), 76; Julia M. Flory, 18.
36. Edward Braun, *The Director and the Stage* (New York: Holmes and Meier, 1982), 93; Jane Milling and Graham Key, *Modern Theories of Performance* (New York: Palgrave, 2001), 43, 51.
37. Julia M. Flory, 5.

38. Christopher Innes, *Edward Gordon Craig* (Cambridge: Cambridge University Press, 1983), 3.
39. "McBride, Lucia McCurty," *The Encyclopedia of Cleveland History*, http://ech.cwru.edu/ech-cgi/article.pl?id=MLM (accessed July 18, 2011).
40. L. M. Knight, "Letter to Walter Flory—December 17th, 1918," CPH Archives (accessed May 31, 2011).
41. Raymond O'Neil, "Letter to Walter Flory—December 18, 1918," CPH Archives (accessed May 31, 2011).
42. Walter Flory, "Letter to Raymond O'Neil—December 21, 1918)," CPH Archives (accessed May 31, 2011).
43. Walter Flory, "Letter to Charles S. Brooks—March 11, 1919," CPH Archives (accessed May 31, 2011).
44. Ruth Fischer, "The Play House: The Nation's First Professional Resident Theatre Company" (Cleveland, OH: Play House, 1963), 2.
45. Raymond O'Neil, "Letter to Mrs. Edna Strong Hatch—February 22, 1921," CPH Archives (accessed May 31, 2011).
46. Oldenburg, 56, 60.
47. Julia M. Flory, 65.
48. Mrs. Cary Alburn, "*Why the Chimes Rang* as Presented in Cleveland," *The Drama*, vol. 11, no. 2 (November 1920): 61, 64.
49. "Library Players Score Big Success," *Plain Dealer*, February 5, 1921, 7 (Women's Magazine Section); Irving Marsan Brown, *Cleveland Theatre in the Twenties* (PhD diss., Ohio State University, 1961), 70.
50. Witchey and Vacha, *Fine Arts in Cleveland*, 74.
51. Ibid.; Brown, 161.
52. Mackay, 115; Brown, 163.
53. Walter Flory, "Letter to Raymond O'Neil—July 7, 1917," CPH Archives (accessed May 31, 2011).
54. Ibid.
55. Julia M. Flory, 36.
56. Walter Flory, "Report of the President of the Play House," taken from *The Play House: How it Began* by Julia M. Flory (Cleveland, OH: Press of Western Reserve University, 1965), 37–54.
57. Ibid., 54–5.
58. Walter Flory, "Letter to Charles S. Brooks—March 11, 1919," CPH Archives (accessed May 31, 2011).
59. Henry Turner Bailey, quoted in *The Cleveland Year Book 1921*, edited by Mildred Chadsey (Cleveland, OH: Cleveland Foundation, 1921) 266.
60. Ibid.
61. Witchey and Vacha, 61.
62. Donald Rosenberg, *The Cleveland Orchestra Story: Second to None* (Cleveland, OH: Gray, 2000), 43–4; Brown, 16; *The Cleveland Year Book 1921*, 272.
63. Rosenberg, 40.

64. Witchey and Vacha, 70.
65. Helen Chew and C. E. Gehlke, *Directory of Civic and Welfare Activities of Cleveland* (Cleveland, OH: Cleveland Foundation, 1923), 191.
66. "Membership," *The Bulletin of the Cleveland Museum of Art* (Cleveland, OH: Cleveland Museum of Art), vol. 2, no. 3 (1916), 7–8; Julia M. Flory, 21; Cleveland Orchestra, "Program" (Cleveland, OH: Musical Arts Association, 1966), 985.
67. William Ganson Rose, *Cleveland: The Making of a City* (Kent, OH: Kent State University Press, 1990), 783.
68. Witchey and Vacha, 59.
69. Ibid., 68; "The Cleveland Museum of Art," in *The Encyclopedia of Cleveland History*, edited by David D. Van Tassel and John J. Grabowski (Bloomington: Indiana University Press, 1987), 252.
70. Rosenberg, 48; William Ganson Rose, 736; Witchey and Vacha, 68.
71. Finance Committee, "This letter sent October 1st to…—September 17, 1918," CPH Archives (accessed May 31, 2011).
72. Walter Flory, "Letter to Raymond O'Neil—February 17, 1919," CPH Archives (accessed May 31, 2011).
73. Walter Flory, "Report of the President of the Play House," 42–3; William A. Allman, *An Investigation of a Successful Civic Theatre as Exemplified by the Play House* (Master's thesis, Ohio University, 1951), 13.
74. Walter Flory, "Report of the President of the Play House," 43.
75. Dean, 3–4.
76. Ibid., 8.
77. Julia M. Flory, 66. According to the US Inflation Calculator, the debt of $1,200 in 1919 would be the equivalent of $15,132.20 in 2011. US Inflation Calculator, "Find the U.S. Dollar's Value from 1913–2011" http://www.usinflationcalculator.com/ (accessed July 30, 2011).
78. Rose, 781.
79. Mildred Chadsey, ed., *The Cleveland Year Book 1922* (Cleveland, OH: Cleveland Foundation, 1922), 114.
80. Ibid., 115.
81. Brown, 8; Chadsey, 117.
82. Rose, 779.
83. Brown, 5.
84. They experienced a total loss of 56 members. Margaret T. Numsen, "Membership Report," *Bulletin of the Cleveland Museum of Art*, vol. 6, no. 9 (November 1919): 141.
85. Frederic Allen Whiting, "Your Museum Calls for Help," *Bulletin of the Cleveland Museum of Art*, vol. 9, no. 7 (July 1922): 120.
86. Rosenberg, 75.
87. Ibid., 76.
88. Julia M. Flory, 67–8.

89. Ibid., 68.
90. Brown, 28.
91. Ibid.; John Wray Young, *The Community Theatre and How It Works* (New York: Harper and Brothers, 1957), 2–3.
92. Chansky, 6; Dean, 36.
93. Dean, 36.
94. Chansky, 6.
95. "The Copley Theater (1916–1957?)," The Boston Athenæum, http://www.bostonathenaeum.org/node/224#n (accessed July 30, 2011); "A History of the Provincetown Playhouse," http://www.provincetownplayhouse.com/history.html (accessed August 1, 2011); Joseph Wesley Zeigler, *Regional Theatre* (New York: Da Capo Press, 1977), 10; Howard Taubman, *The Making of the American Theatre* (New York: Coward-McCann, 1965), 150–1.

3 LEARNING CURVE

1. "Harvard Group Brings Plays to Duchess Theatre," *Plain Dealer* (Cleveland), April 10, 1921, 66.
2. Julia M. Flory, *The Play House: How It Began* (Cleveland, OH: Press of Western Reserve University, 1965), 70.
3. Melvin R. White, "Thomas Wood Stevens: Creative Pioneer," *Educational Theatre Journal*, vol. 3, no. 4 (December 1951), 283–4; Julia M. Flory, 70.
4. "Play House to Repeat Oscar Wilde's Comedy," *Play House*, October 2, 1921, 3.
5. John Vacha, *Showtime in Cleveland* (Kent, OH: Kent State University Press, 2001), 104; Flory, 70.
6. Chloe Warner Oldenburg, *Leaps of Faith: History of the Play House, 1915–1980* (Cleveland, OH: Private publication by author, 1985), 21.
7. Flory, 71.
8. K. Elmo Lowe, "Letter to Frederic McConnell—July 9, 1922," CPH Archives (accessed June 11, 2012).
9. Ibid.
10. Frederic McConnell, "Letter to K. Elmo Lowe—July 14, 1922," CPH Archives (accessed June 11, 2012).
11. Oldenburg, 23.
12. Ibid.
13. Ibid., 24.
14. Harlowe Holt, "Town Gadabout," source unknown, Play House Scrapbook (1929), CPH Archives (accessed June 11, 2012).
15. "Birthday—Max Eisenstat," *Plain Dealer*, September 6, 1936, 15-A.
16. Oldenburg, 24.
17. "Birthday—Max Eisenstat;" Vacha, 104.

18. Flory, 72. Flory recounts her conflicting feelings about the cyclorama being dismantled: "This truly tore my heartstrings, but doubtless it *was* an impractical contraption." Ibid.
19. Frederic McConnell, quoted in Oldenburg, 23.
20. Frederic McConnell, quoted in "Play House Season's Plans," *Plain Dealer*, September 4, 1921, 40.
21. "Projected Budget: 1922–1923," CPH Archives (accessed June 11, 2012).
22. Vacha, 104.
23. Joseph Wesley Zeigler, *Regional Theatre: The Revolutionary Stage* (New York: Da Capo Press, 1973), 12.
24. An example of this dictate is seen in a Charles D. Brooks's letter to McConnell in which he lists the "building of the audience" as the second-most important endeavor of the Play House (producing quality plays was listed first). Charles S. Brooks, "Letter to Frederic F. McConnell—March 8, 1923," CPH Archives (accessed June 11, 2012).
25. Ibid.; Frederic McConnell, "Director's Report on Play House Extension—30 January 1922," CPH Archives (accessed June 11, 2012).
26. Irving Marsan Brown, *Cleveland Theatre in the Twenties* (PhD diss., Ohio State University, 1961), 189.
27. Charles S. Brooks, quoted in Flory, 84.
28. "Progressive (Political) Parties," *The Encyclopedia of Cleveland History*, edited by David D. Van Tassel and John J. Grabowski (Bloomington: Indiana University Press, 1987), 799.
29. "Education," *The Encyclopedia of Cleveland History*, edited by David D. Van Tassel and John J. Grabowski (Bloomington: Indiana University Press, 1987), 364–5.
30. Thomas Munro and Jane Grimes, *Educational Work at the Cleveland Museum of Art, 2nd Edition* (Cleveland, OH: Cleveland Museum of Art, 1952), 36.
31. Holly Rarick Witchey and John Vacha, *Fine Arts in Cleveland: An Illustrated History* (Bloomington: Indiana University Press, 1994), 68.
32. Ibid., 70; Munro and Grimes, 45, 47.
33. Munro and Grimes, 46–7.
34. Ibid., 35.
35. Donald Rosenberg, *The Cleveland Orchestra Story: Second to None* (Cleveland, OH: Gray, 2000), 119.
36. "Education," *Encyclopedia of Cleveland History*, 365; Witchey and Vacha, 82–3; Rosenberg, 119–20.
37. Rosenberg, 120.
38. Witchey and Vacha, 83.
39. Flory, 79. Unlike O'Neil, McConnell wisely gave the group his blessing, preferring not to exclude any members early in his tenure.
40. Cornelia Curtiss, "Puppet Player's Guild to Stage Marionet [*sic*] Show for Benefit of Park School," *Plain Dealer*, November 13, 1921, 13. Her book

is titled *A Book of Marionettes*. She also penned several plays for puppets as well.
41. "*Beyond the Horizon* Next Play House Bill," *Plain Dealer*, November 20, 1921, 60; William F. McDermott, "Local Group Puppet Play Activities," *Plain Dealer*, November 19, 1921, 10.
42. Cornelia Curtiss, "Music and Marionettes Attractions," *Plain Dealer*, November 26, 1921, 11.
43. Ibid.
44. Flory, 106.
45. Nellie McCaslin, *Historical Guide to Children's Theatre in America* (New York: Greenwood Press, 1987), 13.
46. Jed H. Davis and Mary Jane Larson Watkins, *Children's Theatre: Play Production for the Child Audience* (New York: Harper & Brothers, 1960), 8.
47. McCaslin, 75.
48. Davis and Watkins, 6.
49. McCaslin, 75–6; Davis and Watkins, 6–7.
50. Curtiss, "Puppet Player's Guild," 13, 15.
51. Pamela DiPasquale, interview by the author, email correspondence, June 13, 2012; "Children's Theatre of Main History," Children's Museum and Theatre of Main, http://www.kitetails.org/about-us/our-history/theatre-history/ (accessed July 2, 2012).
52. Roger Bedard, interview by the author, email correspondence, July 2, 2012.
53. Frederic McConnell, "Letter to Mr. Brooks—October 31, 1924," CPH Archives (accessed June 11, 2012).
54. Frederic McConnell, "Letter to Homer H. Johnson," CPH Archives (accessed June 11, 2012); Flory, 79. Collins later became a member of the Group Theatre and performed on Broadway.
55. William Benjamin Clark Jr., *A History of the Play House, 1936–1968* (PhD diss., Tulane University, 1968), 12–13.
56. Frances G. Nash, "Letter to Frederic McConnell—April 11, 1923," CPH Archives (accessed June 11, 2012); Frederic McConnell, "Letter to Miss Irma Milde—May 21, 1923," CPH Archives (accessed June 11, 2012); Oldenburg, 34–5.
57. Oldenburg, 34–5.
58. "Play House's New Curtain Pullers Hold First Show," *Plain Dealer*, January 28, 1934, 50.
59. Ibid.; Oldenburg, 41–2.
60. Clark, 13–14.
61. Flory, 127.
62. Ibid, 128–9.
63. Oldenburg, 33.
64. Frederic McConnell, "Director's Report on Play House Extension—30 January 1922."

65. Oldenburg, 24–5.
66. Flory, 111.
67. "New Play House Expected to Be Ready April 1st," *Plain Dealer*, June 13, 1926, 76; Oldenburg, 27.
68. Flory, 72.
69. Ibid., 111; Oldenburg, 26.
70. Flory, 112–3.
71. Oldenburg, 27.
72. Ibid.; Flory 111.
73. Flory, 112.
74. David C. Hammack and Helmut K. Anheier, "American Foundations: Their Roles and Contributions to Society," in *American Foundations: Roles and Contributions*, edited by Helmut K. Anheier and David C. Hammack (Washington, DC: Brookings Institution Press, 2010), 16–17; James Allen Smith, "Foundations as Cultural Actors," *American Foundations: Roles and Contributions*, 269.
75. Hammack and Anheier, 17.
76. F. Emerson Andrews, *Philanthropic Giving* (New York: Russell Sage Foundation, 1950), 106.
77. "The Cleveland Foundation," *The Encyclopedia of Cleveland History*, compiled and edited by David D. Van Tassel and John J. Grabowski (Bloomington: Indiana University Press, 1987), 234.
78. Diana Tittle, *Rebuilding Cleveland: The Cleveland Foundation and Its Evolving Urban Strategy* (Columbus: Ohio State University Press, 1992), 71–2.
79. Flory, 112.
80. William Benjamin Clark, Jr., "A History of the Play House, 1936–1968" (Ph.D. Dissertation, Tulane University, 1968), 15–6.
81. Cornelia Curtiss, "American Theater Society and Play House to Present Series of Interesting Plays," *Cleveland Plain Dealer*, October 2, 1932, 31, 33; Cornelia Curtiss, "Travel, Guests," *Cleveland Plain Dealer*, October 21, 1932, 14.
82. Oldenburg, 38.
83. In Cleveland, the toll of the Depression is best reflected by the fact that "no other theatre was playing" when the Play House opened its 1934–35 season. Ibid., 42.
84. Cornelia Curtiss, "Cleveland Skating Club Sets Pattern for Other Cities as More Private Rinks Go Up," *Cleveland Plain Dealer*, January 21, 1938, 14; William F. McDermott, "Recalling the Beginnings on 86th Street, the Progress Made and Still to be Made," *Cleveland Plain Dealer*, April 11, 1937, 69; Oldenburg, 33, 36, 43.

4 "CATCH THESE VANDALS!"

1. "Labor Linked with Bombing at Play House," *Cleveland Press*, September 24, 1937, 1; "Union to Aid in Bombing Probe," *Cleveland Press*, September 27, 1937, 4.
2. John Vacha, *Showtime in Cleveland* (Kent, OH: Kent State University Press, 2001), 157.

3. Chloe Warner Oldenburg, *Leaps of Faith: History of the Play House, 1915–1980* (Cleveland, OH: Published by the author, 1985), 49.
4. William F. McDermott, "The Play House," *Theatre Guild Magazine*, vol. 7, no. 12 (September 1930), 44.
5. Oldenburg, 40.
6. C. M. Streator, "What Readers Think of the Play House and Critics," *Plain Dealer* (Cleveland, OH), January 24, 1932, 40.
7. Ibid.
8. It should be noted that this production or the criticism that followed is not mentioned in Chloe Oldenburg's book.
9. Oldenburg, 26, 36; "Free of Debt," *Plain Dealer*, May 25, 1936, 10.
10. Mildred Chadsey, ed., *The Cleveland Year Book 1921* (Cleveland, OH: Cleveland Foundation, 1921), 279.
11. Oldenburg, 35; The Play House finally became an equity house (meaning only union members could join the resident company) in 1958. "Play House." *The Encyclopedia of Cleveland History*, edited by David D. Van Tassel and John J. Grabowski (Bloomington: Indiana University Press, 1987), 259.
12. "Stage Union to Install," *Play House*, January 3, 1937, 25.
13. "Explain Why Union Demand was Rejected," *Cleveland Press*, September 24, 1937, 24.
14. Laurence H. Norton and Frederic McConnell, "Play House Statement," cited in "Union Heads Deny Play House Plot" *Plain Dealer*, September 25, 1937, 1.
15. Ibid. The motion to declare the theatre "unfair" was adopted on September 1, 1937. Spencer Fullerton, "C.F.L. Votes Barrington Support," *Plain Dealer*, September 2, 1937, 1.
16. John B. Fitzgerald, quoted in "Union Heads Deny Play House Plot," 4.
17. Ibid., 1; "Labor Linked with Bombing at Play House."
18. "Labor Linked with Bombing at Play House."
19. John B. Fitzgerald and William Finnegan, "Union Statement," *Cleveland Press*, October 4, 1937, 1.
20. Paul Bellamy, "Ill-Timed Picketing," *Plain Dealer*, October 5, 1937, 8.
21. Andrew Dawson, "Strikes in the Motion Picture Industry," *The Encyclopedia of Strikes in American History*, edited by Aaron Brener, Benjamin Day, and Immanuel Ness (Armonk, NY: M. E. Sharpe, 2009), 654; David Witwer, *Shadow of the Racketeer: Scandal in Organized Labor* (Urbana: University of Illinois Press, 2009), 60–1.
22. *100 Years of Solidarity, 1893–1993* (New York: International Alliance of Theatrical Stage Employees, 1993) 6, 25–6, http://www.iatse-intl.org/about/IATSE-history/index.html (accessed March 28, 2012).
23. William McDermott, "McDermott on Bombs," *Plain Dealer*, September 25, 1937, 7.
24. William Benjamin Clark Jr., *A History of the Play House, 1936–1968* (PhD diss., Tulane University, 1968), 257; McDermott, "McDermott on Bombs."

The $14,800 total reflects McDermott's assertion that the first three union men are paid $75 a week and the remaining two are paid $72.50 a week.
25. "Labor Linked with Bombing at Play House"; "Ace Little Theatre Cuts 20%," *Variety*, January 5, 1932, 51.
26. Oldenburg, 40–1.
27. "Play House Burns Mortgage Today," *Plain Dealer*, May 27, 1936, 1, 8.
28. Ibid.; Oldenburg, 43.
29. Richard Christiansen, *A Theatre of Our Own* (Evanston, IL: Northwestern University Press, 2004), 64; "Boston Athenaeum Theatre History," Proprietors of the Boston Athenaeum, http://www.bostonathenaeum.org/node/224 (accessed April 1, 2012); Gilmor Brown, "A Dream on a Dime," *Ten Talents in the American Theatre*, edited by David H. Stevens (Norman: University of Oklahoma Press, 1957), 165; Howard Taubman, *The Making of the American Theatre* (New York: Coward-McCann, 1967), 150.
30. "Must Broadway Take a Back Seat?" *Literary Digest*, vol. 114, no. 7 (August 13, 1932), 14–15; Clarence Arthur Percy, *The Work of the Little Theatres* (New York: Russell Sage Foundation, 1933), 27–47.
31. Joseph Wesley Zeigler, *Regional Theatre: The Revolutionary Stage* (New York: Da Capo Press, 1973), 109; Christiansen, 147–8.
32. Kenneth Macgowan, *Footlights across America: Toward a National Theater* (New York: Harcourt, Brace, 1929), 103.
33. Nahma Sandrow, *Vagabond Stars: A World History of Yiddish Theater* (Syracuse, NY: Syracuse University Press, 1996), 259, 274.
34. Oldenburg, 35.
35. Vacha, 118; Macgowan, 103.
36. Ibid.
37. Brian M. Harvard, "National Labor Relations Board v. Jones and Laughlin Steel Corp.," *The Encyclopedia of the United States Constitution*, edited by David Andrew Schultz (New York: Facts on File, 2009), 496–7.
38. Nelson Lichtenstein, *State of the Union: A Century of American Labor* (Princeton, NJ: Princeton University Press, 2002), 36.
39. "Timeline," *The Encyclopedia of Strikes in American History*, edited by Aaron Brenner, Benjamin Day, and Immanuel Ness (Armonk, NY: M. E Sharpe, 2009), xxi.
40. Lichtenstein, 39.
41. P. K. Edwards, *Strikes in the United States, 1881–1974* (New York: St. Martin's Press, 1981), 136.
42. Robert Bruno, "Steel on Strike: From 1936 to the Present," *The Encyclopedia of Strikes in American History*, 360.
43. "Timeline," *The Encyclopedia of Strikes in American History*.
44. "Little Steel Strike," *The Encyclopedia of Cleveland History*, edited by David D. Van Tassel and John J. Grabowski (Bloomington: Indiana University Press, 1987), 639.

45. Bruno, 362.
46. American Social History Project, *Who Build America?*, edited by Stephen Brier (New York: Pantheon Books, 1989), vol. 2, 418; Bruno, 363–4.
47. Robert H. Zieger and Gilbert J. Gall, *American Workers, American Unions: The Twentieth Century* (Baltimore: Johns Hopkins University Press, 2002), 97.
48. American Social History Project, 418; Bruno, 363–4.
49. Bruno, 364.
50. American Social History Project, 418.
51. Bruno, 364.
52. "Little Steel Strike," *The Encyclopedia of Cleveland History*; American Social History Project, 418.
53. American Social History Project, 419.
54. "60 Hurt in Night Steel Strike Clash," *Plain Dealer*, July 27, 1937, 1.
55. Bruno, 364.
56. Christopher R. Martin, "The News Media and Strikes," *The Encyclopedia of Strikes in American History*, edited by Aaron Brenner, Benjamin Day, and Immanuel Ness (Armonk, NY: M. E. Sharpe, 2009), 46.
57. George Seldes, *Lords of the Press* (New York: Blue Ribbon Books, 1941), p. 400.
58. Paul Bellamy, "Catch These Vandals!" *Plain Dealer* (September 28, 1937), 22-A.
59. Laurence H. Norton, quoted in "Union Letter of Teachers Stirs Anger," *Plain Dealer*, June 13, 1934, 1.
60. The third trustee, Mrs. Malcolm McBride, had no connection to unions nor apparently did her husband.
61. "Wagner Act Aids Tilt with Critic," *Plain Dealer*, March 11, 1938, 5.
62. "Labor Union's Rights: High School Pupils Will Settle One Point Tonight," *Plain Dealer*, January 20, 1905, 10; Delos Franklin Wilcox, *Analysis of the Electric Railway Problem* (New York: published by the author, 1921), 543–4.
63. Alexander C. Brown, "What the Chamber of Commerce Can Do in Promoting Better Industrial Relations in a Community," *Constructive Experiments in Industrial Cooperation between Employers and Employees* (New York: Academy of Political Science in the City of New York), vol. 9, no. 4 (January 1922): 213–4, 216–7; "Blood Was Shed," *The Spokesman Review* (Spokane, WA), August 2, 1896, 1; Anthony T. Kronman, *History of the Yale Law School* (New Haven: Yale University Press, 2004), 114–5; "Back at Foundry Today," *Plain Dealer*, May 7, 1935, 14; "Hanna, Leonard C. Jr.," *The Encyclopedia of Cleveland History*, 486; "Advertisement—Annual Report of the M.A. Hanna Company," *Plain Dealer*, February 19, 1933, 22.
64. To combat this perception, wives of union members eventually penned letters to the editors of the *Cleveland Press* and the *Plain Dealer*. Clark Jr., 246.
65. Philip Dray, *There Is Power in a Union: The Epic Story of Labor in America* (New York: Doubleday, 2010), 8.
66. Ibid., 421.

218 *Notes*

67. Play House Programs, "The Play House—October 4, 1939," 3, CPH Archives (accessed June 18, 2012).
68. McDermott, "McDermott on Bombs."
69. Paul Bellamy, "Ill-Timed Picketing," *Plain Dealer*, October 5, 1937, 8.
70. Ibid.; "Union Heads Deny House Plot," 4.
71. Play House Programs, "The Play House—October 1, 1937," 15, CPH Archives (accessed June 18, 2012).
72. Ibid.

5 CATERING TO CLEVELAND

1. The book's title page is typed except for the "45" of the final year, suggesting that the book was created during the war without any idea when it would conclude.
2. Donald J. Rauch, "Letter to 'Max'—May 11, 1942," CPH Archives (accessed September 7, 2012).
3. Donald J. Rauch, "Letter to 'Max'—November 14, 1942," CPH Archives (accessed September 7, 2012).
4. Donald J. Rauch, "Letter to 'Dear Gang'—February 17, 1943," CPH Archives (accessed September 7, 2012).
5. "Wedding Announcement," date unspecified, CPH Archives (accessed September 7, 2012).
6. Donald J. Rauch, "Letter to 'Maxie'—December 17, 1944," CPH Archives (accessed September 7, 2012).
7. "Elderkin, N. S., Jr.," "The Play House Log of Participation in World War, 1940–1945," CPH Archives (accessed September 7, 2012).
8. "Hartman, Elek," "The Play House Log of Participation in World War, 1940–1945," CPH Archives (accessed September 7, 2012).
9. Frederic McConnell, "Play House Call Board Note," CPH Archives (accessed September 7, 2012).
10. Chloe Warner Oldenburg, *Leaps of Faith: History of the Play House, 1915–1980* (Cleveland, OH: Published by the author, 1985), 56.
11. William F. McDermott, "New Lunt and Fontanne Play Forgets the World and Goes in for Laughter," *Plain Dealer*, September 20, 1942, 13-B.
12. "About Us—History," The Pasadena Playhouse, http://www.pasadenaplayhouse.org/about-us/history.html (accessed September 25, 2012).
13. "Our History," McCarter Theatre Center, http://www.mccarter.org/AboutUs/AboutDefault.aspx?page_id=38 (accessed September 25, 2012); "Our History," The Goodman Theatre, http://www.goodmantheatre.org/About/Our-History/ (accessed September 25, 2012).
14. William. F. McDermott, "Play about London Actors in Bombing Raids is Well Done at Play House," *Plain Dealer* (Cleveland), April 16, 1942, 14; William F. McDermott, "New Theater Year," *Plain Dealer*, September 29, 1940, 13-B; Oldenburg, 56–57, 59.

15. Glenn C. Pullen, "Shows Without Men Prove Their Worth in War Time," *Plain Dealer*, January 7, 1945, 11-B.
16. "Two Exiled Czech Stars Will Become Play House Guests," *Plain Dealer*, February 14, 1940, 12; Arthur Spaeth, "The Play," *Cleveland News*, March 6, 1940, 20.
17. Spaeth, "The Play."
18. "Nazi Demands Met: Hitler Gets Almost All He Asked as Munich Conferees Agree," *New York Times*, September 39, 1938, 1.
19. Spaeth, "The Play"; "Two Exiled Czech Stars Will Become Play House Guests."
20. William F. McDermott, "Play House Will Introduce a Pair of Famous Czech Clowns in New Play," *Plain Dealer*, March 3, 1940, 15-B.
21. "Czech Comics Arrive to Act in Own Play," *Plain Dealer*, February 16, 1940, 10.
22. McDermott, "Play House Will Introduce a Pair of Famous Czech Clowns in New Play"; "V&W: Famous Czech Comedians to Appear at City Club," *The City* (Cleveland), Vol. 25, No. 28 (March 13, 1940), 3.
23. Paul Bellamy, "Freedom of the Theater," *Plain Dealer*, February 16, 1940, 8.
24. "Czech Comics Arrive to Act in Own Play"; "Popeye Adopted by Czechs," *Plain Dealer*, March 17, 1940, 16-B; Eleanor Clarage, "Main Street Meditations," *Plain Dealer*, February 21, 1940, 11; Hulda Schuele, "Tea Treats Have Continental Tang," *Cleveland Press*, April 15, 1940, 16.
25. Clarage, "Main Street Meditations."
26. "Society by Christine," *Cleveland Press*, March 28, 1940, 18; "At Play House Reception for Czech Comedians," *Cleveland Press*, March 28, 1940, 18–9.
27. Charles H. Kellstadt and Fred P. Auxer, "Letter to Mr. T. L. Sidlo, Pres.—December 20, 1941," CPH Archives (accessed September 7, 2012); Oldenburg, 60; Marjorie Western, "Drama Will Put Punch into War Bond Sale Campaign," *Cleveland News*, April 21, 1942, 2; Marie Daerr, "Cleveland's U.S.O. Posts Keep Visiting Soldiers Happy Between Trains, Busses," *Cleveland Press*, February 5, 1942, 11.
28. Oldenburg, 60.
29. "Play House Calendar (March)," March 1942, CPH Archives (accessed September 7, 2012).
30. "The Welfare Bulletin," (Cleveland, OH: United States Coast Guard), January 22, 1942, 1.
31. Frederic McConnell, "Program Notes (Reprinted from Play House Program)," CPH Archives (accessed September 7, 2012).
32. "Cleveland: A Historical Overview," in *The Encyclopedia of Cleveland History*, edited by David D. Van Tassel and John J. Grabowski (Bloomington: Indiana University Press, 1987), 47.
33. J. E. Vacha, "World War II," in *The Encyclopedia of Cleveland History*, edited by David D. Van Tassel and John J. Grabowski (Bloomington: Indiana University Press, 1987), 1072.
34. Oldenburg, 55.

35. Ibid., 56; William Benjamin Clark Jr., *A History of the Play House, 1936–1968* (PhD diss., Tulane University, 1968), 66.
36. "Senate Vote Bars Colony Transfer," *Plain Dealer*, June 18, 1940, 4; Clark Jr., 67.
37. Clark Jr., 71.
38. Oldenburg, 59.
39. "Play House Maps $30,000 Campaign," *Plain Dealer*, July 15, 1942, 10.
40. Ibid.; "Play House Serviced Periled by War: $30,000 Fund Sought," *Cleveland News*, July 15, 1942, 1.
41. Robert A. Weaver, "Letter to 'Citizen of Cleveland'—July 27, 1942," CPH Archives (accessed September 7, 2012).
42. Clark Jr., 81, 86–7.
43. Oldenburg, 60.
44. Frederic McConnell, "Letter (unspecified)—August 23, 1942," CPH Archives (accessed September 7, 2012).
45. Clark Jr., 82.
46. Oldenburg, 57.
47. "Play House Shows for Tonight are Sold Out," *Plain Dealer*, December 31, 1942, 7.
48. "Play House Revives *Clarence* Tonight," *Plain Dealer*, December 12, 1942, 16.
49. Clark Jr., 84.
50. William F. McDermott, "Do Theatergoers Want Good Shows and Superior Acting at Lower Prices?" *Plain Dealer*, January 10, 1943, 13-B.
51. Oldenburg, 60.
52. Clark Jr. 87.
53. Ibid., 73.
54. "Playhouse Square: Resident Companies," Playhouse Square, http://www.playhousesquare.org/default.asp?playhousesquare=52&urlkeyword=Resident-Companies (accessed September 29, 2012).
55. Brooks Atkinson, "At the Theatre: Play House Dedicates Its Third Showcase with Freshly Designed *Romeo and Juliet*," *New York Times*, October 17, 1949, 19.
56. Oldenburg, 62.
57. Frederic McConnell, "A Proposal for a New Theatre—April 9, 1937," CPH Archives (accessed September 7, 2012).
58. Frederic McConnell, "Program Notes," Play House Program, January 23, 1945, CPH Archives (accessed September 7, 2012); Glenn C. Pullen, "Old Church Is Eyed by Heard of Play House," *Plain Dealer*, October 21, 1947.
59. "Joint Committee—Playhouse [sic] Building Project—Agenda Meeting March 19, 1946," CPH Archives (accessed September 7, 2012).
60. Leonard C. Hanna, "Letter to Walter—October 22, 1946," CPH Archives (accessed September 7, 2012).

61. Frederic McConnell, "Letter to Walter—October 28, 1946," CPH Archives (accessed September 7, 2012); "Joint Committee—Playhouse [sic] Building Project—Agenda Meeting March 19, 1946."
62. Walter L. Flory, "Letter to Mr. Leonard C. Hanna, Jr.—October 2, 1946," CPH Archives (accessed September 7, 2012).
63. "Hough Riots," *The Encyclopedia of Cleveland History*, edited by David D. Van Tassel and John J. Grabowski (Bloomington: Indiana University Press, 1987), 526.
64. M. L. Sloan, "Letter to Mr. Frederic McConnell—undated," CPH Archives (accessed September 10, 2012).
65. Flory, "Letter to Mr. Leonard C. Hanna, Jr.—October 2, 1946."
66. W. Ward Marsh, "Play House Project Grows," *New York Times*, October 24, 1948, X3; "Swasey, Ambrose," *The Encyclopedia of Cleveland History*, edited by David D. Van Tassel and John J. Grabowski (Bloomington: Indiana University Press, 1987), 946.
67. "South Euclid Run for C.T.S. Voted," *Plain Dealer*, March 16, 1948, 1; "The Play House Grows," *Plain Dealer*, May 7, 1948, 14; Oldenburg, 63.
68. Frederic McConnell, "Letter to Frank [Draz]—December 5, 1947," CPH Archives (accessed September 10, 2012).
69. Walter L. Flory, "Letter to Mr. David Stevens—November 4, 1947," CPH Archives (accessed September 7, 2012).
70. Frederic McConnell, "Letter to Mr. Frank Draz—June 20, 1947," CPH Archives (accessed September 7, 2012); Frederic McConnell, "Letter to Mr. Frank Draz—June 10, 1947," CPH Archives (accessed September 7, 2012).
71. Walter L. Flory, "Letter to Dr. David H. Stevens—March 29, 1948," CPH Archives (accessed 9/7).
72. Walter L. Flory, "Memo to the Trustees of the Play House Foundation and to the Members of the Special Joint Play House and Play House Foundation Committee—April 24, 1948," CPH Archives (accessed September 10, 2012).
73. "Play House Buys Former Church," *Plain Dealer*, April 9, 1948, 13.
74. Clark Jr., 99.
75. Frederic McConnell, "Letter to Mr. Walter L. Flory, President of the Play House Foundation—April 13, 1948," CPH Archives (accessed September 10, 2012); Julia McCune Flory, *The Play House: How It Began* (Cleveland, OH: Press of Western Reserve University, 1965), 117–8.
76. Julia McCune Flory, 122.
77. Walter L. Flory, "Letter to Mr. George H. Lundy—June 10, 1949," CPH Archives (accessed September 10, 2012).
78. Walter L. Flory, "Memorandum from Walter L. Flory to Members of the Building Committee of the Play House Foundation—March 22, 1950," CPH Archives (accessed September 10, 2012).
79. Oldenburg, 68.
80. Ibid., 75.

81. Joseph Wesley Zeigler, *Regional Theatre: The Revolutionary Stage* (New York: Da Capo Press, 1973), 1.
82. Margo Jones, *Theatre-in-the-Round* (New York: Rinehart, 1951), 55–6; Jeffrey Ullom, *The Humana Festival: The History of New Play at Actors Theatre of Louisville* (Carbondale: Southern Illinois University Press, 2008), 7.
83. Zeigler, 2–5.
84. Jones, *Theatre-in-the-Round*, 51.
85. Helen Sheehy, *Margo: The Life and Theatre of Margo Jones* (Dallas, TX: Southern Methodist University Press, 1989), 60.
86. William F. McDermott, "Play House Opens Season with a First Performance of an Interesting Drama," *Plain Dealer*, October 14, 1943, 8.
87. Sheehy, 60–1.
88. Oldenburg, 53; Norris Houghton, *Advance from Broadway: 19,000 Miles of American Theatre* (New York: Harcourt, Brace, 1941), 73–4.
89. Amnon Kabatachnik, *Blood on the Stage, 1950–1975: Milestone Plays of Crime, Mystery and Detection* (New York: Scarecrow Press, 2011), 560.
90. "Offbeat Play Will Open Friday," *Plain Dealer*, November 16, 1969, 2-G; Oldenburg, 104.
91. Atkinson, "At the Theatre"
92. Frederic McConnell, "Play House in Cleveland Wins 10-Year Freedom from Proscenium," *Documents of American Theater History, Volume 2: Famous American Playhouses, 1900–1971* (Chicago: American Library Association, 1973), 107–8.
93. Ibid., 109.
94. Oldenburg, 73.
95. Ibid., 61.

6 ESCAPING NO-MAN'S-LAND

1. Elijah Ford, interviewed by Britt Goodman, video recording at the Play House, September 2010 (date unspecified).
2. "Ohio's Decayed Cities—Cleveland's Hough," January 14, 2005 http://www.urbanohio.com/forum2/index.php?topic=2047.0 (accessed October 31, 2012).
3. Bureau of the Census, "Changes in Economic Level in Nine Neighborhoods in Cleveland: 1960 to 1965" (Washington, DC: Bureau of the Census, 1966), Series P-23, No. 20, 1–7; Marc E. Lackritz, "The Hough Riots of 1966" (Cleveland, OH: Regional Church Planning Office, 1968), 39.
4. Luke Ondish, "Hough: Building and Tension," *Cleveland in the Sixties*, Case Western Reserve University, http://www.case.edu/artsci/sixties/luke.html?nw_view=1352833785& (accessed November 13, 2012).
5. Lackritz, 39.

6. "City of New York & Boroughs: Population and Population Density from 1790," http://www.demographia.com/dm-nyc.htm (accessed November 2, 2012).
7. Robert G. McGruder, "Owners Deny Ice-Water Story: Charge Police Refused to Help," *Plain Dealer*, July 23, 1966, 11.
8. "Hough Riots," *The Encyclopedia of Cleveland History*, edited by David D. Van Tassel and John J. Grabowski (Bloomington: Indiana University Press, 1987), 526; Lackritz, 7; Dennis Hilliary, transcript of interview, Cleveland Citizens Committee on Hough Disturbances, August 23, 1966, 33.
9. Michael D. Roberts, "Funeral Fund Helped Spark Riot," *Plain Dealer* (Cleveland), July 23, 1966, 1.
10. Lackritz, 7; Roberts, 5.
11. McGruder, 11.
12. Hilliary, 33.
13. Lackritz, 7; Roberts, 5; McGruder, 11.
14. McGruder, 11.
15. "Hough Riots," *The Encyclopedia of Cleveland History*, 526.
16. Norman Mlachak, "Just Like War, Awed Policemen and Firemen Say," *Cleveland Press*, July 19, 1966, 1.
17. Lackritz, 19.
18. Richard R. Wagner, quoted in "Jury's Riot Probe Goes 'Step Beyond'" by Kenneth D. Huszar, *Plain Dealer*, August 2, 1966, 7.
19. Sam Giaimo, "Names of Rioters Revealed to Jury," *Cleveland Press*, July 27, 1966, 1.
20. Kenneth D. Huszar, "Jury's Riot Probe Goes 'Step Beyond.'"
21. Lackritz, 26.
22. Grand Jury, Louis B. Seltzer (foreman), "Special Grand Jury Report Relating to Hough Riots" (Cleveland, OH: County Grand Jury, August 9, 1966), I-1.
23. Terence Sheridan, "Jury Blames Hough Riot on Professionals, Reds," *Plain Dealer*, August 10, 1966, 1, 8; "Jury Pinpoints Hough 'Thorns,'" *Plain Dealer*, August 10, 1966, 8.
24. "Jury Hough Report Praised, Belittled," *Plain Dealer*, August 11, 1966, 9.
25. Ibid.
26. Lackritz, 31.
27. Ibid., 32; "Jones Claims Abuse by Police Began in '61," *Plain Dealer*, August 25, 1966, 7.
28. Lackritz, 32.
29. "Editorial: Walter L. Flory," *Plain Dealer*, July 5, 1951, 8; "Editorial: A Builder of the Play House," *Plain Dealer*, August 20, 1956, 20; "Death Rings Down Curtain on Actor Rolf Engelhardt," *Play House*, December 12, 1955, 5; Chloe Warner Oldenburg, *Leaps of Faith: History of the Play House, 1915–1980* (Cleveland, OH: Published by the author, 1985), 100; Harlowe R. Hoyt, "Play House Pioneer: Tippy O'Neil's Death Recalls Early Days," *Plain

Dealer, April 21, 1957, 2-G; Engelhardt performed more than 400 roles at the Play House, where he began as an apprentice in 1927 ("Death Rings Down Curtain on Actor Rolf Engelhardt.")
30. Glenn C. Pullen, "Star Fears Being Typed—Martyn Green to Give up Spaceship," *Plain Dealer*, June 17, 1958, 33; Oldenburg, 103.
31. Oldenburg, 76–80.
32. Ibid., 91.
33. Leonore Klewer, "Letter to Mr. W. McNeil Lowry—February 12, 1964," CPH Archives, Kelvin Smith Library, Case Western Reserve University (hereafter referred to at CPH Archives) (accessed October 15, 2012); W. McNeil Lowry, "Letter to Mrs. Leonore Klewer, Manager—February 24, 1964," CPH Archives (accessed October 15, 2012).
34. Board of Trustees, "Minutes of the Board of Trustees of the Play House—January 5, 1960," CPH Archives, 1–2 (accessed October 15, 2012).
35. "Play House Gets Grant of $130,000," *Plain Dealer*, October 13, 1957, 32; Oldenburg, 99.
36. "Rosenberg Drama," *Plain Dealer*, March 16, 1969, 34; Oldenburg, 103.
37. Philip W. Porter, *Cleveland: Confused City on a Seesaw* (Columbus: Ohio State University Press, 1976), 181.
38. David C. Perry, "Cleveland: Journey to Maturity," *Cleveland: A Metropolitan Reader*, edited by W. Dennis Keating, Norman Krumholz, and David C. Perry (Kent, OH: Kent State University Press, 1995), 23.
39. Porter, 186.
40. Elijah Ford, interviewed by Britt Goodman.
41. K. Elmo Lowe, "Memorandum to: The Play House Board of Trustees—April 8, 1963," CPH Archives, 1 (accessed October 15, 2012).
42. Kenyon C. Bolton, quoted in "Minutes of the Board of Trustees of the Play House—January 15, 1963" by the Board of Trustees, CPH Archives, 3 (accessed October 15, 2012).
43. Board of Trustees, "Minutes of the Board of Trustees of the Play House—June 15, 1964," 5 (accessed October 15, 2012).
44. Board of Trustees, "Minutes of the Board of Trustees of the Play House—September 13, 1965," CPH Archives, 5 (accessed October 15, 2012).
45. Board of Trustees, "Minutes of the Board of Trustees of the Play House—April 17, 1967," CPH Archives, 6 (accessed October 15, 2012).
46. Bruce Weber, "The Unsung Hero of Nonprofit Theater is Still Selling," *New York Times*, September 23, 1997, E2.
47. Joseph Wesley Zeigler, *Regional Theatre: The Revolutionary Stage* (New York: Da Capo Press, 1973), 177–8.
48. Gerald M. Berkowitz, *New Broadways—Theatre across America: Approaching a New Millennium* (New York: Applause Books, 1997), 105.
49. Zeigler, 177.
50. Roche Schulfer, quoted in "The Unsung Hero of Nonprofit Theater is Still Selling," by Bruce Weber.

51. Jeffrey Ullom, *The Humana Festival: The History of New American Plays at Actors Theatre of Louisville* (Carbondale: Southern Illinois University Press, 2008), 60.
52. Danny Newman, interviewed in "Play House Seeks Funds," *Plain Dealer*, June 30, 1963, 1-G.
53. K. Elmo Lowe, quoted in "Play House Seeks Funds."
54. Board of Trustees, "Minutes of the Board of Trustees of the Play House—September 30, 1963," CPH Archives, 1 (accessed October 15, 2012); F. H. Roth, "The Play House and Play House School of Theatre Treasurers' Report—July 1, 1963 to January 31, 1954," CPH Archives (accessed October 17, 2012), 2.
55. Board of Trustees, "Minutes of the Board of Trustees of the Play House—June 28, 1965," CPH Archives, 1 (accessed October 15, 2012); Play House, "Cash Statement of Income and Expenses—March 31, 1967," CPH Archives, 3 (accessed October 17, 2012).
56. Oldenburg, 90.
57. Board of Trustees, "Minutes of the Board of Trustees of the Play House—January 5, 1960," 1; Ford, interviewed by Britt Goodman.
58. Oldenburg, 95.
59. Ibid., 96; Molly Bellamy, "Play House Masked Ball to Have Golden Cast," *Plain Dealer*, March 16, 1965, 20.
60. Oldenburg, 67, K. Elmo Lowe, "Letter to Mrs. Warren J. Henderson—September 14, 1961," CPH Archives (accessed June 13, 2012).
61. Carol Poh Miller and Robert A. Wheeler, "Cleveland: The Making and Remaking of an American City, 1796–1993," in *Cleveland: A Metropolitan Reader*, edited by W. Dennis Keating, Norman Krumholz, and David C. Perry (Kent, OH: Kent State University Press, 1995), 43.
62. "Erieview," *The Encyclopedia of Cleveland History, Second Edition*," compiled and edited by David D. Van Tassel and John J. Grabowski (Bloomington: Indiana University Press, 1996), 396.
63. Carol Poh Miller and Robert A. Wheeler, *Cleveland: A Concise History, 1796–1996* (Bloomington: Indianan University Press, 1997), 164.
64. Ibid.
65. Porter, 187.
66. Ibid., 184.
67. Miller and Wheeler, *Cleveland: A Concise History, 1796–1996*, 164.
68. Cleveland City Planning Commission, "History of the City Planning Commission, the 'Grubb Years: 1957–1969,'" *Cleveland: City Planning in the 20th Century* (Cleveland, OH: Cleveland City Planning Commission, 1968), 91.
69. Lackritz, 40.
70. Porter, 186.
71. Eugene Segal, "Staff Hike Asked: Slowdown is Noted in Housing Renewal," *Plain Dealer*, January 26, 1964, 1, 7

72. Eugene Segal, "University City Attains Mushroom Growth within Year," *Plain Dealer*, July 4, 1961, 92; Porter, 186–7.
73. Porter, 186.
74. Lackritz, 40.
75. Frederic McConnell, quoted in Oldenburg, 82.
76. Oldenburg, 82.
77. Board of Trustees, "Minutes of the Board of Trustees of the Play House—January 5, 1960," 2.
78. Board of Trustees, "Minutes of the Board of Trustees of the Play House—May 24, 1960," CPH Archives, 1 (accessed October 15, 2012).
79. Board of Trustees, "Minutes of the Board of Trustees of the Play House—January 15, 1963," CPH Archives, 3 (accessed October 15, 2012).
80. Ibid., 3–4.
81. Board of Trustees, "Minutes of the Board of Trustees of the Play House—September 30, 1963," 5–6.
82. Board of Trustees, "Minutes of the Board of Trustees of the Play House—February 25, 1964," CPH Archives, 11–15 (accessed October 15, 2012).
83. Board of Trustees, "Minutes of the Board of Trustees of the Play House—September 30, 1963," 5–6; Board of Trustees, "Minutes of the Board of Trustees of the Play House—February 25, 1964," 13–15.
84. "The Voters Face Up to It," *Plain Dealer*, November 6, 1963, 20.
85. Board of Trustees, "Minutes of the Board of Trustees of the Play House—May 26, 1964," CPH Archives, 2; Board of Trustees, "Minutes of the Board of Trustees of the Play House—June 15, 1964," 2; Board of Trustees, "Minutes of the Board of Trustees of the Play House—February 25, 1964," 11–15.
86. Play House Survey Committee, "Re-location [*sic*] Survey Committee Report—May 18, 1965," CPH Archives, 2–3, 5 (accessed October 15, 2012).
87. Ibid., 6–7.
88. "Fenn College," *Encyclopedia of Cleveland History, Second Edition*, 422.
89. Harry Lenhart Jr., "Origin of a University: Rhodes is a Midwife for Baby CSU," *Plain Dealer*, December 21, 1964, 4.
90. "Fenn to Become Cleveland State U. Today," *Plain Dealer*, September 1, 1965, 5.
91. Donald Sabath, "$100-Million Complex Set for CSU Area," *Plain Dealer*, July 1, 1966.
92. John Vacha, *Showtime in Cleveland* (Kent, OH: Kent State University Press, 2001), 203.
93. Board of Trustees, "Minutes of the Board of Trustees of the Play House—April 17, 1967," 6.
94. Relocation Committee, "Report of Relocation Committee—June 26, 1967," CPH Archives, 1–2 (accessed October 17, 2012); Board of Trustees, "Minutes of the Board of Trustees of the Play House—January 22, 1968," CPH Archives, 3–6 (accessed October 17, 2012).
95. Play House Foundation, "Minutes of the Play House Foundation Meeting—May 8, 1968," CPH Archives, 1 (accessed October 15, 2012).

96. Board of Trustees, "Minutes of the Board of Trustees of the Play House—July 8, 1968," CPH Archives, 3–4 (accessed October 17, 2012).
97. Alan L. Littman, "Letter to Ken [Bolton]—June 13, 1966," CPH Archives, 1 (accessed October 15, 2012).
98. Board of Trustees, "Minutes of the Board of Trustees of the Play House—August 16, 1966," CPH Archives, 7 (accessed October 17, 2012).
99. Board of Trustees, "Minutes of the Board of Trustees of the Play House—July 8, 1968," 3–4.
100. James M. Naughton, "Stokes Is Elected Mayor," *Plain Dealer*, November 8, 1967, 1.
101. "3 Police, 3 Civilians Killed on East Side: Guard Called," *Plain Dealer*, July 24, 1968, 1.
102. Porter, 240, 242.

7 THE "ENDANGERED THEATRE"

1. Julius Novick, *Beyond Broadway: The Quest for Permanent Theatres* (New York: Hill and Wang, 1968), 26–7.
2. Ibid., 27.
3. Ibid., 27–8.
4. Peter Bellamy, "Of Things to Come," *Plain Dealer* (Cleveland), July 14, 1968, 1-H; Peter Bellamy, "Greene Taking over Helm of Play House," *Plain Dealer*, April 18, 1969, 1.
5. "Moliere a la Marx Bros. Due at Play House," *Plain Dealer*, November 3, 1968, 5-I.
6. Bellamy, "Greene Taking over Helm of Play House," 1, 6.
7. Ibid., 6.
8. Peter Bellamy, "Preferred the Theatre to Defending Criminals," *Plain Dealer*, December 21, 1969, 1-H; Peter Bellamy, "Play House Chief Lowe Eyes Retirement Role," *Plain Dealer*, April 18, 1969, 6.
9. Chloe Warner Oldenburg, *Leaps of Faith: History of the Play House, 1915–1980* (Cleveland, OH: Published by the author, 1985), 104.
10. Peter Bellamy, "Two 'Firsts' for Wexler: Play House Acquires Writer-in-Residence," *Plain Dealer*, January 27, 1970, 1.
11. Bellamy, "Play House Chief Lowe Eyes Retirement Role"; Board of Trustees, "Minutes of the Board of Trustees of the Cleveland Play House—September 16, 1970," CPH Archives, Kelvin Smith Library, Case Western Reserve University (hereafter referred to at CPH Archives), 1–2 (accessed December 10, 2012).
12. "Play House Head Found Dead," *Toledo Blade*, March 13, 1970, 17; John Vacha, *Showtime in Cleveland* (Kent, OH: Kent State University Press, 2001), 185.
13. Oldenburg, 105; Peter Bellamy, "New Play House Chief Sets Tour," *Plain Dealer*, May 22, 1970, 6-C.

14. Bellamy, "New Play House Chief Sets Tour."
15. Peter Bellamy, "Beckett Heaps Boredom on the Top of Obscurity," *Plain Dealer*, November 2, 1970, 10-C; Oldenburg, 108.
16. Tony Mastroianni, "Revival Ruins Greek Play," *Cleveland Press*, December 5, 1970, A-8.
17. Peter Bellamy, "*Lysistrata* at Play House Plumbs Depth of Vulgarity," *Plain Dealer*, December 5, 1970, 7-C.
18. Peter Bellamy, "New Director Hopes to Restore Joy to Theater," *Plain Dealer*, January 19, 1971, 2-B.
19. Oldenburg, 108.
20. Richard Halverson, interviewed by David Stashower, video recording at the Cleveland Play House, September 24, 2010.
21. Bellamy, "New Director Hopes to Restore Joy to Theater."
22. Mastroianni, "Revival Ruins Greek Play."
23. Donald Sutherland, "Aristophanes and the Scope of Comedy," in *Classical Comedy—Greek and Roman: Six Plays* (New York: Applause Theatre Book Publishers, 1987), 4.
24. "*Lysistrata*," *Plain Dealer*, December 8, 1970, 16-A.
25. Albert I. Borowitz, "Letter to the Editor—December 9, 1970," CPH Archives (accessed December 10, 2012).
26. Rex Partington, "Readers Forum: Economic, Not Artistic," *Plain Dealer*, December 9, 1970, 10-A.
27. Board of Trustees, "Minutes of the Board of Trustees of the Cleveland Play House—December 14, 1970," CPH Archives, 4 (accessed December 10, 2012).
28. Ibid.
29. Ibid., 5.
30. Ibid.
31. Board of Trustees, "Minutes of the Board of Trustees of the Cleveland Play House—November 8, 1970," CPH Archives, 2 (accessed December 10, 2012); Board of Trustees, "Minutes of the Board of Trustees of the Cleveland Play House—December 14, 1970," 4; Oldenburg, 109.
32. Stuart Levin, "Letter to 'Friends'—January 9, 1971," CPH Archives (accessed December 10, 2012), 1–3.
33. Peter Bellamy, "2 Play House Chiefs Resign," *Plain Dealer*, January 11, 1971, 1, 7.
34. Professional Acting Ensemble, "Memo to Officers and Trustees, Advisory Committee and Play House Foundation—January 12, 1971," CPH Archives, 1–3 (accessed December 10, 2012).
35. Board of Trustees, "Minutes of the Board of Trustees of the Cleveland Play House—January 17, 1971," CPH Archives, 1 (accessed December 10, 2012).
36. Cleveland Play House, "Press Release—January 19, 1971," CPH Archives (accessed December 10, 2012).
37. Bellamy, "Director Hopes to Restore Joy to Theater."
38. "Lowe Condition Reported Poor," *Plain Dealer*, January 22, 1971, 7.

39. "Led Theater to Professionalism: Play House's K Elmo Lowe Dies," *Plain Dealer*, January 27, 1971, 1; Oldenburg, 109.
40. Peter Bellamy, "Play House Remains as Lowe's Monument," *Plain Dealer*, January 27, 1971, 8-E.
41. Gerald M. Berkowitz, *New Broadways—Theatre across America: Approaching a New Millennium* (New York: Applause Theatre Books, 1997), 98.
42. "Great Lakes Theater Festival," *The Encyclopedia of Cleveland History*, compiled and edited by David D. Van Tassel and John J. Grabowski (Bloomington: Indiana University Press, 1987), 468–9; Holly Rarick Witchey and John Vacha, *Fine Arts in Cleveland* (Bloomington: Indiana University Press, 1994), 154.
43. Vacha, 208.
44. Oldenburg, 111.
45. Ibid., 112.
46. Halverson, interview.
47. Ibid.
48. Richard Oberlin, "Plans for Renewal of the Play House—April 14, 1971," CPH Archives (accessed December 10, 2012).
49. Cleveland Play House, "Application to the Cleveland Foundation—June 1976," CPH Archives, 1 (accessed December 10, 2012).
50. Executive Committee, "Minutes of the Executive Committee of the Board of Trustees of the Cleveland Play House—November 1, 1976," CPH Archives, 2 (accessed December 10, 2012).
51. Executive Committee, "Minutes of the Executive Committee of the Board of Trustees of the Cleveland Play House—December 16, 1976," CPH Archives, 1 (accessed December 10, 2012).
52. Berkowitz, 105–6.
53. "Cleveland Play House," *Theatre Profiles 3*, edited by Marsue Cumming (New York: Theatre Communications Group, 1977), 65.
54. "Alley Theatre," *Theatre Profiles 3*, 15; "Dallas Theater Center," *Theatre Profiles 3*, 77; "Milwaukee Repertory Theater Company," *Theatre Profiles 3*, 177; "Actors Theatre of Louisville," *Theatre Profiles 3*, 11.
55. "Letter to Mr. Richard Oberlin, Director—undated," CPH Archives (accessed December 10, 2012). The page is located in a box filled with papers filed in chronological order; therefore, the assumed date that letter was written or received was between March 1, 1977 and April 12, 1977.
56. Board of Trustees, "Minutes of the Board of Trustees of the Cleveland Play House—September 8, 1976," 3.
57. "Cleveland Play House," *The Encyclopedia of Cleveland History*, CWRU.edu, http://ech.case.edu/cgi/article.pl?id=CPH (accessed December 21, 2012).
58. Board of Trustees, "Minutes of the Board of Trustees of the Cleveland Play House—November 10, 1983," CPH Archives, 2 (accessed December 10, 2012).
59. Thor Eckert Jr., "How the Cleveland Play House Sprouted Its New Complex," *Christian Science Monitor*, January 12, 1984, http://www.csmonitor.com/1984/0112/011211.html (accessed December 11, 2012).

60. Robert M. Beckly and Sherrill M. Myers, *Theater Facilities: Guidelines and Strategies* (Milwaukee: Center for Architecture and Urban Planning Research, University of Wisconsin-Milwaukee, 1981), 43, 45.
61. Berkowitz, 101.
62. Roger Danforth, interviewed by the author, Cleveland Play House Schubert Library, video recording, November 12, 2010.
63. "Cleveland Play House," *Theatre Profiles 6*, edited by Laura Ross (New York: Theatre Communications Group, 1984), 58; "Cleveland Play House," *Theatre Profiles 7*, edited by Laura Ross and John Istel (New York: Theatre Communications Group, 1986), 127.
64. Catherine Albers, interviewed by the author, Eldred Theater, Case Western Reserve University, audio recording, December 11, 2012.
65. Berkowitz, 122.
66. Ibid., 89–90.
67. Suzanna Andrews, "The Board is Taking Center Stage," *New York Times Magazine*, December 2, 1990, 41–4.
68. Berkowitz, 119.
69. Danforth, interview.
70. Board of Trustees, "Minutes of the Board of Trustees of the Cleveland Play House—May 19, 1987," CPH Archives, 1–2 (accessed December 10, 2012).
71. Marianne Evett, "Woman to Lead the Play House," *Plain Dealer*, May 20, 1987, 1; Board of Trustees, "Minutes of the Board of Trustees of the Cleveland Play House—May 19, 1987," 5; Danforth, interview.
72. Evett, "Woman to Lead the Play House," 1, 9; Board of Trustees, "Minutes of the Board of Trustees of the Cleveland Play House—May 19, 1987," 5.
73. Danforth, interview.
74. Josephine Abady, quoted in "Play House Drops Resident Staff" by Marianne Evett, *Plain Dealer*, January 7, 1988, 4-F.
75. Ibid.
76. Denis C. Mullaney, "Letter to the Editor: Play House Changes," *Plain Dealer*, February 27, 1988, 6-B.
77. Albers, interview.
78. Ibid.; Halverson, interview.
79. "Play House Rapped for Dropping Company," *Plain Dealer*, January 17, 1988, 5-E.
80. Marianne Evett, "Let's Let Abady Guide Play House," *Plain Dealer*, January 27, 1988, 3-H.
81. Richard H. Hahn, "Change Comes to the Cleveland Play House," CPH Archives, 2 (accessed December 10, 2012).
82. Berkowitz, 118.
83. Cleveland Play House, "Minutes of the Annual Meeting of the Corporation of the Cleveland Play House—July 14, 1987," CPH Archives, 1 (accessed December 10, 2012).

84. Marianne Evett, "Asner, Kahn to Star in *Born Yesterday* at Play House," *Plain Dealer*, June 30, 1988, 7-C.
85. "*Born Yesterday*," Internet Broadway Database, http://ibdb.com/production.php?id=4529 (accessed January 2, 2013).
86. "*The Cemetery Club*," Internet Broadway Database, http://ibdb.com/production.php?id=4327 (accessed January 2, 2013).
87. Board of Trustees, "Minutes of the Board of Trustees of the Cleveland Play House—May 10, 1988," CPH Archives, 4–6 (accessed December 10, 2012).
88. Cleveland Play House, "Long Range Goals—March 26, 1990," CPH Archives, 1 (accessed December 10, 2012); Board of Trustees, "Excerpts—Artistic Mission of the Cleveland Play House, April 7, 1990," CPH Archives, 2, 4 (accessed December 10, 2012).
89. Long Range Planning Committee, "The Cleveland Play House Long-Range Plan, 1990–95," (Cleveland, OH: Cleveland Play House, September 18, 1990), 3; Long Range Planning Committee, "The Cleveland Play House Long-Range Plan, 1990–95," (Cleveland, OH: Cleveland Play House, January 26, 1991), 14.
90. Josephine Abady, quoted in "Minutes of Board of Trustees' Retreat—February 22, 1992" by the Board of Trustees, CPH Archives, 2 (accessed December 10, 2012).
91. Berkowitz, 115.
92. Board of Trustees, "Minutes of Board of Trustees' Retreat—February 22, 1992," 3; Advisory Council, "Responses of the Board of Trustees Survey—November 14, 1989," CPH Archives (accessed December 10, 2012).
93. Dean R. Gladden, "Fax Transmission to Leif Soderberg, Bob Newmark, Boake Sells—March 12, 1993," CPH Archives, 1 (accessed December 10, 2012); Executive Committee, "Meeting of the Executive Committee—March 26, 1993," CPH Archives, 4 (accessed December 10, 2012).
94. Tom Good, quoted in "Meeting of the Executive Committee—March 26, 1993," 4.
95. Boake Sells, quoted in "Minutes of the Meeting of the Executive Committee—April 19, 1993" by the Executive Committee, CPH Archives, 3 (accessed December 10, 2012).
96. Executive Committee, "Minutes of the Meeting of the Executive Committee—June 4, 1993," CPH Archives, 1–5 (accessed December 10, 2012).
97. Board of Trustees, "Minutes of the Cleveland Play House Board of Trustees Retreat—October 30, 1993," CPH Archives, 3–4 (accessed December 10, 2012); Cleveland Play House, "Cleveland Play House Contingency Budget—October 8, 1993," CPH Archives, 1 (accessed December 10, 2012).
98. Executive Committee, "Minutes of the Meeting of the Executive Committee—October 11, 1993," CPH Archives, 3 (accessed December 10, 2012).
99. Dean Gladden, "Memo to Members of the Executive Committee—October 6, 1993," CPH Archives, 1 (accessed December 10, 2012).

232 Notes

100. Danforth, interview.
101. Ibid.
102. Executive Committee, "Minutes of the Meeting of the Executive Committee—January 5, 1994," CPH Archives, 2–5 (accessed December 10, 2012).
103. Executive Committee, "Minutes of the Meeting of the Executive Committee—June 4, 1993," 7.
104. Marianne Evett, "Shortsighted Play House Board Can Only See Box Office," *Plain Dealer*, February 13, 1994, 4-G.
105. Tony Chase, "Artistic Differences," *Theatre Week*, April 4–10, 1994, 25.
106. Robert Blattner, quoted in "Press Release—January 11, 1994" by the Cleveland Play House, CPH Archives, 1–2 (accessed December 10, 2012).
107. Josephine Abady, quoted in "Abady Dismissed Despite 'Terrific' Work in Cleveland" by Carolyn Jack, *Backstage*, January 21–27, 1994, 26.
108. Jack, "Abady Dismissed Despite 'Terrific' Work in Cleveland," 26.
109. Tazewell Thompson, "Letter to Bob Blattner—February 2, 1994," CPH Archives, 2 (accessed December 10, 2012).
110. Evett, "Shortsighted Play House Board Can Only See Box Office," 4-G.
111. Anonymous, taken from discussions and interviews with Cleveland Play House staff.
112. Josephine Abady, quoted in "A Renaissance in Cleveland" by Michael Riedel, *Theatre Week*, July 13–19, 1992, 18.
113. Anonymous, quoted in "Artistic Differences" by Tony Chase, 28.
114. Ibid., 19.
115. Evett, "Shortsighted Play House Board Can Only See Box Office," 4-G.
116. Dean Gladden, interviewed by the author, Alley Theatre, Houston, TX, audio recording, November 9, 2012.
117. Robert Blattner, quoted in "Artistic Differences" by Tony Chase, 28.
118. Albers, interview.
119. Gladden, interview, November 9, 2012.
120. Blattner, quoted in "Artistic Differences."
121. Dean Gladden, interview by the author, Shaker Heights, OH, August 6, 2013.
122. Chris Jones, "Cleveland Ousts Abady," *Variety*, January 17–23, 1994, 115.
123. Edward L. Bettendorf, "Letter to Robert A. Blattner, President—January 25, 1994," CPH Archives, 2 (accessed December 10, 2012).
124. Jones, "Cleveland Ousts Abady."
125. Porter Anderson, "Are We Bored with Boards Yet?" *Village Voice*, vol. 39, no. 5, February 1, 1994, 90.
126. Chase, "Artistic Differences," 27, 29.
127. Herb Gardner, "Text of Telegram to Cleveland Play House Board of Trustees (undated)," CPH Archives, 1 (accessed December 10, 2012).
128. Chase, "Artistic Differences," 26.

129. Robert Blattner, interviewed by the author, Kelvin Smith Library, Case Western Reserve University, Cleveland, OH, notes from conversation, March 26, 2013.
130. Ibid.; Dean Gladden, interviewed by the author, Cleveland, OH, notes from conversation, August 6 2013.
131. "New Artistic Director Named for Circle in the Square," *New York Times*, August 24, 1994, C13.
132. Mel Gussow, "Josephine Abady, 52, Director of Plays on and Off Broadway," *New York Times*, May 30, 2002, A23; Tony Brown, "Josephine Abady, Play House's Controversial Artistic Director," *Plain Dealer*, Wednesday, May 29, 2002, B7.
133. Peter Hackett, quoted in "Press Release: The Cleveland Play House Remembers Josephine Abady—May 28, 2002" by the Cleveland Play House, CPH Archives, 1 (accessed December 10, 2012).
134. Richard Hahn, quoted in "Josephine Abady, Play House's Controversial Artistic Director" by Tony Brown.
135. Danforth, interview.
136. Gladden, interview, November 9, 2012.
137. Berkowitz, 95.
138. Ibid.
139. Ibid., 119.
140. Danforth, interview.
141. Berkowitz, 121.
142. Albers, interview.
143. Gladden, interview, November 9, 2012.

8 A PLACE TO CALL HOME

1. Rich Exner, "Cleveland Weather History: Find Cleveland Weather Details for Any Date since 1900," *Plain Dealer* (Cleveland), September 5, 2008, http://www.cleveland.com/datacentral/index.ssf/2008/09/cleveland_weather_history_find.html?appSession=057371263134259 (accessed March 24, 2013); Wendell Alcorn, "TRW Donates HQ to Cleveland Clinic," CoStar Group, December 10, 2002, http://www.costar.com/News/Article/TRW-Donates-HQ-to-Cleveland-Clinic/45848 (accessed March 24, 2013).
2. Board of Trustees, "Minutes of the Board of Trustees' Special Meeting and Retreat—November 12, 1994," CPH Archives, 1–2 (accessed March 1, 2013).
3. Ibid.; Chris Jones, "Cleveland Taps Hackett as New Play House A.D.," *Variety*, October 17–24, 1994, 169; "IN FOCUS: New Leader Picked for Cleveland," *Backstage*, vol. 35, no. 41, October 14, 1994, 2, 23.
4. Board of Trustees, "Minutes of the Board of Trustees' Special Meeting and Retreat—November 12, 1994," 1–2.

5. Peter Hackett, quoted in "Cleveland Taps Hackett as New Play House A.D." by Chris Jones.
6. Board of Trustees, "Minutes of the Board of Trustees' Special Meeting and Retreat—November 12, 1994," 3.
7. Kenneth Jones, "Peter Hackett Leaves Cleveland Play House for Academic in September 2004," *Playbill*, December 30, 2003, http://www.playbill.com/news/article/print/83542.html (accessed March 19, 2013); "*The Smell of the Kill*," Internet Broadway Database, http://ibdb.com/production.php?id=13333 (accessed April 7, 2013).
8. Board of Trustees, "Minutes of the Board of Trustees' Special Meeting and Retreat—November 12, 1994," 3.
9. Ibid.
10. Board of Trustees and Advisory Council, "Minutes of the Board of Trustees and Advisory Council—May 14, 1996," CPH Archives, 1 (accessed March 1, 2013).
11. Board of Trustees, "Minutes of the Board of Trustees' Special Meeting and Retreat—November 12, 1994," 2.
12. Ron Wilson, interviewed by the author, Eldred Hall, Case Western Reserve University, dictation, April 9, 2013.
13. Board of Trustees and Advisory Council, "Minutes of the Board of Trustees and Advisory Council—March 21, 1996," CPH Archives, 1 (accessed March 1, 2013).
14. Cleveland Play House, "Budget Comparisons—February 13, 1997," CPH Archives, 1 (accessed March 1, 2013).
15. Executive Committee, "Minutes of the Meeting of the Executive Committee—June 9, 2004," CPH Archives, 2–3 (accessed March 1, 2013); Executive Committee, "Minutes of the Meeting of the Executive Committee—May 18, 2004," CPH Archives, 1 (accessed March 1, 2013).
16. Jones, "Peter Hackett Leaves Cleveland Play House for Academic in September 2004."
17. Executive Committee, "Minutes of the Meeting of the Executive Committee—October 14, 2004," CPH Archives, 1–3 (accessed March 1, 2013).
18. Marianne Evett, quoted in "Peter Hackett Leaves Cleveland Play House for Academic in September 2004."
19. Michael Bloom, interviewed by the author, telephone, February 25, 2013.
20. Kevin Moore, interviewed by the author, Bricco Restaurant, Cleveland, OH, audio recording, February 28, 2013.
21. Moore, interview, February 28, 2013.
22. Alec Pendleton, interviewed by the author, Cleveland, OH, audio recording, February 26, 2013.
23. Bloom, interview.
24. Pendleton, interview.
25. Bloom, interview.

26. Ibid.
27. Moore, interview, February 28, 2013.
28. Peter Kuhn, interviewed by the author, Cleveland, OH, audio recording, February 26, 2013.
29. Kevin Moore, interviewed by the author, Cleveland, OH, email correspondence, November 12, 2013. Moore provided additional details about the closing of the Club: "A task force was appointed by Alan Rauss in 2006, studied the issue for nearly a year, and then made its recommendation to the Board. According to Alec [Pendleton], there was general consensus on the task force that the Club was failing and should be closed, and that the departure of Dean Gladden in 2006 removed the staunchest supporter of the Club and made the decision possible....The decision to close the Club was made in June 2007, about six weeks after I came to CPH (among the first things the board asked me to do was to shut down the Club and negotiate the deal with Creative Cafes)." Ibid.
30. Finance Committee, "Minutes of the Meeting of the Finance Committee—May 15, 2007," CPHAOF Archives, 1 (accessed March 1, 2013).
31. Board of Directors, "Minutes of the Special Meeting of the Board—June 6, 2007," CPHAOF, 2 (accessed March 1, 2013).
32. Board of Directors, "Minutes of the Special Meeting of the Board—June 6, 2007," 1–3.
33. "Treasurer's Report of the Annual General Meeting—July 19, 2007," CPHAOF, 1 (accessed March 1, 2013).
34. Kevin Moore, email correspondence, November 12, 2013.
35. Mark Alan Gordon, interviewed by the author, telephone, December 17, 2012.
36. Ibid.
37. Pendleton, interview.
38. Ibid.
39. Ibid.
40. Finance and Investment Committee, "Minutes of the Meeting of the Finance and Investment Committee—September 9, 2008," CPHAOF, 5–6 (accessed march 1, 2013); Board of Directors, "Minutes of the Meeting of the Board of Directors—September 25, 2008," CPHAOF, 2–3 (accessed March 1, 2013); Moore, interview, February 28, 2013.
41. Board of Directors, "Minutes of the Meeting of the Board of Directors—November 20, 2008," CPHAOF, 2–4 (accessed March 1, 2013).
42. Finance and Investment Committee, "Minutes of the Meeting of the Finance and Investment Committee—January 20, 2009," CPHAOF, 1 (accessed March 1, 2013).
43. Bloom, interview.
44. Pendleton, interview.
45. According to staff members, a tumultuous relationship between Dean Gladden and Gund representatives caused Bloom to fear that the contributions might cease.

46. Kuhn, interview. Moore remembers the quote concerning the "train leaving the station" coming from Deena Epstein, senior program officer at the George Gund Foundation, who was also at the meeting. Moore, email correspondence, November 12, 2013.
47. Moore, interview, February 28, 2013.
48. Executive Committee, "Minutes from the Meeting of the Executive Committee—February 19, 2009," CPHAOF, 2–5 (accessed March 1, 2013).
49. "Minutes of the Vision 100 Meeting—March 5, 2009," CPHAOF, 1 (accessed March 1, 2013).
50. Executive Committee, "Minutes of the Meeting of the Executive Committee—October 15, 2009," CPHAOF, 1 (accessed March 1, 2013); Tony Brown, "Cleveland Clinic Buys Cleveland Play House Site; Pressure Now on MOCA to Move," *Plain Dealer*, October 16, 2009, http://www.cleveland.com/onstage/index.ssf/2009/10/cleveland_clinic_buys_clevelan_1.html (accessed March 23, 2013).
51. Kevin Moore, interviewed by the author, Cleveland, OH, April 28, 2010.
52. Moore, email correspondence, November 12, 2013.
53. Ibid.
54. Ibid.
55. Bloom, interview.
56. Ibid.
57. Executive Committee, "Minutes from the Meeting of the Executive Committee—November 2, 2006," CPHAOF, 1 (accessed March 1, 2013).
58. Tony Brown, "Cleveland Clinic Buys Cleveland Play House Is Best Deal under Worst Circumstances," *Plain Dealer*, July 24, 2009, http://www.cleveland.com/onstage/index.ssf/2009/07/cleveland_clinic_buys_clevelan.html (accessed July 2, 2013).
59. Kathryn Kroll, "Recession Will Last Longest in Midwest, including Ohio, Two Reports Show," *Plain Dealer*, June 17, 2009, http://www.cleveland.com/business/index.ssf/2009/06/economy.html (accessed August 1, 2013).
60. Alec Friedhoff and Siddharth Kulkarni, "Metro Monitor," The Brookings Institution, July 1, 2013, http://www.brookings.edu/research/interactives/metromonitor#M17460-recession-overall-nv (accessed August 1, 2013); Thomas J. Sheeran, "Cleveland Sues 21 Banks for Home Loans Gone Bad," *USA Today*, January 11, 2008, http://usatoday30.usatoday.com/money/economy/housing/2008-01-11-cleveland-sues-subprime_N.htm (accessed July 26, 2013); Frank Jackson, quoted in "Community Revitalization Advocates Gather in Cleveland, Ohio" by Steve Dubb, October 2010, http://community-wealth.org/content/community-revitalization-advocates-gather-cleveland-ohio (accessed August 1, 2013).
61. Jackson, quoted in "Community Revitalization Advocates Gather in Cleveland, Ohio."
62. Robert L. Smith, "Cleveland's Manufacturing Industry Roaring Back, Expected to Surpass National Growth Rate," *Plain Dealer*, February 13,

2013, http://www.cleveland.com/business/index.ssf/2013/02/clevelands_manufacturing_indus.html (accessed August 2, 2013).
63. Tom Waltermirew, quoted in "Cleveland's Manufacturing Industry Roaring Back, Expected to Surpass National Growth Rate."
64. Ibid.
65. Steven Litt, "Cleveland's New Convention Hotel Could Bring Life to the Mall and Connect a Disconnected Downtown," *Plain Dealer*, July 25, 2013, http://www.cleveland.com/architecture/index.ssf/2013/07/the_new_cleveland_convention_h.html (accessed August 2, 2013).
66. Ibid.; Steven Litt, "Cleveland's New Convention Center and Global Center for Health Innovation Aren't Stand-Alone Icons, and That's a Good Thing," *Plain Dealer*, http://www.cleveland.com/architecture/index.ssf/2013/06/clevelands_new_convention_cent.html (accessed August 2, 2013).
67. Rich Exner, "2010 Census Population Numbers Show Cleveland below 400,000; Northeast Ohio Down 2.2 Percent," *Plain Dealer*, March 9, 2011, http://www.cleveland.com/datacentral/index.ssf/2011/03/2010_census_figures_for_ohio_s.html (accessed August 2, 2013); Robert L. Smith, "Cleveland's Urban Scene Gets a Boost from Young Adults Moving In," *Plain Dealer*, January 21, 2013, http://www.cleveland.com/business/index.ssf/2013/01/clevelands_urban_scene_gets_a.html (accessed February 17, 2013).
68. Richey Piiparinen, "Not Dead Yet: The Infill of Cleveland's Urban Core," *Briefly Stated*, Center on Urban Poverty and Community Development, Mandel School of the Applied Arts, No. 12–02 (April 2012), http://blog.case.edu/msass/2012/04/18/Briefly_Stated_12–02_-_Not_Dead_Yet_The_Infill_of_Clevelands_Urban_Core.pdf (accessed July 27, 2013).
69. Ibid.; Scott Suttell, "Downtown Cleveland Proves to Be Population Hot Spot," *Crain's Cleveland Business*, May 4, 2012, http://www.crainscleveland.com/article/20120504/BLOGS03/120509891 (accessed February 17, 2013).
70. Robert L. Smith, "Cleveland's Inner City is Growing Faster Than its Suburbs as Young Adults Flock Downtown," *Plain Dealer*, April 28, 2012, http://www.cleveland.com/business/index.ssf/2012/04/clevelands_inner_city_is_gorn.html?utm_source=twitterfeed&utm_medium=twitter (accessed August 2, 2013); Richard Florida, "Cleveland's Downtown Rebound," *The Atlantic Cities*, May 4, 2012, http://www.theatlanticcities.com/jobs-and-economy/2012/05/clevelands-downtown-rebound/1917/ (accessed August 26, 2013).
71. Bloom, interview.
72. Tony Brown, "Proposed Renovation of Playhouse Square's Allen Theatre Promises Big Payoff, *Plain Dealer*, June 5, 2010, http://www.cleveland.com/onstage/index.ssf/2010/06/proposed_renovation_of_playhou.html (accessed August 2, 2013).
73. Kuhn, interview.
74. Ibid.
75. Bloom, interview.

76. Michael Bloom, quoted in "Cleveland Play House's First Season in Playhouse Square Home: Fall Theater Preview," *Plain Dealer*, September 11, 2011, http://www.cleveland.com/onstage/index.ssf/2011/09/cleveland_play_houses_first_se.html (accessed August 2, 2013).
77. Brown, "Proposed Renovation of Playhouse Square's Allen Theatre Promises Big Payoff."
78. Peggy Turbett, "Allen Theatre: A New Gem for Playhouse Square," *Plain Dealer*, September 17, 2011, http://blog.cleveland.com/pdmultimedia/2011/09/allen_theatre_a_new_gem_for_pl.html (accessed August 2, 2013); Niki Swank, "Allen Theater, Playhouse Square," *Builders Exchange Magazine*, vol. 10, no. 10, http://www.bxmagazine.com/article.asp?ID=1219 (accessed August 2, 2013).
79. Joanna Connors, "Allen Theatre Renovation Nears Completion at Cleveland's Playhouse Square," *Plain Dealer*, August 11, 2011, http://www.cleveland.com/arts/index.ssf/2011/08/clevelands_allen_theatre_renov.html (accessed August 2, 2013); "Allen Theatre and Renovation," Turner Construction Company, http://www.turnerconstruction.com/experience/project/15F7/allen-theatre-renovation-and-addition (accessed August 2, 2013).
80. Joanna Connors, "The Renaissance of Cleveland's Allen Theatre: How Theater Renovation Brought Together Three Institutions," *Plain Dealer*, September 18, 2011, http://www.cleveland.com/arts/index.ssf/2011/09/the_renaissance_of_clevelands.html (accessed August 2, 2013). According to Moore, the "real savings was about 25%" as opposed to half as hoped. Moore, email correspondence, November 12, 2013.
81. Pendleton, interview. Although he currently serves as the Chairman of the Board of Trustees, this interview was conducted while he was chairman-elect.
82. Bloom, interview.
83. Kuhn, interview.
84. Moore, interview, February 28, 2013.
85. Michael Bloom, quoted in "Cleveland Play House Gets Edgy in 2011–12 Season, the First at Playhouse Square," *Plain Dealer*, March 13, 2011, http://www.cleveland.com/onstage/index.ssf/2011/03/cleveland_play_house_tweaks_ar.html (accessed August 2, 2013).
86. Kevin Moore, interviewed by the author, Cleveland Play House, Cleveland, OH, audio recording, June 26, 2013.
87. Bloom, interview.
88. Kuhn, interview.
89. Pamela DiPasquale, interviewed by the author, Cleveland Play House, Cleveland, OH, notes from conversation, July 13, 2013. DiPasquale reported that Rex Partington attempted to eliminate the education program during his brief tenure. Moore also clarified that the Cleveland Play House staff were "not formal trainers of CSU students.... We do work with CSU undergraduates

regularly, and have a solid relationship with the CSU Department of Theatre, but our formal training program is through CWRU." Moore, email correspondence, November 12, 2013.
90. Bloom, interview; Kuhn, interview.
91. "Cleveland State University," *US News and World Report—Education*, http://colleges.usnews.rankingsandreviews.com/best-colleges/cleveland-state-university-3032 (accessed August 3, 2013); Jessica Bixby, "Every Night Is Student Night at CPH!" Cleveland Play House, February 3, 2012, http://www.clevelandplayhouse.com/blog/2012/02/every-night-is-student-night-at-cph (accessed August 3, 2013).
92. Michael Bloom, quoted in "Cleveland Play House Announces 2011–12 Season" by Lisa Craig, CPHAOF (accessed March 5, 2013).
93. Bloom, interview.
94. Ibid.

CONCLUSION: THE NEW "NO-MAN'S-LAND"

1. Ed Gilchrist, "Michael Bloom Closes Out His Tenure as Artistic Director at Cleveland Play House," email correspondence to NEOPAL listserv, May 23, 2013 (accessed May 23, 2013).
2. Michael Bloom, quoted in "Cleveland Play House Artistic Director Michael Bloom Bows Out after Nine Seasons" by Andrea Simakis, *Plain Dealer* (Cleveland), May 23, 2013, http://www.cleveland.com/onstage/index.ssf/2013/05/cleveland_play_house_artistic.html (accessed May 23, 2013).
3. Ibid.
4. Cleveland Play House, "Press Release: Cleveland Play House Names Laura Kepley Artistic Director—September 23, 2013," email correspondence and CPHAOF (accessed September 23, 2013).
5. Oskar Eustis, quoted in "Congratulations, Laura Kepley!" by the Cleveland Play House, October 3, 2013, http://www.youtube.com/watch?v=0YuH9yacpno&feature=youtu.be (accessed October 20, 2013).
6. Susan Booth, quoted in "Congratulations, Laura Kepley!"
7. Curt Columbus, quoted in "Congratulations, Laura Kepley!"
8. Kevin Moriarty, quoted in "Congratulations, Laura Kepley!"
9. Ibid.
10. Al Paulus, quoted in "Annual General Meeting Minutes—July 26, 2012," CPHAOF Archives, 2 (accessed March 1, 2013).
11. Kevin Moore, interviewed by the author, Cleveland Play House, Cleveland, OH, audio recording, June 26, 2013.
12. Ibid.
13. Peter Kuhn, interviewed by the author, Cleveland, OH, audio recording, February 26, 2013.

14. Alec Pendleton, interviewed by the author, Cleveland, OH, audio recording, February 26, 2013.
15. Moore, interview, June 26, 2013.
16. Kevin Moore, interviewed by the author, Cleveland, OH, audio recording, February 28, 2013; "Excerpts from Cleveland Play House Strategic Plan, 2013–2017—April 12, 2013," CPHAOF Archives, 4 (accessed April 12, 2013).
17. "Excerpts from Cleveland Play House Strategic Plan, 2013–2017—April 12, 2013," 4–5.
18. Pendleton, interview.
19. Andrea Simakis, "Cleveland Play House's *One Night with Janis Joplin*: Musical Kicks Off North American Tour at Allen Theatre," *Plain Dealer*, May 23, 2013, http://www.cleveland.com/onstage/index.ssf/2012/07/cleveland_play_house_one_night.html (accessed August 18, 2013); Michael Bloom, interviewed by the author, telephone, February 25, 2013.
20. Moore, interview, February 26, 2013.
21. Pendleton, interview.
22. Moore, interview, June 26, 2013.
23. Kuhn, interview.
24. Christopher Johnston, "The Arts District Difference," *American Theatre*, www.tcg.org/publications/at/oct11/cleveland.cfm (accessed August 18, 2013).

Bibliography

100 Years of Solidarity, 1893–1993. New York: International Alliance of Theatrical Stage Employees, 1993. http://www.iatse-intl.org/about/IATSE-history/index.html Accessed March 28, 2012.
"3 Police, 3 Civilians Killed on East Side: Guard Called." *Plain Dealer*. July 24, 1968.
Abbott, Virginia Clark. *The History of Woman Suffrage and the League of Women Voters in Cuyahoga County, 1911–1945*. Cleveland, OH: League of Women Voters, 1949.
"About Us—History." The Pasadena Playhouse. http://www.pasadenaplayhouse.org/about-us/history.html. Accessed September 25, 2012.
"Ace Little Theatre Cuts 20%." *Variety*. January 5, 1932.
"Advertisement—Annual Report of the M.A. Hanna Company." *Plain Dealer*, February 19, 1933.
"Advertisement: Seat Sale Thursday." *Plain Dealer*. January 13, 1907.
"Advertisement: Stillman Theatre," *Plain Dealer*, June 10, 1917, 44.
Advisory Council. "Responses of the Board of Trustees Survey—November 14, 1989." CPH Archives. Accessed December 10, 2012.
Albers, Catherine. Interviewed by the author. Case Western Reserve University. Audio recording. December 11, 2012.
Alburn, Cary. "*Why the Chimes Rang* as Presented in Cleveland." *The Drama*, vol. 11, no. 2 (November 1920).
Alcorn, Wendell. "TRW Donates HQ to Cleveland Clinic." CoStar Group. December 10, 2002. http://www.costar.com/News/Article/TRW-Donates-HQ-to-Cleveland-Clinic/45848. Accessed March 24, 2013.
"Allen Theatre and Renovation." Turner Construction Company. http://www.turnerconstruction.com/experience/project/15F7/allen-theatre-renovation-and-addition. Accessed August 2, 2013.
Allman, William A. *An Investigation of a Successful Civic Theatre as Exemplified by the Play House*. Master's thesis, Ohio University, 1951.
American Social History Project. *Who Build America?* Edited by Stephen Brier. New York: Pantheon Books, 1989.
"Amusements." *Plain Dealer*. April 28, 1908.
"Amusements." *Plain Dealer*. March 22, 1884.
Anderson, Porter. "Are We Bored with Boards Yet?" *Village Voice*. February 1, 1994.

Andrews, F. Emerson. *Philanthropic Giving*. New York: Russell Sage Foundation, 1950.
Andrews, Suzanna. "The Board Is Taking Center Stage." *New York Times Magazine*. December 2, 1990.
"Annual General Meeting Minutes—July 26, 2012." CPHAOF Archives. Accessed March 1, 2013.
Armstrong, Foster, Richard Klein, and Cara Armstrong. *A Guide to Cleveland's Sacred Landmarks*. Kent, OH: Kent State University Press, 1992.
"The Atheneum." *Plain Dealer*. July 18, 1853.
"At Play House Reception for Czech Comedians." *Cleveland Press*. March 28, 1940.
Atkinson, Brooks. "At the Theatre: Play House Dedicates Its Third Showcase with Freshly Designed *Romeo and Juliet*." *New York Times*. October 17, 1949.
"Back at Foundry Today." *Plain Dealer*. May 7, 1935.
"Bans Picketing at Play House." *Cleveland News*. October 11, 1939.
Beckly, Rober M., and Sherrill M. Myers. *Theater Facilities: Guidelines and Strategies*. Milwaukee: Center for Architecture and Urban Planning Research, University of Wisconsin-Milwaukee, 1981.
Bedard, Roger. Interviewed by the author. Email correspondence. July 2, 2012.
Bell, Archie. "Hauptmann's *The Sunken Bell* for Special Local Matinee." *Plain Dealer*. March 26, 1911.
Bell, Archie. "Sarah Bernhardt and Mrs. Leslie Carter are Features at Theatres." *Plain Dealer*. November 13, 1910.
Bellamy, Molly. "Play House Masked Ball to Have Golden Cast." *Plain Dealer*. March 16, 1965.
Bellamy, Peter. "2 Play House Chiefs Resign." *Plain Dealer*. January 11, 1971.
Bellamy, Peter. "Beckett Heaps Boredom on the Top of Obscurity." *Plain Dealer*. November 2, 1970.
Bellamy, Paul. "Catch These Vandals!" *Plain Dealer*. September 28, 1937.
Bellamy, Paul. "Freedom of the Theater." *Plain Dealer*. February 16, 1940.
Bellamy, Peter. "Greene Taking over Helm of Play House." *Plain Dealer*. April 18, 1969.
Bellamy, Paul. "Ill-Timed Picketing." *Plain Dealer*. October 5, 1937.
Bellamy, Peter. "*Lysistrata* at Play House Plumbs Depth of Vulgarity." *Plain Dealer*. December 5, 1970.
Bellamy, Peter. "New Director Hopes to Restore Joy to Theater." *Plain Dealer*. January 19, 1971.
Bellamy, Peter. "New Play House Chief Sets Tour." *Plain Dealer*. May 22, 1970.
Bellamy, Peter. "Preferred the Theatre to Defending Criminals." *Plain Dealer*. December 21, 1969.
Bellamy, Peter. "Play House Chief Lowe Eyes Retirement Role." *Plain Dealer*. April 18, 1969.
Bellamy, Peter. "Play House Remains as Lowe's Monument." *Plain Dealer*. January 27, 1971.

Bellamy, Peter. "Of Things to Come." *Plain Dealer.* July 14, 1968.
Bellamy, Peter. "Two 'Firsts' for Wexler: Play House Acquires Writer-in-Residence." *Plain Dealer.* January 27, 1970.
Berkowitz, Gerald M. *New Broadways—Theatre across America: Approaching a New Millennium.* New York: Applause Books, 1997.
Bettendorf, Edward L. "Letter to Robert A. Blattner, President—January 25, 1994." CPH Archives. Accessed December 10, 2012.
"*Beyond the Horizon* Next Play House Bill." *Plain Dealer.* November 20, 1921.
Binns, Archie. *Mrs. Fiske and the American Theatre.* New York: Crown Publishers, 1955.
"Birthday—Max Eisenstat." *Plain Dealer.* September 6, 1936.
Bixby, Jessica. "Every Night Is Student Night at CPH!" Cleveland Play House. February 3, 2012. http://www.clevelandplayhouse.com/ blog/2012/02/every-night-is-student-night-at-cph. Accessed August 3, 2013.
Blake, Ben. *The Awakening of the American Theatre.* New York: Tomorrow Publishers, 1936.
Blattner, Robert. Interviewed by the author. Case Western Reserve University, Cleveland, OH. March 26, 2013.
"Blood Was Shed." *The Spokesman Review* (Spokane, WA). August 2, 1896.
Bloom, Michael. Interviewed by the author. Telephone. February 25, 2013.
Board of Directors. "Minutes of the Special Meeting of the Board of Directors—June 6, 2007." CPHAOF. Accessed March 1, 2013.
Board of Directors. "Minutes of the Meeting of the Board of Directors—September 25, 2008." CPHAOF. Accessed March 1, 2013.
Board of Directors. "Minutes of the Meeting of the Board of Directors—November 20, 2008." CPHAOF. Accessed March 1, 2013.
Board of Trustees. "Minutes of the Board of Trustees of the Play House—January 5, 1960." CPH Archives. Accessed October 15, 2012.
Board of Trustees. "Minutes of the Board of Trustees of the Play House—May 24, 1960." CPH Archives. Accessed October 15, 2012.
Board of Trustees. "Minutes of the Board of Trustees of the Play House—January 15, 1963." CPH Archives. Accessed October 15, 2012.
Board of Trustees. "Minutes of the Board of Trustees of the Play House—September 30, 1963." CPH Archives. Accessed October 15, 2012.
Board of Trustees. "Minutes of the Board of Trustees of the Play House—February 25, 1964." CPH Archives. Accessed October 15, 2012.
Board of Trustees. "Minutes of the Board of Trustees of the Play House—May 26, 1964." CPH Archives. Accessed October 15, 2012.
Board of Trustees. "Minutes of the Board of Trustees of the Play House—June 15, 1964." Accessed October 15, 2012.
Board of Trustees. "Minutes of the Board of Trustees of the Play House—June 28, 1965." CPH Archives. Accessed October 15, 2012.
Board of Trustees. "Minutes of the Board of Trustees of the Play House—September 13, 1965." CPH Archives. Accessed October 15, 2012.

Board of Trustees. "Minutes of the Board of Trustees of the Play House—August 16, 1966." CPH Archives. Accessed October 17, 2012.
Board of Trustees. "Minutes of the Board of Trustees of the Play House—April 17, 1967." CPH Archives. Accessed October 15, 2012.
Board of Trustees. "Minutes of the Board of Trustees of the Play House—January 22, 1968." CPH Archives. Accessed October 17, 2012.
Board of Trustees. "Minutes of the Board of Trustees of the Play House—July 8, 1968." CPH Archives. Accessed October 17, 2012.
Board of Trustees. "Minutes of the Board of Trustees of the Cleveland Play House—September 16, 1970." CPH Archives. Accessed December 10, 2012.
Board of Trustees. "Minutes of the Board of Trustees of the Cleveland Play House—November 8, 1970." CPH Archives. Accessed December 10, 2012.
Board of Trustees. "Minutes of the Board of Trustees of the Cleveland Play House—December 14, 1970." CPH Archives. Accessed December 10, 2012.
Board of Trustees. "Minutes of the Board of Trustees of the Cleveland Play House—January 17, 1971." CPH Archives. Accessed December 10, 2012.
Board of Trustees. "Minutes of the Board of Trustees of the Cleveland Play House—September 8, 1976." CPH Archives. Accessed December 10, 2012.
Board of Trustees. "Minutes of the Board of Trustees of the Cleveland Play House—November 10, 1983." CPH Archives. Accessed December 10, 2012.
Board of Trustees. "Minutes of the Board of Trustees of the Cleveland Play House—May 19, 1987." CPH Archives. Accessed December 10, 2012.
Board of Trustees. "Minutes of the Meeting of the Board of Trustees and Advisory Council—March 1, 1988." CPH Archives. Accessed December 10, 2012.
Board of Trustees. "Minutes of the Board of Trustees of the Cleveland Play House—May 10, 1988." CPH Archives. Accessed December 10, 2012.
Board of Trustees. "Excerpts—Artistic Mission of the Cleveland Play House, April 7, 1990." CPH Archives. Accessed December 10, 2012.
Board of Trustees. "Minutes of Board of Trustees' Retreat—February 22, 1992." CPH Archives. Accessed December 10, 2012.
Board of Trustees. "Minutes of the Cleveland Play House Board of Trustees Retreat—October 30, 1993." CPH Archives. Accessed December 10, 2012.
Board of Trustees. "Minutes of the Board of Trustees' Special Meeting and Retreat—November 12, 1994" CPH Archives. Accessed March 1, 2013.
Board of Trustees and Advisory Council. "Minutes of the Meeting of the Board of Trustees and Advisory Council—March 1, 1988." CPH Archives. Accessed December 10, 2012.
Board of Trustees and Advisory Council. "Minutes of the Board of Trustees and Advisory Council—March 21, 1996." CPH Archives. Accessed March 1, 2013.
Board of Trustees and Advisory Council. "Minutes of the Board of Trustees and Advisory Council—May 14, 1996." CPH Archives. Accessed March 1, 2013.
Bordman, Gerald Martin, and Thomas S. Hischak. "Play House." *Oxford Companion to American Theatre.* Oxford: Oxford University Press, 2004.

"Boston Athenaeum Theatre History." Proprietors of the Boston Athenaeum. http://www.bostonathenaeum.org/node/224. Accessed April 1, 2012.

"Born Yesterday." Internet Broadway Database. http://ibdb.com/production.php?id=4529. Accessed January 2, 2013.

Borowitz, Albert I. "Letter to the Editor—December 9, 1970." CPH Archives. Accessed December 10, 2012.

Braun, Edward. *The Director and the Stage*. New York: Holmes and Meier, 1982.

Brooks, Charles S. "Letter to Frederic F. McConnell—March 8, 1923." CPH Archives. Accessed June 11, 2012.

Brooks, Charles S. "The Play House." *Theatre Arts Monthly*, vol. 10, no. 8 (August 1926).

"Brooks, Charles Stephen." *The Encyclopedia of Cleveland History*. http://ech.cwru.edu/ech-cgi/article.pl?id=BCS1. Accessed March 21, 2011.

"Brooks, Minerva Kline." *The Encyclopedia of Cleveland History*. http://ech.cwru.edu/ech-cgi/article.pl?id=BMK. Accessed March 21, 2011.

Brown, Alexander C. "What the Chamber of Commerce Can Do in Promoting Better Industrial Relations in a Community." *Constructive Experiments in Industrial Cooperation between Employers and Employees*. vol. 9, no. 4 (January 1922).

Brown, Gilmor. "A Dream on a Dime." In *Ten Talents in the American Theatre*, edited by David H. Stevens. Norman: University of Oklahoma Press, 1957.

Brown, Irving Marsan. *Cleveland Theatre in the Twenties*. PhD diss., Ohio State University, 1961.

Brown, Tony. "Josephine Abady, Play House's Controversial Artistic Director." *Plain Dealer*. Wednesday, May 29, 2002.

Brown, Tony. "Cleveland Clinic Buys Cleveland Play House Is Best Deal under Worst Circumstances." *Plain Dealer*. July 24, 2009. http://www.cleveland.com/onstage/index.ssf/2009/07/cleveland_clinic_buys_clevelan.html. Accessed July 2, 2013.

Brown, Tony. "Cleveland Clinic Buys Cleveland Play House Site: Pressure Now on MOCA to Move." *Plain Dealer*. October 16, 2009. http://www.cleveland.com/onstage/index.ssf/2009/10/cleveland_clinic_buys_clevelan_1.html. Accessed March 23, 2013.

Brown, Tony. "Proposed Renovation of Playhouse Square's Allen Theatre Promises Big Payoff." *Plain Dealer*. June 5, 2010. http://www.cleveland.com/onstage/index.ssf/2010/06/proposed_renovation_of_playhou.html. Accessed August 2, 2013.

Bruno, Robert. "Steel on Strike: From 1936 to the Present." In *The Encyclopedia of Strikes in American History*, edited by Aaron Brenner, Benjamin Day, and Immanuel Ness. Armonk, NY: M. E. Sharpe, 2009.

Bureau of the Census. "Changes in Economic Level in Nine Neighborhoods in Cleveland: 1960 to 1965." Washington, DC: Bureau of the Census, 1966. Series P-23, No. 20.

"*The Cemetery Club.*" Internet Broadway Database. http://ibdb.com/production.php?id=4327. Accessed January 2, 2013.

Chadsey, Mildred, ed. *The Cleveland Year Book 1921.* Cleveland, OH: Cleveland Foundation, 1921.

Chadsey, Mildred, ed. *The Cleveland Year Book 1922.* Cleveland, OH: Cleveland Foundation, 1922.

Chansky, Dorothy. *Composing Ourselves: The Little Theatre Movement and the American Audience.* Carbondale: Southern Illinois University, 2004.

Chase, Tony. "Artistic Differences." *Theatre Week.* April 4–10, 1994.

Chernow, Ron. *Titan: The Life of John D. Rockefeller.* New York: Random House, 1998.

Chesterton, G. K. "Is New York Drifting to a Tragic Future?" *Plain Dealer.* July 26, 1914.

Chew, Helen, and C. E. Gehlke. *Directory of Civic and Welfare Activities of Cleveland.* Cleveland, OH: Cleveland Foundation, 1923.

"Children's Theatre of Main History." Children's Museum and Theatre of Main. http://www.kitetails.org/about-us/our-history/theatre-history/. Accessed July 2, 2012.

Christiansen, Richard. *A Theatre of Our Own.* Evanston, IL: Northwestern University Press, 2004.

Cigliano, Jan. *Showplace of America: Cleveland's Euclid Avenue, 1850–1910.* Kent, OH: Kent State University Press, 1991.

"City of New York & Boroughs: Population and Population Density from 1790." http://www.demographia.com/dm-nyc.htm. Accessed November 2, 2012.

Clarage, Eleanor. "Main Street Meditations." *Plain Dealer.* February 21, 1940.

Clark, William Benjamin, Jr. *A History of the Play House, 1936–1968.* PhD diss., Tulane University, 1968.

Cleveland City Planning Commission. "History of the City Planning Commission, the 'Grubb Years: 1957–1969.'" *Cleveland: City Planning in the 20th Century.* Cleveland, OH: Cleveland City Planning Commission, 1968.

Cleveland Orchestra. "Program." Cleveland, OH: Musical Arts Association, 1966.

Cleveland Play House. "Application to the Cleveland Foundation—June 1976." CPH Archives. Accessed December 10, 2012.

Cleveland Play House. "Budget Comparisons—February 13, 1997." CPH Archives. Accessed March 1, 2013.

Cleveland Play House. "Cleveland Play House Contingency Budget—October 8, 1993." CPH Archives. Accessed December 10, 2012.

Cleveland Play House. "Congratulations, Laura Kepley!" October 3, 2013. http://www.youtube.com/watch?v=0YuH9yacpno. Accessed October 20, 2013.

Cleveland Play House. "Long Range Goals—March 26, 1990." CPH Archives. Accessed December 10, 2012.

Cleveland Play House. "Minutes of the Annual Meeting of the Corporation of the Cleveland Play House—July 14, 1987." CPH Archives. Accessed December 10, 2012.

Cleveland Play House. "Overview and Mission." http://clevelandplayhouse.com/about/overview-and-mission. Accessed March 19, 2013.
Cleveland Play House. "Press Release: Cleveland Play House Names Laura Kepley Artistic Director—September 23, 2013." E-mail Correspondence and CPHAOF. Accessed September 23, 2013.
Cleveland Play House. "Press Release: The Cleveland Play House Remembers Josephine Abady—May 28, 2002." CPH Archives. Accessed December 10, 2012.
Cleveland Play House. "Press Release—January 11, 1994." CPH Archives. Accessed December 10, 2012.
Cleveland Play House. "Press Release—January 19, 1971." CPH Archives. Accessed December 10, 2012.
"Cleveland Play House." *The Encyclopedia of Cleveland History*. CWRU.edu. http://ech.case.edu/cgi/article.pl?id=CPH. Accessed December 21, 2012.
"Cleveland Play House's First Season in Playhouse Square Home: Fall Theater Preview." *Plain Dealer*. September 11, 2011. http://www.cleveland.com/onstage/index.ssf/2011/09/cleveland_play_houses_first_se.html. Accessed August 2, 2013.
"Cleveland Play House Gets Edgy in 2011–12 Season, the First at Playhouse Square." *Plain Dealer*. March 13, 2011. http://www.cleveland.com/onstage/index.ssf/2011/03/cleveland_play_house_tweaks_ar.html. Accessed August 2, 2013.
"Cleveland RTA Honored for 'HealthLine' BRT." *Metro Magazine*. April 12, 2011. http://www.metro-magazine.com/News/Story/2011/04/Cleveland-RTA-honored-for-HealthLine-BRT.aspx. Accessed May 14, 2011.
"Cleveland State University." *US News and World Report—Education*. http://colleges.usnews.rankingsandreviews.com/best-colleges/cleveland-state-university-3032. Accessed August 3, 2013.
Connors, Joanna. "Allen Theatre Renovation Nears Completion at Cleveland's PlayhouseSquare." *PlainDealer*. August 11, 2011. http://www.cleveland.com/arts/index.ssf/2011/08/clevelands_allen_theatre_renov.html. Accessed August 2, 2013.
Connors, Joanna. "The Renaissance of Cleveland's Allen Theatre: How Theater Renovation Brought Together Three Institutions." *Plain Dealer*. September 18, 2011. http://www.cleveland.com/arts/index.ssf/2011/09/the_renaissance_of_clevelands.html. Accessed August 2, 2013.
"The Copley Theater (1916–1957?)." The Boston Athenæum. http://www.bostonathenaeum.org/node/224#n. Accessed July 30, 2011.
"Course; Atrocious Futurist." *Plain Dealer*. March 15, 1914.
Craig, Lisa. "Cleveland Play House Announces 2011–12 Season." CPHAOF. Accessed March 5, 2013.
Crawford, Brad, and William Manning. *Ohio*. New York: Random House, 2005.
Cumming, Marsue, ed. *Theatre Profiles 3*. New York: Theatre Communications Group, 1977.
Curtiss, Cornelia. "American Theater Society and Play House to Present Series of Interesting Plays." *Plain Dealer*. October 2, 1932.

Curtiss, Cornelia. "Cleveland Skating Club Sets Pattern for Other Cities as More Private Rinks Go Up." *Plain Dealer.* January 21, 1938.
Curtiss, Cornelia. "Music and Marionettes Attractions." *Plain Dealer.* November 26, 1921.
Curtiss, Cornelia. "Puppet Player's Guild to Stage Marionet [*sic*] Show for Benefit of Park School." *Plain Dealer.* November 13, 1921.
Curtiss, Cornelia. "Travel, Guests." *Plain Dealer.* October 21, 1932.
"Czech Comics Arrive to Act in Own Play." *Plain Dealer.* February 16, 1940.
Daerr, Marie. "Cleveland's U.S.O. Posts Keep Visiting Soldiers Happy between Trains, Busses." *Cleveland Press.* February 5, 1942.
Danforth, Roger. Interviewed by the author. Cleveland Play House Schubert Library. Video recording. November 12, 2010.
Davis, Jed H., and Mary Jane Larson Watkins. *Children's Theatre: Play Production for the Child Audience.* New York: Harper & Brothers, 1960.
Davis, Katharine S., and Elizabeth Lawrence. *Two Gardeners: A Friendship in Letters.* Edited by Emily Herring Wilson. Boston: Beacon Press, 2003.
Davis, Linda H. *Onward and Upward: A Biography of Katherine S. White.* New York: Harper and Row, 1979.
Dawson, Andrew. "Strikes in the Motion Picture Industry." Edited by Aaron Brenner, Benjamin Day, and Immanuel Ness. Armonk, NY: M. E. Sharpe, 2009.
Dean, Alexander. *Little Theatre Organization and Management.* New York: Appleton, 1926.
"Death Rings Down Curtain on Actor Rolf Engelhardt." *Plain Dealer.* December 12, 1955.
"Deny Ohio Women Will Help Move to Fight Democrats." *Plain Dealer.* September 15, 1914.
DiPasquale, Pamela. Interviewed by the author. Cleveland Play House. Cleveland, OH. Notes from conversation. July 13, 2013.
DiPasquale, Pamela. Interviewed by the author. E-mail correspondence. June 13, 2012.
Dray, Philip. *There is Power in a Union: The Epic Story of Labor in America.* New York: Doubleday, 2010.
Dubb, Steve. "Community Revitalization Advocates Gather in Cleveland, Ohio." October2010. http://community-wealth.org/content/community-revitalization-advocates-gather-cleveland-ohio. Accessed August 1, 2013.
Eckert, Thor, Jr. "How the Cleveland Play House Sprouted Its New Complex." *Christian Science Monitor.* January 12, 1984. http://www.csmonitor.com/1984/0112/011211.html. Accessed December 11, 2012.
"Editorial: A Builder of the Play House." *Plain Dealer.* August 20, 1956.
"Editorial: Walter L. Flory." *Plain Dealer.* July 5, 1951.
Edwards, P. K. *Strikes in the United States, 1881–1974.* New York: St. Martin's Press, 1981.

Eisenstat, Max. "Letter to Mr. Francis K. Draz—June 18. 1945." CPH Archives. Accessed September 7. 2012.

"Elderkin, N. S. Jr." "The Play House Log of Participation in World War, 1940–1945." CPH Archives. Accessed September 7, 2012.

Evett, Marianne. "Asner, Kahn to Star in *Born Yesterday* at Play House." *Plain Dealer*. June 30, 1988.

Evett, Marianne. "Let's Let Abady Guide Play House." *Plain Dealer*. January 27, 1988.

Evett, Marianne. "Play House Drops Resident Staff." *Plain Dealer*. January 7, 1988.

Evett, Marianne. "Shortsighted Play House Board Can Only See Box Office." *Plain Dealer*. February 13, 1994.

Evett, Marianne. "Woman to Lead the Play House." *Plain Dealer*. May 20, 1987.

"Excerpts from Cleveland Play House Strategic Plan, 2013–2017—April 12, 2013." CPHAOF Archives. Accessed April 12, 2013.

Executive Committee. "Minutes of the Executive Committee of the Board of Trustees of the Cleveland Play House—November 1, 1976." CPH Archives. Accessed December 10, 2012.

Executive Committee. "Minutes of the Executive Committee of the Board of Trustees of the Cleveland Play House—December 16, 1976." CPH Archives. Accessed December 10, 2012.

Executive Committee. "Meeting of the Executive Committee—March 26, 1993." CPH Archives. Accessed December 10, 2012.

Executive Committee. "Minutes of the Meeting of the Executive Committee—April 19, 1993." CPH Archives. Accessed December 10, 2012.

Executive Committee. "Minutes of the Meeting of the Executive Committee—June 4, 1993." CPH Archives. Accessed December 10, 2012.

Executive Committee. "Minutes of the Meeting of the Executive Committee—October 11, 1993." CPH Archives. Accessed December 10, 2012.

Executive Committee. "Minutes of the Meeting of the Executive Committee—January 5, 1994." CPH Archives. Accessed December 10, 2012.

Executive Committee. "Minutes of the Meeting of the Executive Committee—May 18, 2004." CPH Archives. Accessed March 1, 2013.

Executive Committee. "Minutes of the Meeting of the Executive Committee—June 9, 2004." CPH Archives. Accessed March 1, 2013.

Executive Committee. "Minutes of the Meeting of the Executive Committee—October 14, 2004." CPH Archives. Accessed March 1, 2013.

Executive Committee. "Minutes from the Meeting of the Executive Committee—November 2, 2006." CPHAOF. Accessed March 1, 2013.

Executive Committee. "Minutes from the Meeting of the Executive Committee—February 19, 2009." CPHAOF. Accessed March 1, 2013.

Executive Committee. "Minutes of the Meeting of the Executive Committee—October 15, 2009." CPHAOF. Accessed March 1, 2013.

Executive and Finance Committee. "Minutes of the Joint Meeting of the Executive and Finance Committee—March 11, 1987." CPH Archives. Accessed December 10, 2012.

"Exiled Actress Here." *Plain Dealer.* March 31, 1910.

Exner, Rich. "2010 Census Population Numbers Show Cleveland below 400,000: Northeast Ohio Down 2.2 Percent." *Plain Dealer.* March 9, 2011. http://www.cleveland.com/datacentral/index.ssf/2011/03/2010_census_figures_for_ohio_s.html. Accessed August 2, 2013.

Exner, Rich. "Cleveland Weather History: Find Cleveland Weather Details for Any Date since 1900." *Plain Dealer.* September 5, 2008. http://www.cleveland.com/datacentral/index.ssf/2008/09/cleveland_weather_history_find.html?appSession=057371263134259. Accessed March 24, 2013.

"Explain Why Union Demand was Rejected." *Cleveland Press.* September 24, 1937.

"Fenn to Become Cleveland State U. Today." *Plain Dealer.* September 1, 1965.

Finance Committee. "Minutes of the Meeting of the Finance Committee—May 15, 2007." CPHAOF Archives. Accessed March 1, 2013.

Finance Committee. "This letter sent October 1st to...—September 17, 1918." CPH Archives. Accessed May 31, 2011.

Finance and Investment Committee. "Minutes of the Meeting of the Finance and Investment Committee—January 20, 2009." CPHAOF. Accessed March 1, 2013.

Finance and Investment Committee. "Minutes of the Meeting of the Finance and Investment Committee—September 9, 2008." CPHAOF. Accessed March 1, 2013.

Fischer, Ruth. "The Play House: The Nation's First Professional Resident Theatre Company." Cleveland, OH: Play House Promotional Materials, 1963.

Fitzgerald, John B., and William Finnegan. "Union Statement." *Cleveland Press.* October 4, 1937.

Flexner, Eleanor. *Century of Struggle: The Woman's Rights Movement in the United States.* Cambridge, MA: Belknap Press of Harvard University Press, 1959.

Florida, Richard. "Cleveland's Downtown Rebound." *The Atlantic Cities.* May 4, 2012. http://www.theatlanticcities.com/jobs-and-economy/2012/05/clevelands-downtown-rebound/1917/. Accessed August 26, 2013.

Flory, Julia McCune. *The Play House: How It Began.* Cleveland: Press of Western Reserve University, 1965.

Flory, Walter. "Letter to Charles S. Brooks—March 11, 1919." CPH Archives. Accessed May 31, 2011.

Flory, Walter L. "Letter to Dr. David H. Stevens—March 29, 1948." CPH Archives. Accessed September 7, 2012.

Flory, Walter L. "Letter to Mr. George H. Lundy—June 10, 1949." CPH Archives. Accessed September 10, 2012.

Flory, Walter L. "Letter to Mr. Leonard C. Hanna, Jr.—October 2, 1946." CPH Archives. Accessed September 7, 2012.

Flory, Walter. "Letter to Raymond O'Neil—July 7, 1917." CPH Archives. Accessed May 31, 2011.
Flory, Walter. "Letter to Raymond O'Neil—December 21, 1918." CPH Archives. Accessed May 31, 2011.
Flory, Walter. "Letter to Raymond O'Neil—February 17, 1919." CPH Archives. Accessed May 31, 2011.
Flory, Walter L. "Memo to the Trustees of the Play House Foundation and to the Members of the Special Joint Play House and Play House Foundation Committee—April 24, 1948." CPH Archives. Accessed September 10, 2012.
Flory, Walter L. "Memorandum from Walter L. Flory to Members of the Building Committee of the Play House Foundation—March 22, 1950." CPH Archives. Accessed September 10, 2012.
Ford, Elijah. Interviewed by Britt Goodman. Video recording at the Cleveland Play House. September 2010. Date unspecified.
"Free of Debt." *Plain Dealer*. May 25, 1936.
Friedhoff, Alec, and Siddharth Kulkarni. "Metro Monitor." The Brookings Institution. July 1, 2013. http://www.brookings.edu/research/interactives/metromonitor#M17460-recession-overall-nv. Accessed August 1, 2013.
Fullerton, Spencer. "C.F.L. Votes Barrington Support." *Plain Dealer*. September 2, 1937.
Gardner, Herb. "Text of Telegram to Cleveland Play House Board of Trustees." Date unspecified." CPH Archives. Accessed December 10, 2012.
Giaimo, Sam. "Names of Rioters Revealed to Jury." *Cleveland Press*. July 27, 1966.
Gilchrist, Ed. "Michael Bloom Closes Out His Tenure as Artistic Director at Cleveland Play House." E-mail correspondence to NEOPAL listserv. May 23, 2013. Accessed May 23, 2013.
Gladden, Dean. Interviewed by the author. Alley Theatre. Houston, TX. Audio recording. November 9, 2012.
Gladden, Dean. Interviewed by the author. Shaker Heights, OH. August 6, 2013.
Gladden, Dean. "Memo to Members of the Executive Committee—October 6, 1993." CPH Archives. Accessed December 10, 2012.
Gladden, Dean R. "Fax Transmission to Leif Soderberg, Bob Newmark, Boake Sells—March 12, 1993." CPH Archives. Accessed December 10, 2012.
"Good Old Fashioned Fairy Story is Told in Beautiful Dramatic Form." *Plain Dealer*. February 18, 1912.
Gordon, Mark Alan. Interviewed by the author. Telephone. December 17, 2012.
"Gordon to Oppose Suffrage in House." *Plain Dealer*. December 21, 1913.
Goulder, Grace. "Society Arranges Two Dramas Here." *Plain Dealer*. April 12, 1916.
Goulder, Grace. "They're Seals and Seedlings Now." *Plain Dealer*. December 26, 1915.

Gussow, Mel. "Josephine Abady, 52, Director of Plays On and Off Broadway." *New York Times*. May 30, 2002.

Hahn, Richard H. "Change Comes to the Cleveland Play House." CPH Archives. Accessed December 10, 2012.

Halverson, Richard. Interviewed by David Stashower. Video recording at the Cleveland Play House. September 24, 2010.

Hammack, David C., and Helmut K. Anheier. "American Foundations: Their Roles and Contributions to Society." In *American Foundations: Roles and Contributions*, edited by Helmut K. Anheier and David C. Hammack. Washington, DC: Brookings Institution Press, 2010.

Hanna, Leonard C. "Letter to Walter—October 22, 1946." CPH Archives. Accessed September 7, 2012.

Harper, Ida Husted, ed. *The History of Women's Suffrage*, vol. 6. New York: J. J. Little and Ives, 1922.

Hartman, Elek. "The Play House Log of Participation in World War, 1940–1945." CPH Archives. Accessed September 7, 2012.

Harvard, Brian M. "National Labor Relations Board v. Jones and Laughlin Steel Corp." In *Encyclopedia of the United States Constitution*, edited by David Andrew Schultz. New York: Facts on File, 2009.

"Harvard Group Brings Plays to Duchess Theatre." *Plain Dealer*. April 10, 1921.

Harwood, Herbert H. *Invisible Giants: The Empires of Cleveland's Van Sweringen Brothers*. Bloomington: Indiana University Press, 2003.

Hershey, Rice. *The Play House: Sixty Years of Professional Resident Theatre*. Cleveland, OH: Play House Promotional Publication, 1975.

Hilliary, Dennis. Transcript of Interview. Cleveland Citizens Committee on Hough Disturbances. August 23, 1966.

"A History of the Provincetown Playhouse." http://www.provincetownplayhouse.com/history.html. Accessed August 1, 2011.

Holt, Harlowe. "Town Gadabout." Source unknown. Play House Scrapbook (1929). CPH Archives. Accessed June 11, 2012.

Hoyt, Harlowe R. "Play House Pioneer: Tippy O'Neil's Death Recalls Early Days." *Plain Dealer*. April 21, 1957.

"Hoop La! Cleveland Artists at Play." *Plain Dealer*. January 12, 1913.

Houghton, Norris. *Advance from Broadway: 19,000 Miles of American Theatre*. New York: Harcourt, Brace, 1941.

Huszar, Kenneth D. "Jury's Riot Probe Goes 'Step Beyond.'" *Plain Dealer*. August 2, 1966.

"IN FOCUS: New Leader Picked for Cleveland." *Backstage*, vol. 35, no. 41 (October 14, 1994).

Innes, Christopher. *Edward Gordon Craig*. Cambridge: Cambridge University Press, 1983.

Jack, Carolyn. "Abady Dismissed Despite 'Terrific' Work in Cleveland." *Backstage*. January 21–27, 1994.

"Joint Committee—Playhouse [sic] Building Project—Agenda Meeting March 19, 1946." CPH Archives. Accessed September 7, 2012.

Johnston, Christopher. "The Arts District Difference." *American Theatre*. www.tcg.org/publications/at/oct11/cleveland.cfm. Accessed August 18, 2013.

"Jones Claims Abuse by Police Began in '61." *Plain Dealer*. August 25, 1966.

Jones, Chris. "Cleveland Ousts Abady." *Variety*. January 17–23, 1994.

Jones, Chris. "Cleveland Taps Hackett as New Play House A.D." *Variety*. October 17–24, 1994.

Jones, Kenneth. "Peter Hackett Leaves Cleveland Play House for Academic in September 2004." *Playbill*. December 30, 2003. http://www.playbill.com/news/article/print/83542.html. Accessed March 19, 2013.

Jones, Margo. *Theatre-in-the-Round*. New York: Rinehart, 1951.

"Jury Hough Report Praised, Belittled." *Plain Dealer*. August 11, 1966.

"Jury Pinpoints Hough 'Thorns.'" *Plain Dealer*. August 10, 1966.

Kabatachnik, Amnon. *Blood on the Stage, 1950–1975: Milestone Plays of Crime, Mystery and Detection*. New York: Scarecrow Press, 2011.

Kellstadt, Charles H., and Fred P. Auxer. "Letter to Mr. T. L. Sidlo, Pres.—December 20, 1941." CPH Archives. Accessed September 7, 2012.

Kelly, Lora. "Cleveland's Little Theater." *Plain Dealer*. May 13, 1917.

Kelly, Lora. "Splurge? Yes-siree! Futurists Made It." *Plain Dealer*. April 28, 1915.

Kitchen, Karl K. "All about Awful Art." *Plain Dealer*. March 24, 1913.

"'Kliz' Illustrator Dies: G.H.H. Clisbee was Former Art Editor of *Cleveland News*." *Plain Dealer*. December 6, 1936.

Klewer, Leonore. "Letter to Mr. W. McNeil Lowry—February 12, 1964." CPH Archives. Accessed October 15, 2012.

Knight, L. M. "Letter to Walter Flory—December 17th, 1918." CPH Archives. Accessed May 31, 2011.

"Kokoon Art Klub Runs Riot in Oils." *Plain Dealer*. July 22, 1911.

"Kokoon Club Will Move." *Plain Dealer*. December 14, 1913.

Kraditor, Aileen S. *The Ideas of the Woman Suffrage Movement, 1890–1920*. New York: Columbia University Press, 1965.

Kroll, Kathryn. "Recession Will Last Longest in Midwest, including Ohio, Two Reports Show." *Plain Dealer*. June 17, 2009. http://www.cleveland.com/business/index.ssf/2009/06/economy.html. Accessed August 1, 2013.

Kronman, Anthony T. *History of the Yale Law School*. New Haven: Yale University Press, 2004.

Kuhn, Peter. Interviewed by the author. Cleveland, OH. Audio recording. February 26, 2013.

"Labor Linked with Bombing at Play House." *Cleveland Press*. September 24, 1937.

"Labor Union's Rights: High School Pupils Will Settle One Point Tonight." *Plain Dealer*. January 20, 1905.

"Labor Vandalism in New Outbreak." *Plain Dealer*. August 1, 1937.

Lackritz, Marc E. "The Hough Riots of 1966." Cleveland, OH: Regional Church Planning Office, 1968.
Lake, D. J. *Atlas of Cuyahoga County, Ohio*. Philadelphia, PA: Titus, Simmons, and Titus, 1874.
"Leader of Suffrage Party in County Has Charming Personality, a Quick Mind and Statesmanship." *Plain Dealer*. May 24, 1914.
"Led Theater to Professionalism: Play House's K Elmo Lowe Dies." *Plain Dealer*. January 27, 1971.
Lenhart Jr., Harry. "Origin of a University: Rhodes Is a Midwife for Baby CSU." *Plain Dealer*. December 21, 1964.
"Letter to Mr. E. F. Lenihan—April 5, 1918." CPH Archives. Accessed June 11, 2011.
"Letter to Mr. Richard Oberlin, Director—Date unspecified." CPH Archives. Accessed December 10, 2012.
Levin, Stuart. "Letter to 'Friends'—January 9, 1971." CPH Archives. Accessed December 10, 2012.
"Library Players Score Big Success." *Plain Dealer*. February 5, 1921.
Lichtenstein, Nelson. *State of the Union: A Century of American Labor*. Princeton, NJ: Princeton University Press, 2002.
Lind, Louise. "Case WRU Becomes Area Reality Today." *Plain Dealer*. July 1, 1967.
Litt, Steven. "Cleveland's New Convention Center and Global Center for Health Innovation Aren't Stand-Alone Icons, and That's a Good Thing." *Plain Dealer*. http://www.cleveland.com/architecture/index.ssf/2013/06/clevelands_new_convention_cent.html. Accessed August 2, 2013.
Litt, Steven. "Cleveland's New Convention Hotel Could Bring Life to the Mall and Connect a Disconnected Downtown." *Plain Dealer*. July 25, 2013. http://www.cleveland.com/architecture/index.ssf/2013/07/the_new_cleveland_convention_h.html. Accessed August 2, 2013.
Littman, Alan L. "Letter to Ken [Bolton]—June 13, 1966." CPH Archives. Accessed October 15, 2012.
Long Range Planning Committee. "The Cleveland Play House Long-Range Plan, 1990–95." Cleveland, OH: Cleveland Play House, January 26, 1991. CPH Archives. Accessed December 10, 2012.
Long Range Planning Committee. "The Cleveland Play House Long-Range Plan, 1990–95." Cleveland, OH: Cleveland Play House, September 18, 1990. CPH Archives. Accessed December 10, 2012.
"Lowe Condition Reported Poor." *Plain Dealer*. January 22, 1971.
Lowe, K. Elmo. "Letter to Frederic McConnell—July 9, 1922." CPH Archives. Accessed June 11, 2012.
Lowe, K. Elmo. "Letter to Mrs. Warren J. Henderson—September 14, 1961." CPH Archives. Accessed June 13, 2012.
Lowe, K. Elmo. "Memorandum to: The Play House Board of Trustees—April 8, 1963." CPH Archives. Accessed October 15, 2012.

Lowry, W. McNeil. "Letter to Mrs. Leonore Klewer, Manager—February 24, 1964." CPH Archives. Accessed October 15, 2012.
"Lysistrata." *Plain Dealer*. December 8, 1970.
Macgowan, Kenneth. *Footlights across America: Toward a National Theater*. New York: Harcourt, Brace, 1929.
Mackay, Constance D'Arcy. *The Little Theatre in the United States*. New York: Henry Holt, 1917.
Marsh, W. Ward. "Play House Project Grows." *New York Times*. October 24, 1948.
Martin, Christopher R. "The News Media and Strikes." In *The Encyclopedia of Strikes in American History*, edited by Aaron Brenner, Benjamin Day, and Immanuel Ness. Armonk, NY: M. E. Sharpe, 2009.
Mastroianni, Tony. "Revival Ruins Greek Play." *Cleveland Press*. December 5, 1970.
"McBride, Lucia McCurdy." *The Encyclopedia of Cleveland History*. http://ech.cwru.edu/ech-cgi/article.pl?id=MLM Accessed July 18, 2011.
McCaslin, Nellie. *Historical Guide to Children's Theatre in America*. New York: Greenwood Press, 1987.
McConnell, Frederic. "Director's Report on Play House Extension—30 January 1922." CPH Archives. Accessed June 11, 2012.
McConnell, Frederic. "Letter (unspecified)—August 23, 1942." CPH Archives. Accessed September 7, 2012.
McConnell, Frederic. "Letter to Frank [Draz]—December 5, 1947." CPH Archives. Accessed September 10, 2012.
McConnell, Frederic. "Letter to Homer H. Johnson," CPH Archives. Accessed June 11, 2012.
McConnell, Frederic. "Letter to K. Elmo Lowe—July 14, 1922." CPH Archives. Accessed June 11, 2012.
. "Letter to Miss Irma Milde—May 21, 1923." CPH Archives. Accessed June 11, 2012.
McConnell, Frederic. "Letter to Mr. Brooks—October 31, 1924." CPH Archives. Accessed June 11, 2012.
McConnell, Frederic. "Letter to Mr. Frank Draz—June 10, 1947." CPH Archives. Accessed September 7, 2012.
McConnell, Frederic. "Letter to Mr. Frank Draz—June 20, 1947." CPH Archives. Accessed September 7, 2012.
McConnell, Frederic. "Letter to Mr. Walter L. Flory, President of the Play House Foundation—April 13, 1948." CPH Archives. Accessed September 10, 2012.
McConnell, Frederic. "Letter to Walter—October 28, 1946." CPH Archives. Accessed September 7, 2012.
McConnell, Frederic. "Play House Call Board Note (from scrapbook)." CPH Archives. Accessed September 7, 2012.
McConnell, Frederic. "Play House in Cleveland Wins 10-Year Freedom from Proscenium." *Documents of American Theater History*. Vol. 2, *Famous American Playhouses, 1900–1971*. Chicago: American Library Association, 1973.

McConnell, Frederic. "Program Notes (Reprinted from Play House Program)." CPH Archives. Accessed September 7, 2012.
McConnell, Frederic. "Program Notes." Play House Program. January 23, 1945. CPH Archives. Accessed September 7, 2012.
McConnell, Frederic. "A Proposal for a New Theatre—April 9, 1937." CPH Archives. Accessed September 7, 2012.
McDermott, William F. "Do Theatergoers Want Good Shows and Superior Acting at Lower Prices?" *Plain Dealer*. January 10, 1943.
McDermott, William F. "Local Group Puppet Play Activities." *Plain Dealer*. November 19, 1921.
McDermott, William F. "McDermott on Bombs." *Plain Dealer*. September 25, 1937.
McDermott, William F. "New Lunt and Fontanne Play Forgets the World and Goes in for Laughter." *Plain Dealer*. September 20, 1942.
McDermott, William F. "New Theater Year." *Plain Dealer*. September 29, 1940.
McDermott, William F. "Play about London Actors in Bombing Raids is Well Done at Play House." *Plain Dealer*. April 16, 1942.
McDermott, William F. "The Play House." *Theatre Guild Magazine*, vol. 7, no. 12 (September 1930).
McDermott, William F. "Play House Opens Season with a First Performance of an Interesting Drama." *Plain Dealer*. October 14, 1943.
McDermott, William F. "Play House Will Introduce a Pair of Famous Czech Clowns in New Play." *Plain Dealer*. March 3, 1940.
McDermott, William F. "Recalling the Beginnings on 86th Street, the Progress Made and Still to be Made." *Plain Dealer*. April 11, 1937.
McGruder, Robert G. "Owners Deny Ice-Water Story: Charge Police Refused to Help." *Plain Dealer*. July 23, 1966.
"Membership." *The Bulletin of the Cleveland Museum of Art*. Cleveland, OH: Cleveland Museum of Art, vol. 2, no. 3, 1916.
"Militants Wreck Suffrage Merger." *Plain Dealer*. November 15, 1915.
Miller, Carol Poh, and Robert A. Wheeler. *Cleveland: A Concise History, 1796–1990*. Bloomington: Indiana University Press, 1990.
Miller, Carol Poh, and Robert A. Wheeler. "Cleveland: The Making and Remaking of an American City, 1796–1993." In *Cleveland: A Metropolitan Reader*, edited by W. Dennis Keating, Norman Krumholz, and David C. Perry. Kent, OH: Kent State University Press, 1995.
Milling, Jane, and Graham Key. *Modern Theories of Performance*. New York: Palgrave, 2001.
Milner, Florence. *My Acquaintance with Charles S. Brooks*. New York: Harcourt, Brace, 1932.
"Minutes of the Vision 100 Meeting—March 5, 2009." CPHAOF. Accessed March 1, 2013.
"Miss Charlotte Cushman." *Plain Dealer*. June 4, 1851.

Mlachak, Norman. "Just Like War, Awed Policemen and Firemen Say." *Cleveland Press*. July 19, 1966.
"Moliere a la Marx Bros. Due at Play House." *Plain Dealer*. November 3, 1968.
Moore, Kevin. Interviewed by the author. Cleveland, OH. Audio recording. February 28, 2013.
Moore, Kevin. Interviewed by the author. Cleveland, OH. Notes from interview. April 28, 2010.
Moore, Kevin. Interviewed by the author. Cleveland, OH. Audio recording. June 26, 2013.
Moore, Kevin. Interviewed by the author. Cleveland, OH. Email correspondence. November 12, 2013.
Moody, Richard, and Don B. Wilmeth. "Community Theatre/Little Theatre Movement." *The Cambridge Guide to American Theatre*, edited by Don B. Wilmeth Cambridge: Cambridge University Press, 2007.
Mootz, William. "Actors Theatre's First Ten Years: From Rags to Riches." *Courier-Journal* (Louisville). May 26, 1974.
"Mr. Mansfield's Repertoire." *Plain Dealer*. April 20, 1897.
Mullaney, Denis C. "Letter to the Editor: Play House Changes." *Plain Dealer*. February 27, 1988.
Munro, Thomas, and Jane Grimes. *Educational Work at the Cleveland Museum of Art*. 2nd ed. Cleveland, OH: Cleveland Museum of Art, 1952.
"Music and Musicians." *Plain Dealer*. June 28, 1903.
"Music and Musicians." *Plain Dealer*. December 29, 1907.
"Must Broadway Take a Back Seat?" *Literary Digest*. vol. 114, no. 7 (August 13, 1932).
Nash, Frances G. "Letter to Frederic McConnell—April 11, 1923." CPH Archives. Accessed June 11, 2012.
Naughton, James M. "Stokes Is Elected Mayor." *Plain Dealer*. November 8, 1967.
"Nazi Demands Met: Hitler Gets Almost All He Asked as Munich Conferees Agree." *New York Times*. September 39, 1938.
"New Artistic Director Named for Circle in the Square." *New York Times*. August 24, 1994.
"New Play House Expected to Be Ready April 1st." *Plain Dealer*. June 13, 1926.
Novick, Julius. *Beyond Broadway: The Quest for Permanent Theatres*. New York: Hill and Wang, 1968.
Numsen, Margaret T. "Membership Report." *Bulletin of the Cleveland Museum of Art*, vol. 6, no. 9 (November 1919).
Oberlin, Richard. "Plans for Renewal of the Play House—April 14, 1971." CPH Archives. Accessed December 10, 2012.
"Oh Joy! What a Gay Time They'll Have." *Plain Dealer*. April 15, 1915.
"Ohio's Decayed Cities—Cleveland's Hough." January 14, 2005. http://www.urbanohio.com/forum2/index.php?topic=2047.0. Accessed October 31, 2012.
"Ohio Suffragists to Gather Here This Week." *Plain Dealer*. November 18, 1915.
"Offbeat Play Will Open Friday." *Plain Dealer*. November 16, 1969.

Oldenburg, Chloe Warner. *Leaps of Faith: History of the Play House, 1915–1980*. Cleveland, OH: Published by the author, 1985.

Ondish, Luke. "Hough: Building and Tension." Cleveland in the Sixties. Case Western Reserve University. http://www.case.edu/artsci/sixties/luke.html?nw_view=1352833785&. Accessed November 13, 2012.

O'Neil, Raymond. "Letter to Mrs. Edna Strong Hatch—February 22, 1921." CPH Archives. Accessed May 31, 2011.

O'Neil, Raymond. "Letter to Walter Flory—December 18, 1918." CPH Archives. Accessed May 31, 2011.

"The Opening of the New Opera House." *Plain Dealer*. September 7, 1875.

"An Opera House Burned." *New York Times*. October 30, 1892.

"Our History." McCarter Theatre Center. http://www.mccarter.org/AboutUs/AboutDefault.aspx?page_id=38. Accessed September 25, 2012.

"Our History." The Goodman Theatre. http://www.goodmantheatre.org/About/Our-History/. Accessed September 25, 2012.

Painter, Neil Irvin. *Standing at Armageddon: The United States, 1877–1919*. New York: W. W. Norton, 1987.

Partington, Rex. "Readers Forum: Economic, Not Artistic." *Plain Dealer*. December 9, 1970.

"Peeks at Garments at Futurist Ball." *Plain Dealer*. April 28, 1915.

Pendleton, Alec. Interviewed by the author. Cleveland, OH. Audio recording. February 26, 2013.

Perry, Clarence Arthur. *The Work of the Little Theatres*. New York: Russell Sage Foundation, 1933.

Perry, David C. "Cleveland: Journey to Maturity." In *Cleveland: A Metropolitan Reader*, edited by W. Dennis Keating, Norman Krumholz, and David C. Perry. Kent, OH: Kent State University Press, 1995.

Piiparinen, Richey. "Not Dead Yet: The Infill of Cleveland's Urban Core." Briefly Stated. Center on Urban Poverty and Community Development. Mandel School of the Applied Arts. No. 12–02 April 2012. http://blog.case.edu/msass/2012/04/18/Briefly_Stated_12–02_-_Not_Dead_Yet_The_Infill_of_Clevelands_Urban_Core.pdf. Accessed July 27, 2013.

"*Pillars of Society*." *Plain Dealer*. September 15, 1910.

"Plain Deals." *Plain Dealer*. May 29, 1914.

"Plain Deals." *Plain Dealer*. February 11, 1914.

"A Play with Record." *Plain Dealer*. December 18, 1901.

"Play House Burns Mortgage Today." *Plain Dealer*. May 27, 1936.

"Play House Buys Former Church." *Plain Dealer*. April 9, 1948.

"Play House Calendar (March)." March 1942. CPH Archives. Accessed September 7, 2012.

Play House. "Cash Statement of Income and Expenses—March 31, 1967." CPH Archives. Accessed October 17, 2012.

Play House Foundation. "Minutes of the Play House Foundation Meeting—May 8, 1968." CPH Archives. Accessed October 15, 2012.

"Play House Gets Grant of $130,000." *Plain Dealer.* October 13, 1957.
"The Play House Grows." *Plain Dealer.* May 7, 1948.
"Play House Head Found Dead." *Toledo Blade.* March 13, 1970.
"Play House Maps $30,000 Campaign." *Plain Dealer.* July 15, 1942.
"Play House's New Curtain Pullers Hold First Show." *Plain Dealer.* January 28, 1934.
Play House Programs. "The Play House." October 4, 1939. CPH Archives. Accessed June 18, 2012.
Play House Programs. "The Play House." October 1, 1937. CPH Archives. Accessed June 18, 2012.
"Play House Rapped for Dropping Company." *Plain Dealer.* January 17, 1988.
"Play House Revives *Clarence* Tonight." *Plain Dealer.* December 12, 1942.
"Play House Season's Plans." *Plain Dealer.* September 4, 1921.
"Play House Seeks Funds." *Plain Dealer.* June 30, 1963.
"Play House Serviced Periled by War: $30,000 Fund Sought." *Cleveland News.* July 15, 1942.
"Play House Shows for Tonight are Sold Out." *Plain Dealer.* December 31, 1942.
Play House Survey Committee. "Re-location [*sic*] Survey Committee Report—May 18, 1965." CPH Archives. Accessed October 15, 2012.
"Play House to Repeat Oscar Wilde's Comedy." *Plain Dealer.* October 2, 1921.
"Playhouse Square: Resident Companies." Playhouse Square. http://www.playhousesquare.org/default.asp?playhousesquare=52&urlkeyword=Resident-Companies. Accessed September 29, 2012.
"Poiret Girl of Future May Seem Shocking Now, but She'll Be Comfortable and Eugenic, Then." *Plain Dealer.* October 18, 1914.
"Popeye Adopted by Czechs." *Plain Dealer.* March 17, 1940.
Porter, Phillip W. *Cleveland: Confused City on a Seesaw.* Columbus: Ohio State University Press, 1976.
Professional Acting Ensemble. "Memo to Officers and Trustees, Advisory Committee and Play House Foundation—January 12, 1971." CPH Archives. Accessed December 10, 2012.
"Projected Budget: 1922–1923." CPH Archives. Accessed June 11, 2012.
Pullen, Glenn C. "Old Church Is Eyed by Heads of Play House." *Plain Dealer.* October 21, 1947.
Pullen, Glenn C. "Shows Without Men Prove Their Worth in War Time." *Plain Dealer.* January 7, 1945.
Pullen, Glenn C. "Star Fears Being Typed—Martyn Green to Give up Spaceship." *Plain Dealer.* June 17, 1958.
Rauch, Donald J. "Letter to 'Dear Gang'—February 17, 1943." CPH Archives. Accessed September 7, 2012.
Rauch, Donald J. "Letter to 'Max'—May 11, 1942." CPH Archives. Accessed September 7, 2012.
Rauch, Donald J. "Letter to 'Max'—November 14, 1942." CPH Archives. Accessed September 7, 2012.

Rauch, Donald J. "Letter to 'Maxie'—December 17, 1944." CPH Archives. Accessed September 7, 2012.
Relocation Committee. "Report of Relocation Committee—June 26, 1967." CPH Archives. Accessed October 17, 2012.
Riedel, Michael. "A Renaissance in Cleveland." *Theatre Week*. July 13–19, 1992.
Roberts, Michael D. "Funeral Fund Helped Spark Riot." *Plain Dealer*. July 23, 1966.
Rose, William Ganson. *Cleveland: The Making of a City*. Kent: OH: Kent State University Press, 1950.
Rosenberg, Donald. *The Cleveland Orchestra Story: Second to None*. Cleveland, OH: Gray, 2000.
"Rosenberg Drama." *Plain Dealer*. March 16, 1969.
Ross, Laura, ed. "Cleveland Play House." *Theatre Profiles 6*. New York: Theatre Communications Group, 1984.
Ross, Laura, and John Istel, eds. "Cleveland Play House." *Theatre Profiles 7*. New York: Theatre Communications Group, 1986.
Roth, F. H. "The Play House and Play House School of Theatre Treasurers' Report—July 1, 1963 to January 31, 1954." CPH Archives. Accessed October 17, 2012.
Sabath, Donald. "$100-Million Complex Set for CSU Area." *Plain Dealer*. July 1, 1966.
Sandrow, Nahma. *Vagabond Stars: A World History of Yiddish Theater*. Syracuse, NY: Syracuse University Press, 1996.
Schuele, Hulda. "Tea Treats Have Continental Tang." *Cleveland Press*. April 15, 1940.
Schweinfurth, J. A. "Residence of J. H. Ammon, Cleveland, OH." *American Architect and Building News*, August 20, 1881. James R. Osgood, 1881.
"Sea Dog 'Hardens' Italy's Princeling." *Plain Dealer*. June 10, 1914.
Segal, Eugene. "Staff Hike Asked: Slowdown is Noted in Housing Renewal." *Plain Dealer*. January 26, 1964.
Segal, Eugene. "University City Attains Mushroom Growth within Year." *Plain Dealer*. July 4, 1961.
Seldes, George. *Lords of the Press*. New York: Blue Ribbon Books, 1941.
"Sell Sweets for Hospital Benefit." *Cleveland News*. December 11, 1941.
Seltzer, Louis B. (Foreman). "Special Grand Jury Report Relating to Hough Riots." Cleveland, OH: County Grand Jury. August 9, 1966.
"Senate Vote Bars Colony Transfer." *Plain Dealer*. June 18, 1940.
"Seventy-Fifth Anniversary of the Play House." Cleveland, OH: Play House Promotional Publication, 1990.
Sheehy, Helen. *Margo: The Life and Theatre of Margo Jones* (Dallas, TX: Southern Methodist University Press, 1989).
Sheeran, Thomas J. "Cleveland Sues 21 Banks for Home Loans Gone Bad." *USA Today*. January 11, 2008. http://usatoday30.usatoday.com/money/economy/housing/2008-01-11-cleveland-sues-subprime_N.htm. Accessed July 26, 2013.

Sheridan, Terence. "Jury Blames Hough Riot on Professionals, Reds." *Plain Dealer*. August 10, 1966.
"Showman Here on Trail Dad Broke." *Plain Dealer*. February 3, 1930.
Simakis, Andrea. "Cleveland Play House Artistic Director Michael Bloom Bows Out after Nine Seasons." *Plain Dealer*. May 23, 2013. http://www.cleveland.com/onstage/index.ssf/2013/05/cleveland_play_house_artistic.html. Accessed May 23, 2013.
Simakis, Andrea. "Cleveland Play House's *One Night with Janis Joplin*: Musical Kicks Off North American Tour at Allen Theatre." *Plain Dealer*. May 23, 2013. http://www.cleveland.com/onstage/index.ssf/2012/07/cleveland_play_house_one_night.html. Accessed August 18, 2013.
"60 Hurt in Night Steel Strike Clash." *Plain Dealer*. July 27, 1937.
Sloan, M. L. "Letter to Mr. Frederic McConnell—Date unspecified." CPH Archives. Accessed September 10, 2012.
The Smell of the Kill. Internet Broadway Database. http://ibdb.com/production.php?id=13333. Accessed April 7, 2013.
Smith, James Allen. "Foundations as Cultural Actors." In *American Foundations: Roles and Contributions*, edited by Helmut K. Anheier and David C. Hammack. Washington, DC: Brookings Institution Press, 2010.
Smith, Robert L. "Cleveland's Inner City is Growing Faster Than its Suburbs as Young Adults Flock Downtown." *Plain Dealer*. April 28, 2012. http://www.cleveland.com/business/index.ssf/2012/04/clevelands_inner_city_is_gorn.html?utm_source=twitterfeed&utm_medium=twitter. Accessed August 2, 2013.
Smith, Robert L. "Cleveland's Manufacturing Industry Roaring Back, Expected to Surpass National Growth Rate." *Plain Dealer*. February 13, 2013. http://www.cleveland.com/business/index.ssf/2013/02/clevelands_manufacturing_indus.html. Accessed August 2, 2013.
Smith, Robert L. "Cleveland's Urban Scene Gets a Boost from Young Adults Moving In." *Plain Dealer*. January 21, 2013. http://www.cleveland.com/business/index.ssf/2013/01/clevelands_urban_scene_gets_a.html. Accessed February 17, 2013.
"Society by Christine." *Cleveland Press*. March 28, 1940.
"Society Events." *Plain Dealer*. May 14, 1912.
"South Euclid Run for C.T.S. Voted." *Plain Dealer*. March 16, 1948.
Spaeth, Arthur. "The Play." *Cleveland News*. March 6, 1940.
"Stage Hands Join Fight on Ben-Ami." *Plain Dealer*. May 11, 1929.
"Stage Union to Install." *Plain Dealer*. January 3, 1937.
Streator, C. M. "What Readers Think of the Play House and Critics." *Plain Dealer*. January 24, 1932.
"Suffrage Leaders Chosen by Party Here." *Plain Dealer*. February 2, 1914.
Sutherland, Donald. "Aristophanes and the Scope of Comedy." In *Classical Comedy—Greek and Roman: Six Plays*. New York: Applause Theatre Book Publishers, 1987.

Suttell, Scott. "Downtown Cleveland Proves to Be Population Hot Spot." *Crain's Cleveland Business.* May 4, 2012. http://www.crainscleveland.com/article/20120504/BLOGS03/120509891. Accessed February 17, 2013.

Swank, Niki. "Allen Theater, Playhouse Square." *Builders Exchange Magazine,* vol. 10, no. 10. http://www.bxmagazine.com/article.asp?ID=1219. Accessed August 2, 2013.

Taubman, Howard. *The Making of the American Theatre.* New York: Coward-McCann, 1965.

Taylor, William Alexander. *The Biographical Annals of Ohio, 1902–1903.* The State of Ohio Handbook, 1903.

"Theaters: *The Merchant of Venice*." *Plain Dealer.* January 25, 1900.

Thompson, Tazewell. "Letter to Bob Blattner—February 2, 1994." CPH Archives. Accessed December 10, 2012.

"Timeline." In *The Encyclopedia of Strikes in American History,* edited by Aaron Brenner, Benjamin Day, and Immanuel Ness. Armonk, NY: M. E. Sharpe, 2009.

Tittle, Diana. *Rebuilding Cleveland: The Cleveland Foundation and Its Evolving Urban Strategy.* Columbus: Ohio State University Press, 1992.

"Treasurer's Report of the Annual General Meeting—July 19, 2007." CPHAOF. Accessed March 1, 2013.

Truesdale, Maude. "A Cleveland Group Puts Art on the Stage and Makes the Box Office its Test." *Plain Dealer.* February 17, 1924.

Tucker, S. Marion. "Progress, Problems and Prospects." *Conference on the Drama.* Pittsburgh: Carnegie Institute of Technology, 1926.

Turbett, Peggy. "Allen Theatre: A New Gem for Playhouse Square." *Plain Dealer.* September 17, 2011. http://blog.cleveland.com/pdmultimedia/2011/09/allen_theatre_a_new_gem_for_pl.html. Accessed August 2, 2013.

"Two Exiled Czech Stars Will Become Play House Guests." *Plain Dealer.* February 14, 1940.

Ullom, Jeffrey. *The Humana Festival: The History of New American Plays at Actors Theatre of Louisville.* Carbondale: Southern Illinois University Press, 2008.

"Union Heads Deny Play House Plot." *Plain Dealer.* September 25, 1937.

"Union Letter of Teachers Stirs Anger." *Plain Dealer.* June 13, 1934.

"Union Speaks in Play House Fight." *Cleveland Press.* October 10, 1939.

"Union to Aid in Bombing Probe." *Cleveland Press.* September 27, 1937.

US Inflation Calculator. "Find the U.S. Dollar's Value from 1913–2011." US Inflation Calculator. http://www.usinflationcalculator.com. Accessed July 30, 2011.

"V&W: Famous Czech Comedians to Appear at City Club." *The City* (Cleveland), vol. XXV, no. 28 (March 13, 1940).

Vacha, John. *Showtime in Cleveland.* Kent, OH: Kent State University Press, 2001.

Van Tassel, David D., and John J. Grabowski, eds. *The Encyclopedia of Cleveland History.* Bloomington: Indiana University Press, 1987.

"The Voters Face Up to It." *Plain Dealer.* November 6, 1963.
"Wagner Act Aids Tilt with Critic." *Plain Dealer.* March 11, 1938.
Weaver, Robert A. "Letter to 'Citizen of Cleveland'—July 27, 1942." CPH Archives. Accessed September 7, 2012.
Weber, Bruce. "The Unsung Hero of Nonprofit Theater is Still Selling." *New York Times.* September 23, 1997.
"Wedding Announcement." Date unspecified. CPH Archives. Accessed September 7, 2012.
"The Welfare Bulletin." Cleveland, OH: United States Coast Guard. January 22, 1942. CPH Archives. Accessed September 7, 2012.
Western, Marjorie. "Drama Will Put Punch into War Bond Sale Campaign." *Cleveland News.* April 21, 1942.
White, Melvin R. "Thomas Wood Stevens: Creative Pioneer." *Educational Theatre Journal,* vol. 3, no. 4 (December 1951).
Whiting, Frederic Allen. "Your Museum Calls for Help." *Bulletin of the Cleveland Museum of Art,* vol. 9, no. 7 (July 1922).
Wilcox, Delos Franklin. *Analysis of the Electric Railway Problem.* New York: Published by the author, 1921.
"Will Play in Ibsen Drama," *Plain Dealer.* December 6, 1914.
Wilson, Ron. Interviewed by the author. Case Western Reserve University. Cleveland, OH. April 9, 2013.
Witchey, Holly Rarick, and John Vacha. *Fine Arts in Cleveland: An Illustrated History.* Bloomington: Indiana University Press, 1994.
Witwer, David. *Shadow of the Racketeer: Scandal in Organized Labor.* Urbana: University of Illinois Press, 2009.
"Woman's Page: Society Clubs." *Plain Dealer.* November 6, 1912.
Young, John Wray. *The Community Theatre and How It Works.* New York: Harper and Brothers, 1957.
Zeigler, Joseph Wesley. *Regional Theatre: The Revolutionary Stage.* New York: Da Capo Press, 1973.
Zieger, Robert H., and Gilbert J. Gall. *American Workers, American Unions: The Twentieth Century.* Baltimore: Johns Hopkins University Press, 2002.

Index

47 Workshop, 55
77th Street Theatre (complex), 108–13, 112f, 117, 126, 132, 135
 challenges of, 152–4
 financial issues and, 119–20
86th Street Theatre (complex), 66, 115, 126, 129
 after downtown move, 191
 controversy over, 179–80
100 Years of Solidarity, 82
7710 Euclid Corporation, 110–12

A313 papers, 95–8
Abady, Josephine, 158–70, 177, 178, 179, 184, 195
 board of directors and, 160–1, 163
 Circle in the Square Theater and, 169
 financial issues and, 162–4
 firing of, 165–70
 and firing of artistic staff, 159
 hiring of, 158–9, 172
 programming and, 161–2
Abbott, Dave, 183
Actors Equity, 77–8, 84, 127
Actors Theatre of Louisville, 118, 155, 171
Adding Machine, The (Rice), 72
administrative issues. *See also* board of directors
 O'Neil and, 41–7
African Americans. *See also* Hough neighborhood
 post-WWII migration of, 122
 programming and, 167

After Quiet Pleasures, 68f
Akalaitis, JoAnne, 172
Aladdin (Brooks), 65
Albers, Catherine, 156, 159–60, 167, 172
Alda, Alan, 127
Allen Theatre, 1, 183
 renovation of, 188, 188f
Alley Theatre, 9, 114, 116, 118, 151, 155, 171
Alliance Theatre, 144, 196
American Repertory Theatre, 144
Ammon House, 15–16, 33, 34, 35, 68, 183
Amorous Flea, The (Molière), 143
Anderson, Maxwell, 98, 99
Anderson, Porter, 168
Anderson, Robert, 147
Andrews, Suzanna, 157
Andreyev, Leonard, 84
Angell, Ernest, 10, 19–20
Angell, Katherine, 10, 18, 19–20, 21
archives, preservation of, 3
Arena Stage, 9, 151, 162, 170, 199
Arena Theatre, 114, 118
Aristophanes, 146–8
Arms and the Man (Shaw), 66
Arsenic and Old Lace (Kesselring), 106, 119
art theatre, 29–30
 CPH as, 31–3, 38, 51–2
Arts and Crafts Theatre, 55
Asner, Ed, 161
Ass and His Shadow, The (Voskovec & Werich), 100

266 *Index*

Associate Artists Program, Hackett and, 177
Atkinson, Brooks, 108
audiences, 32
 demographics of, 167, 192
 lack of support from, 155

Backward in High Heels, 2
Bailey, Henry Turner, 44
Baker, George Pierce, 55
Baldwin, Lillian, 61
Barefoot in the Park (Simon), 143
Barnes, Clive, 127
Barnum, P. T., 11–12
Barrie, Marthena, 10, 23, 24
Barrymore, Ethel, 13
Bear, The (Chekhov), 34
Bedard, Roger, 64–5
Bellamy, Paul, 90, 93, 101
Bellamy, Peter, 146, 147–8
Ben-Ami, 84–5
Benelli, Sam, 67
Berkowitz, Gerald M., 151, 163, 170
Beyond Broadway: The Quest for Permanent Theatres (Novick), 143
Beyond the Horizon (O'Neill), 62
Black Comedy (Shaffer), 145
Blattner, Robert, 165, 166, 169, 175
Bloom, Michael, 2, 182–5, 187, 189, 190, 192, 193, 195–7, 199
board of directors
 86th Street Theatre and, 179–80
 1960s relocation and, 137–8
 Abady and, 160–1, 163
 antiunion views of, 90–1
 changing composition of, 157–8
 and concerns about crime, 129–30
 downtown relocation and, 184–5
 financial issues and, 153–5
 Lowe's resignation and, 143–4
 Lysistrata and, 146–9
 Oberlin's dismissal and, 156–7
 questionable decisions of, 170–1
 relocation options and, 152
 retreat of, 175
 role of, 37, 39, 42–3, 45–7, 49, 55
 white flight and, 139
 during World War II, 104
Bolton, Kenyon, 129, 149
Bolton Theatre, 155–6, 187
bombing. *See* theatre bombing
Booth, Clare, 99
Booth, Susan, 196
Born Yesterday (Kanin), 113, 161
Borowitz, Albert I., 148
Brecht, Bertolt, 2, 188
Bright Ideas (Coble), 176
Brooks, Charles S., 18, 19, 20, 39, 46, 51, 58, 114, 145
 educational outreach and, 59–60
 founding role of, 10
 fund-raising and, 68–9
 marionette shows and, 64–5
 new facility and, 67–8
 search committee and, 55
Brooks home, 13, 16
Brooks, Minerva, 10, 18, 20, 21, 26–7
Brooks Theatre, 67, 68f, 106, 108, 109, 117, 127, 176, 177, 184, 188
Broomstick, 83
Brown, Alexander C., 90
Brown, Tony, 185, 187
Bruno, Robert, 86–7
Burton, Harold, 88

Carnegie, Andrew, 69
Case Institute of Technology, 138
Case Western Reserve University, 138–9, 181–2
 CPH archives and, 3
 Master of Fine Arts program of, 176, 177
casting
 Abady and, 161–2
 McConnell and, 58
Cedar Avenue Theatre, 36, 37, 40, 42, 59f, 63, 66–7, 68
Celebrezze, Tony, 133–4

Cemetery Club, The (Menchell), 162
Century of Struggle: The Woman's Rights Movement in the United States (Flexner), 26
Chaplin, Charlie, 84
Charlotte's Web (White), 19
Chase, Mary, 145
Chase, Tony, 168
Chekhov, Anton, 34
Chernow, Ron, 14
Chicago Little Theatre, 84
children's theatre, 59–66, 133, 157–8, 162
Children's Theatre Guild of New Orleans, 63
Children's Theatre of Maine, 64
Children's Theatre: Play Production for the Child Audience (Davis & Watkins), 63
Christmas Carol, A, 164
Cigliano, Jan, 15
Cincinnati Little Civic Theatre, 84
Cinderella, 41
Circle in the Square Theater, 169
Citizens Committee for Review of the Grand Jury Report, 125, 126, 128
Clarence (Tarkington), 106
Clark, William B., Jr., 65, 105
Cleveland
 African American migration to, 122 (*see also* Hough neighborhood)
 CPH's relationship with, 5–6, 6–7
 cultural institutions in, 44–7
 deterioration of, 128–30
 economic hardships in, 48–9
 federal urban funding and, 133–4
 and neglect of urban population, 121, 128–9
 political trends in, 26–7
 post-recession recovery of, 186–7
 racial strife in, 120
 recession of 2008 and, 185–6
 reputation of, 121
 servicemen from, 103–4
 turn-of-century character of, 10–12
 union strikes in, 87, 88
Cleveland Center of the Drama League of the Americas, 41
Cleveland Clinic, 137, 179, 183, 184
Cleveland College, affiliation with, 65
Cleveland: Confused City on a Seesaw (Porter), 128
Cleveland Development Foundation, 138
Cleveland Museum of Art, 44–6, 49–50, 60–1, 66
Cleveland: Now!, 140
Cleveland Orchestra, 1, 44, 46–7, 50, 60–2, 66, 192
Cleveland Orchestra Story: Second to None, The (Rosenberg), 45
Cleveland Plan, 61
Cleveland Play House, 1–2
 1915–1921 era of, 31–3
 1950s–1960s era of, 126–7
 1969–1971 era of, 145–50
 2013 strategic plan of, 199–200
 attempts to categorize, 29
 changing locations of, 34–5 (*see also* specific theatres)
 divisions among members of, 33–5
 downtown relocation of, 182–93
 financial and leadership challenges of, 4–6 (*see also* board of directors; financial issues; funding)
 founding of, 4
 legacy of, 200–1
 move of, 1–2
 opening of, 1
 post-1921 era of, 33–7
 productions of (*see* programming; specific plays)
 theatre complex project of, 155–6
Cleveland Public Library, 40–1, 53
Cleveland School of Music, 44
Cleveland School of the Arts, 45, 182
Cleveland State University, 138, 191, 192

Cleveland State University
 Department of Theatre, 189
Cleveland Suffrage League, 26
Cleveland Urban Renewal
 Commission, 137
Clisbee, George, 10, 23, 25
Clybourne Park, 193
Coble, Eric, 176
Collins, Russell, 65
Columbus, Curt, 196
Command (Haines), 116
community involvement/outreach
 decreased, 130–3
 McConnell and, 58–9
 Playhouse Square location and, 191–2
community theatre, 29–30
 CPH's transition to, 58
 unions and, 84–5
Congressional Union, 26
Connors, Joanna, 188
Copley Theatre Stock Company, 84
Cornberg, Sol, 98
Coward, Noel, 146
Craig, Edward Gordon, 16, 19, 28, 31, 37, 43, 47, 50, 62
Crane, C. Howard, 188
Creative Cafes, Inc., 181
crime, rise of, 128–30, 133–4
Curtain Pullers, 65–6, 133, 157
Cushman, Charlotte, 11
Cuyahoga Community College, 138
cyclorama, 16–17, 36, 58

Dallas Theatre Center, 155, 196
Dancing at Lughnasa (Friel), 178
Danforth, Roger, 156, 158, 164, 170–2, 175
Davey, Marvin, 87, 88
Davis, Jed H., 63
Dean, Alexander, 30, 48, 53
Death of Tintagiles, The (Maeterlinck), 19, 33
Dempsey, Mrs. John B., 90
Denver Theatre Center, 178

DiPasquale, Pamela, 191
Dobama Theatre, 151
Doll's House, A (Ibsen), 32
Dray, Philip, 92
Draz, Frank, 112
Drunkard, The (Barnum), 11–12
Drury, Francis E., 10, 15–16, 34, 35, 67–8
Drury, Julia, 15–16
Drury Theatre, 117, 187
Duchess Theatre, 55
Dumb Messiah, The, 42

Earnshaw, Allen, 22
educational outreach, 59–66
 Cleveland Art Museum and, 61
 Cleveland Orchestra and, 61–2
Educational Work at the Cleveland Museum of Art (Munroe & Grimes), 61
Effect of Gamma Rays on Man-in-the-Moon Marigolds (Zindel), 116, 145
Eisenstat, Max, 56–8, 95, 126
Elderkin, N. S., Jr., 97–8
Ellsler, John A., 12
"endangered theatre" designation, 163–4, 173
Endgame, 146
Engelhardt, Rolf, 126
Erieview development, 133–4, 137, 186
Euclid Avenue
 deterioration of, 128–9
 federal funding and, 134
 history of, 13–15
Euclid Avenue home, 10–11, 13–16
Euclid Avenue Opera House, 12, 13, 191
Eustis, Oskar, 196
Evans, Fred "Ahmed," 140
Eve of St. Mark, The (Anderson), 98, 99, 116
Every Good Boy Deserves Favor (Stoppard & Previn), 1, 2, 192
Evett, Marianne, 160, 166, 167, 178

federal funding, Hough neighborhood and, 133–4
Federal Urban Redevelopment Program, 133–4
Feigenbaum, Abe, 122–3
Feigenbaum, Dave, 122–3
Fences (Wilson), 167
Fenn College, 137–8
Fichandler, Zelda, 114, 157, 170
financial issues, 82–4. *See also* funding
 77th Street Theatre and, 110–13, 119–20
 1983–1984 season, 156–7
 board's neglect of, 152–5
 current, 197–200
 early 1940s, 103–7
 Hackett and, 178–83
 O'Neil and, 47–50
 during World War II, 98, 118–20
Fine Arts in Cleveland (Witchey and Vacha), 44
Finegan, William, 78
Fiske, Minnie Maddern, 32
Fitzgerald, John B., 78–80, 82
Flexner, Eleanor, 26
Flight to the West (Rice), 99
Flory, Julia McCune, 9–10, 27, 33, 34, 40, 42, 46, 55, 59, 60, 62, 67
Flory, Walter L., 34–6, 37, 38–9, 42, 43, 46, 47–8, 51, 58, 109–13
 death of, 126
 new facility and, 67–9, 70
 relocation and, 67
 search committee and, 55
 significance of, 72–3
 unions and, 90
Ford, Elijah, 121, 129
Ford Foundation, 151, 154
founders, 22–3
 futurist and women's suffrage movements and, 25–8
 identities and connections, 16–24
 public's attitudes toward, 28
Freed, Donald, 116

Freed, Eugene, 127
Friel, Brian, 178
funding, 67–71, 127, 132
 board of director transitions and, 157
 competition for, 151
 federal, Hough neighborhood and, 133–4
 sources of, 154–5
fund-raising model, 59
futurist movement, critics' responses to, 25–6

Gable, Clark, 116
Galileo (Brecht), 2, 188, 192
Game's Afoot, The (Ludwig), 189
Garden of Semiramis, The, 36, 37f
Gardner, Bertram, 125
Gardner, Herb, 166, 169
George Washington Slept Here (Moss & Hart), 106
Ghosts (Ibsen), 32
Gibson, Emily, 60–1
Girdler, Tom, 87
Gladden, Dean R., 163, 167–70, 172, 179
Glenville neighborhood, 151
Glenville Shootout, 140
Goff, Frederick H., 70
Goldman, James, 164
Good, Tom, 163
Goodman Theatre, 84, 98, 131, 144, 178, 184
Gordon, Mark Alan, 181–2
Gordon, William, 18, 26
Granny Maumee (Torrence), 41
Grapes of Wrath, The, 178
Great Depression, 70, 72, 76, 83
Great Lakes Shakespeare Festival, 151
Great Lakes Theatre Festival, 181
Greek Theatre, 56
Greene, William, 144–6, 170
Grey, Joel, 65, 166
Grimes, Jane, 61
Guare, John, 166

Gund Foundation, 183
Gundry, Mrs. John M., 18, 21
Guthrie Theater, 9, 171
Guthrie Theater Workshop, 144
Guthrie, Tyrone, 127, 157
Guthrie-Rea proposal, 136

Hackett, Peter, 169
 appointment of, 175
 Associate Artists Program and, 177
 legacy of, 175–6
 programming and, 176–8
Hahn, Richard, 161, 169
Haines, William Wister, 116
Halverson, Richard, 147, 152, 160
Hanna, Leonard C., Jr., 90, 109–11, 136
Hanna, Marcus A., 12–13, 25, 28
Hansel and Gretel, 62–3, 64, 65, 66
Hart, Moss, 106
Hartman, Elek, 98
Harvey (Chase), 145, 168
Hatcher, Jeffrey, 189
Hauptmann, Gerhart, 32
Having Our Say, 178
Hayes, Helen, 106
He Who Gets Slapped (Andreyev), 84–5
Heart of the City, The (Storms), 99
Heavy Barbara (Voskovec & Werich), 99, 100f, 102, 115
Hedda Gabler (Ibsen), 32, 72
Hessman, Howard, 162
Hilliary, Dennis, 123
Hines, Maurice, 199
Historical Guide to Children's Theatre (McCaslin), 63
Hitler, Adolf, 100
Hohnhorst, Anna, 10
Hohnhorst, Henry, 10, 23, 25, 43
Hough neighborhood, 151
 and decreased community involvement, 130–3
 and fear of crime, 127–30
 living conditions in, 122
 urban funding and, 133–4
 white flight and property devaluation and, 133–40
Hough Riots, 5, 110, 121–5
 city neglect and, 128–9
 city response to, 124–5
 disconnect with CPH and, 126–40
 subscriptions and, 132
Houghton, Norris, 115
Hour Glass, The (Yeats), 34
Hughes, Adella Prentiss, 44–5, 47
Hull House, 51
Hull House Theatre, 84
Humana Festival at Actors Theatre of Louisville, 144
Humana Festival of New American Plays, 131
Hume, Sam, 55, 56

I Can't Hear You When the Water's Running (Anderson), 147
Ibsen, Hendrik, 72
Ideas of the Woman Suffrage Movement, The (Kraditor), 19
In the Next Room, or The Vibrator Play (Ruhl), 2, 189
In the Round (Jones), 114
Indianapolis Junior Civic Theatre, 63
Inherit the Wind, 152
Inquest (Freed), 116
institutional theatre, 33
International Alliance of Theatrical Stage Employees (IATSE). *See* Local 27 (IATSE)
Irving, Henry, 13
It's a Wonderful Life, 2

Jackson, Frank, 186
Jackson, Leo, 124
Jacques Brel Is Alive and Well and Living in Paris, 151
Jar the Floor (West), 178
Jelliffe, Rowena, 41
Jelliffe, Russell, 41
Jest, The (Benelli), 67

Joe Egg (Nichols), 145
Johnson, Phillip, 158
Johnson, Tom L., 26, 34
Johnston, Christopher, 201–2
Jones, Chris, 168, 175
Jones, Kenneth, 178
Jones, Margo, 114–15, 116
Jones, Myrta L., 21
Jones, Trish Pugh, 131
Jory, Jon, 33, 127, 131, 157
Joseph, Helen, 62
Julliard School, 69
Junior League, children's theatre and, 64
Junior Repertory Theatre of Minneapolis, 63

Kahn, Madeline, 161
Kanin, Garson, 113, 161
Karamu House, 41
Kaufman, George, 106
Keller, Henry, 16–17, 18, 22, 23, 25
Kelly, Katherine Wick, 56
Kelvin Smith Library, CPH archives and, 3
Kennedy, Robert F., 140
Kepley, Laura, 195–7
Kerr, John H., 136
Kesserling, Joseph, 106
King, Martin Luther, Jr., 140
Kirkham, George, 155
Kite Runner, The, 2
Klein, Herbert, 101
Kokoon Arts Klub, 21–2, 24, 38
Korean War, 127
Kraditor, Aileen S., 19
Kreymborg, Alfred, 31
Kuhn, Peter, 180, 182–5, 187, 189, 190, 192, 200

labor unions. *See* Local 27 (IATSE); unions
Lackritz, Marc E., 122
Lausche, Frank J., 104

leadership. *See also* board of directors
shift in, 37–50
League of Resident Theatre (LORT), 127, 140–1
Leaps of Faith (Oldenburg), 75, 152
Legacy of Light (Zacarias), 2
Liberated Theatre, 100–1
Lichtenstein, Nelson, 86
Lion in Winter, The (Goldman), 164
Lips Together, Teeth Apart (McNally), 178
Lithgow, Arthur, 151
"Little Steel" strike, 87–9
Little Theatre (Chicago), 31
Little Theatre movement, 29–31
 children's theatres and, 63
 CPH and, 51, 53–4
 fiscal management and, 48
 folding of, 84
 social purposes of, 52
Little Theatre Organization and Management (Dean), 30, 48
Littman, Alan L., 139
Local 27 (IATSE)
 1937 context of, 85–9
 bargaining tactics of, 82–3
 and charges of anti-Americanism, 92
 expectations of, 80–5
 picketing by, 81, 81f
 tension with CPH, 77–86
 theatre bombing and, 77–80
Locher, Ralph, 123–4, 134
Logan, John, 2, 189
Longwood Gardens, 69
Looking Glass Theatre, 184
Lost Highway (Myler), 176
Love, Janis (Myler), 176
Lowe, K. Elmo, 56–7, 59f, 83, 106, 115, 118, 129, 140, 150, 170, 184
 1960s relocation and, 137
 death of, 150
 as director, 127
 Newman and, 131–2
 programming debate and, 76–7

Lowe, K. Elmo—*Continued*
 resignation of, 141, 143
 strengths of, 171
 training program and, 144
Lowe, Michele, 176
Ludwig, Ken, 2, 153, 189
Lunt, Alfred, 106
Lysistrata (Aristophanes), 146–9, 170–1

Maeterlinck, Maurice, 19, 32, 33
Mahler, Gustav, 44
Manhattan Theatre Club, 144, 169
Mann, Emily, 166
Margin for Error (Booth), 99
marionettes, 16–17, 33, 60, 62–3, 64–5
Mark Taper Forum, 9
Martin, Joe, 180
Mastroianni, Tony, 147–8
Mather, Samuel, 14
McBride, Lucia McCurdy, 38–9, 42, 43
McCarter Theatre, 98, 178
McCaslin, Nellie, 63
McConnell, Frederic, 29, 55–6, 59f,
 71, 127, 159, 184
 death of, 126
 Hough neighborhood and, 135–6
 leadership style of, 56–8
 Local 27 and, 78–9
 new facility and, 67–8
 open stage and, 107–13, 117–18, 120
 Play House Scholarship Fund and, 65
 programming and, 62, 72, 76–7, 99
 and push to expand, 118–19
 regional theatre and, 113–18
 relocation and, 66–7
 strengths of, 171
 veterans and, 98
 Voskovec and Werich and, 101
 World War II and, 101–3
McDermott, William F., 76, 82, 115
McGuire, F. T., 113
McKinley, William, 13
McLaughlin, Robert, 85
McNally, Terence, 178

media, anti-union bias of, 89–90, 93
Menchell, Ivan, 162
Men's Club, 136
Men's Committee, 165
Metropolitan Opera, 69
Miller, Arthur, 153
Miller, Carol Poh, 26
Miller, Robert Anthony, 26
Millionaire's Row, 14, 15, 191
Milwaukee Repertory Theatre, 151, 155
Misanthrope, The (Molière), 168
Molière, 31, 143
Moore, Kevin, 179–81, 182–5, 187,
 193, 197–200
Moriarity, Kevin, 196
Morse, Robert W., 138
Moscow Art Threatre, 16
Mother Love (Stringberg), 33
Mulhauser, Frank, 55
Mullins, Esther, 65
Mummers Theatre, 151
Munich Agreement, 100
Munro, Thomas, 61
Museum of Contemporary Art, 179, 189
Music School Settlement, 44
Musical Arts Association, 137
My Name is Asher Lev, 2
Myler, Randal, 176

National Labor Relations Act
 (Wagner Act), 86, 89
Ness, Eliot, 78f, 93
New Ground Theatre Festival, 1, 192
New York Shakespeare Festival, 172
Newberry, John Strong, 43, 51
Newman, Danny, 130–2
Newman, Paul, 65
Newmark, Bob, 175
Nichols, Peter, 145
Nickel Plate Railroad, 14
Nine Girls (Pullen), 99
Northern Stage Company, 175
Norton, Laurence H., 78, 90
Novick, Julius, 143

Noyes, Florence Fleming, 23–4, 33
Noyes School of Rhythm, 23–4
Nuit Futuriste!, La, 23, 24, 25–6

Oberlin, Richard, 145, 149–50, 196
 directorship of, 150–6
 dismissal of, 156–7, 171
Ohio Association Opposed to
 Woman's Suffrage, 18–19
Old Globe, 162
Oldenburg, Chloe Warner, 33, 57, 59,
 67, 71, 75, 118, 149, 152, 153, 179
Olivier Theatre, 118
On Golden Pond, 178
One Night Productions, 199
One Night with Janis Joplin, 199–200
O'Neil, Angelina, 16
O'Neil, John H., 16
O'Neil, Raymond, 16, 17f, 18, 22, 23,
 24, 28, 31, 34, 35, 62, 72
 administrative leadership of, 41–7
 conflicts with board of directors
 and membership, 37–51
 CPH artistic productivity and, 40–1
 death of, 127
 economic management by, 47–50
 founding role of, 10
 limitations of, 56, 73
 resignation of, 33, 39, 51, 52f, 55
O'Neill, Eugene, 62
O'Neill, James, 13
open stage, 107–13, 117–18, 120
Orlock, John, 176
Outcalt Theatre, 189

Papp, Joe, 172
Park School, 62
Parker, Douglass, 147
Parrino, Thomas, 124
Partington, Rex, 145, 148–50, 171
Pasadena Playhouse, 84, 98, 115
Paulus, Al, 197
Peer Gynt (Ibsen), 32
Pei, I. M., 134

Pendleton, Alec, 182, 183, 189, 198,
 199, 200
Peter Pan, 164–5, 178
Philadelphia Story, The, 168
Pickford, Mary, 84
Piiparinen, Richey, 187
Pittsburgh Playhouse, 84
Plain Dealer, 9
Play House Children's Theatre
 (Curtain Pullers), 65–6.
 See also Curtain Pullers
Play House Club, 132, 154, 165,
 179–82
Play House Foundation, 69–70, 72, 109
Play House Scholarship Fund, 65
Play House School of Theatre, founding
 of, 65
Play House Women's Committee, 102
Playhouse Settlement, 41, 44
Playhouse Square, 151, 184
 2008 recession/recovery and, 185–7
 audience demographics and, 192
 benefits of, 187–91
 move to, 6, 182–93
 programming and, 189–90
Polster, William A., 136
Porter, Philip W., 128, 134
Potting Shed, The, 152
Power of Three, The, 183, 191–2, 197
Prescott, Mrs. Charles H., 62
Previn, André, 1, 192
professional status, transition to, 58
programming
 77th Street Theatre and, 113
 Abady and, 161–2
 city's influence on, 3
 commercialization of, 2, 76,
 113–18, 132, 150, 178
 coproductions and, 199–200
 Hackett and, 176–8
 McConnell and, 62, 72, 76–7, 99
 minorities and, 167
 by new playwrights, 144–5
 O'Neil and, 40–1

programming—*Continued*
 at Playhouse Square, 189–92
 during World War II, 98–102, 105–7
Progressive Era, 30, 60–1
Provincetown Players, 54, 84
public schools
 arts promotion in, 60–1
 children's theatre and, 65–6
 Cleveland Museum of Art and, 61
 Cleveland Orchestra and, 61–2
 Curtain Pullers and, 133
 Playhouse Square programming and, 191–2
Public Theater, 196
Pullen, Glenn C., 99
Puppet Players Guild, 62–4, 72
puppet shows. *See* marionettes

racial relations, 5. *See also* Hough neighborhood; Hough Riots
 fear of crime and, 128–30
 white flight and, 133–40
racism, influence of, 110
Radio Golf (Wilson), 2, 189
Ratcliff, Eddie, 129
Rauch, Don, 95–7, 96f
Rea, Oliver, 127
recession of 2008, Cleveland and, 185–6
Red (Logan), 2, 189
Red Rust (Kitchen & Ouspensky), 77
regional theatre
 closures of, 170
 CPH and, 4, 113–14
 developments in, 5
 histories of, neglect of CPH in, 9–10
 origin of, 114
 subscription strategy and, 130–2
 tenets of, 114
 trends toward new playwrights and, 144
Regional Theatre (Zeigler), 9, 113–14, 130–1

Reinhardt, Max, 16
Report of the Relocation Committee, 139–40
Republic Steel, strikes against, 87–9
Republican Party, antiunion position of, 90
Rhys, William, 156–8, 171
Rice, Elmer, 72, 99
Robinson, Edwin Arlington, 56
Rockefeller Foundation, 83, 111, 151
Rockefeller, John D., 14, 69
Rogers, Ginger, 2
Rogers, Will, 84
Romeo and Juliet, 108
Roosevelt, Franklin D., 86, 92
Rosenberg, Donald, 45, 62
Rosmersholm (Ibsen), 32
Royal Hunt for the Sun, The (Shaffer), 145
Ruhl, Sarah, 2, 189

School for Wives (Molière), 143
Schramm, David, 162
Schulfer, Roche, 131
Schwartz, Michael, 183
search committee, 55
Seattle Repertory Theatre, 162, 178
Second National Conference for Progressive Political Action, 60
Security Fund campaign, 104–5, 107
Seldes, George, 89
Sells, Boake, 163, 165, 166, 168
Seltzer, Louis, 124–5
settlement houses, 41, 44
Seventy-Niners Club, 122, 126
Shaffer, Peter, 145
Shakespeare Festival, 105
Shaw, George Bernard, 32, 66
Sheehy, Helen, 115
Shepardson, Ray, 151
Sherman, Mrs. Arthur Carr (Barbara), 97
Showplace of America (Cigliano), 15
Showtime in Cleveland (Vacha), 75

Sidlo, Thomas L., 90
Simon, Neil, 143, 178
Sloan, M. L., 110
Slusser, Louise, 176
Smell of the Kill, The (Lowe), 176
Smith, Leonard, 51
Smith, Robert L., 186
Snyder, Barbara, 183
South Coast Repertory, 162
Speaker, Tris, 19
Spotlight on the Child: Studies in the History of American Children's Theatre (Bedard), 64–5
stagehands, economic issues and, 82, 84
Stages at the Play House, 181
State of the Union (Lichtenstein), 86
steel industry, strikes in, 87
Steel Workers Organizing Committee, 88
Steppenwolf Theatre, 184
Stevens, David H., 111
Stevens, Thomas Wood, 55
Stokes, Carl B., 125, 140
Stoppard, Tom, 1, 192
Storms, Lesley, 99
Strauss, Richard, 44
Streator, C. M., 77
strikes, prevalence of, 86–7
Stringberg, August, 33
subscriptions, 72, 120, 130–2, 148, 153, 156, 160, 162, 164–6, 169, 182, 184, 197–9
Sullivan, Margaret, 122–3
Sun Up (Vollmer), 41
surburban flight. *See* white flight
Sutherland, Donald, 147–8
Swasey, Ambrose, 111
Syracuse Stage, 166

Tappin' Thru Life, 199
Tarkington, Booth, 106
Tempest, The, 140, 143

Ten Chimneys (Hatcher), 189
Terry, Ellen, 13
Theatre '47, 114
theatre bombing, 5, 78f
 impacts of, 77–8, 91–3
 Local 27 and, 78–80
 misunderstanding of, 75
 theatre in search of home, theme of, 2–3, 6, 24–8
TheatreLab, 144, 146
There is Power in a Union (Dray), 92
Thomas, Marlo, 162
Thompson, Tazewell, 166
Three Penny Opera (Brecht), 146
Torrence, Ridgeley, 41
Toy Theatre, 31, 51, 84
Travanti, Daniel J., 162, 166
Treat, Grace, 10, 18, 23, 26–7, 43
Treat, Ida, 18, 23, 25, 34
Trinity Repertory Company, 196
Trip to Bountiful, The, 22
Triumvirate, 57–8, 72, 126–7, 171
Trombly, Bob, 181
Tucker, Samuel Marion, 30–1

unions. *See also* Local 27 (IATSE)
 Cleveland media and, 89–90, 93
 community theatres and, 84–5
 Ohio context of, 80–1
 public perceptions of, 92
 role of, 60
 significance of, 5
 Wagner Act and, 86
United States vs. Julius and Ethel Rosenberg, The (Freed), 116, 127, 141
University Circle, 136
University–Euclid project, 134–5

Vacha, John, 12, 44, 75
Van Zorn (Robinson), 56–7
Vance, Nina, 114, 157
Venus in Fur, 193

Vollmer, Lulu, 41
Voskovec, Jiri (George), 99–102, 100f, 105, 115, 119

Wade, Jeptha, Jr., 14, 45
Wagner Act, 86, 89, 90
Wagner, Richard R., 124
Wagner, Robert F., 86
Waltermire, Tom, 186
Wappin' Wharf, 20
Warner, Worchester, 111
Washington Square Players, 51, 54, 84
Watkins, Mary Jane Larson, 63
Weaver, Robert A., 90, 104
Werich, Jan, 99–102, 100f, 105, 115, 119
West, Cheryl L., 178
Western Reserve University, 136
Wexler, Norman, 145
Whipping Man, The, 190
White, E. B., 19
white flight, 105–6, 133–40
Whiting, Frederic Allen, 50, 60
Who's Afraid of Virginia Woolf?, 13
Wild Duck, The (Ibsen), 72

Williams, Tennessee, 115
Wilson, August, 2, 167, 189
Wilson, Ron, 177
Wings over Europe, 98
Witchey, Holly Rarick, 44
Woman's-suffrage Party, 18, 21, 27
Women's Committee, 132
Women's Committee Board, 71–2
World War I, 31
World War II, 5
 A313 papers and, 95–8
 CPH support of, 101–3
 financial issues during, 118–20
 theatre challenges during, 103–7

Yeats, William B., 34
Yiddish theatre, 84
You Can't Take It with You, 168
You Touched Me (Williams), 115
Youngstown, union strikes in, 88

Zacarias, Karen, 2
Zeigler, Joseph Wesley, 9, 58, 113–14, 118, 130–1
Zindel, Paul, 116, 145

GPSR Compliance

The European Union's (EU) General Product Safety Regulation (GPSR) is a set of rules that requires consumer products to be safe and our obligations to ensure this.

If you have any concerns about our products, you can contact us on

ProductSafety@springernature.com

In case Publisher is established outside the EU, the EU authorized representative is:

Springer Nature Customer Service Center GmbH
Europaplatz 3
69115 Heidelberg, Germany

www.ingramcontent.com/pod-product-compliance
Lightning Source LLC
LaVergne TN
LVHW012059070526
838200LV00074BA/3670